D0680430

THE DISTANCING OF GOD

183825

THE DISTANCING OF GOD

The Ambiguity of Symbol in History and Theology

BERNARD J. COOKE

246
c772

FORTRESS PRESS MINNEAPOLIS

Alverno College
Library Media Center
Milwaukee, Wisconsin

THE DISTANCING OF GOD
The Ambiguity of Symbol in History and Theology

Copyright © 1990 Augsburg Fortress. All rights reserved. Except for brief quotations in critical articles or reviews, no part of this book may be reproduced in any manner without prior written permission from the publisher. Write to: Permissions, Augsburg Fortress, 426 S. Fifth St., Box 1209, Minneapolis, MN 55440.

Scripture quotations unless otherwise noted are from the Revised Standard Version of the Bible, copyright © 1946, 1952, and 1971 by the Division of Christian Education of the National Council of Churches.

Interior design: Publishers' WorkGroup

Library of Congress Cataloging-in-Publication Data

Cooke, Bernard J.
 The Distancing of God : the ambiguity of symbol in history and theology /
Bernard J. Cooke.
 p. cm.
 Includes bibliographical references.
 ISBN 0-8006-2415-7
 1. Christian art and symbolism. 2. Presence of God. I. Title.
BV150.C66 1990
246—dc20 89-37461
 CIP

The paper used in this publication meets the minimum requirements of American National Standard for Information Sciences—Permanence of Paper for Printed Library Materials, ANSI Z329.48-1984. ∞™

Manufactured in the U.S.A. AF 1-2415

94 93 92 91 90 1 2 3 4 5 6 7 8 9 10

Contents

Preface

Nothing is more evident in today's world than change, and few things are so ambiguous as the nature of this change. Civil institutions, moral attitudes, religious behavior, patterns of economic and technological development—all are already quite different from what they were at the beginning of this century, and one can scarcely hazard a guess as to what they will be in the next. This is the observable level of change; still deeper is the shift in those fundamental symbols from which spring people's understandings of life, their deepest motivations and convictions, and consequently their decisions and activity. It has often been observed that people's symbols are the "engine" of their society and culture, which suggests that an insight into the change that has been occurring in humanity's symbols will contribute importantly to grasping the character of today's changing world.

The purpose of this book is twofold: first, to study one aspect of *religious* symbolism—its impact on Western Christians' sense of the presence or distance of the God they worship—as it developed over the past two millennia; and second, to examine briefly the effect on our understanding and nurturing of religious symbols that can come from contemporary social, behavioral, historical, and literary scholarship. I am conscious that even this limited objective cannot be perfectly achieved in one volume; yet I am hopeful that this effort will motivate others, recognizing that the issue is of ultimate theoretical and practical importance, to supplement what I have accomplished.

My claim to professional self-identification is "sacramental theologian"; at least that is what I have worked at for four decades. Today I am more convinced than ever that after centuries of looking at Christian

ritual from the perspective of canon law or moral theology or Aristotelian causality, we have scarcely begun to do sacramental theology. Perhaps this book will move us a step closer to appreciating the rich symbolism that lies at the root of Christianity's power to free humans for a life of vision, imagination, and creativity.

Often a book's preface mentions somewhat specifically an author's debts to other authors or researchers; in the present case this is made impossible because of the extent to which the study rests upon the research and reflection of hundreds of scholars. Without these resources of careful research, analysis, and reflection, the book could never have been envisaged, much less written. However, special acknowledgment must be made of the year I spent as a Fellow at the Woodrow Wilson International Center for Scholars in Washington, D.C., a year that provided not only leisure amid the stimulation of scholars-become-friends from across the globe but also the technical resources to facilitate the research from which this volume has emerged. In a special way I was helped that year by Ann Sheffield's direction of the program in History, Culture and Society, and by the Center's librarian, Zdenek David. A final word of appreciation is owed to J. Michael West and Timothy G. Staveteig, editors at Fortress Press, who have graciously and effectively shepherded the book from manuscript to published text.

HISTORY AND THEOLOGY

John Steinbeck may well be right when he says in *East of Eden* that there is ultimately only one plot for all literature, the struggle between good and evil. But it seems to me that there is a still more basic issue that human reflection has tried to resolve: the relation between the created and the uncreated. This is the classic question of the one and the many, of the unlimited and the limited. It is the question of the transcendence or immanence of divinity in relation to creation, particularly to humans. In at least one worldview, that of Christianity, it is the question of sacramentality, that is, of the way divinity manifests itself through some kind of communicative presence in human affairs.

A THEOLOGY OF PRESENCE

We may be today at the point of breaking through to a new level in dealing with this perennial question. Apparently we can now move toward a deepened understanding of sacramentality which will bypass many of the old controversies and questions. Because we are more aware of presence as a *personal* reality, because we know more accurately the dynamics of symbolic communication as it establishes presence, because we appreciate (through social and behavioral studies) how individual distinctiveness and personal union in love are interdependent, we can examine in more critical detail the consciousness of "God among us" which characterized earliest Christianity's understanding of salvation in Jesus as the Christ.

Since this book essays a "theology of presence" with focus on the function of symbol in enabling or blocking divine presence, it might be well to start with a preliminary description of three ways in which divinity has been said to be in contact with created reality and with human life in particular. First, at a few crucial moments in history there is a special

intervention of the divine in chosen intermediaries, through whom a "message" is left regarding the divine will. Second, there is a presence of a particular divine power whenever there occurs an exercise of the function connected with that power or a shape related to (or resembling) that power—ultimately this leads to the philosophical question of *participation*. Third, there is a continuing personal presence of divinity with humans when the divine "comes down" to join humans and actually share their life experience, communicating with them on a regular and familiar basis. These three generally overlap in people's thinking and in their religious behavior; but it is imporant to keep their distinctiveness in mind. To expand, then, each of these three.

Special Interventions

The imaginative presupposition of this view is that divinity dwells in a realm separated from ordinary human life but has an *interest* in and the *power* to affect what occurs in human affairs. At times this god reveals to humans, through some oracle (be it prophet, omen, or happening), a message that is relevant to their human well-being. The god does not leave the sacred realm, except perhaps to pay a passing visit to the oracular shrine, but acts through some intermediary agency that is part of the human world.

In an extension of this view, an extension that generally occurs as religious communities become institutionalized, certain oracular situations become *established* as sacred intermediaries through which people can regularly contact the divine. Such intermediaries can be sacred places (mountaintops or caves, which touch the heavens or the lower world), or sacred rituals occurring at special sacred times (such as the solstice), or sacred cultic or prophetic persons. The historical emergence of such stable divine-human contacts does not replace completely the function of special interventions. Indeed, the institutionalized intermediaries are often viewed as the agencies through which the divinity continues the protecting (saving) activity that began in the originating event; and they are generally entrusted with preserving the traditions of that original happening. Special mention should be made of canonical religious texts, for in literate cultures these often assume an almost magical role as "Word of God" that leaves little room for ongoing interpretation.

In these situations the basic soteriological question is raised: are these intermediaries chosen to carry on the task of an absent god or is the god somehow present and working through them? In either case, ordinary people must come to such oracles in order to contact the divine.

In speaking of such special events, a distinction must be made between "happenings" that are *mythic* narratives, metaphorical ways of trying to

explain forces in nature or in human society, and happenings that are actual *historical* occurrences. Granted that generally, by the time some record of them is made, these latter are substantially legendized and mythically interpreted through traditional transmission and ritual celebration, they originate from some precise (and theoretically discoverable) point on the space/time continuum—at least the faith community involved claims that there is such a historical link beween the "sacred event" and its own point in time.

Participation in the Divine

Here one encounters *religious* views that humans are "the image of God," *philosophical* reflection on the way in which effects participate in the perfection of a cause, and the complex and historically varying interaction of these two. Besides, the religious notion of image tends to bifurcate: there is a presumed imaging of the divine which occurs because humans *act morally* in a way that is believed to be acceptable to and like unto the gods, and there is a more basic imaging on the level of *essence*. This latter is a taken-for-granted assumption long before it is formalized into any kind of explanation. The reason for this is that humans, as far back as we can trace their thinking, have projected their own way of acting onto the gods. Mythic cosmologies describe ultimate forces anthropomorphically. Since the divine is thought of anthropomorphically, it is not surprising that humans should then come to be looked upon as images of the divine.

In tracing the movement toward philosophical attempts to explain participation, we have to begin with a mentality that is difficult to explain precisely, a mentality that in its earlier religious forms is intertwined with animism and totemism. It has to do with "similarity in form"—the way, for example, that all horses look somewhat alike; or that pictures of horses look like horses; or that all uses of the word "horse" have a similar sound and make people think about horses. So, when people in ancient Mesopotamia thought of the sky as overarching and all-powerful authority, personified in the god Anu, and then observed the authoritative governance of human affairs by a powerful ruler, they concluded that there must be some presence of Anu in this ruler— otherwise the function and form of authority could not be present in the ruler.[1] So, also, statues and talismans involve by virtue of their shape a divine presence without which the visible shape could not exist.

As Greek philosophy emerges, the questions about such sharing in shape and function are no longer dealt with in a religio-mythic fashion

1. See T. Jacobsen in Frankfort, Wilson, Jacobsen, and Irwin, *The Intellectual Adventure of Ancient Man* (Chicago, 1946), 137–44.

but instead by way of rational analysis. The relevant categories shift from "persons" to "underlying causes," the procedure from storytelling to dialectical reflection. Myth continues to be used, as the dialogues of Plato illustrate; but the character and role of myth is changed: it is now a conscious and recognizable pedagogical technique. The Greek philosophy that Christianity inherited had developed sophisticated insights into participation as it touched on words participating in meaning and therefore in human thought, on ideas shared by many persons participating in one common meaning, on these ideas (in Platonic thought) sharing in an exemplar Idea, on sensible things participating in these Ideas and therefore able to be secondary referents for words. Significantly, the discussion about participation in being flows from and is conditioned by the discussion of participation in meaning that one observes in language and human thought; that is, the basic topic of discussion is symbolic causation. Of great significance for the historical development of Western thought, the Platonic tradition passes on to future generations the problems inherent in Plato's mirror image of the relation between intentional and physical orders.[2]

For the most part, it is in this area of thinking that one must situate the Christian understanding of humans as image of God. Philosophically, the focus moved to the "spiritual" dimension of human existence, to the human capacity to think and speak. As the insight into the immateriality of thought grew, emphasis was increasingly laid on the spirituality of the human and therefore on its resemblance to the realm of the divine which is seen as unlimited Spirit. But because of the ultimate coincidence of "the true" and "the good," there developed concomitantly the notion that humans resemble the divine insofar as they are morally good—a development that involved reinterpreting in an ethical sense the biblical "be perfect as I am perfect" and of the Christian ideal of discipleship.[3]

Divine "Dwelling" with Humans

Numerous stories can be found in the religions of the world which recount the visit of some divinity to an individual human or a group. While all such accounts can be classified as "mythic," there are religious traditions—such as the Israelite or the Christian—that claim for such divine dwelling with humans a more ascertainable historical foundation. Without going into any critique of the relative validity of such claims, it will suffice for our purposes at this point to indicate that such personal

2. See R. Henle, *St. Thomas and Platonism* (The Hague, 1954), 323–402.
3. Without going into detail, it is worth noting that we are here in contact with the worldwide quest for wisdom, the search to find and conform to "the will of God" (the Logos, the Dharma) which came into prominence around five or six centuries B.C.E.

presence, if it did occur, would represent a quite distinctive contact of the divine with humans. At the same time, it would introduce into the human symbols for divine/human communication a qualitatively different kind of symbol, one constituted by remembered experience.

More than a "being there" of quite a different order than the ontological participation of some physical effect in its cause, truly personal presence is a reality constituted by a communication of consciousness from one person to another.[4] Here it is a question not of sharing some aspect of being with another but of sharing self as such. Reflection on this kind of presence makes us aware that it takes place in the consciousness of humans, in the mysterious process of knowledge that classical philosophy tries to explain by saying that "the known is in the knower" or that "the knower as knower becomes the known."

Christian understanding of such divine presence to humans is rooted in the religious consciousness of Jesus. Immediately exposed to the divine, whose compassionate love for humans and distinctively for himself constituted his "*Abba* experience," Jesus is seen in Christian belief as an unparalleled instance of continuing divine dwelling with humans.[5] God is not a distanced reality, not a divinity who lives in some sacred realm. Divine transcendence is preserved by the absolute "otherness" of persons in dialogue rather than by ontological "otherness." Jesus' awareness of God comes basically from the "inner word" of his own experience and only in secondary and explanatory fashion from the symbols of his Jewish religion and culture.

In Christianity this personal kind of presence touches people's awareness in faith of the risen Lord being still with them in the communication of his Spirit, acting still as his Father's word. Other symbols—doctrinal formulations, liturgical celebrations, theological and catechetical explanation—function as media to communicate divine revelation to the faithful; but people's shared experience of the God dwelling with them is the primary symbol[6] through which the divine self-giving occurs. If

4. On the biblical treatment of divine presence, cf. S. Terrien, *The Elusive Presence* (San Francisco, 1978). One of the finest discussions of personal presence as applicable to the presence of God is that of P. Schoonenberg, "Presence and Eucharistic Presence," *Cross Currents* 17 (1967): 39–54.

5. E. Schillebeeckx's treatment of Jesus' "*Abba* experience" in *Jesus: An Experiment in Christology* (New York, 1979), 256–71 (hereafter cited as *Jesus*), complements his earlier discussion in *Christ, the Sacrament of the Encounter with God* (New York, 1963) of Jesus' role in establishing the divine presence to human history.

6. Without attempting at this point a description, much less a definition, of symbol, a brief explanation may be helpful. Contrary to a simple sign (e.g., a highway sign "YIELD") that is meant to convey one clear message, a symbol—whether a sensible object that is experienced or an image evoked by language or memory—points to some reality other than itself which cannot be expressed by simple direct language. A symbol conveys cognitive understanding but it also resonates with imagination and emotion and therefore carries a fuller meaning than a simple sign. One can grasp some of the complexity and richness of symbol by reading the explanation given by Paul Ricoeur in *Interpretation Theory* (Fort Worth, Tex., 1976), 45–69.

this word of revelation is accepted, that is, if Christians choose to live in the consciousness of this divine presence, there results the kind of reciprocal indwelling that the last discourse in John's Gospel describes. In this context of personal presence, terms such as "learning to imitate the divine" and "participation in divinity" and come to be understood as growth in personal understanding and affective maturity which comes with "sharing God's mind" through receiving God's self-revealing Word.

In this approach, imaging God by moral perfection and being the image of God according to one's rational nature come together in something that transcends both: *friendship* between humans and God. Growth in "grace" is not some mysterious, hidden sharing in the nature of God *(participatio divinae nature)*; it is an increasing assimilation of "that mind which was [and is] in Christ Jesus." In speaking this way it is essential to retain appreciation for the genuine transcendence of the God revealed in Jesus and an accompanying appreciation for the extent to which Jesus as risen Lord is "the one mediator." Jesus is the unique symbol of God, and the community as experienced in faith is the key symbol of the risen Jesus.

Since this book will focus throughout on symbols' role either in making God present to humans or in distancing God from human consciousness, a brief word about the nature of symbol needs to be said in this introduction. For centuries people have argued about the way in which symbols function. Obviously, no simple and final explanation can be given; but, as was mentioned above, a number of recent developments suggest that we are able today to give a more satisfactory analysis.

Symbols are a certain kind of *sign*. Like any sign they point to something other than themselves; in knowing them we are led to know something else. However, while simple signs point to something else clearly and without overtones—a sign "for sale" in front of a house conveys no other message than that the house is for sale—a symbol touches not only direct knowing but also emotions and memory and imagination. An embrace of a dear friend who is being greeted after a long absence says many things, not all of which could be translated into words.

Our human experience is constantly shaped by symbols: by the connotations of the metaphors we use, the overtones of people's actions, the rituals we engage in to relate to one another in families or in society, the artifacts that surround us, the images used in advertising. Some of these symbols flow from the very nature of things; a happy expression on a person's face lets us know about the inner happiness of that person. Other symbols, like a country's flag, are the result of social convention, a somewhat arbitrary attempt to convey a meaning whose richness goes beyond what mere words can carry. Beneath all these various symbols

lies the fact that we humans exist symbolically, because we are embodied spirits. Our inner awareness and desires and emotions can be shared with one another in human community only because they are translated and symbolized through our bodiliness. Not only are we symbol-making and symbol-using beings; our very being has symbolic depths that we still do not fully understand—put simply: what does it *mean* to be human? The chapters that follow will try to show how the reality of being human has been affected by the way in which symbols made present for people the saving love of God or, on the contrary, distanced the divine reality from people's awareness.

With this tentative delineation of three quite distinct views of divine contact with humans, a contact established through symbols, we can undertake a study of the actual process of Christian history, examining the extent to which one or more of these views was considered, in various circumstances, an explanation of the way God deals with humanity.

1

Christian Beginnings: God Made Present

The first generation of Christianity was one marked by the immediacy of the Easter experience, by the first attempts at establishing Christian identity, by the expectation of the rather imminent arrival of the Parousia or Second Coming of Christ. In this situation the primary symbol by which the unexpected divine action in Jesus was interpreted was Christians' own relatively uninterpreted experience. Increasingly they turned to other sources of interpretation, but their understanding was influenced chiefly by the memory of what they had experienced Jesus doing and by what had been happening in their midst since his death.

As in any other human situation, however, the hermeneutic, that is, the worldview, knowledge, experience, and attitude toward life which the first-generation Christians brought to that initiating experience was a constitutive element of that experience. Since what was happening to them was experienced as God's action, they were conditioned by their previous Jewish religious understandings. But since this was experienced as God's act *in Jesus*, their memory of being with Jesus during his public ministry inevitably entered as a primary source of understanding the saving function of his death and passage into new life. At the same time, the normal process of sharing memories and present understandings with one another meant that others' experience was for each one an interpreting principle.

Informal and constant as this first stage of interpretation was, it would naturally have come to sharper focus when they gathered for their community meals and prayers. It was then that recollection and present experience were expressed in word and gesture, which, because they were giving shape to an emergent tradition, began to fall into certain ritualized patterns. Quite naturally they remembered and discussed Jesus' teaching; and because this came to be seen as a privileged form of "the Word of God," they cherished and preserved those words as

they remembered them. Even while they would not have felt free to alter or simply omit elements of Jesus' teaching, they inevitably injected some of their own understandings—as they had done when they first heard him teach. Collections of his "words and deeds" became, from very early on, the center of the process of community tradition.

At the same time, any remembrance of what Jesus had done in order to understand what they themselves should now do involved the need to sort out the *meaning* of Jesus and his deeds, above all the meaning of his death and resurrection. In this theological endeavor they quite understandably adopted what had been the underlying theological approach of the Bible with which they were familiar from synagogue and temple. That approach was a theology of history, explaining any given element of religious tradition by relating it to the overall process of God's guidance of Israelite history.

It is important to remember that the early Christians, as they reflected on the career of Jesus and on the dynamics leading up to his death, did so in the context of their own Easter experience. This is clear from the constant influence of that experience on the New Testament accounts of Jesus' public ministry. While they began to employ in ever broader and more explicit form the range of interpretive symbols that we find in early Christian literature, they did this within the framework of their own continuing experience of the risen Lord and his Spirit present among them. This experience was controlled to some extent by their expectation of an imminent arrival of the Parousia; the present was seen to be incomplete and "on the way" precisely because the end had not yet come. The breakthrough of truth and understanding which had come with Jesus' passover would receive its full form, and history its full meaning, only with the eschatological realization of "the kingdom of heaven."

In this situation, the earliest Christian generation (or perhaps two) had a pervading sense of the *immanence* of a personal God. Just as Jesus had been in their midst as one of them and still dwelt with them in the mysterious presence of his risen existence, so the God who was his *Abba* was not off in some distant "heaven." Instead, this God lived with them in the communication of the Word and the Spirit.

Jesus' *Abba* experience was, of course, the ground for the early Christians' sense of God being present. While there is dispute among scholars as to whether or not one can apply the term "unique" rather than just "distinctive" to the awareness that Jesus had of the transcendent, the evidence points to the fact that Jesus' experience was that of knowing God in intimate immediacy, of being the "beloved son," of being constantly in the presence of this personal ultimate reality he addressed

with the familiar term "Abba," which was used by children within a family to address their father.

Moreover, the very early practice of Christians' addressing God as "Abba," witnessed to by Gal. 4:6 and Rom. 8:15, would be impossible to explain if it had not been justified by Jesus' own usage and his instruction to them about the way to think about and pray to his Father.

The treasured recollection of Jesus' that his Father was also theirs helped establish "family" as the key model for interpreting what they were and what was happening. This was reinforced by the fact that the early Christians assembled and shared a sense of community in homes rather than in some "institutional" meeting place. God came to them, was present with them, wherever they were. Thus, the normal circumstances of their daily lives spoke to them, functioned as the fundamental symbol of the divine for Jesus' disciples. While the myth they consciously or unconsciously employed to understand their lives had to confront and be interpreted by the narrative myth of Israel's history, the new happening in Jesus was the primary story that gave fuller and more accurate understanding to the earlier traditions.

What this meant was that the division between "the sacred" and "the ordinary" tended to disappear—the walls of separation were broken down. Because of their inbred acceptance of and reverence for the Law, and because they assumed that the precepts of the Law still bound them, Jewish Christians continued to share in Israel's sacred moments.[1] When, however, they were about their "Christian thing," there was not a separating off of sacred times or sacred places or sacred personnel or sacred (religious) actions. The experience of being Jesus' followers was not that of belonging to a new religion; it was the experience of existing humanly in a new world, in a new and final but not yet fully realized period of history.

THE WORLD OF EARLY CHRISTIAN THOUGHT

For these earliest disciples of Jesus, the experience of his public life and especially of his death and resurrection challenged the meaning of everything in their life. Consequently, it challenged the various symbols, linguistic and ritual and societal, that were used to interpret that life.

1. As Brown and Meier point out in *Antioch and Rome*, (New York, 1982), Jewish Christians were divided in their outlook on the obligation to observe the Law—and to that extent on the continuity or discontinuity between Judaism and Christianity. As we will see, the more Jewish elements provided the historical bridge for the cultic emphasis to return and ultimately dominate Christian understanding.

For them it was clear that something had happened that in its radical newness demanded a reassessment of their entire worldview. Since their previous understanding, their hermeneutic of experience, had been so thoroughly religious, it was their religious symbols that faced the most severe challenge. Succinctly put, earliest Christianity faced a task of complete religious remythologizing.

However, immense as this task was, it was not undertaken in a vacuum; nor was it entirely unprecedented. Actually, the need for this kind of reconsideration and reformulation had been a constant element in the culture and religion they inherited. Not only the Jews but other peoples of that time, from China to the Mediterranean world, had long been engaged in a quest for wisdom, that is, for insight as to what was truly transpiring in the world, insight that could guide successful living. During those centuries that Karl Jaspers has called "the axial period,"[2] people had tried to determine the meaning and purpose of human existence and to find the way of fulfilling that purpose.

For Israel that axial period coincided with the highpoint of the prophetic movement and the shattering event of Babylonian deportation. Israel as a people had to appraise the prophetic intervention, which often contradicted the accepted and official interpretation of Israel's history. Israel had also to confront the negating experience of defeat and deportation by the Babylonians, an experience that seemed to give the lie either to the superiority of their God or to their identity as the "chosen people." Not unlike mid-twentieth-century Jews faced with the enigma of the Holocaust, these ancient exiles had to ask seriously whether the traditional interpretation of their history was in error.[3]

The Hellenic quest for wisdom, at least from the fifth century onward, was quite different. The Greeks, too, sought a worldview that would explain and guarantee their survival; but they no longer did so by questioning the personal behavior of some divinity—that they had done in an earlier age. Instead, with the emergence of a philosophical and scientific mentality, Greek thought searched for the causes of things, whether the more immediate and observable causes or the more ultimate "reasons."[4] This movement to a more secular explanation of happenings

2. K. Jaspers, *Origin and Goal of History*, trans. M. Bullock (New Haven, 1953), 262ff.

3. Looking at this crisis period in Israel's history from the perspective of later religious judgment, one can see this as the turning point when a qualitatively new "spiritual" dimension begins to characterize the people's understanding of their identity and destiny and to underpin their religious institutions and practices. However, for those who heard the prophets and experienced exile, this spiritual outcome was probably largely hidden. On the role and impact of the great charismatic prophets during this period cf. W. Brueggemann, *Hopeful Imagination* (Philadelphia, 1986).

4. However, it is good to bear in mind the warning of W. Guthrie in the introduction to his monumental *History of Greek Philosophy* (Cambridge, 1962) that the move from the mythic to the rational was gradual and never complete.

was in Greek thought the impulse toward demythologizing; it was the tragedians and the cosmologists who provided for Greece that challenge to previous explanation which in Israel came from the prophets.

In the earliest decades of Christianity, the writings that provided some intelligible explanation for the experience of Babylonian exile and its sequel were part of the shared religious heritage of Jews and Christians.[5] In differing fashion, the disastrous war leading to Jerusalem's destruction in 70 C.E. and the deepening of that disaster in the Bar Kochba revolt were a catalyst to both Jews and Christians to re-examine and puzzle through a meaning for the happening of history.[6]

Though the paths of their explanations increasingly diverged, Jews and Christians faced a common task of interpreting their shared antecedents. This entailed the need to interpret the traditional symbols by which their common past had been explained. The inherited understanding of their faith in God had been proved inadequate, in the one case by military disaster and in the other by the overarching reality of Jesus' resurrection. But because Jew and Christian both continued to accept the God revealed through Moses and the prophets, neither could deny that the events of human experience must find some hopeful explanation and the God-given symbols of tradition—Scripture and ritual and community—must be susceptible of some true interpretation.

As Jacob Neusner has indicated, it was this struggle to confront the shattered meaning of their experience that led second-century Jewish sages to produce the Mishnah.[7] Basically, Mishnah is a systematizing of life by Torah, at once a down-to-earth statement and an otherworldly ideal of how the men and women of Israel are to live out their lives in conformity with the divine intent. At the same time, it continued the role of halakic midrash, the rabbinic commentary on God's law, by further clarifying the implications of the biblical texts.

5. The extent to which the return from exile provided a key "type" for Christian understanding of Jesus' death and resurrection is still an insufficiently explored area of New Testament studies. Textual allusions to the liturgy of Tabernacles, the prominence of Zerubbabel in both Gospel lineages for Jesus, the use of the opening verses of Deutero-Isaiah at the beginning of the Gospel of Mark, the use of Psalm 117 in reference to Jesus' passover point to this typological relationship.

6. There is increasing evidence of the impact that Jerusalem's destruction had on Christian Jews as well as on their non-Christian compatriots. While the Christian "apologetics" of a few generations ago tried to see New Testament passages that predicted the fall of Jerusalem as evidences for the miraculous powers of Jesus, contemporary New Testament studies have indicated the extent to which these passages reflect the wrestling of early Christianity with the already experienced fact of Jerusalem's tragedy. See H. Koester, *History and Literature of Early Christianity* (Philadelphia, 1982), 2:315.

7. J. Neusner, *Method and Meaning in Ancient Judaism* (Chico, Calif., 1981), 3:1–31, 145–53.

In this Mishnaic enterprise and in its continuation into the Talmudic reflection, the rabbis were seeking the "eternal reasons" with which their own ethical judgments should seek to conform; but they were doing so in the context of probing the mind of that God who had guided their history from the beginning.[8] They did not treat their God as capricious; but neither did they deal with God as a rigid immutability that mechanically shaped their history. Though Yahweh was the Lord and ultimately nothing could stand between Yahweh and the achievement of the divine goals, still this God was one personally involved with free persons, who respected their conscience and guided rather than forced their decisions and behavior.

When one turns from Judaism to the Greek sources of Christian thought, there is a marked difference. From at least as early as Aeschylus one can notice that the anguished search for some explanation of human tragedy moves in the direction of the impersonal or social forces that influence or flow from human moral decisions, even when these latter are not basically free.[9] There is not a complete repudiation of the mythic world of Homeric and Hesiodic theology; indeed, there is for centuries a lingering sense of some suprahuman beings who play a role in human lives. But by the time of Plato and Aristotle, to say nothing of Democritus and Zeno, Greek thought is clearly looking for an explanation of reality in terms of impersonal forces, cosmic and psychic. These forces may find personification in gods and heroes and to some extent even in actual historical personages, but the forces themselves are the ultimate causes whose character is described by philosophers of nature and of society. Greece responds to the wisdom quest with cosmology rather than with theology.[10]

One could group Roman thinkers with the Greek, but their approach is somewhat distinctive. Granted the classical Stoicism of Seneca and Marcus Aurelius or the Epicureanism of Lucretius, Roman thought tends more to stress the underlying forces of social destiny which shape the happenings of people's lives. This is distinctively true of the lives of those who bear a special genius, a special destiny that somehow catches up and determines the destiny of the entire people. Thus one could find in ancient Romans a special shrine and cult to such divinities as Fortuna.[11]

8. On the relation of rabbinic reflection to "divine revelation" see M. Kadushin, *The Rabbinic Mind* (New York, 1965), especially 340–67.

9. On the reflection of this is Aeschylus's *Agamemnon;* see P. Smith, *On the Hymn to Zeus in Aeschylus' Agamemnon* (Chico, Calif., 1980).

10. One can perhaps see best in Stoicism the manner in which a monistic cosmology had absorbed not only religious reflection (e.g., in Cleanthes's *Hymn to Zeus*) but ethics and logic as well.

11. See W. Fowler, *Roman Ideas of Divinity* (London, 1914), 61–80.

Though not unique to them, there was among the Romans a strong tendency to see prominent figures as embodying the forces that guide the destiny of a family or even of Rome itself. Such is the mentality underlying the cult of the emperor in later centuries. Though there was unquestionably a certain apotheosis of emperors with their death, and probably a few, such as Caligula, actually thought of themselves as divine, it is unlikely that most of the emperors looked upon themselves as gods or were so considered by their better-educated compatriots.[12]

Alongside such philosophical or sociopolitical demythologizing of the classic religious symbols of the gods, there existed the mystery religions that promised to their initiates a secret explanation of reality, one that was revealed in ritual and myth.[13] There is relatively little accurate knowledge about the symbolisms used in these mystery cults, but it seems that for the most part they were drawn from the life-giving significances of crops and flocks and human procreation. To that extent their symbols carry us back to the earlier phenomena of historical religious belief and practice when vegetation/fertility rituals were practiced to guarantee crops, flocks, and children.

Though not specifically Greek in its origins or its character, Gnosticism must be mentioned in any description of the Hellenistic world of symbols into which Christianity moved.[14] Mystery cults could appeal to broad masses of the uneducated; the appeal of Gnosticism was more narrowly addressed to a supposedly intellectual elite. Several decades of study still have not managed to provide clear delineation of Gnosticism or clarity about its origins; perhaps because such is not possible. An amorphous, multiform body of teaching that pretended to ultimate insight, Gnosticism was an esoteric explanation of reality in terms of higher entities at work in the universe, forces at the same time cosmic and psychic which shape history by their conflictual tension. The high point of gnostic developments should probably be situated shortly after Christianity's inception; and New Testament writings reflect the influence already exerted by this movement at the time of the earliest Christian generations. For one studying religious symbols, Gnosticism offers a

12. However, from the time of Julius Caesar onward, there is a pronounced development of the cult of the ruler; see S. Weinstock, *Divus Julius* (Oxford, 1971). On the nature of imperial cult see G. Bowersock, "The Imperial Cult: Perceptions and Persistence," in *Jewish and Christian Self-Definition*, ed. E. Sanders and B. Meyer, (Philadelphia, 1982), 3:171–82.

13. On the ancient origin and endurance of the mystery cults see M. Nilsson, *Greek Folk Religion* (New York, 1940), 42–64.

14. On Gnosticism see H. Jonas, *The Gnostic Religion*, 2d ed. (Boston, 1963), *Gnosticism* (New York; 1961); H. Wolfson, *The Philosophy of the Church Fathers* (Cambridge, Mass., 1956), 1:495–574; *New Catholic Encyclopedia*, s. v. "Gnosticism," "Jewish Gnosticism."

fascinating case, since gnostic literature is replete with symbolic mystification.[15]

Interpretative Method in Judaism

Under the impact of historical happenings and growing prophetic insight, the evolution of Israel's traditions required a constant remythologizing. Yet, there was the wise realization that somehow each stage of Israel's religious growth, since it was directed to the same unchanging God and dealt with that God's ultimately unchanging purposes, embodied truth that was not to be lost and a viewpoint from which all consequent generations could learn something. The process of the gradual formation of the biblical canon is essentially educational, directed by the need, generation by generation, to shape believers' ideas and imagination in conformity with the community's traditions.[16] So, the Bible is a collection of theologies, some obviously intended to supplement and even correct their predecessors but none able to lay claim by itself to sufficiency.[17]

At each stage of their religious development the people had a sense of being in contact with the unchanging reality of their God, even though the perception they had of that contact grew more refined as history progressed. But amid this slow evolution of religious understanding, some special instances of religious experience, specifically that of the prophets, transcended their particular historical context and retained a depth of insight that continued to challenge the religious views of later generations.[18]

15. One of the characteristics of gnostic symbolism is its artificiality and abstractness, perhaps because of an absorption of Pythagorean interest in numbers. On the possible influences of Pythagoreanism on Gnosticism, see S. Heninger, *Touches of Sweet Harmony* (San Marino, Calif., 1974). A distinctive facet of gnostic literature was the Hermetic corpus, which probably developed over several centuries. See A. Festugiere, *La revelation d'Hermes Trismegiste*, 4 vols. (Paris, 1944–54). While its influence was less important in the early Christian period, Hermetic religion was destined to have an intriguing and important impact on later countercultural Christianity; see F. Yates, *Giordano Bruno and the Hermetic Tradition* (Chicago, 1964).

16. W. Brueggeman, *The Creative Word* (Philadelphia, 1982). There is striking similarity between this process understanding of Israelite use of traditional texts in ongoing community education and the explanation of *sacra doctrina* in Thomas Aquinas's *Summa Theologica*, Prima Pars, q. 1. See G. Van Ackeren, *Sacra Doctrina* (Rome, 1952).

17. See G. von Rad, *Old Testament Theology* (New York, 1965), 2:410–29.

18. The lasting and evolving impact of the prophetic writings is a striking instance of the "fuller" sense of a classic writing to which attention has been drawn recently by literary critics and biblical scholars alike. An example of this interdisciplinary study is David Tracy's *Analogical Imagination* (New York, 1981), which applies the notion of "classic" beyond texts to key persons and happenings. To some extent, this present-day discussion picks up the earlier debates about the "fuller sense" of Scripture; see R. Brown, "The History and Development of the Theory of a *Sensus Plenior*," *Catholic Biblical Quarterly* 15(1953):141–62 and "The *Sensus Plenior* in the Last Ten Years," *Catholic Biblical Quarterly* 25 (1963): 262–85.

Within the biblical literature each succeeding stage of theological development represents to some extent a commentary on preceding tradition. Once the collection of written traditions becomes crystallized and finally canonical, the process of ongoing Torah takes place through scribal explanation of the given text. By the time of Christianity's origin there were well-established traditions of midrashic commentary, both halakic and haggadic, and distinctive approaches to such commentary led to established schools of interpretation which in turn led to the foundational rabbinic viewpoints of Mishnah and Talmud.[19]

Though theological outlooks differed, certain basic techniques of exegesis were employed by all. *Midrash*, which was an "unpacking" of a given text in the Bible, took two forms: *halakic*, a paranesis on the behavioral demands of a prescriptive text; and *haggadic*, an explication of the pious implications of a particular narrative passage.[20] *Mashal* is harder to describe, since it embraces a number of literary types that to our modern way of thinking seem scarcely species of a common genus. Proverbs are *mashal*; so are parables; so are metaphors of one sort or another. What perhaps can be identified as a common element is that all forms of *mashal* are meant to convey some bit of wisdom to those who can read beyond the obvious sense of an expression.[21]

To confine ourselves to the textual techniques just described would yield too limited a picture of the influences that fed into early Christian interpretation of tradition and of their own experience. Not only scribal explanation expanded for people the meaning of their sacred texts. Perhaps as influential were the great festive ceremonies that year after year and generation by generation conveyed to the people an understanding of themselves in the light of their inherited traditions.[22] Liturgy as well as biblical text was word of revelation; actually the two were inseparable in their constant interaction.

The active involvement of the worshipers was one particularly significant aspect of this ritual "word." When, for example, they prayed or sang the Psalms as their own religious response, there was inevitably an acceptance of the revealed Word *in terms of their specific life experience*. Through weekly participation in the service of synagogue, both ordinary

19. See W. Green, ed., *Persons and Institutions in Early Rabbinic Judaism* (Missoula, Mont., 1977); G. Freeman, *The Heavenly Kingdom* (Lanham, Md., 1986). Probably no scholar today is more responsible for serious restudy of the Mishnah than is J. Neusner; see especially *Judaism, the Evidence of the Mishnah*, 2d ed. (Atlanta, 1988).

20. See A. Wright, *The Literary Genre Midrash* (New York, 1967); R. Bloch, "Midrash," *Approaches to Ancient Judaism*, ed. W. Green, (Missoula, Mont., 1978), 1:29–50; *Encyclopedia Judaica*, vol. 11 (1971), cols. 1507–1514.

21. See "The first and indispensable characteristic of the *mashal* is its poetic form." *Encyclopedia Judaica*, s. v. "Proverb."

22. On the anamnetic aspect of Israelite worship see H. Renckens, *The Religion of Israel* (New York, 1966), 170–87.

Jew and scribal expert acquired an experiential understanding of tradition which made its own contribution to the process of Torah. Besides, there was a feed-in of people's daily lives and daily prayer, both as individuals and in family, that colored their hearing of scribal interpretation in synagogue or temple.

Greco-Roman Methods of Interpretation

As we already mentioned, the problematic of Greek (and with some modification Roman) thought was quite different. Here there was no overarching reality of one God, the tradition of whose interventions in history evolved toward strict monotheism and implied a continuing divine creative presence throughout history. Instead, the original religious myths were more and more emptied of actual reference to historical happenings and interpreted as metaphor or even as allegory. The great sixth- and fifth-century tragedies of Aeschylus or Sophocles, while they retain a profound sense of divine power and influence, are extended metaphors describing those hidden forces that shape human existence, and the gods portrayed in those plays are essentially literary personifications of those forces.[23]

Remythologizing takes place, therefore, not through a process of increasing insight into the reality of the traditional gods, but through increased philosophical and psychological understanding of the forces that function in nature, in human consciousness, and in human activity. The explanation of texts, be they religious or not, comes through literary criticism and philosophical reflection and not through scholarly commentary that is committed to increased understanding of the divine guidance of history.[24]

In this situation, criteria of syntax and style, of rational consistency and dialectical verifiability, rather than fidelity to religious tradition, guide the interpretation of texts. There is no intrinsic need to preserve and justify the text being explained; it may simply be wrong and therefore to be refuted, or literarily inferior and therefore to be criticized. If the text in question has a particular traditional aura—for example, a text of Homer—the later criticism may try to excuse its "error"; but the sharp attack in Plato's *Republic* on the Homeric stories about the gods indicates the extent to which later writers felt free to dissociate themselves from earlier religious understandings.[25]

23. See J. de Romilly, *A Short History of Greek Literature* (Chicago, 1985), 53–57; W. Jaeger, *Paideia*, 2d ed. (New York, 1945), 1:237–67

24. See W. Wimsatt and C. Brooks, *Literary Criticism* (New York, 1959), 3–73.

25. Plato, *Republic*, 377–96. Interestingly, he reflects the allegorical method of interpreting the Homeric stories when he refuses to admit the teaching of these stories to the young whether one treats them as allegory or not, "because the young cannot discern what is allegory" (378d).

Yet, such traditional texts did exist and continued to be part of a people's cultural tradition, which meant that some positive exegesis of them had to be given. What enters in at this juncture is allegorical interpretation. The Homeric myths, for instance, are seen as a "surface story" beneath which are being described those very forces of cosmos and psyche with which later dramatists and philosophers deal. Put into this context of metaphor or allegory, the Homeric stories can be given a perennially valid meaning, one that is flexible enough to allow the *Iliad* and *Odyssey* to continue functioning as classics.[26]

Instead of a fundamentally religious tradition of Torah, what is providing the continuum of interpretation in Greece, at least from the classical period onward, is the continuing civic and cultural tradition of a polis such as Athens or the rhetorical traditions stemming from Lysias and Isocrates or the "scholastic continuity" of a philosophical tradition such as Platonism.[27] By the time of Christianity's appearance on the stage of Mediterranean culture there was a centuries-old and complex body of rhetorical theory to guide and judge the production, explanation, and criticism of texts. We are only gradually coming to appreciate the influence of such literary sophistication on the writers of the New Testament literature and on patristic commentators on that literature.[28]

CHRISTIAN ORIGINS

As Christians began the task of reinterpreting the Jewish and Greco-Roman symbol systems, they were able to draw upon developed theories of symbol interpretation. Yet, Christianity's fundamental and most radical remythologizing flowed from what at first blush seems almost devoid of rhetorical sophistication, the simple teaching of Jesus of Nazareth.

Jesus

Despite the fact that the account of Jesus' teaching that we possess is already influenced by the interpretation and formulation of the early Christian communities and of the authors of the Gospels, it is clear that Jesus' own teaching was symbolic in both form and content and interacted with the existent symbols of Judaism. Moreover, Jesus' utilization of symbolic form and imaginative content seems to have been quite consciously situated within the religious tradition of his people and in relationship to the doctrinal methods prominent in his day. It

26. A key link between this Greek methodology and Christian exegetical method is Philo. On his adaptation of Greek philosophical allegorizing to the Bible, see H. Wolfson, *Philo* (Cambridge, Mass., 1948), 1:3–199.

27. See H. Rose, *Outlines of Classical Literature* (New York, 1957), 105–22.

28. See W. Doty, *The Epistle in Late Hellenism and Early Christianity* (Madison, N.J., 1966).

functioned, then, as part of the process of ongoing commentary on traditional Torah.[29]

The basic teaching form he used, that of parable, involved a constant appeal to the imagery of people's lives, whether it was drawn from the physical world around them (Mark 4:26-32), from their daily family experience (Matt. 24:45-51; Luke 14:7-14), or more specifically from the religious actions with which they were acquainted (Luke 18:9-14). But in appealing to the meaning carried by these images, Jesus' teaching also depended upon the culturally inherited significance that these images conveyed to the consciousness of his hearers.[30] In so doing, it achieved an integration of tradition and existential experience. It would be difficult, for instance, to isolate the parable of the unjust custodians of the vineyard from the hymn of the vineyard in Isaiah 5, even though in its original telling this parable might not have drawn the parallel as explicitly as does the text in the Synoptic Gospels.[31]

Like the oracular teaching of Israel's prophets, the teaching of Jesus was intended to challenge the understandings and attitudes of his auditors. It was meant to question the hermeneutic of experience, both individual and social, with which people approached their everyday life and dealings with one another and approached their God.[32] Put in religious terms, the parables were aimed at conversion—conversion that was both intellectual and affective because it was rooted in a conversion of imagination.[33]

Jesus' parables represented a deliberate use of the symbols and myths of Jewish tradition; such was necessary if he wished to engage his hearers, for these symbols structured both their and his own awareness of God. But even as he recalled the familiar context of their human and religious awareness, he introduced elements of paradox which immediately brought into doubt the prevalent interpretation of that tradition.[34] At the root of this challenge lay Jesus' own awareness of the transcendent, his *Abba* experience, which introduced further deepening

29. See G. Phillips, "Kingdom Speaking and Kingdom Hearing: Matthew's Interpretation of Jesus' Kingdom Tradition," *Interpreting Tradition*, ed. J. Kopas (Chico, Calif., 1983), 73–91.

30. Jacques Guillet, in *Themes of the Bible* (Paris, 1951), details the way in which images such as "rock" gathered connotative richness in the course of Israel's history.

31. See C. Mann, *Mark*, the Anchor Bible (Garden City, N.Y., 1986), 27:455–67.

32. For a study of the role of symbols in the interpretation of experience and the related development of a theology of culture, see B. Meland, *Fallible Forms and Symbols* (Philadelphia, 1976).

33. On the nature of religious conversion, see W. Conn, *Christian Conversion* (New York, 1980). One of the chief sources of Conn's analysis is B. Lonergan's *Method in Theology* (New York, 1972), which stresses the role of religious conversion as the ground for both moral and intellectual conversion.

34. See J. Crossan's "Parables of Reversal," in *In Parables* (New York, 1973), 53–78.

and clarification—but beyond that, a qualitatively new level of inter-pretation which came from immediate encounter with the divine.[35]

His listeners might not understand what they heard Jesus saying—for a variety of reasons—but the parable could be the beginning or continuation of a process that eventually would lead to a truer insight into the reality of God. For the moment the symbol would be dense and puzzling because it would have lost its familiar referent, God as the people thought God to be. But this very puzzlement would have brought into question the validity of that referent. In Jesus' teaching the basic assumptions underlying official formulations of Jewish faith were questioned, for these assumptions about the way in which God deals with humans were not congruent with Jesus' experience of God as Abba. Even the gentler outlook of the school of Hillel, with which Jesus himself shared much, was grounded in an essentially patriarchal worldview and governed by the basic pharisaic agenda of introducing cultic sacrality into the daily life of people.

Simply put, the basic story that Jesus was telling people, the story about the way in which God was involved providentially with human history, was both familiar and strange. Jesus' God was the God of their Israelite Scriptures and liturgy, the God of covenant and temple and Law; but this God was not acting in the manner detailed by the official teachers of the people. The act of ruling implied in the term "kingdom of God" was not that envisaged in the legitimating view of priests and scribes.[36] In applying the notion of "king" to Israel's God, teaching by both groups used a model derived from the traditional (and idealized) view of David as king, even though that model found scant exempli-fication in the history underlying the Books of Samuel, Kings, and Chronicles. Both scribes and priests recognized that Yahweh was king in a unique way, but the kind of authority God exercised was essentially that exercised by Jewish leaders, for their authority was derived from God's. And though God exercised authority and power with both mercy and justice, it was fundamentally God's *dominative* authority that ground-ed the Law and lay behind the authoritative rule of Jewish officialdom. It is this patriarchal view of ruling which is challenged by Jesus' parables of "the kingdom of God"; and in the perspective of the theology that produced the New Testament literature, as Jesus' ministry unfolded and led into the final parable of his death and resurrection, God's act of

35. That this new level of enlightenment comes with Jesus and is rooted in his immediacy to God is explicit in the Johannine prologue's contrast of Jesus with Moses.

36. On Jesus' use of "kingdom" see N. Perrin, *Jesus and the Language of the Kingdom* (Philadelphia, 1976).

ruling was revealed paradoxically as "servanthood."[37] Beneath these differing understandings of "kingdom of God" lay a radical difference in understanding "salvation."

Precisely because the "description" of God acquired this mysterious Servant dimension, did so even for Jesus himself as his public failure forced him to reassess the nature of what was taking place through him,[38] language cannot act as adequate symbolic instrument to formulate or communicate this new insight into the transcendent. Instead, the actions of Jesus carried the more ultimate freight of symbolic import.

Like the imagery of his teaching, Jesus' sign-actions linked the consciousness of those who observed them to their memory of the *magnalia Dei*, a memory that had been exegeted for them by their religious teachers. Much of this memory linkage probably took place at a level of consciousness below full recollection, but nonetheless the emotional impact linked with that memory fed into people's hermeneutic.[39] We must always, of course, take into account the extent to which the New Testament authors' description of Jesus' signs *(semeia)*, particularly in the Gospel of John, emphasizes or even creates the linkage with Israel's traditions.[40] Yet, even when we grant this element of later interpretation, the basic happening of Jesus' healing activity carried intrinsically its own significance. Because his activity, even that of teaching, was a healing, it spoke of a healing God and gave the Israelite myth a further specification as the story of a "God who heals." Such a depiction of Yahweh was in no contradiction to Old Testament passages such as Isaiah 40–42, but indications are that for Jesus' contemporaries God was largely portrayed as a divine judge who supervised that enforcement of the Law which was being carried on by the official leaders of Judaism. It was not accidental that more than one of Jesus' healing actions came into conflict with the officials of his day.

One element of Jesus' signs to which the Gospel narratives draw attention, an element that most likely is rooted in the actuality of Jesus' ministry, is Jesus' refusal to work "empty" signs. Working wonders of one sort or another has always been a means of attracting a following,

37. For a recent study of Jesus' teaching as resembling and yet differing from that of the Pharisees of his day, see B. Lee, *The Galilean Jewishness of Jesus* (New York, 1989.) For a fuller treatment of this contrast betwen the teaching of Jesus and that of the scribes and the priesthood of his day, see my essay "Non-Patriarchal Salvation," *Horizons* 10 (1983): 22–31.

38. One of those who points to the significance of this "crisis" in Jesus' public ministry is J. Sobrino in *Christology at the Crossroads* (Maryknoll, N.Y., 1976), 91–102. See also J. Guillet, *The Consciousness of Jesus* (New York, 1971), 18–29.

39. On the role of memory in early development of Christian tradition, see B. Gerhardsson, *Memory and Manuscript* (Uppsala, 1961), 193–335.

40. On the "sacramentalism" of the Gospel of John, see R. Brown, *John*, Anchor Bible, (Garden City, N.Y., 1966), 29:cxi–cxvi.

and history is filled with charlatans who developed a following by just such spectacular activity. Several scenes of Jesus' ministry describe the crowds as asking for such wonders; and the scene of Jesus' temptation in the desert points to the constancy of the suggestion that he prove his Messiahship by such means.[41]

However, only those actions that bore intrinsically the revelation of God-healing-through-Jesus could speak truthfully as symbols. And only such actions were performed by Jesus, not as arbitrary signs to convey a message but as natural responses to people's needs, responses that carried the message of a God concerned about those needs.[42] To interpret such actions properly, Jesus did not need anyone coming with spectacular credentials. As the parable of Dives and Lazarus makes clear (Luke 16:19-31), the people had the Law and the prophets to give all the guidance that was needed. The God who worked through Jesus' teaching and healing was the God witnessed to in Israel's Scriptures.

God, the *Abba* who polarized Jesus' consciousness, was experienced by Jesus in the ordinariness of life and above all in his own caring concern for people.[43] But this God so known was also the God who had been nurturing Israel as a people for past centuries, and Jesus' historical awareness of these former deeds was an essential component in interpreting what God was doing in him as the eschatological prophet. Israel's history was the great symbol provided by God to help the people recognize the Messiah when he came—but that history needed interpretation. By an inevitable circularity, it could only be ultimately interpreted by the arrival of the Messiah. For Christians the resurrection-of-Jesus symbol created the hermeneutic for interpreting the Old Testament in a manner that permitted it, in turn, to shape the hermeneutic for experiencing Christianity."[44]

Death and Resurrection

Whatever significance was intrinsic to the human career of Jesus, and whatever meaning was conveyed by the symbolisms of his teaching and

41. See my "The Hour of Temptation," *The Way* 2(1962):177.

42. On Jesus' miracles see *Les miracles de Jesus*, ed. X. Leon-Dufour (Paris, 1977); R. Latourelle, *Miracles de Jesus et theologie du miracle* (Montreal, 1986); and L. Monden, *Signs and Wonders* (New York, 1966). The last of these includes a discussion of Jesus' miracles in the context of a thorough treatment of the miraculous element in religions.

43. At the same time it seems that Jesus thought of himself as specially sent, as the eschatological prophet. See Schillebeeckx, *Jesus*, 206–13, 274–94, 475–99. On the background and early tradition of Jesus as eschatological prophet see F. Hahn, *The Titles of Jesus in Christology* (New York, 1969), 352–401.

44. On the process of self-identification by religious groups, including Christianity, see the ongoing project on Jewish and Christian self-definition undertaken by McMaster University in Hamilton, Canada. The first volume was *Jewish and Christian Self-definition*, ed. E. Sanders (Philadelphia, 1980).

healing, came to climax and fulfillment in the event of his passover—his death and resurrection. For this reason, the death/resurrection event provides for Christianity its constituting symbolism, the creative and specifying principle of its doctrine and worship and community identification.[45]

Given the long-established Jewish mentality that focused on certain historical happenings, the "great deeds of God," it was not surprising that the inexplicable happening that had occurred in Jesus was immediately viewed as a "sign." Quite naturally, to a group of people accustomed to seeing God at work in their lives the events of Calvary and Easter were viewed as "Word of God"; something had been said to them in Jesus' being raised, even though they were uncertain just what it was. This is clearly reflected in the opening verses of the Epistle to the Hebrews where the Jesus-event is seen as fulfilling the prophetic revelation of Israel.[46]

As we will see, there began very early a process of giving intelligible shape to the symbolic impact of the Easter-event, but the event itself in its inexhaustible intrinsic significance remained as a living force in the mind of the community as it struggled toward clearer understanding.[47] The Easter-event was an abiding formative principle of the Christian community in its faith and in its life. Theologically what this means is that the risen Christ, who is the Easter-event, is the symbol that shapes Christianity into a human community of believers; he is the basic sacrament, God's own creative Word. This was the theological perspective that began to emerge as the infant church moved toward the divine wisdom interpretation of Matthew 11 and the Johannine view of the "Word made flesh."

Earliest Christian Interpretation

Essentially, the event of Jesus' death and resurrection—and by implication the historical career that had preceded it—was something so new that those experiencing it did not have images or categories of thought

45. Because of its central importance to the claims of Christianity, the resurrection of Jesus has been the object of intense critical study for more than two centuries. For a brief review of recent discussion, see G. O'Collins, *What Are They Saying about the Resurrection?* (New York, 1978); for exegetical studies see R. Brown, *The Virginal Conception and Bodily Resurrection of Jesus* (New York, 1973); and N. Perrin, *The Resurrection according to Matthew, Mark and Luke* (Philadelphia, 1977).

46. For the way in which Hebrews reflects early Christianity's attempts to reconcile the new word in Jesus with the word of Israelitic/Jewish traditions, see G. Hughes, *Hebrews and Hermeneutics* (Cambridge, 1979).

47. On the process by which the New Testament was produced within the context of emergent Christianity, see J. Dunn, *Unity and Diversity in the New Testament* (Philadelphia, 1977). Dunn's *Christology in the Making* (Philadelphia, 1980) studies in greater detail the development of faith in the Easter event.

that fitted it.[48] Careful scriptural study of the past century or so has indicated that in the Gospel accounts of Jesus' appearances after his death one is dealing with very early Christian stories about faith experiences of "the risen one," and that one cannot argue from these accounts to the actual detailed happenings as recounted. Rather, the experience of the earliest disciples—though real and shared and attributable neither to hysteria nor to sublimated grief—were experiences of inner consciousness rather than of sense perception. Much the same problem confronted these disciples that faced Israel's prophets: no words or ideas or images existed to formulate and communicate the experience, for it was without precedent; and the words and images used were unavoidably susceptible to misinterpretation. What does seem verifiable from the New Testament accounts is that the disciples experienced the Jesus they had known as still alive, that he was humanly alive, that in passing through death into a new life he retained his identity, that somehow he had reached fulfillment, and that he was still aware of and present to them. In the first stage of Christian awareness of and reaction to the Easter-event, there was no reflection upon "sharing in divinity" as the reality of grace, nor was there yet more than an incipient reflection upon the historical intervention that had taken place in Jesus' public career. What seems to have dominated was an awareness of the risen Lord being with them, of salvation having occurred in the death and resurrection of Jesus, and this experience of "the day of the Lord" which they shared with one another was the basic symbol in which they sensed a new presence of God in their lives. The saving God they experienced was no longer distanced or "holy" in a way that rendered them "profane"; rather, God was revealed as One present to them in extension of the intimacy enjoyed by their Master. The ecstatic introductory verses of the first Johannine letter reflects the sense of wonder that carried on still into Christianity's second or third generation.

Though they were inadequate, the images and categories that already structured the consciousness of these first Christians had to provide the first forms with which to interpret this happening. Since what had happened was experienced as saving act of God, and Jewish thought already had a highly developed theology of God's actions in history,[49] it is not surprising that the Jesus-event began to be explained through a theology of history. Grounded in the presupposition that the God of Israel who had been definitively revealed in Jesus was the creator divinity

48. On the radical newness implied by the New Testament use of *kainos* and its eschatological implications, see J. Behm, *Theological Dictionary of the New Testament* (Grand Rapids, 1965), 3:447–54.

49. To be more accurate one should say "theologies," for several distinctive views of Israel's salvation are represented in the Hebrew Bible. This has been pointed out in detail by G. von Rad, *Old Testament Theology* (New York, 1962–65).

who controlled the course of history, this earliest Christian theology explained Jesus as the fulfillment of the divine activity that for centuries had been preparing for his advent.

Because the Jesus-event was looked on as the goal of all previous divine activity in history, it was what ultimately gave meaning to that history. Its meaning had been part of the meaning of all that had happened, even though this had been hidden until the actual appearance of Jesus. This implied that all human happenings, especially the more significant ones, were linked with one another in their symbolism.

In such a worldview the literary device of *typology* is appropriate: a person or event or institution of an earlier stage in Israel's historical development can be, or at least can be seen to be, a partial realization and forecast of what occurs in a later person or event or institution, that is, a type.[50] Since God guides the emergence and evolution of personal lives and social structures in order to achieve the overall purpose in history, that purpose will be reflected in persons and their doings throughout history and will link them in an ongoing chain of meaning. Only if this is so can there be a consistent religious myth through which all the various elements of a people's experience find explanation.[51]

To find consistency in their emerging Christology, the earliest Christian theologians, Paul and the authors of the Gospels, turn to this typological form of explanation. Israelite happenings such as the exodus or the return from Babylonian exile were historical signposts pointing to the new exodus of Jesus' death and resurrection. Israelite personages such as David and Moses and the prophets point ahead to "him who is to come," whose career will achieve in greater fullness what they themselves had accomplished for the kingdom of God. The institutions of Law and temple served their temporary purpose by preparing for the more adequate realization of that purpose by Jesus as New Law and as final glory *(kebod)* and presence *(shekinah)* of God.

But if Jesus was seen in this incipient theology as the grounding and first expression of this final revelation, as *the* sign, the living symbol, of humanity's salvation, the Christian community had its own role as symbol. In the Pauline explanation of Christianity this symbolizing function is described through the metaphor of "body":[52] the community externalizes the saving presence of the risen Christ somewhat as human bodiliness gives "materiality" to the spiritual dimension of a person's

50. In some instances, such as Moses or David, the typological link seems to be grounded in the fact that a key individual is somehow a "corporate person" containing in himself in compressed form the social destiny that will gradually unfold in later generations.

51. On the biblical and patristic use of typology see L. Goppelt, *Typos* (Grand Rapids, 1981); J. Danielou, *From Shadows to Reality* (London, 1960).

52. On Paul's use of "body of Christ" see A. Wikenhauser, *Pauline Mysticism* (New York, 1960); also *The Church as the Body of Christ*, ed. R. Pelton (Notre Dame, 1963).

being. Much the same insight is contained in the Johannine tradition's use of the metaphor of the vine and its branches. And while the Synoptic traditions do not have this same metaphysical subtlety in dealing with the relation between Christians and the risen Christ, they clearly indicate the role of the Christian community as a sign of the salvation that occurred in the Jesus-event: Christians are to be light to the world; they are as a city built atop a mountain (a new Jerusalem); they are salt that will provide history its true meaning, its savor.

Though the term "sacrament" (even the roughly equivalent Greek *mysterion*) is not applied to the Christian community, the kind of symbolic intensity that theologians today would name "sacramental" was explicitly attributed to the church by earliest Christian thought. Indeed, this aspect of the community's existence is so basic that it roots the most fundamental of Christian ministries, that of evangelization. By its being and its teaching the church is meant to point beyond itself to the saving act of God in Christ. Its enlivening spirit is the Spirit of prophecy.[53]

While the entire activity of the community was seen to be symbolic, certain actions by their very nature tended to take on special or focused significance, were seen to be more formally symbolic. For example, the ritual of initiating new Christians is explained as early as Paul's letters in terms of signifying acceptance of and linkage with Jesus' death and resurrection (Rom. 6:1-11).[54] Again, as some of the community's gathering for meals took on specific reference to Jesus' final supper and to his consequent passover, they developed into a ritual enactment of this central symbol, an enactment that gave new meaning to the notion of anamnesis, that is, "recollection."[55] John's Gospel provides striking evidence of the extent to which, before the end of the first century, there was a theological explanation of the relation between Christian rituals and the Christ-mystery itself.[56]

Patristic Theories of Sign/Symbol

As Christianity began to expand and spread into the Mediterranean world, there were questions about the meaning of this new movement. What did it stand for? Or, on the other hand, what did it oppose? These questions were asked within the community as well as by non-Christians,

53. See J. Dunn, *Jesus and the Spirit* (London, 1975), 163–82.

54. A. Kavanagh points out in *The Shape of Baptism* (New York, 1978), that other early Christian interpretations of baptism existed alongside this Pauline theology.

55. On the specific Christian meaning of *anamnesis*, see my *Christian Sacraments and Christian Personality* (New York, 1965), 134–35. Briefly, because of the transhistorical character of Christ's risen existence, the event of his death/resurrection is not only recalled but made present in Christian ritual.

56. Perhaps the most striking passage is the sixth chapter, which develops the relation between Jesus' discourse on himself as bread/word of life and the eucharistic use of bread as "body of Christ."

asked distinctively by those of Jewish background who were confronted with the classic problem of the relation between the "two covenants."

Beginning with the teaching of Jesus, the problem of relating Christianity to its Jewish roots focused on the interpretation of the biblical literature.[57] It was clear that Jews and Christians read the texts of Law and prophets differently; even within the Church, Jewish Christians read the Bible differently than did their gentile counterparts.[58] As early as Justin's dialogue with Trypho we have opposing positions staked out between Jews and Christians. Both Justin and his adversary appeal to the same tradition of text, but the basic tradition encompassing these texts is no longer the same; the Christ-mystery has introduced into Justin's exegesis a new perspective that alters quite radically the symbolizing power of the scriptural literature.[59] The change goes even deeper: the very realities to which the biblical texts refer—Israel as a people, Law, temple and synagogue, exodus and return from Babylon— convey symbolically to Christians a new insight into the transcendent, for Jesus as the embodied divine Word speaking in new creative fashion transforms the "message" of previous salvation history.

However, this process of interpreting the biblical symbols by the significance of Jesus as the Christ was two-edged: inevitably, the linkage involved an application of Jewish images and categories to the understanding of Christianity. Formal Jewish Christianity had practically vanished by mid-second century. Paradoxically, though, there was an increasing "reabsorption" of Old Testament thinking into Christian theology, perhaps because it was no longer seen as an obvious threat to the distinctiveness of Christianity. This is particularly noticeable in theological reflection about Christian ritual—not surprisingly when one remembers the centrality of the cultic mentality in biblical texts produced by postexilic Judaism.

Basic Symbol Shifts: Christianity's Worldview

No symbol is more basic to the structuring of human thought and experience than the worldview, the image of space/time which interprets

57. For Christianity this remains an enduring question, because the Bible is accepted by Christians as essential to their own canonical writings.

58. One of the intriguing aspects of this divergence of biblical reading within early Christianity—and one that relates to the cultic distancing of God—is the great contrast between the emphasis on the priestly theology that marked the Jewish Christian community at Rome, and the attraction to prophetic literature that is noticeable in the community out of which the Johannine literature emerged. See Brown and Meier, *Antioch and Rome* and Brown's *Community of the Beloved Disciple* (New York, 1979).

59. The process in question actually began with Jesus' own teaching: in relating Jesus' understanding of the divine to Jewish tradition, the Gospel parables constitute an interpretative commentary on the Old Testament texts and thereby contribute integrally to the process of tradition.

perception in a given cultural situation. This, of course, has been practically a truism since Kant's *Critique of Pure Reason*, but it was already recognized as far back as Augustine.[60]

Today, anthropological reflection has once again emphasized it.[61] The worldview of some cultures is more spatial/analytic—one thinks of Hellenic culture, particularly after the fourth-century philosophical developments. In other cultures one finds a more temporal/narrative character—as in the Israelite biblical tradition. However, there is always some measure of both structure and process, if for no other reason than that humans always live in a relatively ordered though changing world.

The worldview of early Christianity emerges as a synthesis of these two divergent approaches; but as this synthesizing advances, it modifies drastically the outlook characteristic of the first generation or so of Christians. Before detailing the history of this shift it might help to suggest the two interlocking currents of development which mark the period from 80–600 C.E. In two quite different ways the God whom the New Testament texts describe as immediately present and operative in the activity and life experience of Jesus and of first-generation Christians was "distanced," moved off into a realm of "the sacred." One form of this distancing proceeded from Jewish religious roots, the other from Greek philosophy.

Jewish Roots

Traditionally, the God of Israel was viewed as revealed through the actual happenings of human history, at least at certain critical points such as the exodus from Egypt. Israel's worldview, therefore, was basically a story; and its God "defined" in terms of being the principal agent in this story: "I am the God who brought your ancestors out of Egypt" (Jer. 31:32). But as the historical career of Israel proceeded, the special events that were believed to be "word of God" became matter of tradition, of memory—so that Israelites were brought into contact with God's word, not through "the great works of God" themselves, but through recollection of these happenings and through the agents of this recollection, traditional texts and liturgical rituals.

Occasionally, new special happenings occurred—prophetic utterance or exilic punishment or return from Babylon. These served to reinterpret the traditions, but did so by themselves becoming part of traditional recollection. Gradually, in the postexilic period, the contact with Yahweh through such religious traditions crystallized in Bible and in temple

60. See J. Guitton, *Le temps et l'eternite chez Plotin et Saint Augustin* (Paris, 1959), especially 223–271, on the psychological reality of time. See also J. Mouroux, *The Mystery of Time* (New York, 1964).

61. See C. Geertz, *Interpretation of Culture* (New York, 1970), 87–89.

liturgy. These became the privileged locations where Yahweh, still seen as "a God who acts in history," continued to manifest self and will to the chosen people. Yahweh's special dwelling with humans, the Shekinah, focused within the temple on the Holy of Holies. Yahweh's guiding Wisdom/Word/Law was embodied in Torah as this was institutionalized in biblical text and official scribal interpretation.

To put it quite simply, God who had been present in the very happenings of people's lives was at least one step distanced: not those lives themselves but ritual and Torah and the personnel dealing with these became the "holy places" to which Israelites had to betake themselves in order to meet their God. Obviously, some adjustment to this relegation of the sacred to special occasions and persons was required by different situations in which Jews found themselves—in diaspora, or in the somewhat removed situations of Galilee or (in what is one of the most interesting and perhaps most important cases) in the "temporary" alienation of the Essene communities.[62] In this last-named instance, the "sacredness" of the actual Jerusalem temple was extended in Essene thought to the "spiritual sacrifices" of the community's own rituals, though the hope and expectation of return to control of the temple itself still provided the ultimate framework of their space-time imagery.

This Jewish worldview was shattered irreparably with the two-stage obliteration of Jerusalem and temple in 70 and 135 C.E. Without a Holy of Holies to provide a sacred center to the created world, there was need to find some other abode for the divine presence, some other contact point where the people could still discover divine guidance. Rabbinic Judaism turned to Torah, not as dependence upon an isolated historical document, but as a force of divine/human wisdom that through ongoing halakic commentary found externalization (sacramentalization?) in the behavior of the Jewish community.[63]

Jewish Christianity

Christianity, faced with the same need to rationalize the destruction of 70 C.E., explained it rather as the passage of divine favor from Jewish ritual to Christian. However, there was a split in Christian reaction: Jewish Christianity inclined to stress a continuity in ritual and to insist

62. Mention should also be made in this context of the Samaritans, even though the term "Jewish sect" applied to them in a different manner. See J. Purvis, *The Samaritan Pentateuch and the Origin of the Samaritan Sect* (Cambridge, Mass., 1968), 88–129, on the historical origin of the Samaritans. See also J. Macdonald, *The Theology of the Samaritans* (London, 1964); and the earlier study of M. Gaster, *The Samaritans* (London, 1925).

63. On the distinctive Jewish view of the relationship of Torah and history, see J. Neusner, *Major Trends in Formative Judaism: Society and Symbol in Political Crisis*, (Chico, Calif., 1983), chaps. 4–6; and chap. 4 in *Major Trends in Formative Judaism*, second series. *Texts, Contents, and Contexts* (Chico, Calif., 1984).

that an actual institutional as well as theological continuum be maintained; what began in Israel finds even fuller form in Christian worship forms. Hellenic Christianity, on the other hand, interpreted the event as an indication that God was moving them toward a more "spiritual" and universalistic approach to worship and salvation.

Even within Jewish Christianity there was division. Precisely because the sequence of human experience does not occur by a process of annihilation and creation but by one of continuity and discontinuity, the earliest Christians, depending on whether they perceived more or less continuity, broke in differing degrees from their inherited Jewish worldview. Classification of group mentalities runs the risk of oversimplification, but the division suggested by Brown and Meier does provide a workable basis for grasping the diversity of "Judaizing" positions in the first Christian century.[64] Four groups characterized Jewish Christianity and represented four positions regarding the relation between Judaism and the Christian communities. All accepted the principle that what God had done with the chosen people was "revelation" and therefore normative; but they disagreed with the extent to which the institutions of Judaism were to be maintained in Christianity. While one group (principally the Jerusalem community) regarded the religious practices of Judaism, including circumcision, as required of all who would acknowledge the God revealed in the Bible, a second group did not require circumcision but insisted on some Jewish observances, a third group accepted the continuation of Jewish beliefs and practices in the lives of those Jewish Christians who felt so inclined, and a fourth group espoused the principle that the Jesus-event had definitively put an end to the efficacy of and the demand for Judaism. Though not phrased exactly that way, the underlying questions were: in what situation was God encountered? what must they do to fulfill the divine will and so be saved? To put it another way: what were the *media* through which God revealed and saved? Three media received major attention: the Law, the temple, and Christianity's own community structures.

Mediation of Law and Scribal Interpretation

Given the central role of the Law in Jewish religious understanding, it was logical that Jewish Christians would start with the view that the Law was to be continued. Not too long before the advent of Jesus, Jewish wisdom reflection had arrived at the insight that wisdom was possessed only by God, but that Yahweh was graciously sharing this divine wisdom with the people through Torah. It was Torah that provided guidance for their journey through history. That elusive goal,

64. Brown and Meier, *Antioch and Rome*, 2–9.

salvation, which by this time was beginning to have some implications of life beyond—could be secured by faithful adherence to this Torah, and by no other means. This would seem to imply that conversion to Christianity did not dispense with the Law; God might wish something *more* but would not revoke the revelation already communicated to the chosen people.

If, in some fashion or other, the Law had to be reverenced and continued—and the acceptance of the Bible as canonical Scripture indicates that such was the belief of early Christianity—there was still the question of the interpretation of this Law. Among the differing approaches to the Law that existed in the Jewish world of Jesus' day, which was mandatory? Was one to find the will of God in the extension of the Law represented by pharisaic commentary? Even here there were the conflicting views of different rabbinic schools. Or was one free to regard such interpretation as scholarly opinion and feel bound only by the narrower legislation of the biblical texts themselves.[65] Or was there perhaps another approach to the entire question, one in which the very reality of God was the basic demand that found only partial expression in explicit laws; and that ultimately stood as a challenge to Israel's formulated Law and, even more so, to particular interpretations of that Law? This last approach was the challenge presented to Israel in the great prophetic oracles, which Christianity saw coming to fulfillment in Jesus.

In Rabbinic Judaism, particularly as it emerges from the ashes of Jerusalem's destruction in 70 C.E., the underlying issue of continuity/discontinuity as applied to the law is resolved by a dynamic understanding of Torah. Normative as they are, the preserved traditions of the great religious teachers and—all the more—the foundational traditions preserved in the Bible must be reverenced, listened to, and carried out in one's life. Still, these are not God's final word but part of a process of guidance that carries on in history, a process of God and rabbis reflecting together on the way in which the people's life can reflect God's saving care and give glory to God in the midst of history. Torah, then, is open-ended and meant to grow organically; though grounded in the Book, Judaism is not confined to being a static religion of the Book.

Christianity saw Jesus in some fashion as a final Word that superseded any other interpretation of Israel's history or Law. But to what extent does he constitute a replacement of the canonical formulations of the Law? For some time, dietary laws and ritual circumcision were a matter of conflict in Christianity, but as Jewish Christianity itself disappeared,

65. The Sadducees rejected the more recent oral law that was proposed as "a fence to protect the Law" and accepted only the traditional written Torah. See C. Mann, *Matthew*, Anchor Bible, 26:cvi ff.

these ceased to be issues. A somewhat different fate, however, seems to have come to those elements of the Law which dealt with liturgical worship and its complements. This brings us to the way (or ways) in which Christianity stressed continuity or discontinuity with the Jerusalem temple.

Mediation of the Temple

Later Christian centuries would interpret the Roman destruction of Jerusalem in triumphalistic fashion, seeing it as divine vengeance upon the Jews for their rejection and murder of Jesus and as proof of the succession of Christianity to the destiny of "chosen people." Textual study has made clear, however, that for Jews at that time, including those Jews who had embraced the teachings of Jesus, Jerusalem's destruction was a traumatic event that demanded a profound assessment of Israel's traditional faith. It was not only questions about the past— what causes could have led to such a catastrophe?—that bothered Christian and non-Christian Jews alike. The future, too, was questionable. Should the temple be rebuilt, if possible? Or did its destruction signal a new direction in divine guidance of history? Was teaching to replace sacrifice as priests gave way to rabbis; and were the Law's prescriptions about liturgy to be interpreted then in a figurative sense? Or should other sacred rituals, with their attendant sacred times and places and priesthood, come into existence as the continuation and realization of Israelite liturgy?

That early Christianity was confronted with these questions is clear from the Epistle to the Hebrews, which is directed to some group of Jewish Christians attracted to the notion of providing a Christian counterpart to sacrifice and priesthood.[66] Considerable evidence points to the Christian community in Rome as the addressee of this letter and as a focus of post–70 C.E. Judaizing.[67]

In this context, it is significant that early New Testament writers in their reflection upon the career of Jesus drew attention to the manner in which the exposure of Jesus himself to divine presence occurred primarily in noncultic situations, and in particular in his own activity of teaching and healing. Working from this paradigm, earliest Christianity, at least that portion of it whose outlook is reflected in the earliest texts of the New Testament and in the traditions that underlay them, discovered the revealing presence of God in the ordinary happenings of their lives and saw these as the "oracular" situations in which God spoke to them. At the same time, Jewish Christians—and probably those

66. For quite a different view regarding the provenance of Hebrews, see G. Buchanan, *Hebrews,* Anchor Bible, 36:246–68.

67. See Brown and Meier, *Antioch and Rome,* 140–58.

most strongly influenced by Essenism—looking for a continuity of sac-
rifice and temple and priest, though one that would be more spiritual,
interpreted Christianity's own emerging patterns of community struc-
ture and ritual along the lines of the earlier Jewish distancing of the
realm of the sacred. Such an interpretation was not only explanation;
it was subtle submission of emerging Christian forms to control by the
earlier Jewish worldview. In the somewhat obscure process we will try
in a moment to sketch, this "return to Judaism" gained the field, so
that by 200 c.e., if not earlier, Christian thought was again accepting
sacred times, sacred places, sacred actions, and sacred people as the
location of divine saving presence.

However, it is important to note that in this Jewish Christian distancing
of the divine, in distinction from the process taking place in Rabbinic
Judaism, the realm of the sacred where God is to be encountered is not
one step removed from the sensible world.[68] Rather, a few privileged
space/time points (e.g., an altar in a church) provide intersection with
sacred space/time and contact with the divine saving power. In the
activity taking place in these sacred events the primary agent is God,
the word being spoken is God's Word, a Word that is both instructional
and creative, a Word that has depths of meaning yet to be probed.
However, the human spoken word has its own intrinsic meaning that
is basic to the revelation being made. It is sacramental.

Hellenism

Interlocked with this Jewish influence on Christian beginnings was
the impact of Hellenic thought and culture. While we will postpone
until our treatment of second-century developments the distinctive
Greek philosophical way of distancing the divine, it should be noted
that it is inaccurate to describe the Judaism of this period as if it were
untouched by the Hellenistic culture that dominated the Mediterranean
basin and the Near East. Recent studies, especially Martin Hengel's
classic *Hellenism and Judaism,* have made clear the major impact of Greek
thought and culture on Judaism, even Palestinian Judaism, from the
Seleucid period onward.

Thus, Christianity in being shaped by the Judaism of the day was
thereby being influenced also by Hellenism. However, the more direct
contribution of Greek philosophical thought to the Christian worldview
becomes a major force only with the second century. By the fourth
century the Greek mode of viewing reality will have become the accepted

68. For a discussion of the struggle in early Rabbinic Judaism to either transcend or
incorporate history, see the two essays of J. Neusner, "The Formation of Talmudic Ju-
daism," and "The Messiah in the Context of the Mishnah," in *Formative Judaism*, 2d series,
(Chico, Calif., 1983), 2:39–89, 91–113.

framework for Christian thinking and the basic source of Christians' doctrinal distancing of God from ordinary life. The more typically Jewish Christian distancing will carry on through ritual.

As Christianity moved into the second century, it was still strongly influenced by its Jewish heritage, particularly in places such as Rome where the community could still be characterized as "Jewish Christianity." By century's end, this Jewish matrix for interpreting the Christ mystery will have given way almost completely to Greco-Roman modes of thought, with two major exceptions: the "apostolic tradition," that is, the rapidly crystallizing canon of New Testament writings joined to the Hebrew Bible as Old Testament sacred literature remained a normative witness to earliest Christian theologizing; and the liturgical formulations for initiation and Eucharist that had emerged in symbiotic relationship to this New Testament literature.[69]

69. One can see the continuity/discontinuity by comparing the creed to which the neophyte responded in the baptizing, even in later centuries, with the creed of Chalcedon or even that of Nicaea.

2

Second Century:
God Thrice Distanced

A WORLD OF SIGN AND SYMBOL

A reflective interlude before beginning a detailed description of second-century developments might be helpful. Tracing Christian understanding of sign and symbol through the patristic period and into the middle ages is a little like straightening out a ball of tangled string. Language, images, philosophical views—all are constantly changing in a vast and complex dialectic of religious thought and religious expression. Even when one has gathered what appears to be enough detailed information, there is the problem of finding a central principle of organization or a basic methodology that can provide unified and coherent understanding.

Much has been gained from a philological approach to the issue. Joseph de Ghellinck, Christine Mohrmann, and Gunther Bornkamm in their studies of "sacrament" or allied terms such as "mystery" have provided guidance for those who in the past half century have researched the historical evolution of Christian rituals.[1] This method fed into monograph studies that traced key ideas such as "image of God" or "man as microcosm."[2] But both methods needed (and still need) to be complemented by more extensive theological study of early Christian

1. J. de Ghellinck, *Patristique et moyen age*, 3 vols. (Gembloux, 1946), and *Pour l'histoire du mot "sacramentum,"* (Louvain, 1924); G. Bornkamm, *Geschichte und Glaube*, 2 vols. (Stuttgart, 1968–71); C. Mohrmann, *Liturgical Latin* (Amsterdam, 1959) and frequent articles in *Vigiliae Christianae*, of which she was an editor from its inception in 1947. The most extensive use of the philological approach was in New Testament studies: see G. Kittel, ed., *Theologisches Worterbuch* (translated into English as *Theological Dictionary of the New Testament* [Grand Rapids, 1964–]. Hereafter, Kittel's work will be cited as TDNT).
2. Cf. A. G. Hamman, *L'homme image de Dieu* (Paris, 1987); G. Conger, *Theories of Macrocosms and Microcosms in the History of Philosophy* (New York, 1922); R. Allers, "Microcosmus, from Anaximander to Paracelsus," *Traditio* 2(1944): 319–407.

and medieval iconography,[3] by further research into the rhetorical and literary-critical theories that at various historical points affected Christian understanding of texts,[4] and particularly by further work on the historical development of Christian biblical exegesis.[5] Perhaps the most critical and, until recently, most neglected area of investigation is the history of Christian understanding of liturgical rituals and of the manner in which these function as symbol.[6]

Underlying all the various developments of Christian symbols there must have been some basic cosmology or worldview that (if we can discover it) would provide the principle of unity that we seek. But Christian cosmology, even if one takes this in its most rudimentary form and prescinds from the rich variety of views that make up Christian intellectual history, is still a tangle: it has been a dialectic of the Greek structured view and the Semitic story view, spatial and temporal imagery in interaction and to some extent in conflict.[7]

By the time of Jesus, there had already been several centuries of confrontation and/or intermingling of these two tendencies, Greek and Semitic. This had occurred differently in diaspora than in Palestine because of the differing relationship of Jewish and Hellenic cultures in the two situations. Philo probably was the most outstanding example of a Jewish thinker trying to bring his religious heritage of narrative

3. Art-historical research, reaching at least as far back as E. Male's *L'art religieux du XIIe siecle en France* (Paris, 1922), has provided the basis for such study. See, for example, F. van der Meer, *Early Christian Art* (Chicago, 1967); P. Lasko, *Ars Sacra: 800–1200* (Baltimore, 1972) or G. Schiller's monumental *Ikonographie der christlichen Kunst*, 4 vols. (Gutersloh, 1966–80). However, what is needed is the kind of theological reflection that G. Ladner did with Grabar's research on Byzantine imperial art; see A. Grabar, *L'Iconoclasome Byzantin* (Paris, 1984), and G. Ladner, "The Concept of the Images of the Greek Fathers and the Byzantine Iconoclastic Controversy," *Dumbarton Oaks Papers* 7 (1953):11–34.

4. A. Wilder, *Early Christian Rhetoric* (Cambridge, Mass., 1971); G. Kennedy, *Greek Rhetoric under Christian Emperors* (Princeton, 1983) and *The Art of Rhetoric in the Roman World, 300 BC—300 AD* (Princeton, 1972).

5. Despite the continuing value of Henri de Lubac's monumental *Exegese medievale*, its synthetic structure needs to be expanded as a result of more recent research. See, for example, J. Leclercq, "The Exposition and Exegesis of Scripture from Gregory the Great to St. Bernard," *Cambridge History of the Bible* (Cambridge, 1969), 183–97; G. Evans, *The Language and Logic of the Bible: The Earlier Middle Ages* (Cambridge, 1984) and *The Language and Logic of the Bible: The Road to Reformation* (Cambridge, 1985); or the extensive publications of Beryl Smalley.

6. The past few decades have produced a large body of scholarly publication dealing with the historical evolution of liturgy; for a synthesis of much of this see A. Martimort, ed., *The Church at Prayer*, 4 vols., (Collegeville, Minn., 1981–1985). This needs to be studied now as a basic current in the history of Christian theology. A. Kavanagh, *On Liturgical Theology* (New York, 1984), has argued for study of the liturgical actions as they functioned symbolically in their actual historical performance, recognizing that this constituted a most fundamental way of doing Christian theology; he has exemplified the method in his recent volume *Confirmation: Origins and Reform* (New York, 1988).

7. In modern times this has been further complicated by science altering our view of space and by historical consciousness changing our view of time.

tradition into conjunction with the world of Platonic analysis. He, however, had resorted to allegorical exegesis much the same way that Greek philosophers had dealt with the Homeric stories, which betrayed the fact that he had not passed beyond syncretism and achieved genuine synthesis.[8]

There is a certain overlap in Hebrew and Hellenic worldviews: both envisage reality as layered, with the upper realm (or realms) housing superior and generally better beings. True, monistic systems like Stoicism tended to replace hierarchical imagery with that appropriate to a living organism. But even the Stoic worldview was absorbed into the vertical imagery of Neoplatonism without too much difficulty.

So much for coincidence of Jewish and Greek views. A basic split appears when one compares each culture's way of relating the "inside" to the "outside" of things. This is, of course, at the very heart of any understanding of sign or symbol. Certain things seem obvious to commonsense observation: a person's inner state of awareness is symbolized by language, and if language is operating authentically there is some direct and literal, if not total, correspondence of the two; but the two are distinct. So a ritual word or gesture can and should be a symbol of inner faith.

But is it this obvious? Do not words and the consciousness accompanying them point to some hidden, spiritual meaning? Historical research indicates that both these views—that word/gesture point straightforwardly to a believer's faith and that they point toward a mystery level of meaning and reality—were applied to Christian rituals virtually from the beginning. Christian baptism was seen as initiatory promise, a *sacramentum;* and at the same time as a *mysterion,* an entry into realms of hidden power and significance.

Still more fundamental than the view taken of the relation between outer word and inner word was the view of the inner and outer aspects of the human person, the relation between soul and body. Clearly, a human exists symbolically; but how the bodily dimension symbolizes the human spirit is seen quite differently in the Semitic view than it is in the Hellenic. For the Hebrew the outside is the inside externalized; but for the Greek, especially in the Platonic tradition, which is the one that most profoundly affected Christianity over the centuries, there is a dichotomy between soul and body and their interaction becomes difficult if not impossible to explain.

The gradual victory of this Platonic outlook can be traced in the shifting understanding of "image of God," the notion that humans symbolize the divine. In its original biblical usage (Gen. 1:26-28), both

8. See H. Wolfson, *Philo* (Cambridge, Mass., 1948), 87–127.

man and woman are created in the image of God and are so in their total being as bodily persons, imaging the Creator precisely by their sexual creativity. By the third century it is only *man*, because of his rationality, who is *imago Dei*; and he becomes more fully "image of God" in proportion as he turns away from involvement with the material world and commits himself to "the things of the spirit."

In between lies the Christian application of "image" to Jesus, an application that takes diversified and debatable form even within the New Testament literature. In the introductory hymn of Colossians, the Christ of glory is described as "the image of God" (*eikon tou theou*), the "first-born of all creation" (*prototokos pases ktiseos*), language that resembles that of the Johannine prologue. But like the beginning of John's Gospel, there has been constant and unresolved discussion of the influence of Greek philosophical or Jewish biblical sources on the passage.[9] It is good to keep in mind, however, that whatever Jewish or Greek ways of thinking were borrowed to explain what had occurred in Jesus, the controlling insight in Christian theology was that Jesus' human career revealed God's saving presence in a unique and ultimate way. This is the perspective of the Synoptic traditions with their description of Jesus as the eschatological prophet and as the "glory of God." This is reflected, too, in the New Testament theology of history in which the "salvation history" that had in Israel's career mirrored the saving activity of God was seen to be epitomized and fulfilled in the life and death and resurrection of Jesus.[10] In experiencing Jesus, the early Christians believed that they had seen "the face of God"—this is reflected in the opening verses of Hebrews and in the language of amazement which characterizes the beginning of 1 John. Because he is divine self-revelation, God's Word embodied, Jesus brings the natural symbolic existence of humans to a new and sublime level. In being sacrament of his Father's creative/healing existence, Jesus achieves humanly his personal identity as Son of God.

Within a very short time there began a spiritualizing of the human/divine coincidence in Jesus as the Christ, with increasing emphasis on his identity and function as divine Logos/Son of God. With the concurrent development of the notion of preexistence of the Word, which is clearly formalized by the time of the Johannine Prologue, there begins a fundamental shift in revelational epistemology: instead of beginning the process of understanding Jesus as the Christ by reflection on his human career, seeing this man's observable behavior as expressing his

9. See E. Lohse, *Colossians and Philemon*, trans. W. Poehlmann and R. Karris, ed. H. Koester (Philadelphia, 1971), 41–60.

10. On eschatological prophet see Schillebeeckx, *Jesus*. On Jesus as *doxa theou*, see s.v. TDNT 2:248–49.

inner consciousness and as imaging the divine saving presence, the procedure now becomes one of starting with the eternal Word and reflecting on how this Word of God relates to God the Father and then relates to humans in its "descent" among us.

While never far below the surface, the soteriological concerns that governed earliest Christology give way to the trinitarian discussion about the relation of divine Logos to divine Father.[11] Here a new aspect of the "image of God" comes to the fore as theologians struggle to explain how the Son of God as the unique Image of the Father shares in being with the Father though remaining distinct. It is in this context that the Cappadocian Fathers make their pioneering contribution to trinitarian theology; but one can see the broader application of their speculation about "image" when one sees how they are used a few centuries later in the iconoclast controversies, when the iconophiles drew upon them as patristic authorities who justified the use of images.[12]

Early Christian usage of "image of God" language was not limited to its application to Jesus. Given the text of Gen. 1:26-28, Christians continued to apply this language to all humans; each person is meant to image the divine. However, it is now faith in Jesus as the Christ that constitutes the deepest level of image. It is in faith that God is known as "the Father of our Lord Jesus Christ"; it is by faith that humans share in Jesus' filial reflection of the divine; it is through faith that they "become light," sharing in the "light that is the life of humans." Faith is God's greatest gift, revealing the extent of divine love by making men and women capable of entering into personal communication with the infinite God.

Everything that a Christian did was meant to bear witness to this God-given power of faith within. All of life was evangelization and worship. But very quickly the Christians developed ritual actions, most notably Christian initiation, that more formally symbolized this inner faith—simultaneously, the creative activity of God's Spirit and the Christian's acceptance of salvation in Christ. To the extent that these rituals borrowed from the liturgical traditions and understandings of Judaism, Christian faith was (as we have already suggested) subjected to a "Judaizing" interpretation. So a Jewish perspective passed into Christian soteriology and spirituality.

11. In R. Gregg and D. Groh's *Early Arianism* (Philadelphia, 1981), the authors draw attention to this underlying soteriological concern of the Arian party.

12. See G. Ladner, "The Concept of the Images," 3:22.

HELLENIZING THE UNDERSTANDING
OF FAITH

In doctrine and formal theology, however, it was the Greek influence
that soon dominated the developing understanding of faith as the con-
vergence of divine and human activity in the process of salvation. For
one trained in Platonic thinking, as were some Christians from as early
as Justin onward (that is, mid-second century), there seemed to be a
natural coincidence between several themes: the inherited religious
notion of "image of God," Jesus as the divine Logos/Image that is
imaged in turn by all creation, faith as witness to God's saving action
in Christ, and philosophical understanding of the intermediate role of
human reason in reflecting both the world of divine Ideas and the
intelligibilities of created things.

Excessive Spiritualization

This wedding of Christian tradition and Greek interpretation inevitably
led to excessive spiritualizing of both the understanding and the practice
of Christian faith.[13] Faith came to be seen less as a commitment that
involves the entire person and more as a process of human thought
probing divine mystery, less as ministering discipleship and more as
contemplation. At that point a tension emerged between the "active"
and the "contemplative" life. Accentuating this movement away from
a view of faith as involvement of the total human person was the den-
igration of human bodiliness in the systems of thought derived from
Plato; the divine action that functioned along with Christian faith must
be one of freeing humans from the enchainment of "the flesh."

With the focus on the intelligibility of things and on human reason
as the basis for humans imaging of the divine, the notion of humanity
as microcosm received a predominantly spiritual interpretation. While
it was a matter of observation that humans shared with other beings
the levels of material, vegetative, and sensitive existence and so sum-
marized the various kinds of created being, there was now more em-
phasis on the knowledge of humans as "containing" all the intelligibilities
of the universe. A human was not the whole world in a physical sense,
but reason could reflect this whole cosmos. As a matter of fact, human
reason, if directed toward its proper object, the "divine ideas," could
go beyond the created dimension of the universe and come to know

13. As we already indicated, this was accompanied by a spiritualizing of Christian
understanding of Jesus—which meant a shift in devotion from memory of his earthly
career (though eucharistic anamnesis inevitably retained some of this) to worship of the
Pantocrator.

those ultimate "reasons" of which "seminal reasons"—the internal structuring forces that cause things to be what they are—were only a reflection.[14]

Added to this was the new power of faith through which human understanding could now reflect the divine as it is in itself, personal and trinitarian. Perhaps the most striking application of this specifically Christian notion of "man as image of God" was Augustine of Hippo's *De trinitate* in which various "trinities" within the human mind are explored as reflections of the divine trinitarian existence. Nor was Augustine alone in this approach; the Cappadocians, especially Gregory of Nyssa, had already used this avenue for developing a philosophically sophisticated trinitarian theology, and the groundwork for such a development was much earlier laid out in Clement of Alexandria's *Paedogogos*. In turn, Augustine's *De trinitate* would provide a paradigm for the future development of Western Christian treatises on the Trinity.

Creation's imaging of the divine shifted gradually from the notion of all creation as a reflection of its Creator, with spiritual beings having a clear preeminence, to the view that only the rational was true image of God. This was particularly the case in Eastern theology, where the iconoclast controversies focused on the imaging function of symbols and sacraments and where, by the time of Pseudo-Dionysius and John Damascene, it is the symbolic forms (icons) and symbolic actions (liturgy) that replace ordinary created things as signs of divine presence and activity.[15] More prominently in the East, but also dominantly in the West, it is the formalized picture of the true world, whether this be the iconic representation of the heavenly world or the diagramatic statement of the underlying forces and structures of the earthly sphere—such as one finds on pages of a medieval *Book of Hours*—that gives a truer insight into reality than does the actual existent physical universe.[16]

If the icon functions this way to picture and in some way to effect the continuum of heavenly and earthly space, the liturgy rather than the happenings of secular history provides the situation for gaining a true knowledge of time, for envisaging what is really happening. The sacred liturgy can do this because it both reflects and shares in the heavenly liturgy—as sacred time it belongs to eternity.

14. It is important to see in the notion of *rationes seminales* (as drawn from Stoicism and Neoplatonism) the coincidence of "inner structuring principle" and "inner meaning." The intelligibility of things was what underlay their being what they were; discovering these hidden intelligibilities was the only reputable object of human reflection—thus the search for the "spiritual meaning."

15. See the discussion of iconoclasm in chap. 4.

16. Interestingly, this Christian development grants to the artistic creation, the icon, a status as "image of God" which runs counter to the classification of Plato himself for whom an artifact is an image of an image of the true world.

While these sacred realities of symbol and sacrament provide the privileged contexts of contemplating the divine, the sensible world is not totally devoid of revealing power. But because it was a long-established pattern of Greek philosophical reflection to seek analytic understandings by appeal to a world of "source power" which lay beyond the space/time context of immediate experience, Christian philosophers naturally located the essential divine saving activity elsewhere than in the sensible things of daily life. Ordinary experience, tied as it was to the sensible world of appearances, could not convey the meaning or the power of true being—at best it could remind, image darkly, or signal. Authentic sacramentality of the kind that functioned in Jesus himself during his lifetime found little, if any, acceptance in a thought-world dominated by the philosophical mentality of *participation*.

The questions raised, most importantly by Plato and his followers, are fascinating and profoundly important, and still beg for some more adequate response. How do individuals in a given species, for example, dog, share in some common way of being? What is the basis for the similarity between humans? What grounds the common intelligibility that underlies our use of common nouns, or of adjectives such as "true" or "good"? Clearly, there must be some distinction between participation in a given perfection and the unparticipated perfection itself—and so Plato postulated the world of such "unparticipateds." However, the problem is that such absolutes turn out to be abstractions, human categories of universality which allow for general predication but are incapable of other than intentional existence, that is, the existence that thoughts have in people's minds. Christians solve this problem by making the divine Logos the location of Platonic Ideas and the model of creation; Stoicism and Plotinus resolve it through a monistic identification of intentional and real worlds and an emanational explanation of "created reality." But however one explains this relationship between participated and unparticipated, even in a monism, the transcendent (God, the One) tends to be isolated in a realm beyond intelligibility, rather than personally present. One is dealing with a relationship grounded in image and imitation rather than with a *conversation*. As late as Tertullian and Irenaeus the Greek *logos* can still be translated as *"sermo"* (spoken word) when applied to Christ, but before long one finds only the ontological implications of *logos* as outgoing and creative reflection of divine reality, the Image that creation, in turn, images. Bishops, liturgy, Scripture can all speak to people, but they do so as mediators established to bridge the gap caused by relegating Jesus, even as the risen Christ, to the distanced and therefore safe-for-orthodoxy sphere of trinitarian Sonship.

In many ways, it is precisely this process that is the core of the fourth-through seventh-century debates about Trinity and Incarnation. These

debates are not only christological, they are eminently soteriological; they intertwine with the implicit understandings of liturgy and logically find a second-wave expression in the iconoclastic controversies of the East. The fundamental problem is that, without people realizing it, participation has replaced sacramentality as an approach to understanding God's presence to humans and even Christ's presence to the Church.

Another way of looking at this is to say that the various Christian symbols—the creeds in particular—functioned (somewhat as did Platonic myths) increasingly as pedagogical signs pointing to certain intellectual formulations, and they tended to lose the historical kind of symbolizing that links present experience with remembered experience, that is, with tradition. Having lost this anamnetic function, these signs can no longer *contain* divine presence and must instead *point* allegorically or by way of ecclesiastical convention to hidden divine action.[17] In this allegorical context, matter and bodies cannot directly bespeak spiritual truth; rather, the sensible world is a conundrum that must be solved, a clouded mirror that can reflect only obscurely, a message written in secret code. The Christian who desires to discover in sensible experience a revelation of God must decode the literal message, must find the deeper spiritual meaning of the sensible world and of the happenings of human history. The way to do this is to use the allegorical method to interpret both text and history.[18]

This way out of the apparent impasse had already been formulated religiously by Philo, who drew on Greek philosophical demythologizing of the Homeric gods to interpret Israel's biblical traditions in a two-level approach. Clearly, in this view, the incredible and naive stories of the Bible could not simply be taken as true description of the God of Israel. Behind the literal level of religious expression lay the level of spiritual meaning, where one could discover an understanding of God which was more open to, even congruent with, the rational reflections of the great Greek thinkers. What this implied, however, was the inability of ordinary experience to "contain" the reality of God, that is, a radical denial of sacramentality. Used by Christians, this method implied also a docetism that extended far beyond the focal question of Jesus' authentic humanity, a docetism that could only partially gain the day

17. It must be noted that this loss of sacramentality was only beginning in the second and third centuries; there is still a large measure of commonsense awareness of some presence of Christ to Christians—some of this continues throughout Christian history, despite its fundamental inconsistency with the outlook of more formalized theology. Perhaps another important shift occurs toward the end of the first millennium with the increasing bureaucratization of the church, though this, too, had started at least as early as Cyprian. See E. Schillebeeckx, *Ministry: Leadership in the Community of Jesus Christ* (New York, 1981), 52–65.

18. See J. Danielou, *The Bible and the Liturgy* (Notre Dame, 1956).

because of the ever-present challenge from Christianity's fundamental commitment to the reality of both creation and incarnation.

This use of the allegorical method betrays—as it had earlier in Philo—a basic inability to synthesize faith and experience. The world of ordinary experience is ruled incompetent to bear either divine Word or divine presence.[19] Icon and liturgy will provide the meeting place of humans with God, but they will do so because they are seen to mirror the world above and not Christians themselves in their historical experience. Ritual has become another world, or better an anteroom of the true sacred world, where for a time humans can begin to live the eternal life promised to them in baptism. Some Christians, those in monastic life, are more privileged, for they are already living out days and years that are totally liturgized. Monasticism comes to be seen as the Christian ideal existence, the model even for those not called to actual monastic life. Monastic spirituality is adapted to both nonmonastic clergy and laity—with less than total success. And liturgy becomes increasingly less relevant to ordinary Christian life, because it no longer recognizes and incorporates the revelatory significances of ordinary people.

Perhaps, though, this judgment should be altered a bit: so pervasive was the influence of monasticism, and more generally of the church, that all activity in medieval Europe was situated within a liturgical framework; the calendar was essentially the cycle of liturgical feasts; the week was focused on the Sunday celebration of Eucharist; holidays of obligation with their proscription of servile labor provided the instrument for providing some semi-just working conditions for the poor. Ordinary life was meant to be sanctified by adding to it certain sacred practices and by baptizing, if possible, some of the folk tales and folk customs that had for centuries provided the controlling myths in people's lives. Folk experience, even when it was the experience of the nobility, was tolerated; it was not seen as a source of revelation. It could not be part of religion; instead, religion existed to mitigate its worst features and to help people reach heaven in spite of "the world, the flesh, and the devil."

But this is carrying us far ahead of ourselves. We need to examine step by step the evolution that led to this alienation of basic human experience from God.

19. It is not accidental that allegorical interpretation will come to full flower with the late medieval emergence of nominalism for which the intrinsic reality of things (their ontological truth) is related only arbitrarily to a transcendent ground. This will produce the seeds of the fifteenth- and sixteenth-century demand for a return to a more down-to-earth relationship of Christians to Jesus of Nazareth.

DISTANCING GOD

Whereas the first and second Christian generations had seen a noticeable rejection of the Jewish cultic situating of God in sacred places, times, actions, and personnel, by the end of the second century Christianity returned in large part to this sacred distancing of the divine. Evidence is mounting that there was neither a complete break with the Jewish mentality in earliest Christianity, nor a simple return to Jewish outlooks in the second century. Instead, there was a continuing current of cultic emphasis that characterized Jewish Christianity; this current was most prominent first in Jerusalem, then in Rome. It was to the Roman community, as we already noticed, that the Epistle to the Hebrews was probably addressed.

Ritual Distancing

Rome, then, may be the real key to the development of cultic Christianity. From its inception, this community of Christians was a special "daughter community" of the Jerusalem church. Apparently there was regular coming and going between the two groups, which probably reflected the broader interchange between Jews in Rome and Jerusalem.[20] While there is little direct evidence of how things happened, it would seem logical that many of the Jerusalem church would have fled to Rome as things reached the point of no return in Jerusalem's revolt against Rome—or even earlier, as they came under attack from the Jewish leadership. It would seem even more logical that as the Jerusalem church went into eclipse the community at Rome would have succeeded to the role of "mother church."

All this helps bring the first letter of Clement into somewhat different perspective. Leaving aside the somewhat anachronistic questions about this letter as incipient assertion of "Roman primacy," one can notice the letter's strong Jewish tone.[21] What seems to come through is the view that Christian institutions should provide a continuum with the Old Testament dispensation. There is no suggestion that rituals be established according to Levitical prescriptions, but some that what is done in Christianity must provide a ritual sacrality to replace what was lost when Leviticus could no longer find implementation in Jerusalem.

One must be careful not to oversimplify this issue; it is clear that the Epistle to the Hebrews was known to the writer of *1 Clement*, though their views on the Jewish cult diverge.[22] In Clement's perspective it is

20. On the political and cultural relations of Rome and Palestine in the period following Pompey's conquest (66 B.C.E.), see S. Freyne, *Galilee from Alexander the Great to Hadrian* (Wilmington, Del., 1980), 57–98.

21. See Brown and Meier, *Antioch and Rome*, 168–71.

22. See *1 Clem.* 36; Brown and Meier, *Antioch and Rome*, 168–71.

the heavenly liturgy (which intersects with Christian worship) rather than the ordinary lives of Christians which is acceptable fulfillment of Jerusalem's liturgies; and Christian leaders are measured against Jewish priests rather than against the prophets of Israel.[23] Perhaps even more significantly, there is very little about this letter (and the same remark could be made about the slightly later Roman writing, the *Pastor* of Hermas) that gives one a sense of the importance of Jesus' historical career, except for his death. Rather, the emphasis is on the original Twelve—which connects us again with the Jerusalem community and its rather strong Judaizing tendencies.[24]

There is no mention in *1 Clement* of the Christian breaking of the bread as the "pure sacrifice" foretold (in the Christian view) by Malachi. However, this link is explicit in Roman teaching as early as Justin; it quickly becomes a commonplace in Christian writings. By itself this use of Malachi to interpret Christian liturgy does not represent a retreat to a Jewish ritual mentality; but the fact that this special and occasional action is mentioned as in continuity with Old Testament sacrifice, thus replacing Paul's insistence that Christians' daily lives constitute this continuity, begins the development of the Eucharist as "sacred ritual" and the loss of its original meaning as a family remembrance of Jesus.

As reflected in Justin's description of mid-second-century Eucharist, the atmosphere of Christian liturgical gatherings is still relatively noncultic. Christians come together to reflect on the apostolic "memoirs" and break bread as *anamnesis* of Jesus' death and resurrection; the leader of the action is "president" and not yet "priest." Yet, Sunday is already "sacred time."

Given his peripatetic career and his broad influence in succeeding decades—on Clement, Irenaeus, Hippolytus and possibly Tertullian—it is probably too limiting to place Justin within the sphere of Roman developments; but it was at Rome that he spent the years of his fullest theological activity and shared in early Christian liturgy. In any event, Justin is foundational in Christian absorption of Platonic thought, in the gradual distancing of God (and Christ as divine) to the realm of "utterly other" ontological fullness and perfection, and in the overshadowing of personal presence of God in Christ by the philosophical notion of "participation." Justin himself, however, still retains much of the sense of the proximity of Christ. For Justin, Christ is still very much the Jesus of his native Palestine. The divine action in history is not seen as one of deification, but rather one of instruction, of imparting the true gnosis. Consonant with this, Justin—along with other early Christian apologists—will attribute key insights of Greek philosophers to

23. *1 Clem.* 32.
24. For example, *1 Clem.* 42–44.

their acquaintance with the revelation contained in the Hebrew Bible. Yet, the basic shift toward emphasis on the divine aspect of Christ is already observable in Justin; "Christology from above" will increasingly characterize Christian theology.

Not long after, more exact dating dependent upon the extent to which the *Apostolic Tradition* of Hippolytus reflects earlier Roman usage, the bishop is coming to be viewed (at least in Rome) as "the high priest," a sacred person whose task is to transmit sacredness to others and to mediate between them and God.[25]

Resistance to Distancing

The *Epistle of Barnabas* suggests that the trend toward cultic inter- pretation of Christianity may not have advanced universally as quickly as it apparently did in Rome. There is common agreement that this letter comes from a Jewish Christian author, probably in Alexandria, though the document is markedly anti-Jewish, opposed even to the legitimacy of the Old Testament dispensation.[26] Despite this Jewish background, the letter takes a strong stand against a ritual replacement of the Jerusalem temple; the dwelling of God with humans no longer relates to buildings, nor is Christian celebration of Eucharist the newer version of Sabbath observance. Christians celebrate the eighth day, a memorial of Jesus' resurrection; and "God dwells in our house, that is, in us."[27]

Given the prominence of allegory in *Barnabas*, the letter may provide an important element in reconstructing the evolution of Christianity in the Alexandrian church, an evolution that sees such external elements as liturgy as symbols (though not causal) of the saving and divinizing action of God within the person rather than as instruments through which God effects grace in the Christian—as "Rome" sees it.

If early Roman views of Christianity are more down-to-earth and institutional, and Alexandrian more gnostic and allegorical, the Syrian church seems to have developed a mystical understanding that still honored historical realities and historical continuity in discipleship. Ig- natius of Antioch, writing to the Philippians,[28] picks up the "imitation of Christ" theme from Paul's letter to that church, "Do as Jesus Christ did, for he, too, did as the Father did."[29] In his letter to the Ephesian

25. The viewpoint of the Hippolytan liturgy will be discussed more thoroughly below.
26. On the Jewishness of Barnabas, the influence of Philo, the use of allegorical method, and the probable Alexandrian origin of the letter, see J. Quasten, *Patrology* (Westminster, Md., 1945), 1:89–91.
27. *Epistle of Barnabas*, 16,9 and 15,8.
28. Phil. 7:2.
29. Philippians 2.

community,[30] Ignatius draws on the notion of union with Christ already
familiar to them from the Pauline epistle, "you do all things in union
with Jesus Christ." This participation of the disciple in the continuing
mystery of Christ finds ultimate expression for Ignatius in his martyr-
dom in Rome.[31]

While this emphasis on doing all things in union with Christ implies
the sacramentality of everyday life and the special sacramentality of
death in union with Christ, Ignatius's stress on sacramentality comes to
focus in his teaching about the early Eucharist and the *episkopos*. Eu-
charist is both symbol and source of unity as well as wellspring of
everlasting life, for it is flesh and blood of the risen Christ.[32] The bishop,
on the other hand, represents and embodies the authority of God the
Father.[33]

The same themes, imitation of and union with the risen Christ, are
prominent in the somewhat later account of the martyrdom of Polycarp
and in Polycarp's letter to the Philipians. Particularly fascinating is the
prayer of the dying Polycarp.[34] Cast in the form of a eucharistic prayer,
it views the martyr's death as sharing in the death and resurrection of
Jesus, as a sacrifice joined with that of "the eternal and heavenly High
Priest." As in Ignatius's letters, the reader gets a strong sense of the
risen Lord and the Father constantly present in the sensible elements
of Christian life and worship. And one notices along with this an almost
total lack of reference back to the Jewish antecedents of Christianity.

Coming out of this Syrian Christianity, though functioning a gen-
eration later in the Roman sphere, Irenaeus still bears the marks of a
mystical-realistic spirituality. The centrality in his thought of the notion
of "recapitulation," which he develops out of the Pauline tradition,
indicates the extent to which Irenaeus maintains an awareness of the
continuing and life-giving presence of the risen Christ. Not only does
this specify his ecclesiology in terms of a "life" model, it provides on-
tological depth to the Christian ideal of discipleship[35] and it situates his
eucharistic theology within a soteriological context; the eucharistic body
and blood of Christ plant in the Christian the seed of risen life.[36] Chris-
tian life is a communion with Christ through the power of his Spirit, a
communion that finds its high point in the eucharistic celebration.

30. Eph. 8:2.
31. Eph. 3:1; Rom. 5:3–6.
32. Phil. 4; Smyr. 7.
33. Magn. 3.
34. *Martyrdom of Polycarp* 14.
35. "Irenaeus's doctrine of recapitulation can be read as the most profound theological
vindication in the second and third centuries of the universal Christian ideal of the
imitation of Christ." J. Pelikan, *The Christian Tradition* (Chicago, 1971) 1:144.
36. "Adversus omnes Haereses," 4,18,5; 5,2,3. Hereafter cited as A.H.

Irenaeus continues the interpretation of Eucharist as the "pure sacrifice" forecast by Malachi, as the symbolic offering of "the first-fruits of creation" which Christians should observe as the symbol of their gratitude to the Creator.[37]

Christian liturgy, then, does not for Irenaeus take on the cultic distancing that one finds in the Jewish-Christian currents of earliest Christianity; rather, sacramental actions function as meeting place of God and humans, of this world and the next—and this through the power of Christ's life-giving Spirit, which shapes humans into the image and likeness of God.[38]

Along with this more mystical view of the church Irenaeus has a more empirical approach; the church (and one can see this term referring more and more to church leadership) is to teach the final truth that is revealed in Jesus. It is through the church that God shares that ultimate truth whose possession constitutes humans' destiny. Yet, though Irenaeus is conversant with Greek philosophical explanations of human knowledge participating in eternal truth and with the emanationist views of human sharing in higher wisdom which characterized Gnosticism, his own understanding is more down-to-earth. Jesus himself was a God-sent teacher, his teaching was continued by his own disciples, and it is continued in those who carry on the apostolic ministry. Though it can be embraced only in faith, the teaching of the Apostles to which Christians subscribe in baptism is not some hidden esoteric truth; rather, it is proclaimed openly and explained by those to whom as successors of the Apostles it has been entrusted.[39] Irenaeus does speak of God as "the invisible Father," perhaps reflecting the baptismal creed,[40] but one gets a sense of a revealing God rather than a hiding God. Although ultimately compatible with apophatic theology, as developed later in the Byzantine tradition, Irenaeus's view of God is certainly not in that tradition; indeed, his combat with Gnosticism inclines him to stress the reality of divine presence to human affairs. Even his metaphorical description of the Word and the Spirit as "the hands of God" reflects this involvement of the divine in creation.[41]

Irenaeus may well represent a continuation of belief in the abiding presence of the risen Christ in the community, with sacralization understood basically in terms of life-giving—the eucharistic body of Christ

37. A.H., 4,17,5.
38. A.H., 5,9,1.
39. A.H., 1,10,1–2; 3,3,1.
40. A.H., 1,10,1; see Quasten, *Patrology* 1:300. Apophatic theology insists on the ineffability and utter transcendence of the divine and is grounded then on *negation*, on denying the applicability to God of all the charactertistics of created being. For an explanation of apophatic theology as it develops in later centuries, see Pelikan, *The Christian Tradition* (Chicago, 1974), 2:32–34.
41. A.H., 5,9,1.

plants in Christians the life of resurrection. Moreover, the notion of *recapitulation* implies a cosmic view in which the abiding presence of the risen Christ is a transforming force that constantly touches the entirety of creation, though concentrated in the Church. One senses an appreciation for the historical Jesus and a clear sense of linkage with earthly reality, at the same time that there is emphasis on the role of the risen Christ as savior. As in Pauline thought, the notion of *recapitulation* seems inseparable from the notion of the risen Christ as head of his body, which is the Church.

What distancing there is seems to be rather the *temporal* separation of the present from the *eschaton* rather than the *spatial* separation of heaven from earth. There are no clear indications that certain sacred buildings or locations, and the sacred acts of liturgy therein performed, are the sublimated fulfillment of Leviticus and of the Jerusalem Temple. However, by 200 C.E. there must have been, in cities with large Christian communities, some nonhome buildings set aside for liturgy; though there is no evidence whether these were simply places of assembly or whether there were already overtones of "house of God."[42]

Before the end of the second century, one begins to find reflection on the nature and effectiveness of the eucharistic action which suggests a distancing of the divine from the sensible elements of liturgy. In Irenaeus, despite the historical emphasis to which we just alluded, one finds in discussion of eucharistic presence a reference to the distinction between bodily and spiritual dimensions of "body of Christ." It is difficult to know whether this represents a movement into the philosophical distancing that will dominate much of the future, or whether this is still part of the "geographical" distancing characteristic of the Jewish tradition. There is already a sense that the sensible ritual is the setting, the occasion, the "container" for the divine saving power; but that the sensible realities do not themselves function to save.

Imago Dei and Christology

Grounded in the use of "image of God" in Ephesians and Colossians to describe Christ's identity and cosmic role, Christian reflection began very early to develop an image-of-God theology as applied to both Christ and Christians. Here the link with the philosophical notion of participation is evident. To quite an extent we are beginning to see the start of the classical trinitarian and christological disputes: the manner of Jesus' participation in divinity, the share of the Word in divine being.

42. Given the spread of Christianity among diaspora Jews it would seem that the synagogue rather than the Jerusalem temple would have been psychologically the referent for Christian gathering places; there may also have been some influence of the Hellenistic religions with their places for the "celebration of the mysteries."

However, the question still had (and to some extent always will have) both ontological and ethical aspects—Christians have some share in divine filiation, though of a different kind than Jesus' sonship; but they are also meant to share in the goodness of which Christ is the exemplar. These two come close together when one sees goodness as a life in open correspondence with Jesus' teaching, views this teaching as a process of illumination, and then (in the Platonic tradition) sees illumination as practically equivalent to creation/grace.

The link of sacramentality to christological issues is absolutely basic and becomes more evident as the disputes of fourth through sixth centuries unfold and then finally lead to the iconoclastic controversy. What happens in the christological disputes is that the *functional* dimension of word as applied to the divine Word is overshadowed and all but forgotten; instead, attention is focused on levels of being. So, in the Incarnation the role of Jesus as communicating *Abba* to humans, and thereby embodying God's self-expression, is neglected in the midst of dispute about one or two hypostases or natures. This leads to a loss of understanding of Jesus' sacramentality, of the manner in which he constitutes a unique instance of *presence*.

Inevitably this touches on the situation and function of the "body of Christ"—whether Jesus' historical body or his risen body in heaven or the eucharistic body. In the later stages of christological dispute, an appeal still is made to the reality of the eucharistic body of Christ as testimony to his true humanity; but one does not find the awareness (which early Christianity had) of God being present because of what happened and is happening in Jesus. Instead, God is relegated to unreachable transcendence. Jesus may be God's messenger; he may be the teacher of God's truth and will; he may be the Image of divine goodness to be imitated; he is no longer the sacrament of God's presence.

Legitimation of Emerging Church Order

Another element in the distancing of God must be examined, though its reflexive understanding and explicit justification remain still quite undeveloped in the second century. This is the emerging church order.

Almost until the beginning of the third century a considerable diversity of patterns characterized the organization of Christian communities around the Mediterranean basin. Gradually, however, the structure of leadership consisting of a single *episkopos* accompanied by the presbyterate and assisted by a diaconate became the universal arrangement. By the nature of things, the authority exercised by this group, and particularly by the bishop, needed to be explained—at least in the baptismal catechesis—and legitimated. This required a theory of the origin of the pastoral office.

As in other aspects of early Christian practice—liturgy, life-style, acceptance and use of certain texts as canonical, doctrinal explanation— the primary criterion for evaluation and justification was *apostolicity*. The Epistle to the Hebrews had earlier reinforced Paul's teaching that there was only one mediator, the risen Lord; but the concrete social reality was that an incipiently clerical group was already beginning to function as mediators, most importantly, perhaps, in the strictly religious realm of worship. The solution was to develop an ideology in which the Twelve were themselves designated by Jesus to start the process of mediating his saving teaching and activity to subsequent generations, a process that continued by way of fulfillment the mediation structures established by God in the priesthood of Israel.[43]

Inevitably, such an explanation existed in tension with the view that the risen Christ continued to be present to Christian communities in the communication of his Spirit, and to guide them through this Spirit. The notion that the Spirit was with the church as an animating principle and the pledge of eschatological fulfillment was clearly retained; but increasingly this presence of the Spirit was understood as focused in the *episkopos* and in those who shared with him in community leadership.[44] The prayer for episcopal ordination in *The Apostolic Tradition* suggests that before 200 C.E. the liturgy embodied this view of the Spirit abiding specially in the bishop, giving him a distinctive power to mediate in prayer to God, and in God's salvation of the people.

Even earlier, the letters of Ignatius contain a legitimation of the authority of the *episkopos* in communities that apparently were not completely accepting of a "monarchical episcopate." Here, the justification did not follow the succession argument that one finds in *1 Clement* but seems grounded instead on the notion that some symbolic link to the Twelve or Christ or God—Ignatius is imprecise at this point—gives them a privileged position of respect and authority.[45] One of the intriguing elements of Ignatius's letters is the absence, in his letter to the Roman community, of any reference to the *episkopos* of this community. This suggests that there was not one; but what, then, are we to do with

43. Jesus clearly did pick certain closer disciples among those who followed them, but there is no New Testament evidence that he envisaged an organized church much less appointing the Twelve as its first bishops. On the emergence of a structured episcopate see my *Ministry to Word and Sacraments,* (Philadelphia, 1980).

44. This is noticeable in the difference between the church order implied in Ignatius's letters and that reflected in the Johannine literature. On the latter, See R. Brown, *The Community of the Beloved Disciple*.

45. The bishop is linked to Christ in Ephesians 6 and to God in Magn. 3–6; the presbyterate to the Twelve in Magn. 7 and Tral. 2.

the "Clement" of *1 Clement*, a document that itself suggests the absence of episcopal structure at that point in Corinth?[46]

To come back to Ignatius: how is the sudden emergence of the tripartite structure of monarchical-episcopate, presbyterate, and diaconate to be explained? Was it due to the strong personality of Ignatius, to the earlier prominence of Peter in the community, to some continuity with patterns of diaspora Jewish community life, to the influence of Essene forms of community leadership, or to civic patterns of the Hellenistic world? Apart from the question of source, the ecclesial mentality of Ignatius's letters reflects two levels of God's presence to the community: immediate presence to the bishop, mediate presence through the bishop to the people.[47]

Justin's understanding of church order a half century later is specially significant, though he pays no particular attention to polity, and only through passing and implicit references can we partially reconstruct his view. The proximate experience out of which he writes is that of residence in Rome, but he can draw also on recollection of Christian life in other communities. He himself is not part of the emerging clerical leadership; without any need, therefore, to legitimate his own authority he takes for granted a presidency of Eucharist on the part of the *episkopos* and a secondary assenting role by the laity.[48] There is not, however, any attempt to link this role of leadership with either Old Testament or apostolic precedents, even though in the *Trypho* there is constant comparison between the two dispensations and the claim that Christian Eucharist fulfills Malachi's prophecy of a spiritual sacrifice.[49]

Toward the end of the century Irenaeus represents a key witness to the early explanation/legitimation of an emerging tripartite church leadership. With his basic concern to preserve orthodox doctrine in the face of gnostic errors, apostolic continuity as a criterion of orthodoxy assumes central importance. Situating this apostolic continuity in the episcopate, Irenaeus finds a theological explanation that actually is a reinterpretation of history. "We can name those who were appointed as bishops in the churches by the Apostles and their successors to our own day."[50] What is more basic to our present concern, however, is

46. "To return to Clement of Rome, as *Hermas Vis.* 2.4.2–3 suggests, he may have been one of the presbyter-bishops who had the specified task of writing letters to other churches in the name of the Roman presbyter-bishops . . . Thus *1 Clement* may have been sent by the collective Roman presbyterate of overseers and have been composed by the hand of its secretary presbyter-bishop." Brown and Meier, *Antioch and Rome*, 164.

47. See Philad. 4–7; Magn, 6–7.

48. Apology 1, 67.

49. *Trypho*, 41.

50. A.H., 3,3,1.

Irenaeus's teaching that the truth-safeguarding presence of the Spirit is situated in the bishops who are the mediators of truth to the faithful.[51]

By the end of the second century, then, one can see rather clearly the incipient but progressive distancing of people from the sense of God's immediate presence that marked Christianity's beginnings. This is most noticeable in the way in which the early Church's public worship is once more incorporating some of the cultic mentality that characterized Jewish temple ceremony. Liturgy is still experienced as entry into the mystery of Christ, but this mystery is increasingly viewed as a realm of "the sacred" distinct from the rest of people's lives. Christianity is becoming more a religion than a way of life. At the same time, one can notice a growing impact of Greek philosophical thought on the formulation of Christian belief, with the result that abstract ideas are beginning—though at this point only *beginning*—to replace people's experience as the medium for understanding the divine. And a third form of distancing is becoming more prominent as official structures are established to organize Christian communities, the division between the ordained and the laity widens, and active discipleship is increasingly considered to belong to church leaders.

51. A.H., 4,26,2. See Pelikan, *The Christian Tradition* 1:120.

3

Patristic Search for Doctrinal Symbols

When one turns from Irenaeus to third-century theology, whether in Rome or Alexandria or Africa or Syria, there is a noticeable increase in the elements of distancing. Only Tertullian is to some extent an exception. In Rome the *Apostolic Tradition* of Hippolytus reflects a strong liturgical reassertion of the Jerusalem temple mentality, the removal of religion to a separate realm of cultic sacrality. The celebrants of Eucharist are now designated as "high priests," the elements of Eucharist are viewed as sacrificial offerings, and the consecratory prayer for the ordination of the bishop asks God "who dwells on high yet has respect unto the lowly" to

> grant unto this thy servant whom thou hast chosen for the episcopate to feed thy holy flock and serve as thy high priest, that he may minister blamelessly by night and day, that he may unceasingly behold and propitiate thy countenance and offer to thee the gifts of thy holy Church, and that by the high priestly Spirit he may have authority to forgive sins according to thy command.[1]

To some extent, this focusing of religion on liturgical actions performed by sacred personnel and interpreted as effectively "sacrificial" was offset by the practice of private prayer. As Hippolytus witnesses, all Christians were urged to turn to God in prayer at the third, sixth, and ninth hours as well as in the morning and evening—and even in the middle of the night. However, in its own way this pattern carries us back to Jewish roots: as J. Jungmann mentions,[2] the practice of prayer at designated hours "was founded on Jewish prototypes" and is reflected

1. *Hippolyte de Rome: La Tradition Apostolique*, 2d ed. (Paris, 1984), 46.
2. Tertullian also speaks of these times of individual prayer; see *De oratione*, c. 25, (*Tertullian's Tract on Prayer* [London, 1953], 35). For a description of private prayer in the early church and its gradual evolution into the canonical hours as the clergy increasingly took over the worship activity of the church, see J. Jungmann, *The Early Liturgy* (Notre Dame, 1958), 97–108.

already in the Acts of the Apostles. Moreover, the practice was grounded in the view that it is necessary on a regular basis to turn away from the entanglements of ordinary profane life. What was distinctively Christian was the content of the prayer; Christians were urged to make the passion and resurrection of Christ the theme of this daily meditation and prayer.

ROME AND ALEXANDRIA

Apart from Hippolytus and the schismatic Novatian, the third-century Roman church manifested little involvement with philosophical interpretations of Christian faith. Novatian, as the first theologian writing systematically in Latin and in Rome, had considerable influence on later developments because of the vocabulary he established. For the most part, however, he is not theologically innovative; he continues the explanations of Hippolytus and Justin and Irenaeus, is influenced by Stoicism rather than by Middle Platonism, and makes evident in his own theorizing the subordinationist tendencies present in most of the earlier thinkers. The process of distancing was aggravated by the Novatian emphasis on the role of the Spirit in taking over in the life of the Church after Jesus' ascension.[3] His explanation of Leviticus exhibits his knowledge and usage of allegorizing.[4]

Bishops Zephrinus and Callistus were on the edges of the emerging trinitarian disputes. Both were attacked for doctrinal deviation by Hippolytus; and Callistus ended up excommunicating Sabellius; but neither possessed either theological sophistication or creativity. Somewhat later in the century, Dionysius of Rome exchanged letters with his counterpart in Alexandria regarding the heresy of Sabellius, and a synod at Rome in 262 C.E. condemned both Sabellianism and subordinationism; but the official approach was one of safeguarding traditional belief rather than of philosophical speculation.

Quite a different atmosphere marked the third-century Alexandrian church; two developments, the creation of philosophical theology and the emergence of monasticism, were taking place—developments that in many ways stood in tension but that would find a somewhat strange marriage in the fourth-century Arian dispute.[5] Despite their differences, both developments would contribute to the view that ordinary human life was not the arena of divine presence.

Already with Justin one finds a discussion of Jesus of Nazareth that

3. See J. Quasten, *Patrology*, 2:230–31.
4. Ibid., 221.
5. Gregg and Groh, *Early Arianism* (Philadelphia, 1981), 131–59, have an interesting and rather convincing treatment of the way in which Athanasius by his *Life of Anthony* won over Egyptian monasticism to his anti-Arian position.

stresses his identity with the divine Logos; and this emphasis becomes much more noticeable with the reflections of Clement and Origen. More than that, the very functioning of the Logos becomes more markedly interpreted in a Platonic mode: in Justin one senses still the Jewish coincidence of "divine word" with "divine wisdom" and "Torah," a coincidence that had continued into the Johannine prologue's use of Logos; in Justin one is dealing with a dialogic process, with God instructing and guiding humans, rather than with an ontological participation in divine knowledge. Contrastingly, Clement casts the role of "the Pedagogue" as one of internal illumination (in faith) as well as specific instruction.

Clement of Alexandria

Clement does not, of course, accept the gnostic contention that humans share by nature in divine truth; for him only faith, receptive of God's revelation, can bring the truth that is salvation.[6] Besides, Clement is deeply touched by the Christian ideal of imitating Christ. The ultimate teaching provided by divine revelation comes in the example of Jesus, in his life and death.[7] Along with this example, the divine-human Pedagogue provides the teaching that can guide humans in a path of life leading to the perfection that is their destiny.[8] Yet, the impact of Jesus as communicator of divine wisdom goes beyond the example provided by his own human activity and beyond the guidance provided by his instruction and exhortation. As Logos, the "inner teacher" working in the faith life of the Christian, Christ shares his own imaging of God and shares his own Spirit-life. This sharing begins with baptism.[9] One who embraces Christ's teaching and follows in his footsteps acquires an "assimilation to God," but an assimilation "in moral excellence."[10] Clement is still basically in the thought-world of Scripture, of Christ replacing Old Testament Torah, of Jesus' injunction to "be perfect, as your heavenly Father is perfect" (Matt. 5:48); but the philosophical notion of participation has clearly entered as a way of interpreting both the distinction and the relationship of the divine and the human. While the Logos, divine-human Pedagogue, mediates divine instruction to humans, God (the Father) remains incomprehensible and ineffable.

If Clement bears witness to the early stage of philosophical distancing of God, there is little trace in his extant writings of the resurgent cultifying of Christian worship. If Clement was influenced by Jewish or

6. Strom., 5,1,1–9
7. Paedogogos, 1,12. Hereafter, it will be cited as Paed.
8. The bulk of Paed. details this.
9. "Being baptized, we are illumined; illumined, we become sons; being made sons, we are made perfect; being made perfect, we are made immortal" Paed. 1,6.
10. Paed., 1,12.

Jewish-Christian currents of thought—he was acquainted both with Philo and the *Epistle of Barnabas*[11]—it was in absorbing the ethical outlook of Israelite prophetism rather than the cultic emphasis of the priestly tradition. Throughout his writings, "being Christian" is viewed in terms of a superior level of moral behavior. Being virtuous is being God-like; the true Gnostic, who exists according to the image and likeness of God, is the person who lives righteously.[12] And while Clement deals extensively with knowledge as an approach to God and insists on faith as that kind of knowing that alone can deal with the divine as it truly is, he still gives priority to volition; the intellect is minister to the will.[13]

Clement does witness, though almost always in passing, to liturgies of baptism and Eucharist. However, there is no indication that sharing in these is being specially "religious"; instead, they seem to exist as means to the end of becoming "true Gnostics." Like Irenaeus before him, Clement sees eucharistic communion in the body and blood of Christ as a situation where Christ-life is imparted to the participants; but whereas in Irenaeus there is a strong realism attached to the eucharistic elements as body and blood of Christ, in Clement the sacramental realism is almost overshadowed by his emphasis on the action being one of sharing Word and Spirit, Word and Spirit that can be the source of truly virtuous Christian life.[14] In Irenaeus, one is still strongly linked in liturgical recollection with the human Jesus; in Clement this anamnetic aspect of baptism or Eucharist is scarcely mentioned.

This does not argue that memory of Jesus was unimportant in people's sacramental experience; it does suggest that theological analysis in Alexandria dealt with liturgical symbolism in nonhistorical fashion. Clement does understand baptism as linkage with Christ, but the stress is on the spiritual effect, most often interpreted as "illumination."[15]

Perhaps of much more lasting importance was the manner in which Clement and his Alexandrian successors dealt with the matter of divine incomprehensibility. Firmly within the outlook of Middle Platonism and drawing from the allegorical exegesis of Philo, Clement denies to any symbolism, including language, the possibility of conveying directly a knowledge of God.[16] Faith does provide an avenue for intellectual contact with God, but if and when such contact is made, there is no medium

11. See Strom., 2,18 where he cites Barnabas. On his debt to Philo see S. Lilla, *Clement of Alexandria* (Oxford, 1971), 140–41.
12. Strom., 2,19.
13. Strom., 2,17.
14. Paed., 2,2.
15. See B. Neunheuser, *Baptism and Confirmation* (New York, 1964), 64.
16. Strom., 5, 81–83.

for adequately conveying such understanding.[17] Instead, the "believing Gnostic" must discern behind the literal significance of words and other symbols the spiritual meaning that leads to insight into the divine. It would be highly instructive if we possessed from Clement a baptismal catechesis, like those later provided by Cyril of Jerusalem or Ambrose, that spelled out such an allegorical interpretation of Christian sacramental liturgies; but there is none. Instead we are left with nothing more than hints, particularly in the way in which Clement sees the visible aspects of Eucharist pointing to the inner action of Word and Spirit. But the point has been permanently made: the "natural" meaning of sensible reality is incapable of conveying a knowledge of a present God. The writer of 1 Tim. 6:15-16 had already spoken of God as the "Lord of lords, who alone has immortality and dwells in unapproachable light, whom no one has ever seen or can see." And the notion that Christianity in general can be referred to as *mysterion* is explicit in Ephesians long before Clement employs it.[18] But with Clement this view passes into Christian theology as a principle of religious epistemology. The literal significance, whether of a text or of experienced reality, cannot itself convey understanding of God. Instead, it is the spiritual meaning that leads to insight into the divine.

Origen

If Clement outlines the theory of the Christian use of symbols, Origen fleshes it out in a full theological synthesis.[19] Much of what had been either taken for granted or slowly developing in implicit fashion now becomes explicit and structured. Christian existence is a movement into mystery, a deepening initiation into the divine sharing with humans springs which from the Word become incarnate.[20] All sensible creation,

17. On Clement's focal treatment of faith in Strom., 2a, see E. Osborn, *The Philosophy of Clement of Alexandria* (Cambridge, 1957), 140–43.
18. On the concrete ritual implications, both anamnetic and soteriological, of *mysterion* in early Christianity, see G. Soehngen, *Der Wesensaufbau des Mysteriums* (Bonn, 1938), 64.
19. The last few decades have seen extensive research into the career and thought of Origen; one can get some idea of this from H. Crouzel's annotated bibliography of literature on Origen (*Bibliographie critique d'Origene* (The Hague, 1971). Crouzel has updated this survey in "The Literature on Origen 1970–1988," in *Theological Studies* 49 (1988): 499–516. See especially, J. Danielou, *Origen* (New York, 1955); H. Crouzel, *Theologie de l'image de Dieu chez Origene* (Paris, 1956) and *Origene et la philosophie* (Paris, 1962); P. Nautin, *Origene* (Paris, 1977); H. Chadwick, *Early Christian Thought and the Classical Tradition* (New York, 1966). For a thematic anthology of texts from Origen, see H. Urs von Balthasar, *Origen, Spirit and Fire*, trans. and ed. R. Daly (New York, 1984). On Origen's Platonism, see E. Ivanka, *Plato Christianus* (Einsiedeln, 1964), 100–51.
20. Danielou, *Origen*, 297–303, summarizes Origen's application of exodus symbolism to the various stages of Christian contemplative progress, from the purgative to the unitive.

and therefore the whole of the sensible reality of Christian life and worship, is a symbol of "heavenly reality."[21]

Undergirding this theological understanding is a worldview that in some ways is more reminiscent of the *Iliad* than it is of the Bible, though Homer's Olympians are replaced by various hierarchies of angels.[22] Apart from God, who dwells in ineffable infinity, there are two worlds that coexist and, to some extent, interact. There is the sensible world of created bodily beings and observable historical happenings; there is the hidden world of spirit, including humans in their inner life, with its own history. Origen does not deny all reality and worth to the sphere of *sensibilia*, but neither has it the ultimacy or the significance of the spirit realm. It is behind the veil of visible things that the real story is unfolding, and it is humans' involvement in this story which determines their true identity and destiny. What is really happening is the progressive fulfillment of the mystery revealed in the incarnate Word, fulfillment in the spiritual life of each believer and in the ongoing life of the Church.[23]

The mixture of methodologies in Origen's approach to biblical exegesis reflects this two-level cosmos. On the one hand, Origen continues the early Christian use of typology to situate both Christ and the Church in the sequence of happenings that we ordinarily refer to as history. Thus Israelite personages such as Moses and Israelite institutions such as the temple will find their meaning and purpose fulfilled in Jesus and Christianity.[24] On the other hand, the observable elements of biblical history that the sacred text describes point to the hidden activity of God's Word and Spirit in the souls of men and women. This is where the history of salvation is being enacted; this is where external happenings find their true meaning.[25]

It is in this second realm where the exegete must search for the spiritual meaning of the biblical text, and where the person of faith must look for the meaning of his or her life experience and for the

21. On Origen's understanding of *mysterion*, especially as applied to Eucharist, see H. Urs von Balthasar, "Le mysterion d'Origene," *Recherches de Science Religieuse* 27(1937): 38–64.

22. On Origen's angelology, see Danielou, *Origen*, 220–45.

23. "He [Origen] formed a single doctrinal unit out of the main spiritual meanings of Scripture, differentiated according to the chief aspects discernible in the *Christus totus*— meanings relating to Christ himself, to the Church, to the spiritual life and to eschatology." Ibid., 166.

24. For example, his treatment in Hom. Lev., 10,1 of Jesus' fulfillment and replacement of the temple.

25. While Origen draws constantly from biblical events such as the exodus to discover deeper spiritual significances, it is not without theological importance that his richest descriptions of the spiritual history of the Christian Gnostic come in his exegesis of the Song of Solomon, in which the basic human experience of lovemaking provides the fundamental symbol.

meaning of those liturgical actions that are intended to interpret Christian existence. The literal meaning of Bible and life and sacrament is of value, especially for the mass of uneducated people; but it is only a step toward the inner significances that image God more directly and that make it possible for the true Christian Gnostic to enter increasingly into intellectual union with the divine.[26] Such spiritual exegesis functions in the realm of faith, but even there it depends upon a special charism.[27]

In the search for the spiritual meaning, Origen took from Greek philosophers and especially from Philo the technique of allegorical interpretation. But if the literal meaning of text and reality was a code to be deciphered, that which guided the process was the Christian contemplative experience of Christ, the Word of God. While Origen does differentiate five "senses" of Scripture, there actually are, as Danielou has pointed out, basically two senses: the literal meaning and the christological meaning. The latter can be distinguished into Old Testament typological references to Christ, or reference to Christ's ongoing life in the Church, or reference to "the last things," or reference to the individual Christian's relation to Christ.[28]

In the final analysis Origen sees the deeper soteriological activity occurring at the level of the ministry of the Word. The task of opening up the inner meaning of the Word is truly a priestly ministry that takes precedence over the institutional priesthood of bishop and presbyter, without denying the historical grounding and intrinsic role of the latter.[29] For Origen the successors to the institutions and rituals of Israel are Christ himself as Word, the Church's proclamation and clarification of the Word, and the fruit of that preaching in the lives of Christians. Instead of temple and sacrifices and cultic priesthood, the Christian era worships God by the virtuous lives and faith of women and men.[30]

This is done, of course, in imitation of and union with the risen Christ whose body they are. Origen retains much of primitive Christianity's vision of ordinary human life, lived in the light of the Easter mystery, as the locus of divine presence and the manifestation of God's saving intent—God's glory. If Tertullian can claim the phrase "The glory of

26. See Danielou's treatment of Origen's view of Eucharist, in *Origen*, 61–68.

27. Gregory Thaumaturgus says of Origen that he possessed this charisma preeminently: "Origen possessed the sovereign gift which he got from God, of being the interpreter of God's word to men. He had the power to listen to God and understand what he said, and then to explain it to men that they too might understand" (Danielou's translation). Or. Paneg., 16 (*Patrologia graeca*, 10, 1093).

28. See Danielou, *Origen*, 139–73.

29. See Hom. Lev., 1,4.

30. Contra Cels., 8, 17–18; 8, 21.

God is the human fully alive,"[31] the whole of Origen's theological an-
thropology is a detailing of that truth. However, there is a basic differ-
ence: if Origen has preserved belief in a presence to Christians of the
risen Lord, he has done so by distancing the spiritual life of Christians
from their sensible bodily existence. Like the literal meaning of a biblical
text, the externals of human life are only a symbol meant to lead the
mind to the truth that comes in contemplation of the inner heavenly
world.

But does the situation of Christian ritual provide a special occasion
for this movement from symbol to reality? No doubt the answer is
affirmative, but Origen provides no particular help in understanding
the manner in which this occurs. For all his concentration on the mean-
ing of things, and probably because of his Platonic tendency to see
sensibilia as incapable of carrying truth, Origen does not adequately
grasp sacramentality.[32] Baptism is described as "illumination," with the
Word and the Spirit working in a new way in the soul of a person; and
this is clearly the foundation for the life of faith in which, it is hoped,
the person will share more and more in the truth revealed by the Word.
Yet Origen's explanations of the meaning of baptismal liturgy for the
most part simply repeat the traditional catechumenal teaching—pro-
viding for that very reason a precious insight into prebaptismal prep-
aration in the Alexandrian church.

As for Eucharist, there is salvific effectiveness connected with the
bread and wine transformed into body and blood of Christ; and this
effectiveness comes from Jesus' death and resurrection. However, the
more important effect takes place on the spiritual level, as the Christian
feeds on the Word and is nourished by that "blood" (that is, principle
of life) which is Christ's own Spirit. This spiritual causation is not apart
from the external elements, for the Word comes to the bread to make
it salvific in a manner linked to the Word coming to flesh in the In-
carnation; yet it does not seem that the bread has a true sacramental
input into the effect.[33]

What is already occurring in Origen is a separation between ordinary
Christian belief and practice, especially as that touches liturgy, and the

31. See *Adv. Marcionem* 2,5–6. This is one of several texts in Tertullian that develops
the theme; it does not, contain, however, the usually quoted citation.
32. L. Lies in *Wort und Eucharistie bei Origenes* (Innsbruck, 1978) details the tendency
of Origen to spiritualize the reality of Eucharist. As Lies describes it, the action taking
place in the ritual is the Word feeding the Christian's life of faith consciousness, and the
external elements of the ritual provide the situation for this to occur. See particularly
98–118.
33. Ibid., 101–2.

understanding and practice of a theological (spiritual) elite.[34] This forecasts a gradual divergence of theological and even doctrinal formulations of Christian faith from the traditional formulations of liturgy.[35] Origen's theology does not appear to work very directly out of liturgical significances, though it obviously is neither ignorant of nor opposed to them. Instead, traditional Christian belief is explained by a combination of Scripture, read according to its spiritual sense, and the cosmology of Middle Platonism. An instance of this fusion of influences, critical to understanding Origen's influence on Christian history's view and use of symbolism, is his explanation of humans as the image of God. Obviously, he is drawing from the Genesis passage that speaks of humans as created in the image and likeness of God and from New Testament references to the Word as paradigm image of the divine (e.g., Col. 1:15). And like Clement before him he incorporates the moral dimension of "imitation" contained in biblical passages such as Matt. 5:48, "Be perfect, as your heavenly Father is perfect." Yet these biblical insights are interpreted by Origen in the context of the philosophical notion that created knowledge shares in unparticipated truth. Humans become increasingly image of God insofar as they reflect in their intellectual life the Word who is the preeminent image of God.[36]

Monastic Distancing

Strangely allied with philosophizing currents represented by Clement and Origen was the basically anti-intellectual movement of emergent monasticism. In its earlier stages especially, nothing in Egyptian or Syrian monasticism is particularly reminiscent of the resurgent Judaism in cult or of the philosophical reinterpretation of the gospel, as far as we have observed.

Instead, there is a flight from the involvement in human communities that regular cultic activity presupposes and a disdain for systematic intellectual reflection on the truths of faith. By this very fact, then, monasticism makes its own distinctive contribution to the distancing of religion from the ordinary lives of people. Monks fled to the desert to find God away from the distractions and temptations of urban life. In doing that, they were continuing the conflict of desert and city that is a major (but not unchallenged) theme through much of the Bible; they

34. See J. Lebreton, "Le desaccord de la foi populaire et de la theologie savante dans l'Eglise chretienne au IIIe siecle," *Revue d'histoire Ecclesiastique* 20 (1924): 481ff.

35. In *Religion and Culture* (Edinburgh, 1948), Christopher Dawson describes the disastrous effects of the separation of law and liturgy in a religious community—living law becomes restrictive legalism and ritual becomes superstition. Mutatis mutandis, one could make the same judgment regarding doctrine/theology and liturgy; their separation leads to abstractness on the one side and semi-magical practice on the other.

36. Hom. Ezek., 4,8; Com. on John, 2, 17–18.

were appropriating to themselves the identity of "dedicated Christians"; and they were reinforcing the outlook that contemplative union with God was incompatible with the "worldly" life that is the lot of most Christians.

For a century or more there was an overlap between the beginnings of monasticism and the continuation of the civic persecution of Christians. Indeed, part of the impetus to flee to the desert may have come from the need to avoid persecution. But as the Constantinian legitimation of Christianity brought an end to persecution in most parts of the Christian world, the ideal of martyrdom as the full witness of Christian faith gradually gave way to the ideal of the Christian ascetic, the spiritual athlete. Obviously, this was an ideal beyond the reach of most Christians; it was reserved for a spiritual elite.

By its very nature, monastic life tended toward a moralistic interpretation of the gospel, emphasized human effort and discipline in the quest for union with God, and looked upon "the grace of God" as essentially an aid to overcoming human weakness and attraction to sin. By its emphasis on *ascesis*, and despite its negative view of the pretensions of scholarly learning, monasticism resonated positively with Greek philosophical emphasis on the superiority of soul to body and on the need for the body to be disciplined so that the soul would be free to seek truth.

It is impossible to discern what, if any, influence gnostic currents of thought had on the early stages of the monastic movement. But it is clear that in several portions of the third- and fourth-century church, perhaps most prominently in Egypt, the Christian Gnostic nurturing the spiritual life by contemplative reflection on divine revelation and the monk practicing bodily mortification as a means to prayerful union with God became close allies. In some instances, and one thinks of the Cappadocian Fathers, the two ideals were realized, not without some tension, in the same individual.

NORTH AFRICA

Close to Egypt as it was geographically, North African Christianity had a distinctively different character. Functioning within the orbit of Rome, both politically and culturally, this portion of Africa was strongly influenced by Roman law and Roman structuring of society. Moreover, our earliest witnesses to North African Christianity show it to be already Latinized—at the same time that Tertullian is writing his major works in Latin, Hippolytus in Rome is still writing in Greek.[37] The linkage

37. On the advanced Latinity of Carthage at that time, see T. Barnes, *Tertullian, A Historical and Literary Study* (Oxford, 1971), 22–29.

with Rome is important in examining the African understanding and use of symbolism, particularly ritual symbolism; there was likely to be more influence from rhetoricians in Rome than from philosophers in Athens or Alexandria; and what philosophical influence existed was more likely to be Stoic than Platonic.

Tertullian

Tertullian himself bears quite clearly the impact of Rome. While there is dispute as to whether he actually was a lawyer or a professional rhetorician,[38] his pattern of thinking and style of expression reflect a training in the skills of law and rhetoric.[39] So, while Tertullian is manifestly a person of faith and prayer, unquestioningly accepting Jesus as the Christ and the God revealed in both Old and New Testament, and even inclined toward the prophetic and charismatic aspect of the church more than to the official institutional aspect, one does not, in reading him, get the impression of a mystical approach to Christianity. Instead one is dealing with a man who passionately but very rationally defends the truth of traditional Christian belief; a man who uses all the skills of argumentation and persuasion to make his (and orthodox Christianity's) case against the likes of Marcion. So, in reading Tertullian one gets the sense that professional leadership is becoming increasingly important as mediation between God and the bulk of the people, that an organizational model for the church has become more prominent, and that distancing of people from God through mediating official structures is becoming more of a factor in the life of Christianity.

This is not to say that Tertullian neglects the mystery dimension of Christianity. He consistently works with the notion that the one God, the Father of the Lord Jesus Christ, not only creates all that exists but has been guiding the course of history since its beginning, guiding it according to a pattern that finds its focus in the incarnate Word. This constitutes the heart of his argument against Marcion, who wanted to separate the God of the Old Testament from the God revealed in Jesus. Christ and the Church are the mystery hidden for long ages and now finally revealed (Eph. 3:9-11).[40] However—and here Tertullian embraces the traditional Christian use of typology—the revelation made in Jesus as the Christ was already being forecast by the persons and events and institutions of Israel. So, for example, in the prophecy of Zacharias the garments of Josuah, first filthy and then kingly, point to the first and second coming of Jesus; more than that, the very name

38. Ibid.
39. Ibid.
40. Adv. Marc., 5,6; 5,11.

Josuah (Jesu) is *sacramentum*.[41] Tertullian is particularly fascinated by Old Testament prefigurings of the cross of Christ, some of which seem rather far-fetched to the modern reader.[42] Even the Old Testament law has "sacred and secret meanings, both spiritual and prophetic."[43]

Mystery and figure continue on in Christianity. Christ is Emmanuel, God-with-us, and not only with but *in* us, for the baptized have put on Christ (Gal. 3:27).[44] Tertullian is insistent on the fleshy reality of the incarnate Word, already battling Marcion on this point in his early *De carne Christi* and then later in the more mature *Contra Marcionem*. Yet he is also clear that this external aspect of Christ was the sign of his real dwelling with humans. In somewhat analogous fashion, the eucharistic bread and wine that Christ made into his body and blood act as *figura* of his human self.[45] Tertullian is not involved in the spiritualization of Eucharistic presence that we noticed with the third-century Alexandrians.

Tertullian, then, seems to reflect a view of reality in which God is present to humans, for that matter to all creation, by providential power, but still rules "from heaven." However, Christ, the incarnate divine Word, God-with-us, continues to dwell with Christians—ecclesially, eucharistically, and spiritually. This is the outlook of *De baptismo,* in which Tertullian describes the introduction of the neophyte, through sacramental liturgy, into the Church and simultaneously into new life.[46] Faith in Christ's birth, death, and resurrection is essential, but it needs to be complemented by the liturgical act; for this was the law given Christians (Matt. 28:18), to go forth and baptize. It is in baptism that sin is forgiven and the Spirit conferred. As for sacramental significances, the notion of water as a cleansing agent seems to be paramount and, as was generally the case in the second century, the linkage with Christ's death and resurrection is not stressed,[47] though Tertullian does say that the efficacy of the ritual derives from Christ's passover as well as from the invocation of the divine names. In Tertullian one encounters the instrumental view of ritual that was already suggested in *1 Clement* and that will become dominant in the West: through the action of the human

41. Adv. Marc. 3,7.
42. Adv. Marc. 3,18; Ad nat. 1,12. See H. Rahner, *Greek Myth and Christian Symbol* (London, 1963); J. Danielou, *From Shadows to Reality* (London, 1960); and *Bible and Liturgy* (Notre Dame, 1956).
43. Adv. Marc. 2,19.
44. Adv. Marc. 3,12.
45. Adv. Marc. 4,40. As E. Evans has pointed out (*Adversus Marcionem* [Oxford, 1972] 2:493), ". . . *figura* does not indicate anything merely figurative, but a visible objective shape."
46. On Tertullian's tendency to link the gift of the Spirit with the baptismal laying on of hands, see Neunheuser, *Baptism and Confirmation*, 85–90.
47. See A. Benoit, *Le bapteme chretien au deuxieme siecle* (Paris, 1953), 227.

minister, Christ washes away the sin of the neophyte and confers the gift of the Spirit as the source of new life. The sacramentality of the liturgical action is neither emphasized nor explained in any detail.[48] Instead, one passage at least seems to suggest that the effectiveness of the ritual is grounded in the positive prescription to baptize that is found at the end of Matthew's Gospel, that is, in a specific act of dominical institution.[49]

What is perhaps more significant than any reflection on the symbolism or mystery aspect of liturgies in Tertullian's references to Eucharist is the taken-for-granted mention of Eucharist as "sacrifice,"[50] of an "altar" as the place of eucharistic liturgy,[51] of the presider as "priest." Tertullian, like his predecessors, does see Eucharist as a *spiritual* oblation—quoting Hosea rather than the usual reference to Malachi—and extends the notion to all prayer, which would seem to suggest that the Eucharist can be called sacrifice precisely because it is authentic Christian prayer.[52] Prayer is acknowledgment of God; it is obedient acceptance of the divine will; and there are times in Tertullian's explanation of prayer when it seems that the basic reason for praying is that it is fulfillment of a God-given precept. Yet, when he refers to the custom of prayer at the third, sixth, and ninth hours, it seems to be with the purpose of guaranteeing constant contact with spiritual realities.[53]

Cyprian

When we turn to the other great pre-Nicene figure of the African church, Cyprian of Carthage, we find little reflection of the philosophical distancing of God, and the ritual distancing of the realm of the sacred seems to be taken for granted; but Cyprian takes a major step in the direction of identifying the ordained, especially the episcopacy, as "the Church" and thereby distancing most Christians from institutional contact with the divine.[54] Just as the cultification of Christianity had grown out of Jewish roots and its spiritualizing out of Platonic roots, the adoption of a hierarchical model to interpret the institutional structures of Christianity was deeply influenced by the experienced patterns of Roman imperial organization and the attitudes that accompanied it. At

48. See Neunheuser, *Baptism and Confirmation*, 391. This is not to say that Tertullian makes no use of the traditional typological symbolisms in explaining baptism. See Danielou, *Bible and Liturgy*, 70–85, 208–13.

49. De bapt., 13.

50. De Orat., 18–19.

51. Ibid., 28.

52. Ibid.

53. Ibid., 25.

54. On Cyprian's role in developing a theology of the *catholic* Church with focus on the episcopacy, see A. D'Ales, *La theologie de Saint Cyprien* (Paris, 1922), 212–23. "He is the first one to theorize about the Church's catholicity" (214).

the same time, Cyprian consistently refers to Old Testament texts for understanding the bishop's office. The influence of Judaism was still strong in Carthaginian Christianity.[55]

Tertullian had already witnessed to the growing prominence of bishops in the church and to their increased assertion of power; with his Montanist leanings, he objected to this development. Cyprian is a key figure in crystallizing this episcopal dominance, as he dealt with the conflict over reconciliation of the *lapsi* and the schismatic activity of Novatian and Felicissimus. His *De unitate ecclesiae* has retained since its composition a major impact on ecclesiology.

As the title of that key work indicates, Cyprian had a compelling interest in maintaining the unity of the Church. One of his favorite figures for the Church is that of a mother uniting her children in familial care and love,[56] but in the nonmetaphorical discussion of ecclesial unity Cyprian focuses on the bishopric. Within a particular church it is the bishop who grounds and guarantees unity, "the bishop is in the church and the church in the bishop; whoever is not with the bishop is not in the church."[57] And on the broader scale it is the episcopacy that maintains the unity of the worldwide Church. "The Church is founded upon the bishops and every act of the Church is subject to these rulers."[58] Cyprian does identify these bishops as "priests,"[59] but it is by their activity as rulers rather than by their cultic function that he sees them unifying the Christian people. In stressing the apostolic origins of the episcopacy, he describes the Twelve as "bishops and rulers."[60] And that Cyprian is dealing with jurisdictional power is quite clear from his controversy with the bishop of Rome. Each bishop is to "direct and govern" his portion of the flock.[61] The bishop is to give an account of his actions directly to God, who alone is to judge them; but other Christians are to live in obedience and subject to the judgment of the bishop. Given the very strong moral orientation of early Christianity, such insistence on the *authoritative* direction of the bishop establishes as unavoidable a mediation between most Christians and the God for whom the bishop speaks.

This image of God working through his chosen ruler/teacher/priests coincides quite easily with the instrumental view of sacramental liturgy. Though the change is subtle, Cyprian's language reflects a shift from Christians doing sacramental rituals, such as gathering to share "the breaking of the bread," to the ordained minister doing the action to or

55. See P. Hinchliff, *Cyprian of Carthage* (London, 1974).
56. De unit., 23.
57. Epist., 66,8.
58. Epist., 33,1.
59. Epist. 66,8.
60. Epist., 3,3.
61. Epist., 59,14.

for the nonordained. Thus he speaks of baptism being "administered" or being "conferred" on people—such words are used even of "baptism of blood,"[62] in the *exomologesis*—the ceremony of reincorporating sinners into the community after their period of penance—he stresses the efficacy of the bishop's act of reconciliation;[63] and in his *De sacramento calicis domini* he views the action as "the sacrifice of the priest."[64] In Cyprian we are clearly dealing with an understanding of Christian ritual through cultic categories that are linked with, though distinguished from, the Jerusalem temple—priest, altar, sacrifice. And we are dealing with the merging of priestly mediation and jurisdictional power; the bishop by virtue of being the ruler of the community is its high priest. At the same time, Cyprian, without using the terminology of sacramentality, describes the role of the celebrant of the Eucharist as one of symbolizing Christ. Thus he reinforces the emerging idea of the ordained acting *"in persona Christi."*[65]

It is worth noting that such a view incorporates *mediation* not only as a descending process—that is, divine grace comes to the ordinary Christian through the pastoral ministry of the ordained—but as an ascending process in which the prayer and devotion of the faithful pass through the sacred ministry of the ordained in official liturgy.[66]

And not only in the external worship of the community does such mediation function; in people's spiritual life they are meant to form their conscience and establish their identity as Christian in relationship to the bishop, obedient to his teaching and in union with his faith, and thus relate to God. For Cyprian membership in the church is clearly conditioned by cooperation with the bishop.

ACCELERATING TRINITARIAN CONTROVERSY

The debates about the relationship of Jesus as Logos to God the Father increasingly dominated the theological scene in the third century, came to a boiling point toward the end of the century, and with christological and pneumatological complications overshadowed all other discussion until well into the seventh century. That would seem to suggest that

62. Epist., 73; Ad Fortun., 1.

63. De Laps., 28; Epist., 55, 133.

64. "For if Jesus Christ, our Lord and God, is himself the chief priest of God the Father, and has first offered himself as sacrifice to the Father, and has commanded this to be done in commemoration of himself, certainly that priest truly discharges the office of Christ, who imitates that which Christ did; and he then offers a true and full sacrifice in the church to God the Father, when he proceeds to offer it according to what he sees Christ himself to have offered" (Epist. 63,14 [text from Quasten, *Patrology* 2:381]).

65. See J. Laurance, *Priest as Type of Christ* (New York, 1984).

66. Hippolytus's *Apostolic Tradition* indicates that this view was already enshrined before the year 200, at least in one tradition, in the prayer for the ordination of a bishop.

reflection on Christian symbols was placed on the back burner, which was true if one takes a narrow view of sacramental theology but very untrue if one discerns trinitarian reflection as precisely an attempt to cope with Christianity's (and God's!) use of symbol.

As Gerhard Ladner has pointed out in his study of iconoclasm,[67] it is to the theory of image worked out by the Cappadocian Fathers in their theology of the Trinity that the Byzantine defenders of images will make appeal in the eighth and ninth centuries. Even apart from specific explanations, the very fact of concentration on trinitarian questions plays a major role in the process of distancing that we have been studying. Theological attention turned more and more to heaven, to the inner reality of the Godhead; defense of Jesus' prerogatives concentrated on his divine aspect; attention to Jesus' identity as Christ faded before emphasis on his nature as Lord.

This shift to debate about the divinity was most marked in the Logos-sarx explanation of incarnation which is characteristic of Alexandrian orthodoxy. Even though a soteriological interest remained basic for both orthodox and "heretics," the theology that triumphed at Nicaea and gradually asserted itself thereafter placed stress on the saving efficacy of the divine Word. We have only today become aware of the extent to which the Logos-sarx Christology drawn from the Johannine prologue pushed into the background the Christologies of the other New Testament writings.[68]

Justin in the second century had already begun the focus on Logos, and even the New Testament literature reflects a movement toward greater attention to the more-than-human aspect of Jesus; but it was in the third century that trinitarian debate came to the fore, and in the fourth that it boiled over in the Arian controversy. With the struggle to find acceptable formulations of belief in Jesus as both human and divine, the liturgical symbols were not by themselves sufficient, though faith in the reality of liturgical happenings was appealed to in the argumentation. Instead there was increased dependence upon language and concepts drawn from philosophy, and greater separation of understanding between theologically educated and noneducated. The creed of Nicaea/Constantinople would find a home in eucharistic liturgy, though functionally it reduplicates the eucharistic prayer that itself is a creed; but the Chalcedonian creed, which would provide *the* normative text for all future orthodox Christology, never became familiar to Christians through liturgy.

67. Ladner, "The Concept of the Images."
68. Schillebeeckx has pointed this out in *Jesus*, and has taken a major step in developing an approach grounded more in the Synoptic traditions.

The Anthropological Issue

Beneath the christological aspects of trinitarian debate lay the fundamental anthropological issue of the relation between body and soul, the relation that roots all human use of symbol. This becomes clear as we observe the way in which the theology of the great Alexandrians obscures the full humanity of Jesus and the way in which post-Nicaean theology and doctrine, and then art and liturgy, de-emphasize the historical Jesus. Recent research into the dispute between Arius and the Alexandrian leadership leaves little doubt about the central role played by conflicting views of Jesus' humanity and its soteriological role.[69] What seems rather clear is that the Arian party had strong soteriological concerns, was worried about the lack of stress by the Alexandrian theologians on Christ's humanity, and dealt with the imitation of Christ in terms of learning from Jesus' historical career rather than in terms of imaging the divine Logos.

The classic statement of the Alexandrian position, and of anti-Arianism in general, is that of Athanasius. Without going into its trinitarian subtleties—for that is not our purpose—we can notice that a worldview other than that of the Bible or, as we will see, of the early baptismal and eucharistic liturgies has come to control theological and doctrinal discussion. Athanasius explains the identity of Father and Son by use of the "light from light" imagery; in developing further the notion that baptism is an illumination, he speaks of the divine Son along with the Father illumining the neophyte. The link with the mystery of the human Jesus is scarcely mentioned, and the reality of Christians somehow participating in God takes on an ontological rather than ethical dimension. Though Athanasius clearly gives an intrinsic saving role to the humanity of Christ, it is in terms of the Word taking on a body with the corruptibility that resulted from sin, crushing death by his crucifixion, and then restoring incorruptibility through the promise of resurrection.[70] Another way of envisaging the process of salvation was the favorite patristic theme of restoring the image of God.[71] Athanasius locates the image primarily in human reason, which has the capacity of mirroring the Logos/Image but has been covered over with the grime of sin. At the same time, the image involves a personal relationship to the Son who is the Image, a relationship that is grounded in grace rather than nature.[72] Humans must, with the help of grace, work to cleanse their

69. Probably the most thorough recent treatment is that of Gregg and Groh, *Early Arianism*.

70. Incarnation, 9 and 29.

71. On Athanasius's approach to humanity as image of God, see J. Roldanus, *Le Christ et l'homme dans la theologie d'Athanase d'Alexandrie* (Leiden, 1968), 25–123 (hereafter cited as *Le Christ et l'homme*).

72. Ibid., 64–65.

minds clouded by impurities, so that, once again illumined, they can discover the Image that is mirrored in their own image.[73]

As one puts together Athanasius's teaching on humans as image of God and on imitation of Christ, there seems to be no attention paid to imitation of the human Jesus. Rather, what a person is meant to reflect as he or she progresses toward union with God is the Son as divine Image. Consistently with this, in his Logos-sarx Christology Athanasius stresses the function of the Logos to the point of leaving little, if any, place for the human soul of Christ.[74]

In comparing the Arian and anti-Arian positions, one can notice the absence of a truly sacramental role for the human dimension either in ritual or in human experience. For Athanasius and the Alexandrian theologians who will follow him, particularly Cyril, the process of salvation is one of *theosis*, in which the divine activity of God's incarnate Word transforms the human "from within," with no real role for any created instrumentality. On the other hand, for the Arian party the human activity of Christ and of Christians is critically contributory to salvation; but this in terms of moral perfection gained through imitating the exemplary human actions of the Word. One could see the Arian/Alexandrian dispute as two opposing interpretations of participation in divinity, Arius viewing this as conformity to the divine will and Athanasius seeing it more as sharing in being. In the theology of Athanasius the fundamental situation of human nature has been altered by the Incarnation, the unchangeable power and perfection of divinity has been wedded to humanity with the result that humans now have not only the infallibly trustworthy example of the Word but the grace to image that divine Image.[75]

By insisting as he does on the distinction between Christ and other humans,[76] Athanasius is planting the seed of that distancing of Christ from Christian experience that we will notice as a growing phenomenon in the post-Nicene period. But not only does emphasis shift increasingly from the human Jesus to the divine Logos, the battle over the *homoousios* from Nicaea onward means that attention has moved from the function of the Logos as saving "inner teacher"/savior to the ontological status of the Logos within the Trinity.

73. Ibid. 78–79. "For practical purposes no revealing action of God is involved; at each moment the way to salvation can open up within a person, who needs only to clean the mirror of the soul in order to see automatically reflected in it the divine image. Athanasius seems attached to imagery that is relatively far from the thought world of the Bible and which belongs instead to a Neoplatonic universe."

74. See Quasten, *Patrology* 3:73.

75. On the different soteriologies of Arius and Athanasius, see Gregg and Groh, *Early Arianism*, 161–83.

76. Ibid., 13, 69–70.

Despite the fact that his best-known writing is entitled "On the Incarnation," Athanasius had marshalled the Nicene forces to defend the *divine* prerogatives of the preexistent Logos; and to some extent at least, this heightened the difficulty of later theologians in dealing with the reality and role of the human Jesus, the incarnate Logos. As Pelikan has pointed out, "the trinitarian developments had not really prepared the church for the problematics of the christological issue."[77] And no aspect of the Incarnation was to receive less adequate treatment than the human experience of Jesus as sacrament of the divine saving presence. To some extent, Arius with his emphasis on the growth in moral perfection by the Word-become-flesh was in a better position than Athanasius to point up the saving significance of Jesus' historical career and resurrection; but his practical denial of authentic human consciousness in Jesus, coupled with his denial of full divinity to the Logos, made it impossible to recognize Jesus' *Abba* experience as the root of Christian sacramentality.

On the other hand, Athanasius and the Alexandrian School in general, presupposing a basically Platonic anthropology, could not grant human sensible activity the intrinsic causal power in the realm of spirit that is essential for a full sacramental symbol. The meaning of ritual that shaped the human spirit as it moved to contemplate the divine could not be the obvious meaning of the observable action; instead, the liturgy could be a sign of the inner working of the Word and the Spirit as well as a sign (and pledge) of the individual's faith. It is a striking paradox that in the context of such theological reflection, there is an assumed realism regarding the symbolisms of both baptism and Eucharist, a realism that is appealed to in christological argumentation.[78]

Both the strengths and dangers of the Alexandrian emphasis on the strictly divine being and prerogatives of the Logos would become apparent in the wake of Nicaea. For one thing, such allies of Athanasius as Apollinaris would quickly make explicit the neglect of Jesus' human consciousness in a Logos-sarx Christology. Moreover, the more "literalminded" approach of the Antiochean theologians would nurture the Logos-anthropos understanding of the Incarnation and, with it, a greater appreciation of the human dimension of Jesus. This would increasingly stand over against the Alexandrians and catalyze the disputes that prepared for Ephesus and Chalcedon.

Our focus on early Christian understanding of symbolism requires, before going on to those fifth-century conflicts, a careful look at the

77. Pelikan, *The Christian Tradition* 1:228–29.
78. However, it is worth noting that in arguing from baptism to the divinity of the Logos, Athanasius sees baptism as an assimilation to the divine Logos rather than to the human Christ. See Contra Arian., 2,43; Gregg and Groh, *Early Arianism*, 47.

theology of the Cappacodian Fathers—for it was they who wrestled most creatively with a functional understanding of the Trinity and, in so doing, laid the foundation for the defense of created symbols in the iconoclast dispute.

Cappadocian Fathers

Standing as a bridge between Nicaea and I Constantinople, Basil and the two Gregories provided much of the linguistic and categorical clarification that would guide the developments up to Chalcedon.[79] Since this involved a defense of the Nicene *homoousios* in the midst of the first strong wave of backlash, much of the attention of these Cappadocian Fathers was focused on philosophical reflection about the eternal generation of the Son, and the procession of the Spirit, with the inevitable distancing of Christ that came with concentration on the divine element in the Incarnate Word. At the same time, the strong attraction to contemplative prayer that marked all three theologians led to an immediacy of Christ in their Christian experience, and also to a strong sense of involvement with divine mystery.

Of the three, Basil of Caesarea was the acknowledged master; yet both Gregory of Nazianzus and Gregory of Nyssa went beyond him in some of their theologizing. In some ways, Basil's theology is more down-to-earth. For example, his letter to Caesaria[80] reflects a basic faith in the risen Christ's abiding presence: it speaks about the reserved eucharistic bread in a way that presupposes it is Christ's body, a source of eternal life for those who communicate. The letter refers approvingly to the common practice of Christians, particularly the desert hermits, taking home the consecrated bread from the eucharistic celebration so that they could communicate on a daily basis.

Basil's principal vehicle of theological communication was his preaching, and it is here particularly that one sees his intent to share accurate theological insight in a way that people can grasp. Of special interest for a study of Christian symbolism is his explicit rejection of allegory in explaining the Bible. "I take all in a literal sense, for I am not ashamed of the gospel."[81] This is even more significant because Basil—and the same is true of the two Gregories—devotes a great deal of attention to Old Testament writings, and therefore has need to explain their abiding meaning for Christian believers.

This is not to say that Basil deals only with the immediately empirical aspects of Christian experience. It is Basil, in his treatise on the Holy

79. See Quasten, *Patrology* 3:228–32.
80. Epist., 93.
81. In Hex. 9, 80.

Spirit and in his twenty-fourth homily, who provides the basic explanation of the concept of image to which the defenders of images appealed.[82] In saying that "the honor paid to the image passes to the prototype" Basil draws from the long-standing philosophical discussion about the presence in sensible realities of the "shape" of the originating Ideas, and the presence in artistic representations of the "shape" of the person or object being depicted. While Basil is concerned in these two classic passages with the honor paid to Christ as the Logos/Image of the Father, the line of thinking obviously extends to such matters as humans being created in the image and likeness of God, the imitation of Christ, and the distinction between imaging by way of nature, which applies to the divine Logos, and imaging by way of imitation which applies to humans—a distinction that becomes a bit blurred by referring to the transformation wrought in baptism as a *theiosis*.

What needs to be added to this picture is the spiritualizing of the observable image that comes out of the Platonic tradition, a spiritualizing we already noticed in Philo and his descendants in the Alexandrian School. What is immediately perceptible in human activity images the inner spiritual activity, that inner spiritual reality images the divine Image/Logos, and the divine Logos/Image mirrors the ultimate divine reality of the Father. Thus the spoken word reflects one's inner thoughts, which in turn—to the extent that they are true—reflect the Logos who is God's own "natural" Word. All this suggests (as we will develop later) that the historical actions of Jesus and the anamnetic celebrations of these actions in liturgy have about them a certain theophanic character which, however, has to be understood in the light of Greek philosophical explanations of participation.

Basil's friend Gregory of Nazianzus is, like Basil, an intriguing combination of appreciation for observable reality and quest for the spiritual. This is reflected in the wide range of realities to which Gregory applies the word *mysterion*.[83] In the sermon, for example, that he preached upon his return home after fleeing the responsibilities of presbyteral ordination, Gregory in one sentence refers both to his ordination and to the feast of Easter on which he is preaching as *mysterion*.[84]

Gregory is fully aware of the problem facing humans when they employ metaphor to name the unnameable. In his fourth theological discourse, on the Son,[85] Gregory has a brief explanation of the "divine

82. G. Ladner, "The Concept of the Images," 3–33.

83. See J. Bernardi, in his introduction to *Gregoire de Nazianze, Discours 1–3* (Paris, 1978), 14–17.

84. Discourse 1, 2.

85. Listed as Discourse 30, 20 in P. Gallay, *Gregoire de Nazianze, Discours 27–31 (Discours theologiques)* (Paris, 1978).

names" (Wisdom, Truth, and so forth) as applied to the second person of the Trinity. But he prefaces the treatment by pointing out that no theologian can deal with simple infinity as it truly is. The best theologian is the one with superior power of imagination and whose own interior life is at most an image or shadow of the truth.[86] In applying the name "Image" to the Son, Gregory makes the common distinction: while in other cases the image resembles its archetype by way of imitation, the Son is the Image by way of sharing the same nature and in a manner far transcending the sharing on the created level between parent and offspring.[87]

Gregory of Nyssa, while espousing the same trinitarian views and linking, as did others in the Nicene party, human salvation with the divinity of the Son and the Spirit, concentrates on the progress of the individual soul as it advances in union with God. Unlike Origen, who reads the Canticle in terms of the nuptials between Christ and the Church, Gregory's interpretation points to the spiritual marriage between the human soul and its God, which is developed in his treatise on virginity.[88] It is there we can notice a key element in the soteriology not just of the Cappadocians but of much of patristic theology—namely, the restoration of the incorruptibility proper to spiritual beings, once possessed by humans but lost through sin, and now regained through baptism.[89] Whereas in a number of other patristic writers, as we already noted, sharing in the eucharistic body of Christ brings a participation in the incorruptibility of his resurrection, Gregory stresses purity of soul, and particularly the purity of virginity, as that which makes it possible to mirror the incorruptibility of God.[90] Such purity of soul can be achieved, of course, only because of the action of Christ within the soul.[91]

Gregory's understanding of humans as image of God involves, then, not only possession of reason but also, through grace, possession of virtue. He does not distinguish between "image" and "likeness," but sees both referring to "purity, freedom from passion, beatitude, opposition to evil, and all that contributes to forming in humans the

86. Discourse 30, 17.

87. Discourse 30, 20. In arguing to the divinity of the Spirit, Gregory argues from the fact that baptism is a divinization; but this could not be if the transforming Spirit were not divine. From the Spirit comes regeneration; with regeneration comes a restoration to our original state; and in this state comes knowledge of God (Discourse 31, 28). Athanasius had already used the argumentation about the Logos in Contra Arian., 2,70.

88. *On Virginity*, 20.

89. See Athanasius, *Incarnation*, 9.

90. *On Virginity*, 11.

91. *On Perfection*. It is worth noting that all the various names that Gregory gives to Christ in this context have to do either with his divine power or to his postresurrection role. The distancing of Christian devotion from Christ *as risen* that we will observe in medieval Christianity has not yet occurred.

likeness of God."[92] Gregory's classic description of this process is provided by his *Life of Macrina*, the moving eulogy of his saintly sister. Probably no theologian of the fourth century reflects more clearly than Gregory of Nyssa the extent to which "purity" has become the key symbol of virtue, for it is the "pure in soul" who see God and are freed from corruptibility.

With the Cappadocian Fathers, particularly the two Gregories, we see the fully developed awareness of the problems involved in human knowledge of a transcendent God and the accompanying development of an apophatic theology.[93] The great Alexandrians, starting with Clement, had already signalled the problem, but it is the disputes with Nemesius that force the Cappadocians to crystallize their thinking about the symbolic dimension of religious thought and language. It is with them that the listing of divine names becomes classic and passes through Dionysius and Boethius into medieval theology. And it is with them that a solution to the incomprehensibility of God is suggested in terms of the soul's imaging of and union with God.

However, it would be a mistake to focus only on the speculative contribution of the Cappadocian Fathers and to overlook the witness they bear to a counterbalancing stream of liturgical reflection.[94] This dialectic between philosophical and liturgical theology is most striking in Gregory of Nyssa, precisely because of his strongly philosophical bent. In Gregory's sermons, particularly those preached for the Easter vigil or for Christmas, we are in the world of Christian mystery, the extension into the present earthly life of the Church of the divine activity that reaches its zenith in the death and resurrection of Jesus, and also of the heavenly liturgy being celebrated by the hosts of heaven. The liturgy celebrates, even as it helps achieve that harmony of the universe that sin had disrupted; and at the very center of this cosmic harmony lies the unfathomable mystery of the Incarnation. Thus, while the development of philosophical theology was helping to distance the God of Christian faith, the liturgy was still playing a key role in preserving for the faithful a sense of the divine saving presence in their midst.

92. *On the Creation of Man* 5,1. On Gregory's view of humanity as image of God, see Quasten, *Patrology* 3:292–93. More extensively see J. Muckle, "The Doctrine of Gregory of Nyssa on Man as the Image of God," *Medieval Studies* 7 (1945): 55–84; and G. Ladner, "The Philosophical Anthropology of Saint Gregory of Nyssa," *Dumbarton Oaks Papers* 12(1958): 59–94.

93. See F. Young, "The God of the Greeks and the Nature of Religious Language," in *Early Christian Literature and the Classical Intellectual Tradition*, ed. W. Schoedel and R. Wilken (Paris, 1979), 45–74.

94. See the important study by J. Danielou, "Le Mystere du Culte dans les Sermons de Saint Gregoire de Nysse," in *Von christlichen Mysterium*, ed. A. Mayer, J. Quasten, and B. Neunheuser (Dusseldorf, 1951), 76–93. Especially important is the section from 89–92.

Eusebius of Caesarea

At about the same time that the great Cappadocians were providing a defense and explication of Nicaea and making possible the triumph of Athanasian theology at Constantinople in 381, quite a different but no less significant contribution to Christian thought was being made by Eusebius of Caesarea. "Except for Origen, Eusebius outdistances all Greek Church Fathers in research and scholarship"[95] and his writings range from exegesis to polemics to history to panegyric. For our study of Christian symbolism, two areas of Eusebius's writings are of special interest: his ecclesiastical history and his praise of Constantine.

Apart from any specific imagery used in the work or from the specifics of Eusebius's methodology, his *Ecclesiastical History* is of immense symbolic importance. In the midst of the philosophical spiritualizing of Christian belief that dominated patristic theology and the widespread tendency to spiritualize the reading of the Scriptures, Eusebius's work safeguards the image of Christianity as a historical mystery and at least implicitly defends the literal meaning of Christian experience.

Eusebius is not writing secular history; his purpose is ultimately apologetic, to trace the gradual triumph of Christianity over its enemies because of the power of God working within it. Yet, it is precisely in the observable happenings that he documents that the divine saving activity occurs. Therefore these historical events, beginning with the career of Jesus himself, reveal the true God. And the Church's memory of its own history, seen as a sequence of divine saving actions *(magnalia Dei)*, provides an indispensable source of faith and theology.

Revision rather than continuity of Christian historical understanding comes from Eusebius's idealizing panegyrics on Constantine. The picture of Constantine painted by Eusebius was probably recognized as one-sided even as it was produced, and the role of Christianity in God's dispensation suggested by Eusebius and claimed by Constantine himself received far from universal acceptance. Nevertheless, Constantine as remembered through Eusebius's description had an immense symbolic impact on succeeding centuries in both East and West.

Christianity had begun with Jesus' reversal of the common expectancy of a Messiah. Instead of claiming political/military leadership, Jesus had identified himself with the Isaian ideal of Suffering Servant; and earliest Christianity had gradually accepted this unexpected meaning of "Messiah" as the key to understanding the enigma of Jesus' death. Theological reflection on this approach to "salvation" suggests that the characterization of Jesus' activity as "service" upends all the understandings of power and authority intrinsic to his or any other patriarchal culture. It

95. Quasten, *Patrology* 3:311.

is the repudiation of physical force or economic power as an ultimate source of human betterment.

This symbol of a Servant Messiah, lacking economic means or military might or social prestige, now with Eusebius's Constantine begins to give way to the opposite symbol of "the holy warrior." On the surface, the use of military language and images seems to have been common in Christianity long before Constantine—even Paul speaks of the "armor of faith." Yet, when one examines carefully the texts of the first three centuries, the use of terms such as "soldiers of Christ" refers to perseverance in the midst of persecution, to enduring allegiance pledged in baptism, to resistance to Satan and his enticements—not the use of violence as a means of ensuring victory for the kingdom of God.[96]

Yet, Constantine comes to be seen as a "holy warrior," a new Messiah whom Eusebius compares not only with the Twelve Apostles but even with Jesus himself. The ideal of "holy war" in a nonmetaphorical sense has begun to find legitimation in Christianity. The imagery of the vision of *"in hoc signo vinces"* now stands in tension with the Gospel scene where Barabbas, the symbol of salvation by violence, is preferred to Jesus, the Suffering Servant. Moreover, as Roman Emperor, Constantine is viewed—and clearly saw himself—as God's specially chosen vicar to mediate divine providence in church and state. Church leaders would reject claims of uncontested supremacy made by Constantine's successors—one thinks of Ambrose in contention with Theodosius; but the symbol would remain to shape Christian understanding of the Church, of salvation, of power and authority, of the interaction of sacred and secular.

Cyril of Jerusalem

Eusebius's Palestinian contemporary (perhaps his disciple) Cyril of Jerusalem, provides through his baptismal catechesis a much different, though very rich, insight into the symbolism functioning in the fourth century. Beyond its intrinsic insights, Cyril's baptismal instruction is important because of its widespread influence: beginning with the troubled years of Cyril's own episcopate—as part of the post-Nicene battles he was deposed and restored three times—large numbers of pilgrims experienced the exciting liturgical life of Jerusalem and returned home to emulate the ritual and to hand on its explanation.

Cyril's baptismal instructions illustrate strikingly the tendency of liturgy to conserve more strongly than doctrine the traditional formulations. "Though they were delivered a quarter century after Nicaea . . .

96. See B. Cooke, "The 'War-myth' in 2nd Century Christian Teaching," in *No Famine in the Land*, ed. J. Flanagan (Missoula, Mont., 1975), 235–50.

they bring to us the voice of the ante-Nicene Church."[97] Caught as he was in the swirl of post-Nicene ecclesiastical politics, Cyril had to be acutely aware of the refined philosophical language and thinking that had moved Christian theology into a thought-world quite different from that of the Bible. When in his fourth lecture he takes his hearers briefly through the Church's belief in the Trinity, or again, when in the eleventh lecture he explains how the Son is true God, Cyril uses without further refinement the language of Nicaea's creed.[98]

Yet the basic framework of his catechetical explanations is the "history of salvation" approach that characterizes the biblical literature; he employs typology in a way reminiscent of the New Testament itself, without the allegorical embellishment we have observed in so many third- and fourth-century writers; and in lectures six through seventeen as he expands his explanation of Christian belief in the three divine persons he draws from scriptural passages and from analogies with his readers' human experience. One feels closer to the human career of Jesus: reference to God as "Father" are still in the context of Paul's "God, the Father of Our Lord Jesus Christ";[99] and writing in Jerusalem, Cyril makes frequent references to the places around them where the events of Jesus' life had actually occurred.

So, at least in his catechetical instructions, Cyril does not exemplify the philosophical distancing of Christ and God that we saw growing in the third and fourth centuries. The same cannot be said with regard to cultic distancing. Though he is far from innovative in this regard, one can see quite clearly in his explanation of baptism as initiation into mystery the extent to which Christian liturgy has become a "sacred precinct."[100]

By this time, Christian imagination has quite permanently placed the risen Christ up in heaven; and Cyril's explanations of the ascension and second coming certainly depict the risen Christ on high at the right hand of the Father. Yet, the definitive stage of the history of salvation which began with Jesus' life and death and resurrection continues on in the life of the Church; and it is into this history and life that the neophyte is inserted in the baptismal mysteries and continues to share in eucharistic ritual.[101]

97. W. Telfer, *Cyril of Jerusalem and Nemesius of Emesa* (London, 1955), 63.

98. Ibid., 124 n. 24, reconstructs the creed of the Jerusalem church, more ancient and simpler than the Nicene creed, which Cyril used as the basis for his instructions.

99. For example, the invocation that begins lecture six, on the "monarchy" of God, ibid., 126.

100. See A. Paulin, *Saint Cyrille de Jerusalem catechete* (Paris, 1959), 177–236 (hereafter cited as *St. Cyrille*).

101. It is the explanation of this initiation into mystery that Cyril provides in the five "mystagogical" catecheses (19–23) that were given the newly baptized during the week after their initiation. In Jerusalem this postbaptismal instruction must have been specially dramatic, since it was given at the place associated with the resurrection of Jesus.

Eucharist was seen as participation in the continuing mystery of Christ through the sharing in bread and wine that were truly changed into his body and blood. It is this sacramental body that symbolizes his presence "in spirit" even though he is not with them "in the flesh."[102] It is in the liturgical mysteries that Christ who reigns on high is present with those who comprise his body, who share his life and his Spirit as they share in the eucharistic mystery of his body and blood.[103]

Cyril does convey a strong sense of Christ's abiding presence with his own, a presence that extends beyond the intensity of the liturgical celebration of mystery to embrace the prayer and catechesis of the catechumens, but that does not clearly extend to the remainder of Christians' lives. These lives, of course, are to be different because of what Christian initiation achieves; but one does not derive from Cyril a feeling that mystery extends beyond cult. What makes one a bit hesitant, however, about making such a statement too absolute is Cyril's constant use of the metaphor of "life" when describing Christian life. "The entire spiritual life is presented as a life in solidarity with or in Christ. This solidarity is not just by way of imitation; it is a mysterious participation in the grace of Christ and a configuration to his mysteries, above all to his death and resurrection."[104] Cyril speaks of a person being planted by God, being engrafted onto the Holy Vine—a clear allusion to the Johannine imagery of the vine and the branches.[105] Configuration to Christ takes place in sacramental liturgy by way of symbolic imitation—the neophyte does not really die in the baptismal ceremony, but the salvation that one obtains is real.[106] The Spirit's imprinting of Christ on the Christian is effected by way of sacramental imaging, but the Christian truly becomes image of Christ.[107] So also the Spirit's power in Eucharist effects, in the figure of bread and wine, the true body and blood of Christ, so that Christians become Christ-bearers, one body with the Lord.[108]

Theodore of Mopsuestia

While Cyril was employing a typological but not allegorical method in explaining Scripture to his catechumens, others in the Antiochean orbit were developing their own exegetical alternative to the Alexandrian approach. The Antiochean theologians were not as violent in their

102. Lecture 14, 30.
103. See Lecture 22.
104. Paulin, *St. Cyrille*, 163; See Cyril, Lecture 3, 11; 12, 15.
105. Lecture 1, 4.
106. Lecture 2, 5–7; 20, 5.
107. Lecture 21, 1.
108. See Cyril's fourth lecture, which is entirely devoted to explanation of the eucharistic mysteries.

rejection of allegory as was Epiphanius.[109] However, Diodorus of Tarsus, who begins the "golden age" of the Antiochean School, strongly opposes the use of allegory and insists that it is not the hidden meaning of the biblical texts that should be sought but rather the literal meaning intended by the inspired writer. Theodore of Mopsuestia goes beyond Diodorus in developing a historical-critical method in handling the Bible, and while he does not deny a mystical meaning, as well as the intrinsic meaning reached by exegesis, the extant remnants of his biblical commentaries indicate that he deals with it even less than does his fellow Antiochean, John Chrysostom.[110]

What provides our best insight into the way Theodore interprets Scripture and ritual as symbols of the divine are his catechumenal instructions, the text of which was discovered and published in 1932. The *Catechetical Homilies* follow the same pattern as those of Cyril of Jerusalem, though Cyril had not given a detailed explanation of the "Our Father" as does Theodore. For our objective of studying Theodore's understanding of symbol, the postbaptismal mystagogical catecheses (12-16) are the most instructive.

Like Cyril before him, and Ambrose and Chrysostom, whose catechizing was taking place at the same time as his (toward the end of the fourth century), Theodore adopts the Pauline theology and centers his interpretation of the initiation ceremony on the *anamnesis* of Jesus' death and resurrection. Unlike the other three, however, Theodore emphasizes the relation of initiation to Christ's resurrection rather than to the death; and he does so within an eschatological perspective. Because the baptismal ritual, in addition to signifying the neophyte's future sharing in resurrection, symbolically links the person with Christ—the baptized "puts on Christ," the new Christian actually begins to live inchoatively the life of resurrection.[111] Thus, while the other three catecheses stress the anamnetic presence in ritual mystery of the *past* event of Jesus' passover, Theodore's stress is on the *present* and *future* linkage of the neophyte to the risen Christ through the power of the Spirit. This same mentality is reflected in Theodore's explanation of the eucharistic presence of Christ. Symbolic gestures of eucharistic celebration are remembrance of the passion and death of Christ; but the transformed elements are more than recollection. By the Spirit's power the bread and wine are changed into Christ's body and blood and are therefore endowed with "the power of spiritual and immortal nourishment."[112]

109. See Quasten, *Patrology* 3:384.
110. Ibid., 404–5.
111. Bapt. Hom. 3,7. See H. Riley, *Christian Initiation* (Washington, D.C., 1974), 325–32.
112. Bapt. Hom. 16.

John Chrysostom

When one turns to the baptismal catecheses of John Chrysostom, Theodore's friend, fellow Antiochean, and fellow disciple of Diodorus, one finds a similar approach to interpretation of symbol. A typical Antiochean, Chrysostom rejects the allegorical approach but, in addition to seeking and explaining the literal sense, he focuses on the spiritual meaning and ethical implications of the biblical texts, that is, the meaning of Scripture as it touches the attitudes and actions of his audience.

At the same time, Chrysostom is keenly aware of the mystery dimension of Christianity, especially as it occurs in sacramental ritual.[113] Respecting the *disciplina arcani* in a homily addressed to a group that included some uninitiated, Chrysostom still manages to suggest strongly the symbolic happening of baptism when the priest, "in a kind of image," signifies in liturgical action what Christians profess to believe in their creed.[114]

As we might expect, it is in his mystagogical instructions that Chrysostom gives his most systematic and detailed account of the mysteries of initiation and Eucharist. Chrysostom devotes much more attention to inculcating moral attitudes than do the other patristic catechists,[115] but he expresses his regret that his need to do so keeps him from fuller explanation of the liturgical mysteries.[116] Still he does speak at some length about the mystery dimension of the liturgical initiation, using particularly the symbolisms of spiritual marriage and rebirth.[117] Like the other classic catecheses of the late fourth century, that of Chrysostom adopts the Pauline theology of baptism as death and resurrection: one is baptized into a resemblance *(homoiosis)* of Jesus' death and resurrection, but shares through this similarity in the reality of the salvation achieved by Christ.[118] The "old man" of sin is buried and one rises, renewed according to the image of the Creator.[119] While the ethical element is prominent in Chrysostom's view of the "new man" and image of God, Christian initiation achieves more than just the remission of sin; there is truly a birth into a new kind of life.[120]

113. For a description of the liturgy as well as the catechesis of Chrysostom's Antioch, see T. Finn, *The Liturgy of Baptism in the Baptismal Instructions of St. John Chrysostom* (Washington, D.C., 1967) (hereafter cited as *The Liturgy of Baptism*).

114. Hom. on 1 Cor 15:29, 40, 1; also Hom. 7,1–2 on 1 Cor 2:6–10.

115. See Finn, *The Liturgy of Baptism*, 207–10.

116. Bapt. Instr. 10, 2–3.

117. On Chrysostom's use of these two metaphors, see Finn, *The Liturgy of Baptism*, 314–20. For a comparison of Eastern and Western symbolisms regarding baptism as "birth," see W. Bedard, *The Symbolism of the Baptismal Font in Early Christian Thought* (Washington, D.C., 1951).

118. Hom. on 1 Cor., 40, 1–2. See Finn, *The Liturgy of Baptism*, 158–69.

119. Bapt. Instr. 2, 11; 10, 10.

120. Bapt. Instr. 9, 20; In Hom. on 1 Cor., 40, 1–2.

The same kind of symbolic realism characterizes Chrysostom's view of Eucharist.[121] Eucharist is an "awesome mystery" in which the chief agent is Christ himself, the celebrant being only the representative of Christ. For that reason, Eucharist is truly the sacrifice of Christ himself, linked both to the Supper and the cross, one and the same though celebrated in many places.[122] Chrysostom is almost excessive in the realism he attaches to the eucharistic body of Christ, speaking in one passage of Christ allowing himself to be actually broken in the sharing of the consecrated bread.[123]

One particularly interesting passage indicates the extent to which Christian liturgy, in the course of being seen as replacement of the Old Testament temple cult, has itself become categorized as cult and to that extent distanced from the rest of Christian life.[124]

> I would have shown greater eagerness to cling to discourses more closely related to mysteries and to put aside my concern about oaths . . . I would have led you into the sanctuary itself, I would have shown you the holy of holies . . . I would have shown you not a wooden chest holding the stone tablets of the Law, but one holding the blameless and holy flesh of the Lawgiver. I would have shown you within it not an unblemished lamb slain in sacrifice, but the Lamb of God who is offered in the mystic sacrifice . . . Here we have no such veil as the Jewish Temple had, but one which inspires a much deeper religious awe. Listen, then, and hear what kind of veil this is, that you may know what kind of holies of holies the Temple had and what kind is this holy of holies of ours.

Chrysostom consistently refers to the eucharistic "table" rather than an "altar," even when he is talking about the Eucharist as a sacrifice; the notion of Christ's eucharistic body as life-giving food provided for the family of God remains as a dominant theme.

The presence of a cultic interpretation of Christian liturgy is evident also in Chrysostom's classic treatise on the priesthood. Not only is the priest (and Chrysostom, like others at that time, is applying the term primarily to the bishop) the presider over mysteries in Eucharist and initiation; Chrysostom describes him as the mediator who brings God's salvation to others in the church.[125] Thus, Chrysostom does reflect the cultic distancing of ordinary Christians even though he is a vocal opponent of the Judaizing faction that still remains as a divisive element

121. See Quasten, *Patrology* 3:479–81 for a listing of key eucharistic passages.
122. Hom. de prod. Judae, 1, 6.
123. Hom. in 1 Cor., 24, 2.
124. Bapt. Instr., 10, 2. Translation from P. Harkins, *Ancient Christian Writers* (Washington, D.C., 1963), 31:148.
125. On the Priesthood, 3, 4–6.

in the Antiochean church.[126] For him the eucharistic celebration is a sacred moment, uniquely powerful in bringing humans into contact with God. To share in it, Christians should be willing to forego any secular activity.[127]

However, his overriding emphasis on Christian behavior, not just in the baptismal instruction but in his years of preaching, kept the *mysteries* of faith from getting too detached and apart from the remainder of people's lives. This will prove historically important because of the unusual circulation the works of Chrysostom enjoyed in succeeding centuries.

126. When dealing with the dispute about the time of celebrating Christ's passover, Chrysostom refers to the "two cities" notion that we already saw in Origen and that will become central in Augustine's thought. "We are citizens of a city above in heaven, where there are no months . . . no cycle of seasons." (Discourses against Judaizing Christians, 3,5,5).
127. On the Incomprehensible Nature of God, Hom. 3, 37–41.

4

Greek Fathers: Icons and Iconoclasm

In the West, with the theological synthesis of Augustine, the Tome of Leo I, and the formulation of Chalcedon, trinitarian and christological thought settled into the patterns that would guide theological reflection for more than a thousand years. In the East the situation continued turbulent for centuries: neither the Nestorians nor the Monophysites were satisfied with the Chalcedonian solution, and the latter party in particular constantly attempted to discover a more refined expression of Monophysitism that would find official acceptance. During the sixth and seventh centuries this produced the Monothelite heresy condemned by Constantinople III in 681. It led only slightly later to the iconoclast controversies of the seventh and eighth centuries, controversies that formally dealt with the issues of religious images but became "a new version of the christological debates."[1]

A review of this complex theological evolution is beyond the scope of this present book, but "the distancing of God" is substantially clarified by probing some of the elements in Eastern Christianity's understanding of Christian symbols, elements that came to sharp expression in the iconoclast controversy. While the West did, from time to time, experience questions and some debate over the issue of religious imagery, most notably at the time of the Reformation, it was in the East that the controversy became the focus of theological debate and led to bitter disputes between church and state and among factions within the church.[2] Obviously, the iconoclast movement dealt with ideas and practices that are at the heart of Christian symbolism, and the conflict illustrates the intellectual and social forces at work in the process we have called the distancing of God.

1. Pelikan, *The Christian Tradition* 2:91.
2. A brief introduction to the topic of religious imagery is provided by J. Engelbregt, *New Catholic Encyclopedia*, s.v. "Iconology and Iconography."

THEOLOGICAL BACKGROUND

Since the dispute over the images evolved out of earlier Christology and cosmology, it might help to review the positions on symbolism of Cyril of Alexandria—because he was claimed as "godfather" of Monophysitism though his Christology was not Monophysite; of Pseudo-Dionysius the Areopogite—because his worldview exercised unparalleled influence on the iconophiles; and of Maximus the Confessor— because his monastic and antimonothelite theology prepared immediately for the thought of John Damascene, Theodore of Studios and Patriarch Nicephorus and provided an orthodox reading of the Areopagite despite the latter's tendency to ascribe only one principle of action to the incarnate Word.

Cyril of Alexandria

The controlling figure at the Council of Ephesus in 431, Cyril was the culminating representative of the Alexandrian theology, which had traditionally stressed the divine aspect of Christ.[3] The denial by Apollinaris of a human soul in Jesus had exposed the danger of overemphasizing the Logos dimension of the Incarnation, and Cyril is careful to attribute full humanity to Christ. At the same time, his constant focus on the *divine* power manifested and present in the incarnate Word did push the humanness of Jesus into the background of christological discussion. Moreover, though his key expression that there was in Christ only one *physis* could and did find an orthodox explanation, it undeniably risked Monophysite interpretation and came to serve as a Monophysite slogan.

This emphasis on the divine carried over, and with obvious good reason, into Cyril's explanations of human salvation. With typical Alexandrian stress on the spiritual, he explained Christian initiation as a process of divine illumination that brought about a divinization of the neophyte. Through this divine action, which was then meant to continue in a Christian's life, especially in faith and contemplation, one became increasingly an image of the divine Image, that is, the divine Logos. In this way, the biblical notion of humans as image of God found in Cyril a christological translation; but the imaging is quite clearly of the divine archetype rather than of Jesus precisely as human.[4]

Cyril's stress on the divine extends to his understanding of initiation. A Christian images Christ, but only because through baptism one receives a participation in the divine nature; it is the divine essence that

3. On Alexandrian development of Logos-sarx Christology as opposed to the Antiochean Logos-anthropos approach, see A. Grillemeier, *Christ in Christian Tradition*, 2d ed. (Atlanta, 1975), 1:153–343.

4. For a detailed study of Cyril's understanding of humans as *imago Dei*, see W. Burghardt, *The Image of God in Man according to Cyril of Alexandria* (Woodstock, Md., 1957).

one images through this *participatio divinae naturae*. This is brought about by the power of God's Spirit granted the neophyte in the liturgy of initiation. While this participation in divine goodness does take form in virtuous living, becoming holy is basically the ontological reality of increased participation in the divine holiness.[5]

Two elements in Cyril's theology, it must be acknowledged, work to balance his relative neglect of the human in his interpretation of the Incarnation and of Christian sanctification. First, in struggling with the reconciliation of divinity and humanity in the Word-become-flesh, Cyril insists on the reality and importance of the historical happenings of Jesus' earthly career. These were not theophanies in which the divine Logos manifested itself in some human appearance; they were truly the actions of the person Jesus who is the Logos. Still, Cyril has difficulty reconciling the Gospel descriptions of Jesus' human limitations with the divine character of the Logos.[6]

Second, in his eucharistic theology Cyril is insistent on the transformation of the elements into the body and blood of the incarnate Logos and on the view that this gives sacramental communion its transformative power.[7] Still, it is hard to escape the impression that for Cyril the humanity of Jesus is an instrument used by the Logos in the work of salvation and that the someone who is Jesus is simply the eternal Logos.[8]

Pseudo-Dionysius (the Areopagite)

Later in the same century, most likely in Syria, appeared an enigmatic figure who, to a large extent because he wrote under the name of "Dionysius the Areopagite," a character who appears in the Acts of the Apostles, was destined to have a major and lasting impact on Christian theology of both East and West. In the area of symbols his influence is hard to overestimate, precisely because the language of symbol fills his work. Indeed, the causal energy that flows through the cosmos as he envisages it is power that works symbolically.[9]

It is difficult to find a Christian thinker whose worldview incorporates a sharper stratification of humans into hierarchical levels of both dignity and power. Thoroughly Neoplatonic, influenced by Proclus or at least

5. Ibid., 163.

6. See Pelikan, *The Christian Tradition* 1:250f.

7. See *Dict. theol. cath.*, s.v. "Cyrille d'Alexandre."

8. On the difficulty of sorting out the exact meaning of Cyril's christological language, especially the *mia physis*, see Grillemeier, *Christ in Christian Tradition*, 478–83.

9. A thorough study of Pseudo-Dionysius's theory of symbols is provided by P. Rorem's *Biblical and Liturgical Symbols within the Pseudo-Dionysian Synthesis* (Toronto, 1984) (hereafter cited as *The Pseudo-Dionysian Synthesis*). The complete works of Dionysius have recently been translated into English by C. Luibheid with the collaboration of P. Rorem in the Paulist series of "The Classics of Western Spirituality," *Pseudo-Dionysius* (New York, 1987).

paralleling him in his philosophical views, Pseudo-Dionysius cannot as a Christian accept the emanational metaphysics of classical Neoplatonism, but he describes a chain of beings that stretches from God to the least of humans, each level receiving being and truth from the level above and mediating them in turn to the level below itself.[10]

Not surprisingly, Dionysius provides an explanation of liturgical symbolism; the expressed objective in his *Ecclesiastical Hierarchy* is to explain the liturgical rites.[11] Here the division of Christians into those who act and those who are acted upon is the presupposed context, because the clergy, belonging to superior orders, has the function of enlightening the laity. This is eminently true of the "hierarch" (the bishop) who possesses the truth and sanctity that is to be shared with the clergy and the laity of his flock.[12] Even the monks, who comprise the top level of the nonordained, are dependent for their faith upon clerical ministration—though the monks have an appreciation of and spiritual participation in liturgy superior to the rest of the laity. The process of "descent" through enlightenment and of "return" through contemplation, in which Christians are involved in sacraments, is a continuing revelation that is at the same time a divinization (*theosis*).[13] In proportion as people are open to and share in this, they image God.

One of the striking aspects of the Dionysian explanation of liturgy is, or at least seems to be, the irrelevance of the human Christ to the whole process. True, one is ritually immersed in the great mystery of God's involvement with humans in the Incarnation; but it seems that what is taking place, even at the central moment of the synaxis, is that God is using the sacred symbols to instruct and thus divinize persons.

10. For a detailed study of Dionysius's cosmology, see R. Roques, *L'Univers Dionysien* (Paris, 1954). Dionysius's *Celestial Hierarchy* details these levels among the angels; the *Ecclesiastical Hierarchy* does the same for the humans who make up the Church.

Dionysius's world is one that exists and acts symbolically. The causal linkage and influence in the universe are intellectual in character: the beings at each level are illumined by those directly above and then enlighten those just below. Each level initiates its immediate inferiors into the truth it itself possesses, its enlightening activity is anagogic for it illumines in order to draw upward. Or to put such a psychological view of causation in religious terms, since for Dionysius there is no other adequate context of explanation, each level acts as mystagogue for those below. The light and the power that permeate the whole come from God, but the divine influence does not bypass the hierarchy's mediation; each level participates in divine truth in its own fashion and therefore acts distinctively in imaging that truth.

11. For a short analysis of the *Ecclesiastical Hierarchy*, see I. Sheldon-Williams, "The Ecclesiastical Hierarchy of Pseudo-Dionysius," *Downside Review* 82(1964): 293–302 and 83(1965): 20–31. The latter is particuarly valuable for its explanation of Dionysius's stress on "unlike symbols."

12. E. H. 400 a-d. Also R. Roques, "Le sens du bapteme selon le Pseudo-Denys," *Irenikon* 31(1958): 427–29.

13. On the "procession and return" theme in Dionysius, see Rorem, *The Pseudo-Dionysian Synthesis*, 58–65.

Christians are transformed by their grasp of the deeper spiritual significance of the liturgy; the external rites are largely meaningless without the spiritual interpretation—an interpretation that is to be provided by the hierarch as mystagogue.[14] What this implies is an instrumental view of liturgical effectiveness: as a teacher would use a metaphor to convey an insight, so the hierarch—and ultimately, God through the hierarch—uses the liturgical symbolism to enlighten and thus "uplift" his flock.

My remark about the apparent irrelevance of the human Christ to liturgical symbolism might seem to require some modification. Rorem has drawn attention to Dionysius's explanation of the way in which the hierarch's breaking of the bread at the conclusion of the central eucharistic action points to the central symbolism of Incarnation.

> The bread which had been covered and undivided is now uncovered and divided into many parts. Similarly, the hierarch shares the one cup with all, symbolically multiplying and distributing the One in symbolic fashion. With these things he completes the most holy sacred-act. For because of His goodness and His love for humanity, the simple, hidden oneness of Jesus, the most divine Word, has taken the route of incarnation for us and, without undergoing any change, has become a reality that is composite and visible.[15]

Incarnation is not an occurrence of the past that began the human career of Jesus; rather, while it found unique expression in Jesus, it is the ongoing mystery of the One finding expression in a created multiplicity whose destiny is to return to its creating origin through contemplative communion. While Christ's sacramental body shared in Eucharist is the focus of this communion, the reader of Dionysius's explanation somehow feels no closer to the *human* Jesus, more in the company of Plotinus than of the Gospel writers.

The same emphasis on spiritual effectiveness marks the Areopagite's explanation of Christian initiation. With much of patristic theology he sees the liturgical act of baptism as an *illumination* by God that brings about a participation in divinity. He regularly refers to baptism as "a divine birth." What is distinctive about the Dionysian explanation is the role assigned the hierarch, who as mystagogue shares with the neophyte his own enlightened insight into the divine mysteries.

Dionysius was not the first to suggest a spiritual interpretation of the various liturgical ceremonies. The classic catechumenate instructions of Ambrose, or Cyril of Jerusalem, or Theodore of Mopsuestia had incorporated considerable appeal to the deeper hidden meaning of the

14. Ibid., 79.
15. Ibid., 76–77, with a translation of E.H. 3, 444a.

rituals. Theodore's detailed typological explanation of Eucharist linked elements of the liturgical celebration with events in Jesus' life and passion—parallel in many ways to the Carolingian liturgical explanation of Amalar. But whereas Theodore finds the hidden meaning of liturgical actions in their anamnetic reference to the happenings of Jesus' historical career, Dionysius points to deeper significance in terms of timeless ontological processes.[16] Symptomatically, Dionysius "invariably linked the uplifting movements to the spiritual process of understanding the rituals and never to the rites by themselves"; the anagogic power of Christian liturgy came with the elements of interpretation provided by the mystagogue.[17]

Dionysius provides a prime instance of the extent to which Christian faith and prayer had moved away from the early Christian consciousness that God was present to humans in the ordinary experiences of their lives. The perspective is much more philosophical than biblically religious; the worldview of Dionysius is clearly that of Stoicism and Neoplatonism, where the divine Logos finds expression and multiplication in the logoi that control the nature and activity of created things. In such a world human reason images in preeminent fashion the archetypal divine Logos and, at the same time, reflects as microcosm the logoi of the rest of creation. The basic dialectic is not that of divine covenant invitation and human response, not even the biblical conflict between God and chaos. Instead, it is the polarity and interaction of unity and multiplicity as these function metaphysically and epistemologically. Christians' contemplation is directed more to the God of the philosophers than to the *Abba* of Jesus' religious experience.

Besides his replacement of personal relation to Christ by a philosophically understood *participatio divinae naturae*, Dionysius crystallized ontologically the clergy/lay division and the superiority of monks within the church, doubly distancing ordinary laity from the God "at the top of the hierarchical ladder." Again, his interpretation of Christian liturgy is not only completely sacralized; the faithful are sharply separated from the "divine hierarch" who is the agent of illumination and through whose mediation alone they are brought into contact with God's saving activity.

Maximus the Confessor

Despite this distance from God's incarnational involvement in ordinary humanness, which is central to New Testament faith, Dionysius—and the Neoplatonic approach to contemplation in general—had an almost

16. Ibid., 108–9, suggests a link in methodology with Iamblichus.
17. See Ibid., 109.

irresistible attraction for those in monastic life. For one thing, there is the appeal of a superior way of life, a level of spiritual existence where one is not weighed down and "soiled" by bodiliness, where the mind can soar beyond the things of earth and bring humans into communion even with God. What takes place in Jesus as the embodiment of God's Word can be situated in such a view if the symbolism of Incarnation focuses on the *divinization* of humans and on the *uplifting* of human psychology that followed from God's entry into history. But this view leaves little place for the astonishment of the first Johannine letter, astonishment that in Jesus, divinity could be seen and heard and touched, astonishment rooted in the mystery of the Word truly becoming flesh, truly becoming human in the full sense.

Paradoxically, despite the ultra-spiritualism of contemplation as they understood it, and despite their reverent espousal of the teaching of "the divine Dionysius," it was the monks who in the Monothelite and Iconoclast controversies fought and died to defend the authentic humanity of Christ. No one better illustrated this monastic fidelity to the Chalcedonian dogma of Jesus being "true God and true human" than Maximus, called the Confessor because of the martyrdom suffered in opposition to the Monothelite heresy. One might expect, then, that his theology would accentuate, or at least grant greater recognition to, the redemptive role of Jesus' humanity. Such is not the case.

Like Dionysius, from whom he constantly draws, Maximus views ideal human existence as a process of the human *imago Dei* being increasingly assimilated to its divine archetype, the Logos, through contemplation.[18] An example of how deeply Greek philosophy had affected Christian theology, Maximus's thought is dominated by the relation between the one and the many, between the Logos and the logoi. His cosmology is one in which the divine One manifests self through the Logos in the multiplicity of creatures, above all in the diversity of humans, and in which the divine energy works within creation to bring all back again into unity.[19]

The focus of this unity amid multiplicity is clearly the mystery of the Incarnation, for it is here that the one unlimited and infinitely intelligible Logos enters the world of logoi to bring them into communion with himself. For Maximus, the Church plays a central role in this great mystery; in his *Mystagogia*, which is a synthesis of his thought, he describes the Church as the icon of God, but an icon that is such because

18. I.-H. Dalmais in his "Mystère liturgique et divinisation dans la Mystagogie de saint Maxime le Confesseur," in *Epektasis: Mélanges patristiques offerts au Cardinal Jean Danielou* (Paris, 1972) (hereafter cited as *Epektasis*), stresses the role of "the mystery of Christ" celebrated in liturgy in achieving this assimilation.

19. A classic description of Maximus's cosmology is provided by H. Urs von Balthasar in his *Kosmische Liturgie: Das Weltbild Maximus des Bekenners*, 2d ed. (Einsiedeln, 1961).

the communion of Christians with one another images and instrumentalizes God's own activity.[20]

The liturgy finds a special place in Maximus's view since it is the center of the sacrality that is meant to mark the whole of Christians' lives. Like Dionysius, Maximus concentrates on the divine aspect of sacramental liturgies: in initiation the stress is on *theosis*, and this divinization continues in Eucharist. However, along with this *theosis* there is an assimilation of the Christian to a Christlike mode of life that is marked specially by fraternal charity and care for the disadvantaged.[21] Christ is present and active in Eucharist, but as one reads Maximus's statements in this regard it is hard to avoid the impression that the reference is to Christ as divine, the Logos unifying the multiple communicants as they share the bread become his body. For Maximus, Eucharist is above all an act of communion, when the one bread is multiplied in its distribution but effects a gathering into unity of the assembled faithful. The mystery received transforms the people into itself and leads them into divinization—for Maximus this is to be understood more realistically than was the case with Dionysius, for whom effectiveness derived from the hierarch's sharing of his enlightenment.[22] At the same time, while the symbolism of the sensible elements does have the role of symbolizing the spiritual power at work, this sensible symbolism is secondary and a propaedeutic for the divinization that comes in contemplation.[23]

Even though he glorifies monastic life and prayer, Maximus concedes to the ordained a superior status and role in the church and its liturgical celebrations. Describing the church building as a symbol of the Christian community, he distinguishes the sacred place, the sanctuary, which is reserved for the clergy, from the nave which is occupied by the laity.[24] The structural distancing of the people from God is unmistakably reflected in the *Mystagogia*, not just in the theology of Maximus but in the liturgical practice of his day which he describes. However, his writings indicate that the more drastic downgrading of the ordinary faithful comes in contrast to monastic life. Sacramental liturgies are important,

20. "The holy church is an ikon of God because it accomplishes the same unity among believers as does God. No matter how different they are in their characteristics and no matter how different their place and way of life, they are still unified in the Church through faith" (*Mystagogia* 1). See L. Thunberg, *Man and the Cosmos* (Crestwood, 1985), 116–8, 126–27; Dalmais, *Epektasis*, 56–57.

21. *Mystagogia* 24. Dalmais details Maximus's treatment of charity as intrinsic to the transformation effected by liturgy.

22. See Thunberg, *Man and the Cosmos*, 168–70.

23. "What happens in the Divine Liturgy is both symbol and reality at the same time. The liturgical acts have—precisely as symbols—a representative character; they participate in the divine reality as secrets and mysteries to be interpreted by the believing mind. Thus, liturgical sharing in these divine things also prefigures and represents the ongoing, and possible, divinization of man" (Ibid., 127).

24. *Mystagogia* 1.

even necessary because of our limited human way of knowing, but Maximus "is inclined to see sacramental life as an expression of ascetic and spiritual life rather than as its source and instigation. In Maximus's mind, monastic life, with its examples of spiritual development and perfection, is always present, seeking its symbolic expressiveness in sacramental and liturgical reality."[25]

THE ICONOCLAST CONTROVERSIES

These three figures illustrate the spiritualization of Christian faith and practice that increasingly characterized Eastern Christianity. In the context of philosphically refined trinitarian debate Christology had become more abstract and the connection with the Jesus of history ever dimmer.[26] With the focus on the intelligible world, where the Platonic and Stoic Logos apparently provided a ready model for understanding the the Johannine Logos, the symbolic role of sensible realities inevitably assumed major importance. But what was the nature of such symbolizing and how trustworthy was it? These were the questions that boiled to the surface in three waves of iconoclast debate during the seventh to ninth centuries.

The Background

Scholarly explanation is divided as to how and why the formal controversy about the images of Christ and the saints actually began.[27] Earliest Christianity had been wary of religious images, influenced no doubt by the Mosaic proscription of graven images. In addition, the overall tendency to accept the basic experience of daily life as the sign of God's presence in their midst meant that there was no need to seek iconic symbols for the divine saving presence. Paul stressed that Christians themselves were the sign of the Spirit's activity in history—and undoubtedly early centuries listened to him. The second-century apologetes appealed to the witness of Christian lives, especially to their moral purity, and to their lack of superstitious beliefs and practices.

Exposure to the Hellenistic world brought with it the question of the compatibility of this pagan culture, particularly of its artistic forms, with Christian faith and life. For the most part, Christian thinkers were

25. Thunberg, *Man and the Cosmos*, 129.
26. Pelikan, *The Christian Tradition* 2:75, quotes George Fedotov: "Practically the whole of Byzantine religion could have been built without the historical Christ of the Gospels" *The Russian Religious Mind*, (Cambridge, Mass., 1966), 1:35.
27. For a description of the rise of iconoclasm in the 720s, see J. Herrin, *The Formation of Christendom* (Princeton, 1986), 331–43.

suspicious of this cultural influence, continuing perhaps the same stand-offish attitude already present in much of Judaism.[28] Certainly there were good reasons for fear of corruption; not all the literature or art or theater of the Greco-Roman world was humanly uplifting or morally refining. Besides, having no historical precedent of their own for development of an iconography, Christians inevitably tended to take over themes and artistic compositions from pagan sources, with the consequent danger of representing Christian faith in misleading images or of allowing pagan notions and attitudes to infiltrate Christian understanding of its own mysteries.[29]

As a result of this threat of cultural perversion, mainstream patristic thought was considerably less than enthusiastic about religious images. This was particularly true of Alexandrian theology and of the broader Origenist influence. The spiritualizing emphasis in this school of thought led to the search for intelligibilities beyond sense experience and to the spiritual meaning of both Bible and liturgy—not to expanded dependence upon sensible images.

Still, the widespread use of religious objects by the common faithful, an inevitable development as large numbers were converted and brought with them their folk customs and practices, gradually led theologians and church officials to find some legitimation for religious images. To some extent, at least, this growing tradition of religious imagery was strengthened by the so-called *acheiropoietoi*: the images of Christ or of Mary attributed by legend to direct divine intervention.[30] Such, for example, were the portrait supposed to have been left by Christ on the veil of Veronica and the cure-working portrait of Christ painted for King Abgar.

As one comes to the seventh century, then, textual support for an orthodox tradition favoring religious images is shaky. There are patristic texts both pro and con, the preponderance being negative.[31] The result was that polemicists on both sides of the debate could appeal to arguments from the Fathers. It is safe to say that patristic theologians, while in some instances allowing a role for religious images, did not encourage such images or see them as an aid to deeper and more accurate insight into the Christian mysteries. But how did this wariness

28. See M. Hengel, *Judaism and Hellenism* (London, 1974) for a detailed study of the mixed reaction of Judaism to Hellenic influences.

29. See K. Weitzmann, "The Survival of Mythological Representations in Early Christian and Byzantine Art and their Impact on Christian Iconography," *Dumbarton Oaks Papers* 14(1960): 45–68. Weitzmann indicates, however, the thorougly Christian nature of Byzantine art. "Byzantine art, in all the phases of its long history, was dominated by religious subject matter, based on the Old and New Testaments and on stories from the lives of the saints or from homiletic literature" (68).

30. See Pelikan, *The Christian Tradition* 1:101.

31. For a listing of some of these texts, see ibid., 100–4.

regarding the icons and religious images in general harden into the iconoclastic movement?[32]

Some elements of the answer are clear. Eastern Christians, especially on the fringes of the empire, were in regular contact with the Jewish and Muslim communities, both of which totally rejected "graven images" as idolatrous. In these circumstances aspersions were cast on Christians for idolatry, Christian polemics and attempts at evangelization were hampered by charges that Christianity lacked "religious purity," and occasionally there were open attacks—such as that launched in 721 by Caliph Yazid II, to destroy religious images in Christian churches in his realm. Understandably, some Christian bishops thought it best to discourage, even to proscribe, the use of icons and of all religious images.[33]

One of the best known of such images was the icon of Christ over the main gate to the imperial palace, whose removal by Leo III was a striking statement of his iconoclastic policy.

Certainly Leo III was motivated religiously, but this does not seem to have been the whole story. He was bitterly antagonistic to the monks, who were the principal defenders of the icons, and determined to break the power they exercised in the empire. No doubt there were also economic aspects to imperial opposition to monasticism for "during the iconoclastic period monastery lands were ruthlessly confiscated."[34] The tension between emperor and monks in the whole dispute was reflected in John Damascene's angry question: "What right have emperors to style themselves lawgivers in the church?"[35]

A rather persuasive case has been made by Ladner, based on Grabar's research in Byzantine art history,[36] that there was a concerted imperial policy of replacing religious iconography with civic art as a means of

32. P. Alexander, *The Patriarch Nicephorus of Constantinople* (Oxford, 1958), stresses the influence of earlier Christian uneasiness about religious images as the principal root of the controversy. See especially 214–17.

33. See Herrin, *The Formation of Christendom*, 307–15. Also A. Grabar, *L'Iconoclasme Byzantin*, 2d ed. (Paris, 1984), 17–57.

This proscription is indicated by a letter of Germanus, patriarch of Constantinople, addressed in 724 to bishop Thomas of Claudiopolis. Germanus blames him for removing the images of Christ and the saints from his episcopal town, suggesting that Thomas had undertaken the move because of Jewish hostility to the images. Apparently Thomas traveled to Constantinople, along with Constantine, the bishop of Nacoleia, in hopes of convincing Germanus of his position. He failed in this, but it may be that at that time the two of them were able to win the emperor, Leo II, to their view.

Whether their influence did play a part or not, Leo III undertook a vigorous campaign of opposition to the use of icons. Significantly, this reversed centuries of imperial policy. As far back as Constantine's adoption of the *labarum* as insignia for his military standards, Eastern Roman emperors had placed their armies and reigns under the protection of Christ and his saints and illustrated this by their own use of religious images.

34. F. Dvornik, "The Patriarch Photius and Iconoclasm," *Dumbarton Oaks Papers* 7(1953): 79.

35. Second Apology, 12.

36. A. Grabar, *L'Iconoclasme Byzantin*, 1.

shaping public opinion. Particularly during the reign of Constantine V, though explicit opposition to religious icons was framed in theological terms—the danger of idolatry, christological misrepresentation, and so on—the art commissioned by the imperial court was propagandistic, designed to shift hero symbolism from Christian saints and monasticism to the emperor and his entourage. If this thesis of Ladner is valid, it highlights the power of symbols as shaping forces in a society.

The Debate

Stage One

Whatever its sources, iconoclasm developed quickly into a major theological debate. In its first stage, the arguments on both sides of the issue were the standard objections against religious images as idolatrous—or at least leading to idolatry among the common people—and the classical response that the reverence paid the image was really directed to the one who was represented. Leo III and his iconoclast supporters built their case against the icons and against religious imagery in general, on the Old Testament condemnation of graven images. No doubt there had been over the centuries some abuse of devotional use of relics or representations of the saints—popular piety has always had a tendency to drift toward magic. However, the deeper level of reaction against the icons seems to have been linked to the spiritualization of religion to which we already referred; sensible objects were incapable of symbolizing the divine and could only be misleading.

John Damascene, the chief defender of images in this first stage, accepts the obvious principle that no sensible image can represent the divine but insists that reverence paid to heroic Christian figures of the past, particularly to the mother of Jesus, the *Theotokos*, indirectly glorifies God whose grace had worked in them. Representations of Jesus were a special case, though for the moment the argument did not proceed on a christological level. For the ordinary illiterate faithful, images had a beneficial didactic role. "What the book is to the literate, the image is to the illiterate."[37] John Damascene argues that a new situation with regard to use of imagery has been created by the Incarnation: the human Jesus indisputably translates in his sensible reality the divine Logos which he is, and there can be no question about worship paid to Jesus.[38] To justify the veneration paid to the icons themselves, whether of Christ or of the saints, Damascene appeals to the principle enunciated earlier

37. First Apology, 17. English translation by D. Anderson, *On the Divine Images* (Crestwood, N.Y., 1980).
38. First Apology, 16, 27.

by Basil in a trinitarian context: "the honor given to the image is trans-
ferred to its prototype."[39]

For the most part, John Damascene's contribution is one of giving
order to the traditional explanations as he responds directly to the
objections of the iconoclasts. He has no developed theory of religious
symbolism or, more specifically, of Christian sacraments, though he
emphasizes the didactic role of the icons.[40] However, he laid the foun-
dation for a resolution of the iconoclast controversy by two key con-
tributions to the debate. He highlighted the new context of religious
symbolism created by the Incarnation; and he clarified and applied the
distinction between images "according to nature" (*kata physin*) and im-
ages "by way of convention or imitation" (*kata thesin* or *kata mimesin*).[41]

Stage Two

The second and more intense phase of the controversy began with
the ascendancy to the throne of Leo's son Constantine V, one of the
more able generals and rulers of Byzantine history but also a most
aggressive and open enemy of the images.[42] He considered himself a
theologian and personally entered the dispute on the very point of
previous iconophile strength, the Incarnation. To the iconophiles he
proposed a dilemma: if they represented Christ in pictorial form, they
were either pretending to provide an appropriate image of the divine
Logos—which was idolatry; or they were imaging only the human
Jesus—which amounted to a denial of the Chalcedonian teaching that
there is only the one hypostasis. Thus, argued Constantine, the de-
fenders of the icons were involved either in idolatry or in Nestorianism.[43]
This meant that the christological roots and implications of the con-
troversy became more explicit and emphasized in this second phase.
Given his leanings toward Monophysitism and a minimizing of the
humanity of Christ, it was logical for Constantine to oppose sensible
representations of Christ and of religious imagery in general. The icon-
oclast Council of Hiereia, which he convoked in 754, confirmed his

39. Ibid., 21; also quoted in Third Apology, 41. On Damascene's borrowing from
Pseudo-Dionysius as well as Basil, see B. Studer, *Die theologische Arbeitsweise des Johannes
von Damaskus* (Ettal, 1956), 116–20. He indicates also the Stoic influence on John
Damascene.

40. See M. Jugie, *Dict. theol. cath.* 8, col. 709: "There are important lacunae in *The
Orthodox Faith* which are not filled by material drawn from his other writings. What one
finds [in Damascene's theology] about the Church, the theological virtues, grace, sacra-
ments . . . cannot be considered the full heritage of Greek patristic thought."

41. Ladner in "The Concept of the Image," 16, sees this distinction as the most basic
in the dispute. "It is this distinction which really overarches all the other ones mentioned."

42. On this second generation of iconoclasm, see Alexander, *Patriarch Nicephorus*, 218–
19.

43. See Pelikan, *The Christian Tradition* 2:128–32.

views and provided the justification for the ensuing campaign to destroy the images and persecute their defenders.

Under his successor, Leo IV, the iconoclast activity remained strong, though he himself was more conciliatory toward the monasteries. Shortly thereafter, under the Empress Irene, there was a reversal of imperial policy, devotion to the icons was once more encouraged and was formally restored at the Ecumenical Council of Nicaea II (787).[44] For the most part the doctrinal formulations of this council were based on the arguments used earlier by John Damascene.

During the period before the iconoclast Council of St. Sophia in 815 (under the Emperor Leo V, "the Armenian") and renewed persecution of the iconophiles,[45] two new figures appeared to complete the theological defense of the images begun by John Damascene: Theodore of Studios, the leader of the monastic party in its struggles against both the secular clergy and the imperial court, and Nicephorus, the patriarch of Constantinople until he abdicated in protest shortly before the Council of St. Sophia.

Stage Three

Theodore and Nicephorous were strange allies. They shared a common enemy and their approach to defending the images was much the same; but as leaders respectively of the monks and the secular clergy, they were political enemies. Recognizing the key role played by Constantine V's formulations of the iconoclast position, they focused on the christological facet of the controversy at the same time that their style of argument was markedly more scholastic than that of John Damascene.[46]

Throughout the centuries of argument about religious images, the central tantalizing question had to do with the similarity of the representation with its archetype. In some way there was an identity that allowed one to know the original by experiencing the "picture." Damascene had already laid the groundwork for a key distinction now made by the iconophiles: the representation was not identical in *essence*, just as humans as *imago Dei* were not the same essence as God; but it was identical in *form*, in the way that the emperor's picture on the coin had the same appearance as the emperor himself. Building on this, Theodore explained that an image has a fundamentally relative being and

44. For a translation of and introduction to the acts of the 754 council in Constantinople and the council of 787 in Nicaea, see D. Sahas, *Icon and Logos* (Toronto, 1986).

45. On the Council of St. Sophia, see P. Alexander, "The Iconoclast Council of St. Sophia (815) and Its Definition (Horos)," *Dumbarton Oaks Papers* 7 (1953): 35–66.

46. On Greek philosophical roots of iconophile arguments to justify icons, see N. Baynes, "Idolatry and the Early Church," *Byzantine Studies* (London, 1955), 116–43.

that the worship paid an icon is relative and directed to the one represented.[47]

The iconoclasts had argued that a "true" image must be of the same essence *(homoousios)* as its archetype. The Eucharist was therefore the only true and admissible created image, the only acceptable object of the worship of the faithful. Against this argument both Theodore and Nicephorus pointed to the fact that Scripture and the liturgy sensibly recalled the earthly career of Jesus with either verbal or enacted symbols.

More theoretically, Theodore argued that the "truth" of an image consisted in its *conformity in likeness* to that which it represented. In fleshing out this argument he drew upon Pseudo-Dionysius's description of the way in which image functioned in his symbolic cosmos. Nicephorus, illustrating the extent to which a scholastic mentality came to characterize later stages of the debate, provided a technical definition of an image as a likeness of the archetype, which has similarity in form but which differs in essence from the archetype, the exact difference dependent upon the material out of which it is crafted. The "truth" of the image resulted from the artistic skill of the craftsman who shaped it to resemble its archetype.[48]

Beneath these differences of the parties lurked the philosophical issue of the relation between bodily and spiritual in the human composite, and the christological question of the relation between divinity and humanity (especially bodiliness) in Jesus as the incarnate Logos. The iconophiles could with justification accuse their adversaries of a new docetism, whereas the iconoclasts could and did counter with the continuing charge of idolatry. Ultimately, the devotion of the faithful and particularly their share in the divine liturgy—which both sides accepted as profession of orthodox faith and as the prime image—triumphed in the restoration of the images.

With the Council of 843 the icons were restored officially to veneration in the Byzantine Empire, but the iconoclast party remained strong for some time. "The danger of an iconoclastic revival in Byzantium after the restoration of orthodoxy in 843 was still considerable for more than one generation and the liquidation of the aftermath of iconoclasm was not as easy as it is sometimes thought."[49] The patriarch Photius still had to contend with the heresy and was largely responsible for preventing any resurgence of the movement.

In the West the iconoclast controversy had relatively little impact, to some extent because the papacy was distancing itself politically from the empire and adopting the Carolingians as its allies and protectors.

47. See Alexander, *Patriarch Nicephorus*, 191–98.
48. Pelikan, *The Christian Tradition* 2:119.
49. Dvornik, "The Patriarch Photius and Iconoclasm," 97.

The response earlier of Gregory I to some iconoclastic activity, and his justification for the use of images, was accepted as sufficient theological argument against the image-breaking tendency. Gregory paid little attention to the theoretical refinements of the Byzantine debaters; he was content to point out that superstitious use of images or relics was unacceptable and that images provided a worthwhile didactic instrument for instruction of the common people. A somewhat more cautious position toward use of religious imagery was taken by the *Libri Carolini* in the early ninth century.[50] Interestingly, both Theodore and Nicephorus appealed to Rome's rejection of iconoclasm in support of their position.[51]

In his widely acclaimed volume *The Spirit of Eastern Christendom*, to which our study is greatly indebted, Pelikan follows his review of the iconoclastic controversy with a chapter on Byzantine liturgy, which he entitles "The Melody of Theology." In so doing, he makes two important points, the overarching role of liturgy in Byzantine theology and the pervasive presence of aesthetic sensitivity in the religious experience of Eastern Christians.

Doxological, prayerful acknowledgment of God rather than rational explanation, is an appropriate characterization of Eastern theology even in its scholastic developments, whereas it does not that accurately describe the more rationally structured thought of Latin Christianity. Liturgy has certainly had impact on theological reflection in the West, but the principle *lex orandi, lex credendi* has been more often stated than followed. The difference goes deeper, however; not just the theology but also the cosmology of Byzantine Christianity is liturgical. Human history is intertwined with the worship of God by the saints and angels in heaven in an unending song of praise, and the "divine liturgy" celebrated in Christian churches is the earthly counterpart and sacrament of the heavenly liturgy.

No author embodies this cosmology more consistently and profoundly than does Pseudo-Dionysius in his *Celestial Hierarchy* and *Ecclesiatical Hierarchy*; and no theologian provides more insight into Eastern aesthetic sensitivity than the Areopagite does in his treatment of the symbolic power of fragrance in the sacrament of *myron*, or in his use of musical harmony as a metaphor for the orderliness of the cosmic hierarchy.[52] Reading Dionysius or those, such as Maximus the Confessor, who were deeply influenced by him, one is caught up into a world of

50. On the *Libri Carolini* see E. Amann, eds. Fliche and Martin, *Histoire de l'Eglise* (Paris, 1947), 6:121–25.

51. See Pelikan, *The Christian Tradition* 2:154–55.

52. Actually, this application of musical harmony to cosmic order was highly developed in Christian theology, drawing from Pythagorianism and Stoicism, before Dionysius. See H.–I. Marrou, "Une theologie de la musique chez Gregoire de Nysse?" *Epektasis*, 505–8.

mystery, given an interpretation of creation in which the sensible world is only a vestibule to reality, pointing as do the icons to the mystery being celebrated in the sanctuary beyond the wall.

ISSUES RAISED BY THE CONTROVERSY

While the issues intrinsic to the iconoclast controversy were not limited to the East, the heated debate that marked more than three centuries brought into prominence the role of symbols in Christian faith and worship. Several aspects of the controversy are, therefore, specially relevant to our study.

First, in religious faith and practice the symbolic role of sensible realities, whether natural or artistic, is debatable. Because of their radical otherness from the divine, created representations seem to be unavoidably idolatrous—though Dionysius had the ingenious argument that their very "negativity" meant that one was not tempted to see them as positively reflective of the divine. Certainly, nothing visible or audible is capable of serving as an appropriate symbol of the divine, unless one moves quite consciously into the use of metaphor and recognizes that such use is rooted in analogy whose presupposition is that the negative moment in the process outweighs the positive. In other words, such sensible symbols would function in union with an apophatic theology— which might help explain how the monks who espoused apophatic prayer, especially after Gregory of Nyssa and Pseudo-Dionysius, could also be the defenders of the icons.

One could, of course, give sensible symbols a clearly "extrinsic" and inferior role. They could be seen simply as aids for the instruction of the illiterate, to be shunned by those more educated or more advanced in contemplation. This pedagogical justification for the icons was a recurrent theme in iconophile argument as it was for Gregory I in the West; but it was not proposed in the East as the most basic defense of religious images.

Second, the deeper issue, one that has returned to center stage in the twentieth century, is the role of human imagination in thinking about the transcendent. Some of the great classic theories of prayer— such as the Spiritual Exercises of Ignatius Loyola—have made a great deal of imaginative re-creation of the mysteries of Christ's life; but for the most part the imaginative moment tends to be limited to an early stage of contemplation. The imaginative is to be bypassed; and the "dark night of the senses" described by some mystics would suggest that such a transcending of image is intrinsic to progress in monotheistic prayer. At the same time, one wonders how many of these masters of

Christian contemplation were influenced by the spiritualism of the Platonic tradition, particularly by the heritage of Pseudo-Dionysius.

One can raise the question not only for contemplative prayer but also for the method of theology. The long-standing method of seeking the spiritual meaning of Scripture, of liturgy, and of Christian life itself pushed theological reflection to move beyond the obvious and the immediate, and to seek true insight in the realm of intelligibilities. The career of Jesus and its narrative witness in the Gospels suggested another approach in which the revelation to be discovered lies in the experiential level of ordinary events, but over the centuries this came to seem too mundane, not sacred enough to fit the divine. The Incarnation remained a bit of a scandal, but the scandal was considerably reduced by concentrating on Jesus as the Logos that manifests in created logoi the splendor of the divine.

Third, all this and the depth of disagreement in the iconoclast controversies suggest strongly that there is a continuing need to clarify the function of symbols in Christian faith and practice. Two opposed views of symbol underlay the more theoretical iconoclast debate. Can symbols truly be that, can they truly image their archetype only if they are of the same essence—as happens with the divine Image, God's own Logos? Or is there another basis for an image being a *true* representation of its archetype, in some sense "identical" with that archetype? In other words, is there a realm of symbolizing that is somehow distinct from the realm of "real" existing?

The response that gained the day was that the same "shape" (or "form" or "idea") can find expression in beings at very different existential levels, even created and uncreated. This shape's occurrence in the image constitutes a certain presence of the archetype. Thus, the symbol/image always exists and functions relatively, turning the thoughts of one who experiences it to the archetype whose resemblance makes the symbol to be just that. To put it in modern terms, the cognitive function of the image is relational communication; it is known not primarily for its physical mode of existing (e.g., as colored oils on canvas) but for its communicative capacity to make something beyond itself known.

Fourth, as the iconoclast controversy progressed, especially as it moved into the second phase of debate with Constantine V and the iconoclast synod of 754, the christological implications became more prominent. Earlier trinitarian theology, particularly that of the Cappadocians, had linked imaging with the procession of the Logos from the Father; and John Damascene had pointed out that the Incarnation placed the function of religious symbols on an entirely new plane. The implications of these earlier insights were spelled out by Nicephorus and Theodore of Studios.

Still, there remained the fuller question about the sacramentality of Jesus and, derivatively, the sacramentality of the church and its liturgy. The root question was whether the humanness of Jesus, his historical career in its down-to-earth experiential reality, functioned as an intrinsically revealing word; or whether, on the contrary, it was only meant to lead contemplative reflection to the intelligible word that was hidden beneath the veils of sensible appearance. Was the incarnate Word communicating what the sensible happenings said, or were these latter only a preparation to be jettisoned as soon as one was spiritual enough to perceive the true hidden meaning? The same question in somewhat modified form applied to the life of the Christian community, where the genuine sacramentality of people's life experience was bypassed in the effort to discover the hidden messages of God on the level of "spiritual insight."

Fifth, this has obvious relevance for Christian liturgy. To what extent, if at all, is the human experience of the worshipers—their daily life experience or the experience of the liturgical action—"Word of God"? Eastern theology would appear to give no place to this experience; the faithful are to be purely receptive of the Word that is communicated to them "from above" by the ordained mystagogue. Another question concerns the anamnetic dimension of celebrating the mysteries of Jesus' life and death and resurrection: does the historical actuality of Jesus' career play any essential role or is the message his life conveys all that matters? Again, one could ask about the presence of Christ involved in liturgy, whether it concerns his risen humanity or is only a matter of the omnipresent Logos finding specially communicative expression through liturgical symbol?

Had the use of icons involved only a representative function for didactic purposes the controversy would have been much less agitated. However, the icons were—certainly for the bulk of ordinary folk—the object of worship, and this because attached to them was some special presence of the mystery or person portrayed. It was much like the earlier veneration of martyrs' relics, and it is significant that the interest in relics waned as veneration of the icons grew.[53] This raised the theological question about the kind of presence established by an image/symbol, a question allied to that about the image's identity with its archetype. In Eastern Christianity of the early medieval period this questioniog was not extended to Eucharist. It was accepted by both camps in the iconoclast controversy that the Eucharist was the privileged symbol of Christ precisely because it involved the reality of Christ through the

53. On the link between veneration of relics and of icons, see Alexander, *Patriarch Nicephorus*, 5.

consecrated elements—one received the reality of Christ in communion. But in the West this hidden agenda would slowly emerge in the early medieval debates about the real presence of Christ in Eucharist and then in the late medieval and Reformation controversies about the evangelical or sacramental nature of the Lord's Supper.

If it took some time and a different context for the questions of sacramentality raised by iconoclasm to touch the liturgical rituals, it took even longer for them to touch Scripture, despite (or because of?) the centuries-long prevalence of allegorical exegesis. The iconophiles did link the role of Scripture to their argument for the images, but only to point out that the words that described Jesus' mysteries were sensible symbols parallel to the icons and served the same instructional and anamnetic role. They did not go the further step and inquire whether or not the sacred pages enjoyed a sacramentality that grounded a saving presence of God in the use of the Bible. This would be reserved, at least as a full-blown theological position, for the sixteenth century in the West. However, already in the iconoclast controversies the fundamental issues were broached: how does created bodily reality (whether used in Scripture or liturgy or art or daily experience) "contain" both communication from and saving presence of the loving God who reveals self in Word and Spirit? Another way of proposing the issue is to ask about the relation of history and eternity—whether the former has any intrinsic and lasting meaning and, if it does, whether the consequence is that "historicalness" is an irreplaceable dimension of Christian symbolism.

Finally, in terms of the process of distancing God we have been tracing, it is worth remarking that by the time of the iconoclast controversy the three modes of distancing are firmly established and taken for granted. *Institutional mediation* is crystallized in both imperial and ecclesiastical hierarchies; it is just a question of which one can lay more ultimate claim to being "vicar of Christ." The liturgy and everything surrounding it, as the church building, is firmly situated in a realm of *ritual sacrality*, carefully separated from the profane space and things of daily life; sacred personnel enjoy a higher level of sacral existence. Hierarchy is now considered an ontological reality which, certainly from Dionysius onward, placed people at different levels of proximity to the divine. And the philosophical notion of *participation* has been thoroughly accepted as the way of understanding relationship to God. *Theosis* rather than personal relatedness is the basic effect of sacramental rituals. Terms like "filiation" are still used, but interpreted in terms of "participation in the divine nature." The kind of sacramentality of Christian life and of historical happenings that the earliest Christian espoused in unformulated fashion has clearly disappeared from the picture.

Sacramentality gave way to moralism. For the iconoclasts, the stress on virtuous behavior as the only acceptable image of Christ and the saints was formal and basic. They appealed to a consistent patristic tradition to support their contention and summarized their case for an ethical image in the sixteenth anathema of the Council of 754.[54] In all religions there is a natural link between religious faith and moral behavior; and Christianity has been consistently threatened with the Pelagian tendency to give human moral effort a priority over faith and grace. So, it is not unusual to discover the iconoclast appeal to moral goodness or even to observe the emphasis on *ascesis* and good works that is found in writers as "contemplative" as Maximus the Confessor. What is distinctively applicable to the topic of this chapter is the teaching that humans become *imago Dei*, icons of the divine, precisely by their ethical behavior.

54. See M. Anastos, "The Ethical Theory of Images Formulated by the Iconoclasts in 754 and 815," *Dumbarton Oaks Papers* 8 (1954): 153–60.

5

The Augustinian World

No theologian has had greater impact on the history of Christianity than has Augustine of Hippo. Not only has there been a current of formally Augustinian theology running through fifteen centuries of Latin Christian theology but also the greatest minds of the Middle Ages and the sixteenth century wrestled with Augustine as with no other preceding thinker. Disagree with him, even on some major points, they did; ignore him they could not. Consequently, Augustine's explanation and use of Christian symbolism is a major factor in the distancing, or making present, of God which we have been studying.

There is a certain appropriateness in prefacing a study of Augustine and his impact on Christian symbolism with a brief mention of Ambrose of Milan. The influence of Ambrose on Augustine was not as great as popular tradition would have it, but he did have considerable influence and he clearly provides a bridge between Eastern, particularly Alexandrian, patristic thought and the Latin Christian theology shaped in large part by Augustine.[1] Moreover, Ambrose had his own independent influence on later centuries.

AMBROSE

Ambrose is an interesting case study in Christian symbolism. A highly educated Roman, a skilled rhetorician and public official, Ambrose combines with this Latin cultural heritage the wide acquaintance with Greek patristic literature that he acquired after his ordination as bishop.[2] Along with the adoption of Alexandrian allegorism in his interpretations of Scripture and liturgy, Ambrose provides through his hymns a cluster

1. On the influence of Ambrose on Augustine, see E. TeSelle, *Augustine the Theologian* (New York, 1970), 30–32, 265–66.
2. See the early chapters in A. Paredi, *Saint Ambrose: His Life and Times* (Notre Dame, 1964); also vol. 1 of H. Dudden, *Saint Ambrose: His Life and Times* (Oxford, 1935). On the influence of Latin literature on Ambrose, see D. Diederich, *Vergil in the Works of St. Ambrose* (Washington, D.C., 1931).

of images drawn from nature that remain a permanent element of Christian liturgy.[3]

The mystagogical catechesis of Ambrose reflects both his acquaintance with Greek baptismal instruction, especially that of Cyril of Jerusalem, and his own distinctive views.[4] Like the other catecheses we have seen, that of Ambrose adopts the Pauline theme of baptism as entry into the death and resurrection of Christ, and attempts to explain the link in terms of "imitation": the descent into the baptismal waters symbolizes Jesus' death.[5] By theologically linking Christ's death to the passion that preceded it, Ambrose gives a mystagogical explanation of Jesus' death and resurrection that simultaneously provides guidance for Christans' moral choices.[6] Thus, the Christian is linked in mystery to the struggle with evil that had been liturgically dramatized earlier, in the renunciation of Satan and in the anointing, which Ambrose explains through the theme of "combat with evil."[7] Ambrose's strong christological emphasis is exemplified in his explanation of the three immersions. The first immersion he explains in terms of Jesus' death and burial; of the second by linking the baptized to Jesus' passion; and the third, after a quick reference to the Spirit, by recalling Peter's threefold attestation of love and interpreting the baptismal profession as a personal response to Christ.[8] The anamnetic aspect of the liturgy is thus intrinsically linked with the present relationship of the new Christians to Christ, as they become part of the Christ-mystery.

It is worth noting that in his catechesis Ambrose matter-of-factly refers to the deacon as "Levite" and to the bishop as "high priest," but the presbyter is not referred to as "priest" (sacerdos).[9] Cultic designations for church officials are by now taken for granted, their office and ministry referred to as "sacred."[10] The regular use throughout the De mysteriis and the De sacramentis of "altar" and "sacrifice" in connection with Eucharist indicates that Christian imagination unquestioningly located Christian liturgy in a sacred realm.

3. See J. Fontaines, "Prose et poesie dans la creation litteraires d'Ambrose," *Ambrosius Episcopus*, ed. G. Lazzati (Milan, 1976), 124–70; A. Michel, *In Hymnis et Canticis* (Louvain, 1976), 59–61.

4. Though there is still some dispute regarding the authenticity of the *De sacramentis* as a work of Ambrose, it certainly reflects the thought and usage of the Milanese church at that time. Our treatment will then draw from it as well as the *De mysteriis*. For a discussion of Ambrosian authorship of the *De sacramentis*, see Finn, *The Liturgy of Baptism*, 17–18.

5. Sacr., 2,23; 2,88–89.

6. See Riley, *Christian Initiation*, 252.

7. Myster. 7. On the combat motif in baptism, see Danielou, *The Bible and the Liturgy*, 41–42.

8. See Riley, *Christian Initiation*, 259–60.

9. Sacr., 1,4.

10. Cain and Abel, 2,15.

AUGUSTINE

Important as Ambrose was—the Middle Ages looked on him as one of the four great "founding fathers" of Western Christendom—he is over-shadowed by Augustine of Hippo, arguably the most influential thinker in Western Christianity. Because Augustine helped shape not only the thought but the imagination of successive centuries, he is particularly significant in our study of Christian symbolism.

His Importance

The depth of Augustine's influence on the understanding and use of symbolism during the late patristic and medieval periods and on into modern times can be seen in the fact that he passed on the controlling images of both space and time, thereby impacting the entire symbolic world of future generations. Moreover, no figure was more influential than Augustine in relating the symbolic worlds of Greco-Roman culture and Christianity to one another, thereby preparing for the synthesis that will be medieval Europe. But perhaps there is an even deeper, and easily overlooked, contribution: through his *Confessions,* Augustine ap-peals to his own experience as that which reveals God's saving activity; in so doing, he implicitly argues that experience is the key witness to and symbol of divine presence in human life. Generations of men and women have read the *Confessions* and have been deeply touched by them precisely because they so concretely illustrate the sacramentality of hu-man life. This is quite different from the appeal to psychological realities as analogues of the divine that Augustine uses in his *De trinitate* and that stands in continuity with the trinitarian speculations of the great Greek Fathers. Not that there is any conflict between the two approaches. Both deal with human awareness, especially self-awareness as *imago Dei.* However, because of its nontechnical style and literary attractiveness, the *Confessions* has worked as an important counteragent to the symbolic distancings we have been studying.

At the same time, however, Augustine also bears witness to the con-tinuing power of these three currents of symbolic distancing. First, his references to Christian liturgies assume that there are special situations of cultic contact with the sacred, that these rituals provide both the context and the instrumentality for divine healing and transformation of humans. Second, Augustine also approaches the sacred through philosophical contemplation. In the early years of his Christian life he clearly seeks a context (such as the retreat at Cassiciacum) in which he can, freed from ordinary earthly cares, come to closer union with God

through prayer and reflection.[11] Beneath this quest for contemplative union with the divine lies the philosophical view of humans as essentially spirit, able to participate increasingly in the spiritual existence proper to God, yet radically distanced by their own temporal mutability from the eternal and immutable God. Third, in the years of his episcopacy Augustine comes to stress more and more the role of ecclesiastical institutions, above all the episcopacy, as the medium through which ordinary Christians receive God's Word and grace and find representation before God.

There is nothing innovative here; Augustine stands in obvious continuity with his patristic predecessors and contemporaries. But it is he who structures the Christian cosmology that synthesizes in both thought and imagery the threefold distancing of divine presence from basic human experience; and it is this cosmology that provides the framework for centuries of Christian perception and reflection.[12]

Before Augustine, a gathering together of Greek learning and world-views had already been accomplished by Posidonius and Varro, and directly or indirectly both influenced the bishop of Hippo. Moreover, during his time at Milan he became acquainted with the writings of Marius Victorinus, who was a key figure in bringing Greek philosophy, particularly Neoplatonism, to the Latin world.[13] But the principal influence was probably Cicero, not just through the structured elements of his philosophical writings but in the *Somnium Scipionis*, which enshrined in Latin imagination the vision of the earth surrounded by the circling and "singing" spheres. From both Cicero and the Neoplatonists Augustine inherited also the Stoic emphasis on a pervading Logos.[14] All this Augustine used to give a more sophisticated version of the biblical picture of the heavens and the earth. The exegesis of the Bible's account of creation, in his *De genesi ad litteram*, is a classic example of the way in which the biblical text was read through the lenses of the philosophy and science that Augustine had inherited.[15]

Beyond the cosmology produced by conjunction of the Platonic/Stoic worldview with the biblical account of the world's origins, Augustine

11. Varro, whose program for humanistic studies was envisaged as a progression of the soul from the visible world toward the invisible, was probably a major influence on Augustine's pursuit of philosophical wisdom. See TeSelle, *Augustine the Theologian*, 45–47.

12. On Augustine's cosmology, see E. Gilson, *The Christian Philosophy of St. Augustine* (New York, 1960), 187–224 (hereafter cited as *Augustine*).

13. See M. Hadot, "L'image de la Trinité dans l'ame chez Victorinus et chez saint Augustin," *Studia Patristica* 6 (1962): 409–42.

14. On Augustine's broad acquaintance with Greek philosophy see TeSelle, *Augustine the Theologian*, 43–55.

15. For a detailed explanation of *De genesi ad literam*, see V. Bourke, *Augustine's Quest of Wisdom* (Milwaukee, 1945), 224–41.

provided for future generations an allegorical understanding of Genesis in terms of the world of spiritual realities. This he did in the final (thirteenth) book of his *Confessions,* where the various elements of the biblical account of creation are transformed into explanations of God's dealing with the human soul. He also laid out, particularly in his *De doctrina christiana*, the outline for a Christian cultural formation *(paideia)* that had immeasurable influence on the development of Christian education in succeeding centuries.[16]

His Worldview

Clearly reflecting its Platonic roots, the Augustinian picture of reality is divided into three "levels": the ultimate world of Ideas, *rationes aeternae*, which Augustine situates in the divine Logos; the world of sensible things that are created according to the eternal reasons, reflect vaguely the divine, and are governed internally by their own *rationes seminales*; and between these, the *ratio humana*, which is uniquely image of the divine and becomes more so as it acquires wisdom by turning to eternal truth as the object of its contemplation.[17]

Amplifying this picture, Augustine accepts the Neoplatonic gradation of being that images the One (which, of course, Augustine identifies with Christianity's God). The One is located either at the top with matter at the bottom, or at the center with matter at the outer edge. To this, Augustine (drawing from Greek physics) adds his understanding of and emphasis on weight *(pondus)* as the ordering force in creation,[18] peoples the "space" between divine and human with angels,[19] and sees the whole universe creatively animated by the power/presence of God's illuminating Word and Spirit.[20]

This imagery is essentially spatial, but it absorbs the temporal because the distinguishing mark of created *sensibilia* is their radical mutability; they are shot through with time. Spiritual creatures, angels and the human spirit, are not mired in the utter mutability of material reality, but neither do they possess the full immutability of the eternal—they

16. In his magisterial study of Augustine's Christian *paideia* (*Saint Augustin et la fin de la culture antique* [Paris, 1938], 376–422), Henri Marrou has detailed both the pattern and the pedagogical influence of Augustine's *De doctrina christiana* on future Christian centuries. In the *De doctrina christiana* Augustine both absorbs and alters the classical education of Greece and Rome in the service of the Bible as the privileged agency of Christian cultural formation. See also E. Kevane, *Augustine the Educator* (Westminster, Md., 1964), 187–256.

17. See Gilson, *Augustine*, 115–21. Augustine's most detailed account of these three levels of *ratio* is found in the first book of *De genesi ad litteram*.

18. See *Confessions* 13, 9–10; De civ. Dei 11, 28.

19. On the role of the angels as foremost members of the city of God, see De civ. Dei 9, 9–13.

20. On "illumination" as a key notion in Augustine's thought, see Gilson, *Augustine*, 77–96.

exist in temporal sequence but are not as radically contingent as are material things.[21] While the earth is filled with the interaction of created powers, and while human history advances amid the turmoil of human achievement and human sin, there is a heavenly realm where those faithful citizens of "the city of God" who persevered to the end of their earthly life are destined to enjoy beatifying peace.

Augustine's vision of humanity's, and more particularly Christianity's, career on earth is, of course, most fully and most influentially detailed in his *De civitate Dei*. The dynamic image of "the city of God" and "the city of this world," locked in an evolving conflict that constitutes the central dialectic of history, provided for the Middle Ages an overarching symbol by which they interpreted events in both church and secular society. To some extent it issued in the notion of a *civitas christiana*; but it would be a mistake to identify this "Christian society" with "the city of God," for there were many members of the *civitas christiana* who could not qualify for citizenship in "the city of God." To some extent it could be applied to the basic medieval conflict between *sacerdotium* and *imperium*, but neither of these coincided exactly with the two dialectical poles of the *De civitate Dei*. No individual or group or institution of the Middle Ages would accept exclusion from "the city of God," for to do so would invalidate the very justification for existence.[22]

One of the interesting issues in interpreting Augustine's world of symbols is the relationship between "the heavenly Jerusalem" and "the city of God." Clearly, both bear somewhat the same and yet somewhat distinctive symbolic import; and the question of the extent to which the earthly city of God reflects and participates in the heavenly realm certainly intertwines with the relationship of the earthly and heavenly liturgies that was a common theme in earlier patristic thought. In terms of relating Augustine's imagery to the image of the city in modern times, it is the heavenly Jerusalem that through its reference to the historical Jerusalem really parallels what we think of as a city; the "city of God" is an assembly of people related to one another by their relation to God rather than a "dwelling place."[23] Still, the city of God as it exists on earth is on its way to its fulfilled expression in heaven, shares partially in what it is destined ultimately to become, and so images the portion of the city of God that already exists in glory.

While this shared existence in history of those who belong to "the

21. For the key texts see B. Cooke, "The Mutability-Immutability Principle in St. Augustine's Metaphysics," *Modern Schoolman* 33(1946): 175–93 and 34(1947): 37–49.

22. It is a tribute to the enduring impact of the *De civitate Dei* that it finds a succession of transmuted expressions in the centuries of the Middle Ages and beyond. See Gilson, *Les metamorphoses de la Cite de Dieu* (Louvain, 1952).

23. For a detailed study of the heavenly and earthly "cities," see E. Lamirande, *L'Eglise celeste selon Saint Augustin* (Paris, 1963).

city of God" is an important aspect of human manifestation of the divine, the focus of Augustine's understanding of humans as *imago Dei* is on the individual, and more specifically the individual's reason *(ratio)*. In this he stands in continuity with earlier patristic explanations at the same time that he incorporates the Platonic/Stoic cosmology of created logoi governed by an ultimate Word (Logos).

The notion of human thought as image of the divine stands at the very heart of Augustine's theory of knowledge.[24] The basic power of knowing is already an image of God, though a dark and yet unillumined mirror. One becomes more an *imago Dei* as the mind in the act of knowing remains open to the divine illumination, in which alone all that is known can be *truly* known. Moreover, in the entire process of self-knowing there is a basic triadic structure—the content of intuitive experience, the act of awareness, and the production of an "image" or internal word. This is simultaneously a conformity to the divine Word and a created reflection of triune divinity. Thus, the fundamental symbol in Augustine's theory of knowledge is the human act of knowing, in which is produced the "inner word" that images both the self and God.[25]

Contained in this explanation of human knowledge as *imago Dei* is an implicit theology of divine presence in sacramental ritual. Augustine as a Christian thinker shared, of course, the notion that the entire universe finds its origin and sustenance in the divine creative power, which is omnipresent. However, divine illumination of human consciousness also involves the element of divine self-revelation, to which humans are invited to respond in faith. Because of this, the external symbolisms of human speech and gesture, especially in sacramental rituals, signify and reveal both the Christian's inner faith and the God who dwells within. While Augustine himself does not draw an explicit link with sacramental theory, his understanding of divine illumination as establishing a divine presence in all human knowing provides a key contribution to medieval reflection about the relation between faith and sacrament.[26]

In Augustine's own practice and explanation of liturgy, however, there remains an overarching and basically simple view of the one great Christian mystery of salvation through Christ's death and resurrection,

24. On Augustine's treatment of the theme *imago Dei* see J. Sullivan, *The Image of God* (Dubuque, 1963).

25. See TeSelle, *Augustine the Theologian*, 306–9; G. Ladner, "St. Augustine's Conception of the Reformation of Man to the Image of God," *Augustinus Magister* (Paris, 1947), 2:867–78.

26. See, for instance, Augustine's impact on the treatment of faith in Hugh of St. Victor, described in chap. 7. For the relevance of Augustine's views to present-day discussions of theological epistemology, see TeSelle, *Augustine the Theologian*, 106 and 211–13.

in which Christian liturgies participate and which they celebrate.[27] This global and somewhat undifferentiated view of Christian ritual is reflected in the fluidity of Augustine's use of the term *sacramentum*. As F. Van der Meer has pointed out in his magisterial treatment of Augustine as bishop, there was not yet the complication of liturgical practice or the separation of liturgical action from its basic meaning which would characterize later centuries and lead to a relatively abstract, even mechanistic, explanation of Christian cult.[28] Augustine quite clearly sees liturgical symbol as causing something objective, not just a psychological change in the subjective awareness of the believing participants in the liturgy; this objective effect was the presence of the mystery being celebrated. "What distinguishes Augustine's thought from that of the Middle Ages is that the functional and symbolic characters of the sacramental symbol are not yet separated."[29]

Yet in treating Christian initiation and ministerial ordination Augustine sees the ritual action as causing both sanctification and another lasting "mark" on the person. This latter effect, to which Augustine appeals in his anti-Donatist writing as a reason for nonrepetition of schismatic baptizing, will be more fully explained in later theology as the "sacramental character."[30] In this way Augustine contributes to the notion of an instrumental effectiveness of sacramental liturgy that functions even without the sanctifying presence of the Spirit; however, such a nongrace-granting ritual is effective only because it symbolizes the faith of the Church.

Summary

Thus, Augustine's thought moves in a world of unfolding symbolic interaction, beginning with the creative role of the Word as *Imago Dei*. Behind the world of perceptible realities, and symbolized by it, lies the truer world of spiritual reality; and it is the lifelong quest of the Christian to move beyond symbols to insight into this spiritual realm, and ultimately to contemplative union with God. In this quest it is the person's own spirit that is the primary image of the divine and, therefore, the primary created object of reflection. This Augustinian worldview will profoundly shape medieval thought and imagination, even though Augustine's sense of the pervading presence of the Christ-mystery will

27. Augustine's most systematic explanation of Christian liturgy is found in his two letters to Januarius.

28. See F. Van der Meer, *Augustine the Bishop* (New York, 1961), 277–316. See also C. Couturier, " 'Sacramentum' et 'mysterium' dans l'oeuvre de Saint Augustin," *Etudes augustiniennes*, ed. H. Rondet (Paris, 1952), 163–274.

29. Van der Meer, *Augustine the Bishop*, 311.

30. See Neunheuser, *Baptism and Confirmation*, 115–27.

gradually give way to a more legalistic approach to Christian life and liturgy.[31]

POPE LEO I

When one turns to the sermons of Pope Leo I, one senses the same atmosphere of transhistorical mystery in the liturgical celebrations. In the course of the liturgical year, particularly in the solemnities of Christmas, Epiphany and Holy Week, Christians not only recall the great events of salvation wrought by Jesus but in some sense share in these events as made present in sacramental anamnesis.[32] At the same time, Pope Leo sees the sacramental liturgy as instrument of divine causation. From the Incarnation flow two results, the example of Christ and his healing action; as Leo tells his flock in the first Christmas homily, "unless he was truly God he could not bring healing, unless he was truly human he could not provide us an example."[33] In another context he will categorize the entire result of the Incarnation as "healing" and link the divine dimension of this healing to sacrament.[34] And speaking in the fifth Christmas homily of the sinless conception of Jesus, he parallels the life-giving power of Mary's womb to the life-giving power of the baptismal font; but immediately goes on to link this sacramental effectiveness to the example given by Christ. What occurs in sacramental mystery must become norm for Christian behavior.[35]

However, one needs to be cautious in interpreting Leo's view of the link between sacramental liturgy and spiritual healing, for the word *sacramentum*, while referring to Christian celebrations in liturgy, has a more inclusive reference to the entire Christ mystery. This is clear from passages such as the conclusion to the tenth Christmas sermon, in which Leo speaks of the just who lived before Christ as justified by their faith and by "this mystery" (*hoc sacramentum*), thus made members of the body of Christ. Even the centuries before the flood were in some fashion

31. However, as we will see, Augustine's adaptation of Neoplatonism to the Roman mentality with its strong emphasis on the notion of *ordo* will be profoundly challenged by a more radical Neoplatonism coming through Macrobius's commentary on the *Timaeus* and through the writings of Pseudo-Dionysius.

32. "As Leo thinks of them, liturgical feasts have the property of abstracting from, annihilating as it were, the time that has elapsed since the Savior's earthly life. These feasts recall the past but they also revive it, allowing it to have an impact on the present." M. de Soos, *Le mystere liturgique d'apres saint Leon le Grand* (Munster, 1958), 26.

33. "Unless he [Christ] was true God, no remedy would be effected; unless he was truly human he would not set an example." Sermo 1, 2.

34. "Two remedies have been prepared for us by the omnipotent physician; one provided by sacrament, the other by example, so that sacrament can bestow what is divine and example can require what is human." Sermon 16 on the Passion, 5.

35. Christmas Sermon 5, 6.

"connected with this mystery" (*huic sacramento fuisse connexa*).[36] Moreover, the mystery (*sacramentum*) that Christians celebrate in liturgy is meant to be a lasting thing in their lives; it will be celebrated continuously if the Lord Jesus is manifested in their daily actions.[37]

It seems that for Leo, then, the mystery dimension of Christianity has to do with the perceived, experienced lives of people rather than with some hidden, behind-the-scene level of preternatural activity. These lives are caught up into the mystery of the Church as body of Christ and are meant to be fulfilled in the life beyond, but the earthly stage of those lives has an intrinsic reality of its own. It is the same historical realism that one associates with Leo's emphasis on the true humanness of the Incarnate Word—the emphasis that was expressed in his *Tome* and that helped at Chalcedon to rectify the slighting of Jesus' humanity that marks the approach of the Council of Ephesus.

GREGORY THE GREAT

Gregory I is an appropriate figure with which to conclude a discussion of Augustine and his immediate influence. Not only is Gregory the funnel through which, in unparalleled fashion, the Augustinian world-view passes on to the Middle Ages; the great pope also presents in an uncomplicated and self-assured fashion a synthesis of Augustine's theological insights.[38] Besides, his acquaintance with Byzantine Christianity during the years he spent in Constantinople, and his contacts with Spanish Christianity, meant that he was aware of traditions and outlooks other than those distinctive of Rome and Carthage; and these too he incorporated into an integrated Christian view of reality.

Despite a solid upper-class education and continuing theological interests, Gregory's approach to theological issues was not that of an academician. He retained as bishop the administrative orientation and sense of responsibility for practical matters that had marked his earlier years as prefect of the city of Rome, with the result that his writings are dominated by practical considerations and by the purpose of communicating an understanding of Christianity to ordinary people. In his *De cura pastorali* he described the ideal pastor (bishop) preaching— significantly the word he uses is "admonishing"—to different groups of people in ways that would, in their distinctive circumstances, lead them to conversion. He himself lived this ideal, even to the point of

36. Christmas Sermon 10, 7.
37. Christmas Sermon 8, 4.
38. See G. R. Evans, *The Thought of Gregory the Great* (Cambridge, 1986), vii–viii (hereafter cited as *Gregory the Great*).

using fanciful hagiography in his *Dialogues* in order to arouse desired religious motivations.

Gregory embraces without any questioning the widespread "two-layer" view of reality—inner reality and external appearance, body and spirit, sensible event and God's hidden activity—with the outside functioning as symbol of the inside.[39] In dealing with the Bible he views the spoken word or the event-word as sign pointing to the message coming from God. This is very clear in his commentary on Ezekiel, where he treats both the prophet's words and his actions as oracle of revelation. Again, in his numerous accounts of marvelous happenings his interest lies in awakening people's awareness of the divine which these supposed events can cause. It is precisely their sign-value that is important.[40] It is in this vein that Gregory handles the notion of humans as image of God. As preeminently exemplified in Christ, who alone is *the* Image of God become bodily image, the lives of men and women manifest in their observable externals the activity of God in their lives.[41]

While Gregory is a meditative rather than analytic exegete, he does pass on to medieval reflection on the Bible a clear description of the "four senses" of Scripture. Carrying out the inner/outer dialectic, Gregory teaches that there is a literal or historical meaning, which is of basic importance, and three spiritual meanings—the allegorical, the anagogical, and the tropological.[42] All of these are meanings intrinsic to the text; Scripture teaches in many ways. It is the difficult task of the exegete or preacher to extract as much of this rich meaning as possible for the sake of the faithful.

A surface reading of Gregory's works, especially the *Dialogues*, often gives the impression of rather fanciful communication of folk legends, and his writings did no doubt contribute to some credulity in succeeding centuries. But a careful examination of his methodology reveals a very positive estimation of the actual happenings of people's lives as the locus of divine communication. At the same time, however, the deeper understanding that God intends to communicate is to be found in the spiritual (allegorical) meanings.

One instance of such allegorical interpretation by Gregory deserves special attention because of the impact that it had on later centuries. This is the "discovery" of tropological meanings, application of texts to appropriate (or not so directly appropriate) instances of Christian moral behavior. It is principally in his *Moralia*, the commentary on the Book of Job, that this method is employed. In his prefatory letter to Leander,

39. Ibid., 14–15, 17–18.
40. Ibid., 46–49.
41. Ibid., 65; Moralia 5.35.64.
42. Evans, *Gregory the Great*, 91–96.

Gregory describes how he was importuned by the monks to whom the book was first given as lectures to "make known not only the words of the story in their allegorical senses but should apply the allegorical senses to the practice of moral virtues."[43] And a bit later in the same letter, he describes himself as involved in moral instruction, discussing morality through use of the allegorical method.

The *Moralia*, widely used in the Middle Ages, provided a thesaurus of judgments about moral matters. But it would be unfair to say that the book brought about a reduction of religion to morality. Such a reduction is a constant tendency in religions, and this tendency is present to some extent from the beginning of Christianity, strengthened by the outlook that Christians were called to a new life-style, to a more idealistic ethic. Moreover, monastic stress on *ascesis* and its links, in some instances, with semi-Pelagian currents of theology fed into this focus on moral behavior. Gregory did, however, provide important support to this tendency, both by the *Moralia* and by the exhortations in the *De cura pastorali* that preachers should concentrate on admonishing Christians for their sins.

A key instance of the inner/outer character of reality and especially of human existence, one that provided a constant concern for Gregory himself, was the tension between contemplation and action.[44] Called from his short career as a monk to be archdeacon of Rome and then its bishop, Gregory complains again and again in his letters about the way in which involvement with external ministries tends to overbalance his own life of prayer. In a subtle but pervasive fashion, this image of the dedicated Christian torn between two basic responsibilities will have widespread impact in subsequent centuries on the understanding of Christian spirituality and on the evolution of monastic life.

Summary

In Gregory I, a final Western spokesman of the patristic period, one can see reflected the three forms of distancing we have been studying—but also certain countercurrents. As one raised to be a Roman administrator, Gregory illustrates the *institutional distancing* of the bulk of people from immediate contact with the divine; he has no hesitation about the indispensable mediatorial role of church officials like himself. In his view of the outside of things as being less important, a sign of the more ultimate and truth-bearing inside, Gregory essentially maintains the Greek and Augustinian view that sensible things participate in and are able to mirror divine reality. This *philosophical distancing* is softened

43. Ad Leandrum 1
44. See C. Butler, *Western Mysticism* (London, 1926), 171–97.

by Gregory's insistence on the reality and importance of the literal meaning of events and this meaning's intrinsic link with deeper meaning; but the tension between inner and outer prevents Gregory from attributing full sacramentality to the visible world.

In the area of *cultic distancing* of God, Gregory's strong moralistic interest and his emphasis on preaching that is aimed at fostering morality do offset the tendency to relegate religion to a sacred realm of liturgical practice. At the same time, though, he was most influential in regulating liturgical practice and in focusing Christians' relation to God on official public worship, which, as it became more splendid in its details, lost much of its earlier communal feeling. As Jungmann describes in his reconstruction of the seventh-century Roman stational liturgies, the people no longer answer the prayers; nor do they take part in the singing, which has become the art-form of a small group. The language is still that of the people, the people still share in offering gifts and they still regularly share in communion; but the process of reducing the congregation to observing rather than doing the liturgy is unmistakably under way.[45] Succeeding centuries will see the laity increasingly isolated from sharing in a liturgy that becomes less intelligible to them and more a distant sacred mystery.[46]

ISIDORE AND VISIGOTHIC SPAIN

While Gregory the Great was in unparalleled fashion a channel through which patristic, particularly Augustinian, thought passed into the formation of medieval Christianity, another late patristic figure must be mentioned. The writings of Isidore of Seville (560–636) were a major force in shaping the worldview of succeeding centuries in the West.[47]

Cultural heir of both Rome and Carthage, Spanish Christianity of the sixth and seventh centuries enjoyed a brief golden age of tranquility and flowering between the earlier Gothic invasions and the arrival of the Muslim armies. No figure is more characteristic of this development and its contribution to medieval Europe than Isidore of Seville, whose voluminous writings provide a precious witness to the view of symbolism that marked the Christianity of his and subsequent centuries.

45. J. Jungmann, *The Mass of the Roman Rite* (New York, 1950), 1:67–74.

46. In the following chapter we will discuss the effect on Christian ritual of the extent to which literacy marked the end of the "Roman Empire" and the emergence of the medieval world. One thing to examine there will be the role of preaching as an oral mode that is grounded, however, in acquaintance with the text of Scripture—clearly, Gregory's advice about preaching is a factor in this development.

47. On the key influence of Isidore's writings, particularly his *Etymologies* (or *Origins*), on both the Carolingian and twelfth-century revivals of knowledge, see J. Fontaine, *Isidore de Seville et la culture classique dans l'Espagne wisigothique* (Paris, 1959), 1:13–14.

Fontaine's detailed study of Isidore's absorption, modification, and transmission of classical rhetoric provides ample evidence of the extent to which the very pattern of liberal education contained in the *Etymologies* implies a particular understanding of symbolism, above all in its refined explanation of the symbolic function of language.[48] But it is in his cosmology that he impacts more obviously on the symbolisms operative in the medieval view of the world. He shares the picture of levels of being leading up to humans, angels, and God, but without the complications to be found in Pseudo-Dionysius. He offers several versions of these levels, which he draws principally from the *Timaeus*, from Augustine, and from Genesis as seen through a tradition of commentaries.[49] At the same time, he preserves the time-honored explanation of the bodily world in terms of the four elements: fire, air, water, and earth. With something less than complete consistency, he also continues an atomistic explanation of the physical world and the notion of elements arising out of combinations of hot, cold, wet, and dry.[50] For Isidore, as for much of the classic and Christian worldview that preceded him, this somewhat eclectic view is more than a primitive explanation of the physical makeup of things; there is a deeper significance attached to these sensible physical realities, for they find their parallels in the spiritual order. It is specially in reflection upon Scripture that one needs to look beyond the surface to the deeper inspired meaning—for all the naturalism absorbed from the encyclopedic collections of the "schools," Isidore still follows the exegetical procedures characteristic of patristic theology.

Isidore's influence on the symbolism of subsequent Christian centuries was not limited to elements in the overall cultural context. His explanations of baptismal and eucharistic liturgy became a major force during the Carolingian liturgical revival and remained such throughout medieval developments of sacramental theology.[51]

48. See ibid., 27–340.

49. "Actually, descriptions of reality that one finds in school manuals of cosmography more easily attract Isidore's interest than does strictly cosmological speculation. Prominent among the sources of Isidore's thought is the kind of sacred cosmography that previous centuries of exegesis had worked out in commentaries on *Genesis*." Ibid., 647.

50. Ibid., 651–57.

51. See especially book 6, "De officiis," in the *Etymologi*. "The work of Isidore of Seville is important for understanding the liturgy of Spain but even more so because of his influence on liturgical thought throughout the Middle Ages." P. Gy, *L'eglise en priere*, ed. A. Martimort (Paris, 1983), 1:66. The classic study of Isidore and the Eucharist is still Geiselmann's *Die Abendmahlslehre an der Wende des christlichen Spatantike zum Fruhmittelalter* (Munich, 1933).

6

Carolingian Renaissance

The centuries that bridge the gap between the late Greco-Roman period and the emergence of medieval Europe are a fascinating and instructive picture of intermingling Mediterranean, Celtic, and Teutonic cultures— and therefore of intermingling symbol systems. Modern historical scholarship has moved us well beyond the popular perception of "barbaric invasions," which imagines hordes of savages moving southward and completely obliterating the cultural heritage of Greece and Rome. Unquestionably, there is much truth in the popular view. Great social disruption followed the southward migrations; most of the Roman imperial structure gave way to much less ordered processes, if not at times to outright chaos; and a great deal of the artistic and literary treasure inherited from Rome and Greece was plundered and destroyed.[1] At the same time, as the successive waves of invasion brought the Teutonic peoples into contact with the declining but still powerful ordering structures of imperial Rome and with the increasingly influential activity of Christianity, there occurred a sociocultural syncretism that gradually and painfully grew into the medieval synthesis.

While much of the continuity that entered into the transition from classical to medieval culture had to do with the unconscious influence and evolution of root symbolisms, there was also some formal understanding and use of theories about linguistic symbols. Granted that this was very limited, it was enough to guarantee a continuing poetic and rhetorical tradition. Through Augustine, Isidore, Cassiadorus, and Boethius the Greco-Roman classical heritage flowed into the Carolingian period. Much of the revived literary education was due to key figures such as Alcuin and Rhabanus Maurus; but they themselves were the beneficiaries of the literary culture that had taken refuge in Ireland

1. On the decline in culture in Gaul in the sixth and seventh centuries and the retention and development of culture in Ireland and England, see P. Riche, *Instruction et vie religieuse dans le Haut Moyen Age* (London, 1981). See also A. Masson, *Jean Gerson* (Lyon: 1894), 20–29, on schools during the sixth to twelfth centuries.

and England until it could return to the continent in force in the ninth century.[2] Without this influence of classical rhetorical theory on the educational initiatives of the Carolingians and their immediate successors, there could not have been the broad discussion of symbolic communication that marked the twelfth to fourteenth centuries.

In this confrontation and gradual but never completely consummated wedding of two worlds, the Christian Church played a unique role and its leaders, such as Gregory I, were aptly cast as *pontifices*. Perhaps most importantly, the liturgical rituals of Christianity provided a pattern of symbolic activity which gradually engaged and transformed the meaning of human life for the newly baptized Teutonic peoples. Initiated into the mysteries of Christianity, they were simultaneously socialized into the cultural forms through which the Christian gospel had found embodiment in the Latin West. And because it is the nature of religious ritual to be conservative of tradition, the Christian liturgy was a particularly effective instrument for preserving the wisdom and worldview of Greco-Roman Christianity. But the transformation was not one-sided; the Christianity of Cyprian and Ambrose, Augustine and Gregory, to say nothing of the Christianity of Athanasius and the Cappadocians, was deeply modified by the legal traditions, by the vernacular languages and by the customs and ethos and folk religion of these newly converted peoples.

Within the limits of the present book it is impossible to describe step by step the complicated interpenetration of these two symbol worlds. Instead, a focus on the "Carolingian renaissance" of the ninth century may provide some insight into the process by which the central symbolisms of the Middle Ages came into being and some insight into the manner in which the distancing of God was intensified, lessened, or modified during these centuries.[3] Again, the ninth century provides a vantage point from which to examine and assess the symbolisms that occupied the consciousness of Europeans as they approached and then experienced the millennium.

2. One can get some idea of the culture of the British Isles by examining the library of Bede and the even more extensive library of his disciple, Egbert. See P. Blair, "From Bede to Alcuin," in *Famulus Christi*, ed. G. Bonner (London, 1971), 241–55; and M. Laistner, "The Library of the Venerable Bede," in *Bede: His Life, Times, and Writings*, ed. A. Thompson (Oxford, 1935), 237–66. For a description of the continuing rhetorical tradition, see the early section of J. Murphy, *Rhetoric in the Middle Ages* (Berkeley, 1974), 3–132.

3. While our concentration will be on developments in the Latin West, it is important to bear in mind a continuing interchange, particularly of Rome, with Byzantine Christianity. It is only with the papal alliance with Pepin and successive Carolingians that the popes established political independence from Constantinople; and the religious link between East and West, though clearly weakening, would not be clearly broken until mid-eleventh century. On the troubled relationship between Eastern and Western Christianity see R. Southern, *Western Society and the Church in the Middle Ages* (London, 1970), 53–90. On the rich heritage of Byzantine theology see Pelikan, *The Christian Tradition* 2.

In *The Implications of Literacy* Brian Stock has insightfully interpreted the Carolingian century in terms of the increase of literacy, the emergence of "textual communities," and the interplay of oral and literate cultures.[4] Certainly, the widespread illiteracy of the European population in the seventh and eighth centuries, the narrow opportunities for formal education, and the loss to Western Europe of so much of the textual heritage of Greece and Rome had major impact on the symbols, and specifically the ritual symbols, through which Christian faith was transmitted. Perhaps most importantly, as Latin was no longer understood by most people and as the laity were increasingly denied active participation in the eucharistic action, liturgical celebration itself became a "text" to be interpreted instead of a mystery one experienced. This is not to say that liturgical participation as sharing in mystery disappeared entirely at this time; the lively controversy between Florus and Amalar, in which the former rails against the allegorizing explanations that are destroying people's awareness of the significances intrinsic to the liturgy itself, makes it clear that a considerable amount of the mystery mentality endured.[5]

DOMINANCE OF MONASTICISM

Study of symbolism in Carolingian Christianity can logically begin with a look at the pervasive influence of monasticism. At first glance, Christian monasticism seems a strange claimant to the role of mediating the symbols of Roman and Teutonic cultures. The monastic movement originated for the most part in the effort of dedicated believers to avoid what they viewed as the spiritually entangling elements of Greco-Roman culture. If anything, it was a countercultural movement; but this designation also is misleading, for monasticism had no ambitions to convert the culture around it; rather, it fled that culture as something beyond redemption. Even Benedictine monasteries, which rapidly became the dominant pattern in the Latin West and took a more positive view of human cultural achievement, were located apart from cities and in a real or artificial "wilderness." Besides, the monastic outlook on life was markedly eschatological; the present life is seen only as a period of testing and preparation for the life to come.

However, monasticism exerted a far-reaching influence on the symbolism of the emerging medieval world precisely by this eschatological perspective and by being a model of ideal Christianity—a model that existed in tension with the political model that had so significantly

4. Brian Stock, *The Implications of Literacy* (Princeton, 1983).
5. See A. Martimort, ed., *The Church at Prayer*, (Collegeville, Minn., 1987), 1:56f.

shaped Christian thought and life from at least as early as the third century. Moreover, by the Carolingian period the early medieval church was already "monasticized" in much of its structure and activity. With their daily meditation upon biblical and patristic texts and their guidance of daily life by the various monastic rules, monasteries were the most obvious instances of "textual communities" and the vanguard of a more literate culture. And the societal organization of Charlemagne and his immediate successors would appreciably extend the monastic impact on church and society.

Ireland was the classic case of a church and a society dominated by monasticism, a monasticism deriving from Eastern Christianity by way of France and therefore quite different from the Benedictine pattern that emerged on the continent. It was a severe regime of disciplined penitential life, its austerity giving concrete embodiment to the "spiritual athlete" ideal that had succeeded the earlier Christian ideal of martyrdom. What this conveyed symbolically about the character of Christianity and the nature of salvation—and the role in each of human sexuality—is not hard to imagine, especially because monastic spirituality was looked upon as *the* way of Christian life, which laity were meant to emulate as far as possible. Undoubtedly this had a profound impact upon distancing "ordinary" Christians from immediate contact with the divine.

In reflecting on the world-denying character of this Celtic monasticism, one can see how it logically reinforced the cultic sacrality that had for several centuries marked Christian liturgy. Christianity had increasingly absorbed from surrounding cultures the view that exercise of human sexuality was not appropriately linked with immediate involvement in "the sacred."[6] So, celibate monastic life with its total exclusion of sexuality, even that sacramentalized in Christian marriage, became the privileged place for the *opus Dei*, the worship of God. Christian liturgy carried the symbolic aura of a sacral spirituality; it was an activity carried on in "sacred space" by those whose own sacredness fitted them to function in such proximity to the divine.

By the seventh century a web of flourishing monasteries had largely replaced the Irish episcopacy in its earlier role as the principal ecclesiastical structure of the country; and for the next few centuries Ireland would be distinctively monastic in ethos, in religious practice, and even in artistic expression. The country's great monastic missionaries would in the sixth and seventh centuries establish in Britain and then on the

6. An indication of the widespread view of this incompatibility of sexual activity with the celebration of cult: Isidore of Seville advises married couples to abstain from intercourse prior to receiving communion. *De eccles. officiis*, 1,18,9 (*Patrologia Latina* [Paris, 1878–90], 83, 756; hereafter cited as PL).

continent a string of monasteries that played a major role in reestablishing literature and culture and in shaping the worldview of early medieval Christianity, particularly attitudes about human life and salvation.

However, it was monasticism grounded in the Rule of St. Benedict that became more widespread on the continent and even in England. And it was this form of monastic life that Louis the Pious and Benedict of Aniane attempted, by the capitulary of 817, to make the universal pattern of monastic life. Their attempts at monastic homogenization failed to overcome the considerable diversity that marked the great monastic institutions that, by that time, dotted the landscape of Europe. But the very fact that such an enterprise was undertaken indicates the magnitude of monasticism's cultural and social importance and the basically "Benedictine" character of the monasticism that played a central role in the Carolingian renaissance.[7]

Without repeating this story,[8] our purpose is to discover monasticism's influence on the symbolisms that bound together the worldview that developed during this first great intellectual awakening of the Middle Ages. Undoubtedly, one of the key overarching symbols during that and succeeding epochs was provided by the liturgical year with its structuring of time through cyclic remembrance of past "mysteries" and anticipation of "the last things." And while such patterned liturgical celebration antedated monasteries by several centuries, medieval monasticism—as we will see shortly—placed such enactment of Christian mysteries in a much different light.

Even more broadly, monastic theology developed as a prayerful reflection on the hidden "mystery level" of Bible, nature, and historical experience. Guided in their scriptural interpretation by the patristic commentaries, monastic thinkers hastened over the literal sense of the text and focused on the allegorical or spiritual and, somewhat, less on the tropological or moral meanings. To a large extent the later medieval "symbolist mentality" was an outgrowth of monasticism and forged an alliance with monastic rather than scholastic theology.

7. D. Knowles, *Christian Monasticism* (New York, 1969), 45. As Knowles has pointed out, this move by Benedict of Aniane nurtured the somewhat legendary view of Benedict of Nursia as the founder of Western monasticism and thereby contributed symbolically to the eventual unification of monastic life.

To realize the impact of monasticism on the reforms undertaken by Charlemagne and by his immediate successors, one need only look at the role played by Alcuin and, a generation later, by Rabanus Maurus in stimulating and organizing education and liturgy and official Latin "literacy." Or again, to appreciate the cultural influence of the great monasteries one can trace the extent to which, for five centuries, monastic manuscript illustration carried across Europe the art forms of Greece, Rome, and the Near East and led to their fusion with the designs of Nordic and Celtic artists.

8. Ibid., 46.

Symbol and law represent two quite different ways of human insight and expression, and so it is an interesting bit of historical dialectic that the Carolingian period, which so reinforced monasticism's symbolic influence on culture, was also responsible for stressing the role of order and law, not just in civil society but in the church and in monastic life itself. Even more striking, prominent monks played a key role in this use of "law" as a model for life. But perhaps this is not surprising, for monasticism drew heavily from the heritage of Augustine, for whom *ordo* was such a fundamental attribute of the true and the good; and Benedictine monasticism is of its essence an *ordered* way of life.

REVIVAL OF OLD TESTAMENT SYMBOLISM

The Carolingian age was one of those periods when there was a felt need to introduce more structure and order into human society and activity. With the ordering forces of imperial Rome clearly weakened beyond recovery, and Teutonic tribal customs still too diverse and un-integrated to provide large-scale societal unity; with monasticism a wide-spread and vibrant but fragmented force within the church, a movement whose relationship to the episcopate-centered official structures was both unclear and at times antagonistic—there was thus a recognized need to clarify roles, responsibilities, privileges, and processes. But where to find a trustworthy guide to doing this?

Traditional customs and structures already in place were a major element in the response to this question—possession was truly nine-tenths of the law. However, in an age that still looked to the Primary Cause to explain happenings and that saw the "will of God" as the only ultimate arbiter of right and wrong, it was to be expected that people looked to the law of God for final guidance. And while theoretically the gospel provided the culminating stage of God's law, the Old Testament also was regarded as the Word of God to be obeyed by humans; and it was the Old Testament period that clearly and in detail spelled out the laws that God has given for human guidance. So, it was to the Old Testament texts that Carolingian thinkers turned, with the result that key symbols for understanding kings and priests and Christ himself were drawn from the pages of the Old Testament, and the pre-Christian Jewish sacral distancing of God and religion infiltrated Christianity yet more deeply.

Sacred Priest-kings

From the earliest stages of recoverable history, there has been a linkage of kingship and priesthood; the ruler has been seen as the one most closely associated with the gods and therefore responsible for a people's

proper relationship to the divine. Priesthoods as they became more established strove for greater independence and at times obtained enough power to threaten the authority of the king—the Pharaoh-god Akhenaton was forced to bend before the influence of the temple priests of Amon. Yet, at least in theory, priesthood was still seen as deriving from the king. At Rome, even after the republican period, the imperial title "pontifex maximus" reflected the continuing notion that priesthoods, though their daily activity was relatively autonomous, were delegated surrogates of the king who remained *the* priest.

The Bible records the ideological struggle between kings and religious leaders that began as early as Samuel and Saul. By and large David's attitude toward the priestly establishment is favorably judged in the biblical traditions; something that was not true of most of his successors. Still, it was David who brought the ark to Jerusalem and officiated at the inception of the royal shrine; Solomon did the same at the consecration of the temple and of its first high priest; and the Jerusalem temple remained essentially the royal shrine up to the time of the Babylonian exile—all of which reflects the king's position atop cultic officialdom.

As a result, it is not surprising to see the aura of sacral priesthood surrounding the Carolingian rulers. Pope Stephen II himself anointed Pepin at St. Denis in 754 with the clear understanding that the ruler and his descendants were chosen and consecrated by God. True, the Pope in this act was claiming a superior authority, for it was he who as priestly vicar of God was anointing Pepin. But the symbolism of the act, linked with Samuel's anointing of David, placed the civil ruler among "sacred" persons.

With Charlemagne the situation is even clearer. Though it was the Pope (Leo III) who on Christmas of 800 crowned Charles as "emperor of the Romans," it was already clear that Charlemagne was acting in affairs of the church with full responsibiity and accompanying authority. Less than a month earlier he had presided at the assembly that passed judgment upon Leo, even though the latter reasserted the claim that "the Apostolic See cannot be judged by anyone." The Pope's action in proclaiming Charles as Augustus, in a ceremony that was consciously parallel to that in which, for centuries, the patriarchs of Constantinople had crowned the Byzantine emperor, was a direct challenge and affront to the imperial claims of Constantinople; but the Eastern Empire was in too weakened a position to do anything about it.

Apart from considerations of legitimacy or *Realpolitik*, Charlemagne's person and role were linked symbolically with David and with Constantine, and thereby enjoyed the sacredness attached to being "God's chosen one." Charlemagne "considered himself to be invested with a

veritable priesthood. After the model of the biblical kings, his primary preoccupation . . . was to guide his subjects in the way of the good . . . the role of spiritual leader was perhaps the one that came most naturally to Charlemagne."[9] Beyond taking the leading role in nurturing and regulating ecclesiastical discipline, the formation of clergy, monastic life and liturgical activity, Charles did not hesitate to preside over councils and to pronounce on doctrinal issues like Adoptianism or the veneration of images. Most likely it was at his instigation that the *Libri Carolini*, with a purportedly official summation of church teaching, were composed.[10]

Despite the decline of the Carolingian Empire, the scandals and internecine struggles that did nothing to better the public image of Charlemagne's successors, and the evident incompetence of the last Carolingians, the symbol of the priest-king managed to survive, to gain strength again in the eleventh century, and to be a basic element of the investiture controversy.

One of the strongest supports for the sacrality of a Christian king was the attribution of kingship to Christ himself, whose vicar the earthly monarch was.[11] Earliest Christianity had had to wrestle with the Davidic kingship meaning of "Messiah" as applied to Jesus; and the New Testament texts reflect the manner in which the term is reinterpreted in prophetic rather than political terms. Yet, as the iconography of both East and West indicates, the notion of the risen Christ as ruling with supreme kingly power had become firmly entrenched by no later than the fourth century. The *Pantocrator* image of Christ is found by the eleventh century, became a dominant motif in Romanesque frescos and passed in somewhat modified form into the "Christ of Last Judgment" on the portals of medieval cathedrals.[12]

9. See L. Halphen, *Charlemagne and the Carolingian Empire* (Amsterdam, 1977), 148.

10. The *Libri Carolini*, probably to be attributed to Leodulf of Orleans, witness to a high level of theological reflection on the nature and function of symbols. Meant as a response to Byzantine iconoclast teaching, though probably not able to work with an accurate text of Nicaea II, the *Libri Carolini* take a surprisingly critical stance toward religious art without espousing the position of the Eastern iconoclasts. What they do reflect is the growing tendency in the West to see official blessings of *res sacratae*, that is, the vessels used at Eucharist, as granting to these objects some invisible, spiritual power. On the artistic and theological theories of the *Libri Carolini*, see C. Chazelle, "Matter, Spirit, and Image in the *Libri Carolini*," *Recherches Augustiniennes* 21(1986): 163–84. Attribution of authorship of the *Libri Carolini* to Leodulf is contested by L. Wallach in *Diplomatic Studies in Latin and Greek Documents from the Carolingian Age* (Ithaca, 1977), 287–94. His conclusion is that Alcuin was the author.

11. While it was only toward the end of the twelfth century that the popes claimed to be "vicar of Christ" whereas previously they had referred to themselves as "vicar of Peter," Byzantine rulers at least as far back as Justinian's Code bore officially the title of "vicar of Christ."

12. See C. Morley, *Medieval Art* (New York, 1942), 104ff. As early as the second quarter of the ninth century, the figure of the Christ of majesty is found on the carved gospel-book covers, on the gold altar of Sant'Ambrogio in Milan, and even earlier (late eighth century), on the Tassilo chalice. See P. Lasko, *Ars Sacra* (Baltimore, 1972), 50–52 (and plate 1), 71, and 364.

This seems to have clear implications for the extent to which a distancing of God and even of Christ, whom Paul described as bridging this distance, had increased through the symbolic overtones of "rulers," be they civil or ecclesiastical, as mediatorial representatives of God to humans and of humans to God. Only those with special sacrality, seen as conferred with official anointing, stood in immediate contact with the realm of the sacred; they were "God's anointed." The Messianic overtones of this view as it touched Charlemagne are explicit and clear: Alcuin, for one, constantly refers to the emperor as "our David." Thus the cultic symbolism of pre–Christian Judaism and the political symbolism of imperial Rome have clearly merged in Carolingian Europe.

High Priests of the New Temple

And if the Old Testament played a determining role in the intepretation of the political ruler, it had an even more basic influence on the understanding of the dignity and function of Christian religious leadership. This was not, of course, something new. As we have seen, there was a tradition going back as far as *1 Clement* which related ecclesiastical officials to the priesthood of the Jerusalem temple. This had already found more detailed and structured expression in the series of treatises *De officiis* that stretched from Ambrose to Isidore. And Rabanus Maurus in his ninth-century *De clericorum institutione* continued the comparison of bishops to the high priest of the temple, of presbyters to the priests, and of deacons to the Levites.[13]

The triumph of Old Testament categories in interpreting Christian worship is clear; Leviticus rather than Hebrews has become the classic source for explaining liturgical leadership in the church. Two of the key influences on Carolingian thought, Isidore and Bede, had already given Leviticus an allegorical interpretation, thus setting up the Old Testament temple and its priesthood as the antecedent and model for the character and function of Christian ministers.[14] Alcuin, among others, draws from them in the task of providing unity and intelligibility to the liturgy and church order of his day.

13. *De clericorum institutione*, 1, 4–7 (PL 107, 299–303). The text is evidence that *sacerdos* had by this time become a common designation for a presbyter. See P. Gy, "Notes on the Early Terminology of Christian Priesthood," *The Sacrament of Holy Orders* (Collegeville, Minn., 1962), 98–115. As early as the eighth century, *sacerdos* is used in the *Collectio Hibernensis* as a distinctive term for the presbyterate; see my *Ministry to Word and Sacrament*, 107.

14. See Isidore, *De eccles. officiis*, 2, 5–8 (PL 83, 780–790); Bede, *De templo Salomonis liber* (PL 91, 755–868), and *In Leviticum* (PL 91, 331–358) and *Quaestiones super Leviticum* (PL 93, 387–396). Speaking of Bede's *De Templo*, I. Douglas says: "The *De Templo* contains many examples of number symbolism and allegorical interpretation but does not contain much factual information nor details of literal interpretation." "Bede's *De Templo* and the *Commentary on Samuel and Kings* by Claudius of Turin," in *Famulus Christi* (London, 1982), 325–33.

When one recalls the basic religio-cultural dialectic of ritual and law to which Christopher Dawson drew attention in his Gifford Lectures,[15] and then studies the controlling influence of the Old Testament on the Carolingian understanding of both king and priest, there can be no denying the extent to which the sacrality of Judaism continued to color the medieval understanding of the *civitas christiana* and to widen the split between liturgical experience and observance of religious law.

CAROLINGIAN LITURGICAL REVIVAL

Despite his important overall contribution to the Carolingian renaissance and his key role in stimulating and structuring formal education, Alcuin's crowning achievement and impact on history may well have come in the area of liturgical reform.[16] It was he, more than anyone, who was entrusted by Charlemagne to bring order and vitality to liturgical life in his domain. In fulfilling this commission, Alcuin became uniquely responsible for bringing Roman liturgical forms into conjunction with those of northern Italy and northern Europe, and thereby giving to the Roman practice a broader influence than it had previously enjoyed.[17] Given the practically universal involvement of people in the regular celebration of eucharistic liturgy, the shift that occurred as more free-floating Celtic patterns slowly gave way to the official tone of the Roman-regulated celebrations was bound to have subtle but lasting symbolic impact. Besides, the distancing of ordinary people from personally involved liturgical experience increased as Latin, no longer understood by the common people, became enshrined as the language of worship; and as Christian ritual became a public ceremony that most people observed.[18] And the establishment of liturgical uniformity, which Charlemagne did so much to foster, came through the use of common normative texts that inevitably introduced overtones of Eucharist as fulfillment of ritual law.[19]

Accompanying this was a fundamental change in the theological understanding of eucharistic liturgy. For centuries, beginning with the earliest Christian generations, believers had gathered for "the breaking of the bread" with the basic intent of glorifying and giving thanks to the Father of Our Lord Jesus Christ for the blessings God had bestowed

15. Dawson, *Religion and Culture*.
16. See G. Ellard, *Master Alcuin, Liturgist* (Chicago, 1956).
17. On the transplanting of the Roman Mass in France and the changes this effected in the form of the liturgy see J. Jungmann, *Roman Rite*, 1:74–86.
18. Ibid., 67–74. Jungmann describes the Roman station liturgy; but he also indicates that the populace was still very much engaged psychologically in the ceremony—somewhat the way people are still attracted to parades today (73).
19. Ibid., 74–81.

in both old and new covenants. Along with this there grew the notion that people nourished their spiritual life by sharing in the eucharistic food and drink. Granting, of course, the recognition that salvation, eternal life, was a divinely bestowed gift, eucharistic liturgy was something that *the people did*. With Isidore of Seville, even though he still preserves much of the mystery view of liturgy—*sacramentum* is often used in the sense of "mystery"—the emphasis is on Eucharist as *God's* action of conferring salvation upon the gathered faithful. People do not *do*; they *receive*. Isidore's influence on medieval understanding of liturgy was decisively important.[20] Logically, too, the understanding of the liturgical celebrant's role changed; he was now thought of as the one who "administered" the sacrament, as the only essential agent of the eucharistic action. This attribution to the celebrant alone of the active role in liturgy was reinforced by the spreading practice of private masses.[21]

Such isolation of the laity from liturgical participation created a new need for sacramental catechesis. Now eucharistic liturgy became something apart from people's immediate religious experience; it became a "word" addressed to their faith, a word that needed interpretation as it became more and more foreign. So the ninth century witnesses a widespread effort to produce explanations of the Mass. Alcuin was one of the principal authors of such works; but probably the most influential was his disciple, Amalarius of Metz, whose radically allegorical commentary had a lasting and disastrous effect on people's understanding and experience of eucharistic liturgy. If allegorical interpretation was needed to arrive at the true understanding of liturgy, this clearly emphasized and reinforced the division between the seen and the unseen, between the apparent and the real; and it gave a meaning to Augustine's distinction between *sacramentum* and *res sacramenti* that was quite other than his intent.

The application to sacramental liturgy of such allegorical interpretation implied unmistakably that people's immediate human experiences during the liturgical action did not carry Christian meaning, and therefore were not symbolic causes of the inner spiritual transformation. One might say that the ordinary meaning of eating bread, for example, was too "profane" to be a word spoken to faith; some more truly spiritual significance had to be discovered. Ordinary human experience was further distanced from the religious sphere in which God conferred salvation.

Another quite different set of circumstances triggered a proliferation

20. See Martimort, *The Church at Prayer*, 1, 66, and 265.
21. On the negative effects of this clericalization of the liturgy, see Fr. Oakley, *The Western Church in the Later Middle Ages* (Ithaca, N.Y., 1979), 82–84.

of baptismal catechesis. Largely as a result of Charlemagne's successful military campaigns, whole population groups were introduced into Christianity. This meant that for a generation or two a large portion of baptisms dealt with adults, with the consequent need for a reconstituted adult catechumenate, or at least for some procedures that would accomplish the goals of the catechumenate. That this need was consciously recognized and positively dealt with is indicated by the questionnaire that Charlemagne, in 812, sent to the episcopacy in his empire, asking them what they were doing or intended to do with regard to baptismal instruction.[22]

The responses to Charlemagne's initiative suggest that there were any number of well-developed baptismal catecheses, and that there was considerable variety in the approaches taken to instructing neophytes. Another striking feature in the various expositions, listed by Susan Keefe in her inventory of Carolingian baptismal texts, is the enduring influence of earlier patristic explanations of baptism.[23] In addition to drawing from Alcuin, Isidore, and contemporary Roman practice—which one might expect—the Carolingian bishops were dependent also on Augustine, Ambrose, Chrysostom, Leo and Cyprian.[24] One can only speculate on the role that such renewed baptismal catechesis played in reinstating, at least partially, the symbols central to the "salvation history" approach to theology which began to find renewed currency as monastic theology developed. What is clear is that typology and allegory increasingly intertwined in art and symbolist theology as medieval Christianity emerged.

ESCHATOLOGICAL SYMBOLISM

One of the more obvious features of the medieval world was the prominence of eschatological symbolism. Not too surprisingly, religious emphasis on life after death as the true life, combining with experiences that seemed to presage the end of the world, resulted in a widespread interest in, even obsession with, "the four last things." There was a negative side of this outlook, particularly among "Romans" like Boethius, who saw the classic culture and civilization they treasured vanishing around them and felt the need to find consolation—as he did in philosophy. This more pessimistic interpretation of the course of

22. See S. Keefe, "Carolingian Baptismal Expositions," in *Carolingian Essays*, ed. U. Blumenthal (Washington D.C., 1983), 169–237.

23. Ibid., 178–218.

24. On Alcuin's role in dealing with the need to fit baptismal instruction and practice to the situation of Carolingian conquest, masses of new catechumens, etc., see D. Bullogh, "Alcuin and the Kingdom of Heaven," *Carolingian Essays*, 41–47.

history faded somewhat during the awakening and positive achieve-
ments of the ninth century; but came back in more accentuated and
apocalyptic form with the approach of the millennium. But there existed
also, particularly in monastic circles, a basically optimistic expectation
of the next life and concomitantly a peaceful acceptance of death as
entry into true life.

Related to this latter view was the pervading image and notion of the
"communion of saints," the idea that the Church was a community of
faith that transcended the temporal limitations of earthly existence, a
community that embraced not only Christians in history but those also
who had passed through death and who temporarily found themselves
in purgatory, waiting to be purified in preparation for union with God;
and also those blessed souls who, together with the angelic choirs, en-
joyed unending bliss in heaven. In some fashion, communication among
these three groups was possible: those on earth could turn to the blessed
and ask them to intercede "before the throne of God" and they, by their
prayers and good works, could bring help to those in purgatory and
even hasten their passage to heaven.

Toward the end of the Middle Ages the imagery of this communion
of saints will find consummate expression in Dante's *Divine Comedy*, and
the density of its symbolism will be revealed through his artistry. But
for centuries prior to that, Christians lived with the vision of their fellow
believers already enjoying the destiny that they hoped would one day
be theirs.

If this encompassing image of the Church militant, suffering, and
triumphant provided a bridge between people and God, it also con-
tributed to the distancing of God in people's awareness. That God
touched their lives people never doubted, but they saw that happening
through a series of mediators. People turned to their special patron
saints, great Christian figures of the past, whom they believed to be in
fullness of heavenly life and specially powerful to intercede for them
with God. The presence of such heavenly patrons to their earthly dis-
ciples was sacramentalized by relics and especially by the place of their
burial; at such shrines people felt themselves in actual personal com-
munication with these patron saints. Despite official cautions about the
veneration of relics, popular belief attributed to them theurgic power
(the power to influence God).

The happenings of life were interpreted within this framework; the
effective forces at work were those of the unseen world. At no time was
this "behind the scenes" explanation more apparent than in the years
immediately before and after the millennium. Never adverting to the
basic artificiality of numbering the passage of time in a fashion that
made a certain year A.D. 1000, people attached enormous significance

and considerable apocalyptic expectation to that date. No doubt some of the more pessimistic anticipation resulted from the social regression that accompanied the collapse of the Carolingian renaissance; the tenth century was one of the more turbulent and chaotic in European history. But a great deal of the significance attached to the millennium was grounded in fear of hidden forces, both cosmic and daimonic.

One feature of this fear of the millennium, a feature that seems characteristic of apocalyptic outlooks, was the symbolic power associated with numbers. Obviously, the number 1000 bore special symbolic weight. But the numbers of the beginning years of the new millennium were seen as powerfully linked with the corresponding years of Jesus' life. When a catastrophic famine swept much of Europe toward the end of the third decade, people feared that this presaged a buildup to the year 1033 and its parallel to Jesus' death at the age of thirty-three. And when, contrary to their worst fears, that year brought a change in the climate and a reversal of food shortages, this was interpreted as an intrinsic parallel to the resurrection.

Clearly, this instance reflects an asssociation of numbers with belief in magical forces that control both nature and human affairs, something that is generally thought of in connection with Pythagorianism or the Hermetic tradition but that has been a much broader phenomenon, an almost instinctive element of human thinking. What is distinctive of the early medieval instance is the linkage with the events of Jesus' life and death, the belief that they bear a continuing power to influence human affairs.

"RETURN" OF SALVATION HISTORY

Whether or not such a link of historical experiences with the "mysteries" of Jesus' life and death can be seen as a widespread outlook, the centuries that stretch from the Carolingians to the twelfth century are marked by a reawakened awareness of history and by attempts to give it some intelligibility. "Christian symbolism views not only nature but also history as a theophany. In the eyes of the Fathers and of the Middle Ages symbolism and the theology of history form a natural unity."[25] The interpretation of contemporary happenings and institutions by relating them to Old Testament Israel, which we studied above, was one aspect of this. Another aspect was the mixture of typology with allegory that can be found in explanations of liturgy such as those of Alcuin and Amalar.

However, the magical overtone in popular perception of the link

25. H. Rauh, *Das Bild des Antichrist* (Munster, 1973), 528.

between 1033 and Jesus' death—presumably at the age of thirty-three—
raises some disturbing questions about the actual functioning of symbols
in a religious community, questions that are not limited to an early
medieval context. For centuries, as we saw, the liturgical experience of
Christians was essentially one of entering actively into the ongoing
Christ-mystery; and the sequence of liturgical feasts was a celebration
of various facets of what was one transhistorical yet history-determining
salvific event. The effectiveness of such liturgy was seen neither as the
power of theurgic symbols, nor in terms of moral obligations performed,
nor even as the occasion for grace being bestowed from on high. Rather,
Christians felt themselves nourished by the eucharistic body of the risen
Christ, being consequently more his ecclesial body, already sharing to
some extent the "true life" that flowed from his death and resurrection.
But as the people became isolated from liturgical activity, religion be-
came identified increasingly with observance of moral precepts, and
liturgy became public ceremonial that most people observed rather than
did.[26]

Yet, the traditional understanding persisted that in the cycle of litur-
gical feasts the events of Jesus' life, death and resurrection had an effect
on Christians' lives. In the theologically sophisticated analysis given in
the thirteenth century by Thomas Aquinas, this is explained in terms
of the continuing influence of the events of Jesus' career as instrumental
causes, conveying to humans God's saving *virtus* (power), which tran-
scends temporal and spatial limitations.[27] However, popular perception
around the turn of the millennium was far from such subtle insights
and easily drifted toward viewing the link between Jesus and liturgy as
"mysterious" in the sense of completely hidden or even as semimagical.

Add to this the shift of attention from the action as a whole to the
action of the ordained celebrant, changing the elements of bread and
wine into the body and blood of Christ, and one can begin to appreciate
the basic reorientation of attitude toward liturgical symbolism that oc-
curred in the West during the centuries linking patristic and medieval
Christianity.[28] It becomes clear, then, why disputes about the "real pres-
ence" of Christ in the Eucharist surfaced in the ninth century, and

26. G. Dix points to the Frankish interpolation of "for whom we offer" in the Roman
canon of the Mass (which later is taken over into the Roman canon itself) as a sign of
the increased liturgical isolation of the people. "In the Roman idea it is the *people themselves*
who are the offerers; in the Gallican interpolation it is the priest who offers *for* them."
G. Dix, *The Shape of the Liturgy* (1945). See also F. Oakley, *The Western Church in the Later
Middle Ages*, (Ithaca, N.Y., 1985). From the point of view of symbol change, it is worth
noting the shift from hearing to seeing in people's attendance at mass, a development
that peaks in the medieval fascination with seeing the consecrated host.

27. *Summa theologiae*, III, q. 62, a. 5.

28. From a slightly different perspective Schillebeeckx, in *Ministry*, points to this change
in the understanding concomitantly of Eucharist and ordained ministry.

continued through and beyond the Middle Ages. There is no need to detail again the debates between Radbertus and Ratramnus in the ninth century or the second round of the dispute, three centuries later, with Berengarius and Lanfranc.[29] But it might be helpful to recall the more encompassing medieval disputes about the nature and role of symbols, most centrally the symbolic function of words, and to realize how these intersected with and affected interpretation of liturgical symbolism. What made possible this intersection was the fact that liturgy had come to be viewed as didactic, as an objective event distinct from and witnessed by a religiously observant community, as instruction for people's faith understandings, and therefore in need of exegesis. People had lost the awareness of *being* the symbol. Augustine's insistence on the inseparability of faith and sacrament was retained, and his statements were cited, but the relationship of faith and sacrament was now understood quite differently than it had been by Augustine himself.

However, the Carolingian century is only the beginning of the theological developments that will harden the division between uneducated participation in religious ritual and the intellectually sophisticated sharing in that same ritual by those who approach religious practices with a philosophically critical interpretation of what is taking place. Because the eucharistic action is so central to Christian worship, it logically became the key instance of this division; and dispute about the orthodox understanding of the Mass focused on the notion of its symbolic character. Already in the ninth century Radbertus and Ratramnus gave the controversy its basic structure—the former stressing the sensible physicalness of the bread and wine, the latter pointing rather to the symbolic import of these external elements, and both suggesting an opposition of "symbolic" and "real" that remained for centuries a presupposition of eucharistic debate.

SUMMARY

Of the three instances of distancing we have been studying, the Carolingian century gives clear evidence of the continuation and deepening of the cultification of worship and of the role of official mediators. But for the moment, since apart from Scotus Erigena[30] creative philosophical

29. Two recent studies have done much to clarify both the context and the underlying issues in the debate: G. Macy's *The Theologies of the Eucharist in the Early Scholastic Period* (Oxford, 1984) and the third chapter of B. Stock's *Implications of Literacy* (Princeton, 1986).

30. John Scotus Erigena, an Irishman who directed the palace school of Charles the Bald during the latter half of the ninth century, was the most original philosopher/ theologian of the period. His principal work, *On the Division of Nature*, was thoroughly Neoplatonic, was questioned as to its orthodoxy, and apparently had little effect on later theology. His most important contribution to medieval thought was the translation into Latin of the works of Pseudo-Dionysius.

reflection was scarcely noticeable, there was no observable movement in using either Platonic or Aristotelian notions of participation to interpret human relationship to the divine. Most Christians were becoming increasingly alienated from personal involvement in liturgy as this became an activity exclusively reserved to the ordained; their presence at Eucharist was now understood in terms of attendance; and "location" of the eucharistic presence of Christ was clearly shifting from the community as body of Christ to the consecrated elements. Monasticism played an ambiguous role in all this: on the one hand, the notion that true Christianity consisted in abandoning ordinary human life and retreating to a life of contemplation in the monastery was a powerful psychological force in distancing the majority of people from immediate relationship to God; on the other hand, monastic *opus Dei*, with its celebration of the liturgical cycles and its absorption of patristic exegesis, reemphasized the "salvation history" approach to understanding Christianity, drew renewed attention to the earthly mysteries of the life of Jesus, and prepared for the flowering of monastic theology in the eleventh and twelfth centuries.

7

Medieval World of Symbols

Heralded by Erigena's almost pantheistic vision of Nature, the late eleventh and the twelfth centuries witnessed a striking recovery of appreciation for the reality of the sensible world. Supported by emerging technology and the accompanying sense of command over the forces that affected human life, drawing from the rising level of education, and expressing itself in rapid development of towns and cities, the European worldview began to shift from a rather pessimistic appraisal of the world to an enthusiastic search to understand and enjoy both nature and human historical existence.

Yet, even as fascination with this-worldly reality and its meaning was expressing itself in a new phase of scientific interest and investigation, the symbolist mentality continued to flourish.[1] The result was a creative, if at times acrimonious, dialectic between two quite different modes of thought, two quite different positions regarding the interaction of imagination and intellectual insight. Speaking very generally and with obvious need for qualification in specific instances, one might say that the dialectic was reflected religiously in the lasting tension between monastic and scholastic theology.[2] Not surprisingly, then, this period will produce both the first analytic explanations of sacramental symbols and an incredibly rich translation of Christian belief by artistic symbols. And the twelfth and thirteenth centuries will make explicit the evolution of Christian life and consciousnss that was already taking place but only beginning to surface in the early medieval centuries.

Even though by the mid-eleventh century the role of laity in formal

1. On this symbolist mentality see M.-D. Chenu, *Nature, Man, and Society in the Twelfth Century* (Chicago, 1968), 99–145. Needless to say, this was connected with emergent medieval reflection on the symbolic role of language; see M. Haren, *Medieval Thought* (New York, 1985), 99–116, and L. de Rijk, *La philosophie au Moyen Age* (Leiden, 1985), 183–203.

2. On the distinctive characteristics of these two approaches to theology, see J. Leclercq, "The Renewal of Theology," in *Renaissance and Renewal in the Twelfth Century*, ed. R. Benson and G. Constable (Cambridge, Mass., 1982), 68–87.

liturgical actions had shrunk to practically nothing, early medieval Christian life was structured by the liturgical cycles and animated by the basic symbolisms of Scripture and sacrament. Monastic life continued to be regarded as a paradigm of Christian life and it was the Cluniac reform of the eleventh century that prepared for the flowering of Christian life in the succeeding two centuries. Appropriately, the liturgical grandeur of Cluny and slightly later of St. Denis[3] functioned as reflections of the glory that must mark the heavenly rituals.

At the same time, the reforming thrust of Cistercian monasticism in the early twelfth century, and of the mendicant friars later in the same century, raised questions as to what life-style truly fulfilled the imitation of Christ. Along with these more structured forms of simpler existence, enthusiasm for the apostolic life of poverty and detachment from the world found expression in any number of wandering preachers and in groups like the *Humiliati* or the Waldensians—which witnesses to the widespread influence of an evangelical model in people's understanding of their Christianity. In subtle but important ways, life outside monastery walls came to be viewed as a genuine translation of gospel ideals, an outlook that was strengthened by the preaching of the Crusades and the literature that glorified Christian chivalry.

Even a cursory examination of the sculpture and stained glass of cathedrals such as Chartres indicates the manner in which the everyday life of people was, on the one hand, incorporated into and interpreted by the "salvation history" of Jesus' life, death, and resurrection, and, on the other hand, understood in the light of eschatological events. And the Corpus Christi hymn composed by Aquinas in the thirteenth century will reflect liturgically this same looking back and looking ahead.

In this way, the historical symbolism that had dominated earliest Christian faith and theology found a renewed role, and it is accompanied by increasing rediscovery of the human Jesus of Nazareth. One can appreciate the symbolic impact of this return to the historical Jesus if one compares the imposing, even overpowering, portrayal of the *Pantokrator* in Catalonian chapels of the Romanesque period with Giotto's thirteenth-century frescoes of Jesus' life. The evangelical revival of the twelfth century inevitably sharpened people's awareness of the events of Jesus' life and simultaneously drew attention to the Old Testament happenings that provided the historical antecedents and the prophecies in the light of which Jesus was interpreted.[4] At the same time, these

3. See Suger's description of the consecration of the abbey church of St. Denis, in E. Panofsky, *Abbot Suger on the Abbey Church of St. Denis* (Princeton, 1946), 82ff.

4. On the influence of the Old Testament, see Chenu, *Nature, Man and Society in the Twelfth Century*, 147–61. This was linked to extensive reflection on *imago* and *imago Dei* in the twelfth century; see S. Otto, *Die Funktion des Bildbegriffes in der Theologie des 12. Jahrhunderts* (Munster, 1963).

events were more and more explained as *exempla* for Christian imitation; while still thought of as the mysteries of Jesus' life, they were not celebrated as *present* mysteries in the way that Augustine or Leo liturgically entered into the Christ-mystery with their community.[5] True, there was a growing sense of sharing in mystery and the emergence of a full-fledged mystical theology. The source, however, was not the anamnetic force of the liturgy but the recovered writings of Pseudo-Dionysius and the mystery in question was above history rather than imbedded in it.

Before the physics and metaphysics of Aristotle are incorporated into theological reasoning in the thirteenth century and instrumentality becomes a dominant notion in the explanation of sacraments, one can view medieval reflection on symbols as a gradual infiltration of Dionysian insights into the mainstream of Augustinian understandings. As Chenu has written in his study of twelfth-century theology, Augustine's view of symbolism is basically different from that of Pseudo-Dionysius, yet common Neoplatonic roots and common Christian beliefs lead to a complex interplay and even confusion of the two approaches in the thinkers of the eleventh and twelfth centuries. Difficult as it is to sort out this symbolist mentality, any serious attempt to understand the Christianity of early medieval Europe must focus on this task, for no period of Christian—or for that matter human—history has been so thoroughly caught up in living symbolically.

To fill out the context of consciousness in which this interaction of dialectically opposed views of symbol was played out, a word should be said about two widely shared experiences that significantly impacted on the medieval European imagination—pilgrimage and crusade. In its own way, the crusading ideal subtly combined two earlier Christian images of discipleship, namely, the martyr and the spiritual athlete. It fully reinstated the image of the holy war and this image was embroidered in the romantic literature of the period, in the legends of Roland, El Cid, and Parsifal, and in the idealized picture of knighthood.

PILGRIMAGE AND DEVOTION

Pilgrimage, for its part, recaptured and gave specific form to a number of classic religious symbolisms.[6] Quite obviously it drew from the perennial imagery of life as a journey; it resonated with the central biblical image of "exodus"—churches such as Vezelay and Moissac served as

5. A symptom of the shift in understanding was the somewhat common abuse of people leaving the church before the communion of the Mass. See J. Jungmann, *Missarum Solemnia: The Mass of the Roman Rite*, (New York, 1955), 1:121.

6. On medieval pilgrimage see J. Sumption, *Pilgrimage* (Oxford, 1975).

oases on the pilgrimage routes; key shrines such as Santiago de Compostela were considered especially sacred space. Moreover, the very way in which architecture developed along the pilgrimage routes illustrates the accompanying shift in liturgical experience. Because of pilgrims' concentration on relics of the saints and their trust in the saving power attached to these relics, people's interest in visiting a church along the route was not to share in the central eucharistic liturgy but to venerate the church's collection of relics. As a result, the apse or section of the building behind the main altar, developed a walkway around the back of the altar and any number of apse chapels where the relics were displayed in ornate reliquaries. Without denying the role of Jesus' death and resurrection as the source of redemption, people turned more and more to intermediaries—saints and angels—as intercessors with God and dispensers of divine mercy.

The Virgin Mary occupied a preeminent place among such mediators, and this was reflected in the proliferation of Romanesque and then Gothic cathedrals dedicated to her name—Notre Dame la Grande in Poitier, Notre Dame de Chartres, Notre Dame de Paris, and so forth. Whereas the special intercessory and healing power of an apostle or of a martyr was focused on one place such as Compostela or Canterbury, Mary's influence was universal because no earthly spot could lay claim to her mortal remains; at her death, according to popular belief (which was accorded dogmatic status in Roman Catholic teaching only in 1950), her divine Son and accompanying angels had borne her, body and spirit, to heavenly glory. Bernard of Clairvaux was the great champion of Mary's special prerogatives and role, and Cistercian spirituality enshrined this Marian heritage. Inevitably, this spiritual teaching and even more so the iconography of stained glass and cathedral statuary implanted in people's imaginations the picture of Mary as queen of heaven and indispensable link between Christians and her divine Son.

This heavenly imagery preserved the notion that the great pilgrimage was life itself. All creation, and in a special way human history, is on its way to a final goal not yet reached. Medieval consciousness was shot through with this eschatological anticipation; monasticism was supported by the expectation of a better life beyond; all religious practice and homiletic exhortation looked to reward or punishment in the future life; and eschatological motifs are omnipresent in medieval art.

A symbol linked with pilgrimage and with the experience of crusade that comes to the fore at this period is that of "quest."[7] The Arthurian

7. For an explanation of "quest" as a search for Paradise and Utopia, see M. Eliade, *The Quest* (Chicago, 1969), 88–111. A more psychologically influenced treatment is provided in the early chapters of C. Sanford, *The Quest for Paradise* (Urbana, Ill., 1969), and by E. Jung and M.-L. von Franz, *The Grail Legend* (New York, 1978).

legends, though they had probably circulated for centuries in oral form and in rather restricted circles, now find rapid and extensive exposure through a series of literary works—from Geoffrey of Monmouth's *Historia Regum Britanniae* in mid-twelfth century, through the *Conte del Graal* of Chretien de Troyes toward the end of the century to Wolfram's *Parzival* between 1200 and 1210.[8] By the time they have taken on this literary shape, the original Arthurian stories have acquired a thoroughly Christian symbolism—so much so that Charles Williams could claim that the underlying story had become that of humanity's salvation through the death of Jesus and its celebration in Eucharist,[9] and Loomis's analysis of the Grail legends concluded that attainment of the Grail was linked with possession of the beatific vision.[10] It was just about this same time, too, that the *Chanson de Roland* took literary shape in France, as did the legend of El Cid in Spain.[11] Thus the holy warrior, either crusading against the infidel or seeking the realm of the sacred, and in either case fighting against the forces of evil, became a dominant symbol of heroic Christian existence.

The great hero was, of course, Jesus, whose struggle against evil had led to his death but who by dying had conquered the forces seeking to destroy humans and had won the ultimate prize of eternal life. He was *the* king leading his armies in battle against Satan and all Satan's minions.[12] If earthly kings caught people's imagination during this period, there was incomparably more fascination with all that concerned the life and death of Jesus.

Already in the eleventh century, with the reopening of the overland route to Palestine, pilgrimages to the Holy Land had grown by leaps and bounds. This, linked to the crusades—more as people imagined them than as they actually were—gave the holy places in Palestine a special symbolic power over the religious consciousness of medieval Christians. People were intrigued with anything connected with the historical life of Jesus, to an extent reminiscent of what occurred in the fourth century after Constantine's recognition of Christianity. Just one example, though perhaps the most striking, of this interest in the relics of Jesus' life and death was Louis IX's building of the Sainte Chapelle in Paris as a reliquary for what was purported to be the crown of thorns.

8. See *Arthurian Literature in the Middle Ages* ed. R. Loomis (Oxford, 1961).

9. See C.S. Lewis's commentary on Williams's Arthurian poems and Williams's posthumous fragments of *The Figure of Arthur, in Arthurian Torso* (Oxford, 1948).

10. R. Loomis, *The Grail: From Celtic Myth to Christian Symbol* (New York, 1963).

11. The *Chanson de Roland* dates from the very end of the eleventh century; see P. Le Gentil, *The Chanson de Roland* (Cambridge, Mass., 1969). The literary poem about El Cid was probably composed in or near Burgos in the early thirteenth century, though it was preceded by oral tradition. El Cid died in 1099; see C. Smith, *Poema de mio Cid* (Oxford, Mass., 1972).

12. See J. Leclercq, *L'idee de la royaute du Christ au Moyen Age* (Paris, 1959).

This was of a piece with the recovery of the human Jesus that is associated with the spirituality of Bernard of Clairvaux and Francis of Assisi. Without diminishing Christian conviction of Jesus' triumphant "sitting at the right hand of the Father," this focus on the events that had brought Christianity into existence more than a thousand years earlier marked a major shift in the evolution of Christology. The two characteristic devotional practices that came to prominence at this time and have remained a treasured part of popular piety were the Christmas crib and the Stations of the Cross, the beginning and the end of Christ's earthly career. However, the movement away from excessive stress on the divine element in the Incarnation was still incomplete, especially in theological reflection. Only implicitly contained in the faithful's sense of Jesus being close to them, and untreated by formal Christology, was the humanity of Jesus *as the risen Christ*. Perhaps more than anything else this contributed to the debates about the eucharistic presence that stretched from the eleventh century to the present.

THE HERITAGE

Augustinian

Structuring the experience of sharing in a community that embraced Christians in the next life as well as those in this life (the "communion of saints") and in a continuing sacred history was the explanation of reality that flowed from Augustine and, with modifications, through Gregory I, Isidore, and the Carolingians into monastic theology, and then through Peter Lombard and Hugh of St. Victor into the thirteenth-century summas.

In this worldview the sensible creation did have an intrinsic symbolism, for it vestigially reflected its Creator; but its functioning as symbol depended upon human interpretation, most importantly, interpretation flowing from faith. In this psychological modification of the Platonic tradition, the literal meaning of things, events, or biblical texts that speak of things and events is basic but transitional. More important is the spiritual meaning (or meanings) that the believing Christian discovered by study, reflection, and prayer—and, of course, through illumination by God. And it is human reason, informed by this insight into the spiritual significance, that is the *imago* in which God is known.

The level of literal meaning is a *sign* pointing to the inner spiritual meaning that carries divine revelation. What remains hazy in this Augustinian hermeneutic is the link between the two levels of meaning. In some instances it is the intrinsic linkage proper to metaphor; in others it is an applied moral lesson that has some connection with the

literal reality of a historical personage or event; but in still other instances the link to some allegorical meaning seems quite arbitrary, determined by creative religious imagination of the "exegete." The danger to authentic religious insight in this open-ended search for the spiritual meaning becomes actualized in some of the medieval use of Gregory's *Moralia*, Isidore's *Etymologies*, and Amalar's allegorical explanation of liturgy. The benefit it preserves is the insistence on the role of the believer's own faith in the actual functioning of sacramentality, especially the sacramentality of liturgical ritual. In this way, it acts as a safeguard against the subtle intrusion of magic into liturgical interpretation, an intrusion that is basic to the Hermetic tradition and that is not wholly absent from the symbolic theurgy of the theology of Pseudo-Dionysius.[13]

Dionysian Currents

Neoplatonism as it flowed into the thought of Augustine and his followers had been moderated by both Latinity and Christian faith. However, with Erigena's translation of Pseudo-Dionysius in the ninth century, a cognate but much purer Neoplatonism begins to influence Latin Christianity's view of symbolism. In many ways the Dionysian view is basically opposed to the Augustinian, but because it already represented an adjustment to Christian belief by accepting the reality of God as Creator, a certain rapprochement could be worked out by twelfth- and thirteenth-century theologians. Hugh of St. Victor is perhaps the most striking example of an enrichment of basic Augustinianism by insights drawn from Pseudo-Dionysius.

Fundamentally, in the Dionysian perspective things *exist* symbolically; to symbolize is their basic finality and therefore their basic function. In the hierarchy of beings that stretches from God down to the least of humans—Dionysius is not particularly interested in what is "below" the human—each level is illumined by what is above it and, in turn, illumines what lies below it. As meaning passes down the ladder of spirits that comprises the heavenly hierarchy and the ecclesiastical hierarchy, each level "instructs" its next lower neighbor by sharing the truth that it is and understands, each level introduces this neighbor into the mystery of the light beyond light, each level in turn functions mystagogically.

From one point of view the Dionysian world is strikingly sacramental; significance is everything; to exist is to symbolize. Everything ultimately is word of God, and its most important meaning is anagogical. At the same time, however, the immediacy of divine presence that one senses

13. One can already see in this medieval wrestling with the effective meaning of liturgy the main lines of the sixteenth century debate about sacramental causation depending on the faith of "recipients" or operating by virtue of the ritual itself (*ex opere operato*).

in the Augustinian, and before that in the Alexandrian, view of sac-
rament is absent from the Dionysian symbolism. For Augustinianism it
is one's own *ratio* illumined in faith that images the Image; God's own
Word is the indwelling Teacher. For Dionysius there is the need to pass
through the hierarchical stages before, as a result of purgation and
illumination, reaching contemplative union with the divine.

Yet, even such a contrast is misleading. There is in the Dionysian
world a considerable degree of immanentism, the ever present danger
of the Neoplatonic inheritance. There is a continuity in illumining that
begins with Light from Light; but the ordinary Christian's illumination
comes to him or her through a series of illumining mediators. The
presence of the divine in human life is more in terms of being caught
up into ineffable mystery than of faith seeking understanding. Even
less is the presence of an I/thou encounter that one associates with
Augustine's *Confessions*. In the Dionysian world one is meant to be im-
mersed in the divine mystery; but it is a matter of ontological partici-
pation rather than of psychological encounter. One becomes
enlightened by emptying oneself, purified not just of sin but almost of
creaturely selfhood, totally open to being taken over by the divine, to
"becoming light."

While much monastic theology with its Augustinian heritage picked
up the historical orientation of earliest Christian theology, the Dionysian
current strengthens the philosophical distancing attached to the notion
of "grace" as ontological participation in the divine. It would be a mis-
reading of Dionysian spiritual theology to see purgation, illumination,
and union as three completely distinct and successive stages on the soul's
journey to God; yet the very notion that union comes only as one ascends
from ordinary human experience to mystic experience implies that such
ordinary human life is distanced from God.

DISTANCING BY THEOLOGY AND LAW

While the Carolingian renaissance saw only a minimal growth in philo-
sophical distancing of the divine, the twelfth and thirteenth centuries
marked a major step in applying philosophical notions of participation
to humans' relation to God. As the full flowering of scholasticism begins
in mid-twelfth century, three figures, Peter Lombard, Hugh of St. Victor
and Gratian, epitomize the manner in which academic theological ex-
planation distances or makes present the God in whom Christians be-
lieve. Their influence must be balanced, however, by the widely
influential spiritual theology of Bernard of Clairvaux. And in addition,

two other influences, liturgical practice and the increased bureaucratization of the official church, will continue, each in its own way, the other two forms of distancing that we have been tracing.

Hugh of St. Victor

Hugh of St. Victor is by any account a key figure in the history of Christian symbolism. The very title of his most important writing, the *De Sacramentis*, and the fact that under this title Hugh synthesizes all Christian thinking in a way that prepares for the great thirteenth-century summas immediately suggests the centrality of symbolism in his thought. Bible and Nature are the two great books that speak about God. If read correctly, they lead the Christian to prayerful understanding of and union with God. Like a true Augustinian, however, Hugh insists that it is only an interpretation in faith of these two books—and in the case of the Bible, of the events that lie behind it—that will lay open the divinely intended spiritual meaning. This being the case, Hugh situates the study of nature within the context of biblical exegesis. His main purpose is to reflect on the work of God's "restoration" through Christ; only in relation to this does he examine God's work of "prior creation."[14]

So, despite Hugh's respect for the literal meaning of text or of experienced happenings—and he does respect this meaning—it is the deeper meaning, the allegorical meaning, that is the goal of his search.[15] And it is this search, grounded in faith, that leads Hugh to plumb in special fashion the deeper significance of those Christian things that were already bearing the name of sacraments. So, while the notion of sacrament has application in Hugh's usage to just about everything, it is in its more restricted use that we find Hugh's understanding of symbolism most clearly focused.

Sacraments fit within Hugh's overall picture of God's "work of restoration." Sacraments such as marriage or baptism help heal the damage of human sinfulness by having three effects: in making spiritual benefit depend upon bodily realities, they humble people and so work against pride; the externals of the sacrament instruct people about the inner healing power that is at work; and a pattern of religious exercises that are diverse enough to maintain human interest and yet constant and frequent enough to keep people occupied doing good rather than evil will nurture the inner healing power which is the *res* of the sacraments.[16]

It is in discussing the second of these three effects that Hugh's view

14. Prologue, 3.
15. As he explains it in Prologue 4, Hugh's understanding of allegory comes much closer to biblical typology than it does to more modern understandings of allegory.
16. De sacr. 1,9,3–4.

of sacramental symbolism is expressed. It seems quite clear that for him the signifying function of the sacramental sign is limited to *telling* the Christian what it is that is being given him/her by God through the cooperation of the liturgical minister; the sign does not participate in *causing* this inner effect. The external sacrament is the vessel in which the spiritual antidote is contained, and which tells us about this antidote; but the inner cure does not come from the vessel but from what it contains. "Vessels do not cure the sick but medicine does."[17]

The causal independence of the inner power from the sacramental sign is emphasized by Hugh's statement that God could have worked out the inner healing of people without such external symbols. And as a matter of fact, some may have received from God the inner saving effect without any external sacraments; and so one cannot justifiably argue to an absolute necessity of sacraments.[18] That there is some intrinsic link in meaning between external sign and inner power Hugh recognizes; this is why the externals can instruct the believer regarding the inner salvation. And it is part of divine wisdom that in the creation of sensible things God already implanted this link in significance to humans' restoration. But Hugh does not go the next step and give any causal effectiveness to the symbolizing of the external sign; only the human minister of the sacrament is seen as somehow cooperating with God in effecting the internal healing.

This seems related to another typically Augustinian element in Hugh's view of sacrament, the aspect of faith. There are indeed sacraments of faith, that is, sacraments that require faith and are intended for the sanctification of the faithful; but faith itself is sacrament of the future face-to-face contemplation of God. Amplifying this point, Hugh uses St. Paul's example of a mirror in which one sees somewhat obscurely— "in a glass darkly"—that which will be viewed directly in final contemplation.[19]

Sacraments are intended for human sanctification, that is, restoration, and it is in Hugh's explanation of the Eucharist that he most clearly

17. Ibid., 1,9,4.
18. Ibid., 1,9,5.
19. "Therefore those who see through faith see the image, those who see through contemplation see the thing. Those who have the faith have the sacrament; those who have contemplation have the thing. Faith, then, is the sacrament of future contemplation, and contemplation itself is the thing and the virtue of the sacrament; and we now receive meanwhile the sacrament of sanctification, that sanctified perfectly we may be able to take the thing itself. If, then, the highest good is rightly believed to be man's contemplation of his Creator, not unfittingly is faith, through which he begins in some manner to see the absent, said to be the beginning of good and the first step in his restoration; this restoration increases according to increases of faith, while man is enlightened more through knowledge that he may know more fully, and is inflamed with love that he may love more ardently" (Ibid., 1,10,9).

states that the external elements, in this case the bread and wine, though changed by the words of institution, do not effect sanctification. Sanctification is caused by that which the externals signify, that is, the body and blood of Christ. Christ himself is the food received; he is the food that nourishes the life of grace. All three together, the bread and wine, the body of Christ, the spiritual nourishment that body causes, make up the sacrament.

In repeating the centuries-long notion that the eucharistic body of Christ is food for the soul, Hugh comes closest to moving away from the reduction of sanctification to morality; yet he does basically remain with the moralistic interpretation of Christian perfection. Though the destiny of humans beyond death is contemplative union with God, in this earthly life sanctification is a matter of being healed from the damage of sin, the work of "restoration" which Hugh has said is the central topic of his *De sacramentis*. And such healing is a matter of love rather than knowledge, love that is nourished by Christ's self-gift in Eucharist. In this worldview, increased understanding is a good to be sought but is preliminary to or reflective of sanctity rather than intrinsic to it; and so the symbolizing function of sacramental externals cannot logically be seen as causative of the *res* in sacramental actions.

The signifying role of those sensible realities to which Hugh attaches the notion of sacrament is in the last analysis didactic rather than theurgic. This is the more noteworthy when one adverts to the considerable influence upon Hugh of the thought of Pseudo-Dionysius. One cannot but wonder whether a more legalistic approach to liturgical actions, with a consequent loss of the notion of initiation into mystery, had not by Hugh's day conditioned people away from the context of mystagogy that is so central to the Dionysian world of symbol.

Gratian

If one speculates about the influence of legal thinking in Hugh, there is no need to speculate when examining the work of his contemporary, the Camaldolese monk Gratian. His *Decretum* provided the pattern and much of the stimulus for the explosive development of canon law in the twelfth and thirteenth centuries and for the accompanying dominance of legal categories in the operative ecclesiology of that period.

The section on sacraments in the *Decretum* provided the most extensive collection of patristic comments on sacramental practice and so became the documentary source from which Peter Lombard worked when writing the fourth book of his *Sentences*. Because the *Sentences* emerged as the basic theological textbook of the next three centuries, Gratian's treatment of sacraments had immense influence on the development of sacramental theology. It provided a list of topics and questions with

which theologians in succeeding centuries occupied themselves, a list that inevitably reflected the legal outlook and interests of its author and helped shape both the agenda and the approach of sacramental theology.[20]

Gratian had no systematic reflection about Christian symbolism, nor would one expect such from a Roman law. However, the flowering of legal studies and the immense influence of canon lawyers that marked the late twelfth and thirteenth centuries were major factors in shaping the model that henceforth dominated the official view of the church. Law, specifically ecclesiastical law, became a key symbol for interpreting the kind of authority and power exercised by church leadership and therefore a key symbol for understanding the nature of Christianity and of salvation.

The Broader Revolution

Yet, important as was the influence of Gratian and of canon law developments in general, this was but one manifestation of a deeper and revolutionary change in medieval society and culture. As Stock has detailed, the centuries from the eleventh to the thirteenth witnessed a renewed stress on the distinction between appearances and reality, an effort in several areas of thought to give more rationalized explanation of people's personal, societal, and religious experience.[21] Symbolism and ritual did not disappear as modes of insight and communication, but they were increasingly complemented by the explosive growth of legal codification and the philosophical developments that came with the re-entry of Aristotle into European thought. With more widespread education, people were less content simply to *do* things like the Mass; they wished an explanation of what was happening, especially as the "doing" became more and more a clerical monopoly. Interpretation thus became a central intellectual task.

Nowhere was this hermeneutical interest more tellingly evident than in the disputes about the nature of the Eucharist. This had begun as early as the Carolingian period with the allegorical explanations of Amalar and the theological theories of Rabanus Maurus and then the disputes between Ratramnus and Radbertus. In the twelfth century it

20. On the intertwined development of emerging scholastic theology and legal study in the late eleventh and twelfth centuries see S. Kuttner, "The Revival of Jurisprudence," in *Renaissance and Renewal in the Twelfth Century*, 299–323.

21. Stock lists some of the basic themes of his study: "the placing of spoken testimony within a legalistic framework determined by texts; the questioning of the formal validity of ritual and symbol, together with a literate conception of inner as genuine reality; the separation of subject and object through which the dispassionate observer of events is isolated from a mixture of events and interpretations; and a linking of literacy with reform, by which the local, the particular, and the unwritten become elements in a programme of higher religious culture." *Implications of Literacy*, 71.

erupts in the controversy over the views of Berengarius, views that raised the whole issue of symbols' claim to "reality." While interest in safeguarding the real grace-giving presence of Christ in Eucharist was the overt motivation of the dispute, the very fact that debate centered on the eucharistic *body* of Christ suggests the deeper levels of the questions being raised, for these centuries witnessed a radical shift in the meaning attached to "body."

Four studies taken in combination provide an intriguing insight into this migration of meaning. In 1949 Henri de Lubac's *Corpus mysticum* laid out in detail the way in which the term "mystical body," originally and traditionally applied to the eucharistic body of Christ, was transferred in the eleventh and twelfth centuries to the church.[22] To a large extent this was related to the Berengarian disputes about the "real body" of Christ and the ensuing insistence that the body of Christ in Eucharist was *corpus verum*. But it was also part of the loss of the "mystery celebration" approach to sacramental liturgy as sacramental theology moved toward a more instrumental view of ritual causality.

In addition, though the designation *corpus Christi* continued to be applied to the Christian community in the sense initiated by Paul's epistles and developed by the Fathers, it began to acquire some more "secular" implications as *corporations* started to emerge in medieval life. Yves Congar briefly but tellingly sketched this evolution in his *Ecclesiologie du haut Moyen Age*, concentrating on papal institutions as they emerged in interaction with the political structures of the early medieval period.[23] One feature of this evolution was the double application of a human model for interpreting social existence: The *civitas christiana*, like the human person, was composed of soul and body with the *sacerdotium* providing for soul and the *imperium* taking care of the body—which clearly put church officialdom in a position of moral control. But the human body itself provided a model of society; it was a striking instance of unity achieved through harmonious interaction of differing parts under the direction of the head—an anthropomorphic explanation that obviously intersected with the Pauline notion of "body of Christ."

This corporate understanding of society, in its earlier medieval developments, still had strong implications of the "mystery presence" of Christ in the unfolding of human history; and so it was not illogical for the notion of "mystical body" to attach to the church from the twelfth century on. Yet as the model of "body," even of "mystical body," became more prominent in legal thinking about society, the religious implications of "body" gradually dimmed; and a more secular mentality that

22. H. de Lubac, *Corpus Mysticum: L'Eucharistie et l'Eglise au Moyen Age* (Paris, 1949).
23. Y. Congar, *L'ecclesiologie du haut Moyen Age* (Paris, 1968).

used the human body in metaphorical explanation of corporations found application even to the church itself. E. Kantorowicz in *The King's Two Bodies* and Brian Tierney in *Foundations of the Conciliar Theory* complement one another in laying out the legal history that gave expression to this profound and far-reaching shift in the symbolism of the human body.[24] And as mystery became less the atmosphere of both sacramental liturgy and civil society, the distancing of God, though not less affected by increasingly clerical and legally prescribed liturgy, was importantly reinforced by the secularization of political symbolism.

It would be very revealing to relate to these changes in the symbolism of the body the symbolic dimensions of human bodiliness that are reflected in medieval ethical thinking about sexuality, or in the symbolism attached to woman during these centuries, or in explanations about the achievement of Christian sanctity. However, such a comparative study must wait for something that is scarcely in its beginning stages, namely the examination of medieval thought and life from a feminist perspective critically aware of the patriarchal worldview that the Middle Ages apparently inherited from preceding centuries.

Peter Lombard

Medieval scholars would probably agree with the assessment that Peter Lombard matched neither Hugh of St. Victor nor Gratian, under both of whom he studied, in insight and creativity. Yet it was he who became the "Master of the Sentences," who produced the text which, from the thirteenth to the sixteenth century, all young masters were required to explain to their students. His influence upon the evolution of late medieval and early modern theology was incalculable, yet difficult to define, because much of it was negative: by setting the pattern of questions to be discussed, he automatically excluded from the theological agenda of succeeding centuries many of the most important issues that needed discussion. Besides, the very notion that the pursuit of religious insight could be achieved by responding to a series of structured *quaestiones* and *sententiae* rested on a presumption about theological method and about the relation of faith and reason that favored rationalization over symbolic insight.

In two places in his synthesis, however, Lombard could not avoid some explanation of the nature and function of symbols in Christian faith and life: in his treatment of the Trinity and of the sacraments. In both cases, however, the symbols as described by Peter Lombard point to a distanced rather than a present God: in the case of trinitarian

24. B. Tierney, *Foundations of the Conciliar Theory* (Cambridge, 1955) and E. Kantorowicz, *The King's Two Bodies: A Study in Mediaeval Political Theory* (Princeton, 1957); see especially chap. 5 (193–272), "Polity-centered Kingship: Corpus Mysticum."

theology the language used and the employment of models drawn from human thought both stress *dissimilarity* between divine and human; and his explanation of sacraments' effecting grace is in terms of instrumental causality rather than of divine presence through symbol.

Wrestling with the problem confronting all Christian theologians, that of finding language that can convey some understanding of the triune character of the one God and at the same time avoid implications of either subordinationism or tritheism, Lombard follows a clearly Augustinian path. He sees an assertion about God, even when framed positively, as being essentially a negation of its opposite, the rejection of a false understanding.[25] However, he admits more positive insight than this, using as a key to trinitarian language the distinction between relative and essential predication.[26] At the same time, he follows Augustine in using the operations of the human mind as an image of the triune divinity. He is careful, however, to limit the extent to which the mind can be a symbol of the divine, insisting that any similarity is greatly outweighed by dissimilarity.[27]

Lombard's brief discussion of sign and symbol is straight out of Augustine's *De doctrina christiana*, but his definition of sacrament goes a bit further in stressing the *causation* of grace.[28] Basically, sacraments have been instituted by God as a remedy for the wounds caused by sin, original sin and a person's own sins.[29] Like Hugh, Peter Lombard maintains that sacraments have the triple purpose of humbling humans, instructing them, and keeping them busy in worthwhile pursuits.[30] Lombard represents no advance in probing the symbolic causality exercised by sacramental celebrations, a negative prognosis for the future of theological instruction until the seventeenth century.

THIRTEENTH CENTURY

To approach the flowering of medieval theology in the thirteenth century through nothing more than a study of the great summas, the *questiones disputatae*, and the commentaries on Boethius or Pseudo-Dionysius is automatically to neglect a key element of medieval scholasticism, the extensive commentary on the Bible. It is precisely in this commentary

25. "Such words seem to be used, not to state anything positive, but rather to exclude from the divine simplicity what is not there." Sent. 1, dist. 24, 2.

26. Sent. 1, dist. 27, 5–6.

27. "In our minds there is an image of the Trinity, but a weak one; whatever similarity to the Trinity it possesses is greatly outweighed by its dissimilarity." Sent. 1, dist. 3, 17.

28. "Sacraments were instituted not only to signify but also to sanctify. Things instituted merely to signify are only signs and not sacraments." Sent. 4, dist. 1, 2.

29. Sent. 4, dist. 1, 1.

30. Sent. 4, dist. 1, 3.

that one finds a key to much of that century's reflection on the nature and use of symbols. Already in the early decades of the twelfth century, one can discern the movement away from a fanciful understanding of nature to a more empirical, incipiently scientific, approach; and Abelard's *Sic and non* marks the early application of such a realist outlook to traditional patristic texts. Before the end of the century Hugh of St. Victor's *De sacramentis* will emphasize the importance of the literal meaning of Scripture, though at the same time espousing the greater importance of the spiritual sense.[31]

One will not find, of course, the kind of technical exegesis to which we have become accustomed in the twentieth century; but inherited explanations of the senses of Scripture were in most cases applied with considerable scholarly sophistication. This required a conscious dependence upon theories of rhetoric and poetry, as well as an awareness of the extent to which the texts in question reflected diverse interpreting mentalities and distinctive originating contexts. Moreover, the fact that the masters saw preaching on the text as well as classroom explanation to be part of their evangelical responsibility indicates an awareness of the different "publics" to which their exegesis was to be directed.[32]

As the thirteenth century begins, the application of critical techniques to discover the Bible's literal meaning is accepted as basic to biblical exegesis. This is evidenced by the late twelfth-century commentaries of Peter Comestor, Peter the Chanter, and Stephen Langton, which exerted an influence on thirteenth-century theological instruction parallel to that of Peter Lombard.[33] Comestor's *Historia scholastica* was particularly influential and intrinsically significant, for it once more insisted on the Bible as history, as a narrative of faith experience, instead of fragmenting Scripture into a collection of moral *exempla* or a thesaurus of spiritually nourishing truths.

This is not to say that scholarly explanation of the Bible took over as the ultimate purpose of exegesis. Hugh had already insisted that *historia* should lead to discovery of the spiritual meaning, and Peter the Chanter

31. "History is the basis and source of sacred doctrine; from it, as honey from the honeycomb, the truth of allegory is drawn." Hugh, *Didascalion*, Patrologia latina 176, 801.

32. On medieval preaching see J. Longere, *La predication medievale* (Paris, 1983). An indication of the extent to which scholastic methodology influenced the handling of Scripture is provided by the *artes praedicandi* that were produced in the late twelfth and early thirteenth centuries. Already in the Carolingian period ready-made homilies, along with liturgical books, had been provided to priests (see Longere, 46–8), but the medieval *artes praedicandi* provided a more structured theory of the composition of sermons. On the *artes praedicandi* see M. Jennings, "The Preacher's Rhetoric: The *Artes componenendi sermones* of Ranulph Higden," in *Medieval Eloquence*, ed. J. Murphy (Berkeley, 1978), 112–26; M. Charland, *Artes praedicandi* (Ottawa, 1936); and J. Murphy, *Rhetoric in the Middle Ages* (Berkeley, 1974), 43–64 (on the influence of Augustine's *De doctrina christiana*) and 269–355 (on *artes praedicandi*).

33. See M.-D. Chenu, *Towards Understanding St. Thomas* (Chicago, 1964), 236–40.

describes the three stages of studying Scripture—and therefore the three tasks incumbent on the *magister*: the text is to be explained, the questions it raises are to be discussed by disputation, and its content is to be preached to the faithful.[34] Besides, the preaching continues to be filled with allegorical references or applied meanings of one kind or another.[35] Thus, the immediate reality of the text and of the happenings with which it deals regains an intrinsic but not yet primary significance.

Something comparable was taking place in rational reflection on the human experience of nature and society. At twelfth-century centers of learning such as Chartres, there had already been a revolutionary awakening to the reality and wonder of the sensible world; but the effort to explain it was largely controlled by a Platonic neglect of empirical explanation in favor of an appeal to a deeper and real world of causal forces—Chartres was a center for study of the *Timaeus*. With the entry into medieval Europe of Aristotle's physical and ethico-political treatises, philosophical reflection and incipient scientific research (in the manner of Roger Bacon) were directed to explaining phenomena rather than to triggering human awareness of truths of a world beyond. Yet here, too, the explanation of observable happenings came through discernment of causes that lay behind these happenings. If the "four causes" were understood *metaphysically*, as gradually happened in the philosophical reflection of Thomas Aquinas, the integrity of sensible reality could be maintained; but if they were understood *physically*, as another level underneath observed reality, that observed reality was once more reduced to mere translation of "real" reality and the grounds of full sacramentality were destroyed.[36]

Moreover, in such a prevailing dichotomy between what was apparently happening and what was really happening, there was a concomitant division between the understanding of events possessed by the ordinary nonphilosophical person and that of the philosophically educated observer. Transferred into the realm of religious experience, theologians and ordinary faithful experienced Christian life and Christian liturgy differently, the latter drifting to superstition and the former to abstraction.[37]

34. Petrus Cantor, *Verbum abbreviatum*, c. 1, PL 205, 20.

35. See J. Baldwin, *Masters, Princes, and Merchants* (Princeton, 1970), 107–16, for a description of some sermons preached within the circle of Peter the Chanter.

36. This has obvious implications for medieval theories of the change effected in the eucharistic elements, and for the way in which "transubstantiation" would be understood then and later. It makes considerable difference whether one sees the term as referring to a hidden physical level of reality, at which Christ was present bodily; or whether one understands the term as referring to a transcendental transformation of bread's sacramentality. For a present-day discussion of this issue see E. Schillebeeckx, "Transubstantiation, Transfinalization, Transignification," *Worship* 40(1966): 324–38.

37. To follow through on the cultural dynamics suggested by Stock (see above, n. 21), one must balance off the "literate" development of biblical commentaries with the style and influence of popular preaching.

Theoretically, this split in Christian experience could have been less-
ened, perhaps even healed, by the incorporation of good biblical exe-
gesis into popular preaching. What happened instead is suggested by
the *artes praedicandi* that proliferated in the early thirteenth century.[38]
Reflecting both their homiletic context and their preachers' professorial
self-identity, many sermons became increasingly scholastic in style; the
topics discussed were often removed from the experience and interests
of ordinary people; and a new literary form, the university sermon,
replaced (at least in literate circles) the simple homily and contemplative
reflections on Scripture such as the ones Bernard of Clairvaux had
addressed to his monks.

Central as the *explicatio sacrae paginae* was to theological education in
the first half of the thirteenth century, the emphasis on Scripture study
could not withstand the growing prominence of systematized theology.
It tells us something about the course of late medieval and early modern
theology and religion that the summas rather than the biblical com-
mentaries of Aquinas become the object of explanation and academic
formation, and that the biblical commentaries of Peter Lombard were
all but forgotten in the centuries that saw his *Sentences* function as
Europe's common theological textbook.

Theological Explanation of Symbols

One's understanding of the function of Christian religious activity, and
specifically of sacramental rituals, is governed by the broader under-
standing of soteriology. So the thirteenth-century view of Christian
sacraments was deeply affected by the emphasis on Christ's death as
satisfaction, on grace as help in achieving *justification*, and on growth in
holiness as increasing *participation* in and approximation to divine life.[39]

Hugh's *De sacramentis* had spoken of Christ's gift of grace and the
Spirit as making virtue possible;[40] Peter Lombard had interpreted Jesus'
passion and death as sacrifice that merited human salvation;[41] William
of Auvergne continued the Anselmian tradition by explaining the In-
carnation in terms of *satisfactio condigna*; so also did William of Auxerre
in his *Summa aurea*, when he spoke of Christ meriting and making
satisfaction.[42] And Alexander of Hales described Jesus' passion as ef-
fecting satisfaction,[43] as the meritorious cause of grace and the for-
giveness of sin,[44] together with resurrection as the cause of justification,

38. See above, note 32, and especially the M. Jennings essay.
39. On early medieval understandings of grace, see H. Rondet, *The Grace of Christ*
(Westminster, Md., 1966), 167–208.
40. De sacr. 2, 2, 1.
41. Sent. 3, dist. 18.
42. See J. Riviere, in *Dict. Theol. Cath.* s.v. "Redemption."
43. *Summa theologica*, Inq. 1, tract 5, q. 5 (Quaracchi, ed., t. 4, 215)
44. Ibid., 216–17.

and in a more metaphorical vein as opening the gates of paradise.[45] And Peter Cantor's *Summa de sacramentis* interpreted the saving effect of Jesus' death as weakening the power of human inclination to sin,[46] opening the gates of heaven and remitting the penalty due to sin,[47] and healing the wounds of sin.[48]

Functioning within this approach to soteriology, Albertus Magnus describes sacraments' effectiveness in terms of the traditional metaphor of "medicine": sacraments heal the infirmity that results from sin. However, he gives priority to the sanctifying effect of sacraments and links this sanctification with the healing from sin.[49] Peter Cantor, on the contrary, goes back to the early patristic understanding of the effect of Eucharist: it vivifies Christians because it is Christ himself as their spiritual food.[50]

Well into the thirteenth century there remains imprecision, even ambiguity, in the explanations of soteriology and its application to sacraments. It remains for the next generation of theologians, Aquinas and Bonaventure in particular, to produce explanations that lay open the fundamental tension in thirteenth-century thinking about Christian symbols.

Bonaventure

In his explanation of sacraments Bonaventure is, as he himself acknowledges, deeply influenced by his master, Alexander of Hales. The *proemium* of his commentary on the fourth book of Lombard's *Sentences* lays out the basic thesis that will dominate his view of sacramental effectiveness: Sacraments are medicine to heal the harm caused by human sin. He is not, as we have seen, the first to use the medical metaphor to explain the action of divine grace; but few theologians have exploited it so consistently.[51] Though Bonaventure is conversant with the Aristotelian philosophy around him and not infrequently draws from it, he had made himself the mouthpiece of the resistance against

45. Ibid., 222–24.

46. De baptismo 5, in *Pierre le chantre, summa de sacramentis* (Louvain, 1954) 1:

47. Ibid., 28.

48. Ibid., 29.

49. ". . . three things are needed for something to be a sacrament: [1] institution of significance, [2] that it signify not only sanctification (*res sacra*) but also that which sanctifies (*res sacrans*) . . . and [3] that which sanctifies (*res sacrans*) heals the infirmity of sin or what results from sin." De sacr., tract. 1, q. 2.

50. De Eucharistia 56 (ed. Dugauquier, 138).

51. As he develops this metaphor in dist.1, part 1, a.1, q.3, he draws especially from Hugh's *De sacramentis*. So also in the *Breviloquium* 6,1,2 ". . . sacraments are sensible signs, divinely instituted as medicine, in which 'beneath the cloak of sensible things the divine power works secretly'; so that they [sacraments] 'represent by similitude, signify by institution, confer by consecration some spiritual grace' through which the soul is cured of the infirmity of sin."

Aristotelianism.[52] So, instead of the almost severely analytic explanation of Aquinas or Albert and despite the scholastic form of his commentary on Lombard, the tone of Bonaventure's treatment is often more reminiscent of the writings of Bernard of Clairvaux.

One cannot expect, then, the precision one might wish in Bonaventure's response to the question of sacramental causality. He sees the significance of sacramental ritual as essential because the instruction it provides is a needed healing of human ignorance.[53] Yet there seems to be no link between this significance and the grace conferred in sacraments. Indeed, Bonaventure draws upon another metaphor in common usage—that of medicine contained in a bottle—to say that grace in no way derives from the sacraments; they are only the situation to which a Christian goes to obtain the grace that comes "from the eternal springs."[54] The external sign of the sacrament points to the grace that is in the soul but is not causative of it.[55]

Bonaventure has been accused of denying that sacraments cause grace, and there are passages that apparently state this position quite boldly; yet, his position is more nuanced. Within the framework of scholastic terminology he expresses his view by saying that the sacramental ritual is a condition sine qua non in the causing of grace, that it is the efficient cause of the sacramental character, and that it is a dispositive cause of grace insofar as it heals the impediments to grace and thus allows it to work effectively.[56] Bonaventure is also open to the position that the divine power (virtus) that causes grace is joined to sacraments by special divine decree (ordinatio) rather than by any natural link.[57] But if one listens to Bonaventure, not in his scholastic argument but in the context of his metaphors, he clearly attributes healing effectiveness to the external action of sacraments; the question that remains unanswered is how this healing relates to grace. In some passages Bonaventure seems on the verge of explaining the causative power of Christian symbolism but the symbolist tradition, even with the infusion of Pseudo-Dionysius that Bonaventure receives via Hugh of St. Victor, lacks an adequate metaphysics.

However, more than the tradition of medieval symbolism is at work in Bonaventure's theology, and that "more" is of capital importance for

52. See M. D. Chenu, *Towards Understanding St. Thomas*, 35. Also, E. Gilson, *Philosophy of Bonaventure* (Paterson, N.J., 1965), 4–7.
53. Dist.1, part 1, art.1, q. 2.
54. Ibid., q.3.
55. Ibid.
56. Ibid. q.4.
57. Ibid. Perhaps the most accurate statement of Bonaventure's position is contained in question 5, where he discusses the difference between Old Testament sacraments and Christian sacraments: "The causality of sacraments is nothing other than a certain effective orientation to receiving grace that is brought about through divine establishment."

any theological study of the history of Christian thought or imagination. From his "father in God," Francis of Assisi, Bonaventure had inherited a contemplative awareness of the pervading divine presence. This mystical consciousness caused every detail of experience to be Word of God, to speak of God's loving blessing of human life. There was no need to seek for hidden allegorical meanings that would reveal God's activity in human affairs, God's hand was evident in everything.

As a result, the symbol world of Franciscan spirituality has a freshness that springs from its discovery of the mystery dimension of the ordinary. Without formalizing it into a theological explanation, indeed—and, we might say, tragically—without relating it to the significance of liturgical ritual, Franciscan spirituality recognizes and celebrates the sacramentality of creation. This explains, at least partially, the lasting attractiveness of the Franciscan movement, even to those who profess no religious belief.

Bonaventure is thoroughly dominated by this vision of God's working in all things, by what the Jesuit poet Gerard Manley Hopkins will refer to centuries later as "the grandeur of God . . . deep down things." Though Bonaventure's vision of reality was drawn immediately from Francis, its resonance with the mysticism of Bernard or of the Victorines or for the matter of Augustine of Hippo points to a deep current of Christian faith that in every age, despite the recurrent desiccation of both liturgy and theology, retains an awareness of the mystery of human experience and of the meaningfulness of all that is.[58]

Before leaving the topic of the Franciscan impact on medieval Christians' view and use of symbols, one other element demands attention. The Franciscan movement was unquestionably a major influence in turning people's attention to the mysteries of the *human* Jesus, thereby confirming the historical character of Christian symbolism. However, this attention tended to be commemorative of the Jesus of past history, a fond memory of his deeds and words, epitomized in the two great devotions of the Christmas crib and the Stations of the Cross. This did not deny the continuing existence of Christ in heavenly glory; but without a theological recovery of the fully transformed-human reality of Jesus' resurrection—and this would not come for another seven centuries—Francis and his followers could not be more than an important step on the way toward an integral Christology.

Moreover, the pious commemoration of the mysteries of Jesus' life and death became expressed in devotional practices other than the

58. See E. Gilson, *Philosophy of Bonaventure*, 62–69. Gilson's remark more than a quarter century ago that "St. Francis lived continuously in the midst of a forest of symbols" (65) suggests a fascinating linkage with present-day anthropological study, in which a key influence has been Victor Turner's notion of a "forest of symbols."

sacramental liturgies. Combined with the focus of medieval faith and theology on the mystery of eucharistic "real presence" and the resultant prominence of eucharistic devotions which came to overshadow the Mass itself in popular interest, this Franciscan nurture of devotional practices contributed to the decline of liturgy as the principal expression of most people's religious attitudes.

Thomas Aquinas

A more formalized and, within its thought-world, more adequate metaphysics grounded the sacramental theology of Thomas Aquinas. Still, despite clear reference (which we will examine) to grace and salvation involving some ontological "reconstruction" of the human, Thomas, like his contemporaries, was deeply affected by the legal justification approach to sacramental effectiveness that came from Gratian through Peter Lombard. Not incidental to the logic of issues discussed in *Summa Theologiae*, the topic that links his explanation of the mysteries of Christ and the following section on the sacraments is "the judicial power of Christ."[59]

However, what distinguishes Aquinas's explanation of sacraments from those preceding the thirteenth century is his decision to situate sacramental effectiveness at least partly within a framework of the Aristotelian explanation of causality. (Actually, there are two sides to Thomas's view about the effect of sacramental liturgies: they act as signs and they act as instrumental causes. There does not seem to be any real fusing of these two functions.)

In the treatment of sacraments in the third part of the *Summa theologiae* (from question 61 onward) Aquinas's basic approach to sacraments is in terms of their utilization by God as instrumental causes of grace. Sacraments have two basic purposes, the healing *(remedium peccati)* and sanctification *(animae perfectio)*;[60] and the grace conferred in sacraments that fulfills both these purposes is basically sanctifying grace, a share in likeness with God's way of being *(participatio similitudinis divinae naturae)*.[61] However, he adds that in the conferring of sacramental grace there is also an added help for achieving the purpose of a particular sacrament.[62] Thus, in giving grace the sacraments achieve the justification of a person;[63] they do so because they draw from the justifying power of Christ's passion;[64] but their role is simply that of instrumental

59. ST, 3, 59.
60. Ibid., 61,2.
61. Ibid., 62,2.
62. Ibid.
63. Ibid., 61,3.
64. Ibid., 62,5.

causes.[65] Since sacraments are instrumental causes, they can be said to "contain grace" but only in the manner in which the causative power (*virtus*) of any instrument exists in the instrument as a transitory and "fluid" force while the instrument is being used by the principal cause.[66]

The causal effectiveness of sacraments is not limited to justifying the individual through grace, though this is its primary and ultimate goal. Sacraments also cause a "character" or, in some cases, the parallel reality of the *res et sacramentum*.[67] The character, effected in baptism, confirmation, and ordination, is a share in Christ's priesthood that enables a Christian to participate in the church's cultic worship of God. For the ordained clergy this is an active power of administering sacraments, but for the bulk of Christians the power granted them by the character of baptism is essentially *receptive*; it makes it possible for them to receive the other sacraments.[68] As for the distinctiveness of the confirmational character, Aquinas reflects the vagueness perennially associated with theological attempts to rationalize the separation of confirmation from baptism: the character of confirmation confers a certain strength to confront Christian life in adult fashion.[69]

But if the sacramental liturgies function as causes, they also work as signs. They point commemoratively to the passion of Christ that is the source of the justification achieved in sacrament; they indicate the justification that is occurring; and they act as promises of the life of glory beyond.[70] It is interesting, however, to see how the signifying role of sacraments is linked in Thomas's thought with justification through faith in Christ. So necessary is such faith that only through anticipatory faith could those who lived prior to Christianity find salvation; hence the need for Old Testament sacraments.[71] And for those who live after the saving death of Christ there is the need of external signs, sacraments, so they can signify their faith acceptance of this salvation.[72] It does not seem, however, that the sacraments *insofar as they are signs* function to cause faith; they do cause the infused virtue of faith as part of their causation of grace, but this they do as instruments. As signs they tell about the existence of faith in the believer.

Explanation of Eucharist is always a test case of a theologian's view of sacrament, never so much so as in the thirteenth century when dispute about "the real presence" was still lively despite Lateran IV's adoption

65. Ibid., 62,1.
66. Ibid., 62,3.
67. Ibid., 63.
68. Ibid., 63,2.
69. Ibid., 72,5.
70. Ibid., 60,3.
71. Ibid., 61,3.
72. Ibid., 61,4.

of "transubstantiation" as an expression of belief in the transformation of the elements into the body of Christ.[73] In light of the liturgical distancing we have already noticed in the Middle Ages, it is worth noting that the entire discussion of the manner in which the Eucharist sanctifies people takes for granted that the situation is one of *receiving* a sacrament. There is not a hint that "grace," however that is viewed, is "conferred" or "increased" by the Christian sharing actively in the celebration of the eucharistic mystery.

That Eucharist causes grace in its recipients is obvious; the sacrament "contains" Christ, who is the cause of grace. As for the causality exerted by the external signs of the use of bread and wine, insofar as these signify the passion of Christ there is effected in the individual what Christ's passion effected in history, that is, salvation. In describing the parallel between the effect of bread on physical life and the effect of the Eucharist on spiritual life, Aquinas picks up the classic notion of the Christian being nourished by the body of Christ; and he draws also from the ancient idea that the bread made of many grains is a sign of Christian unity. It is here that one finds most explicitly the idea that the external "species" have an effectiveness precisely because of their signifying power.[74]

Aquinas's response to the question "Does the Eucharist remit venial sin?" is worth noting, for it runs counter to the prevalent tendency, even in Thomas himself, to treat remission of sin in a context of legal forgiveness. Following Ambrose's statement that the daily bread of Eucharist is given to remedy the daily frailty of humans, Thomas sees the charity caused in Eucharist as an inner life force "removing" venial sin.[75] This situates the "forgiveness" of sin in the context of *healing* which, as we just saw, was central to the explanation of sacramental effectiveness in both Hugh and Bonaventure.

However, when Thomas deals with the Sacrament of Penance his treatment is clearly controlled by the notion of legal judgment, the exercise of the power of the keys.[76] The actual forgiveness of sins is, of course, a divine action. Christ, by virtue of his divine authority and his human merits, is the primary agent of the sacramental absolution; the confessor acts as Christ's minister and instrument by virtue of the character of ordination that conforms him to Christ.[77] Even though the

73. On the diversity of eucharistic theologies in the twelfth and thirteenth centuries see G. Macy, *The Theologies of the Eucharist in the Early Scholastic Period* (Oxford, 1984); and especially 140, for an evaluation of the dogmatic force of Lateran's IV's use of "transubstantiation."

74. ST 3, 78, 6, 1 and 2.

75. Ibid., a. 4.

76. For background on medieval understandings of "the keys," see Congar, *L'ecclesiologie du haut Moyen Age*, 138–86.

77. ST, Suppl., 19, 2.

action of confessional absolution removes the moral barrier between the sinner to God, emphasis on the mediating role that belongs exclusively to the ordained makes it clear how the basic institutional distancing of the ordinary Christian from God has become solidly entrenched.[78] Closely allied with this is a relatively new distancing that becomes prominent from as early as the twelfth century onward: the "true" (that is, rationally tested) understanding of the mysteries of faith belongs to the theologically educated, which presumably applies also to the ordained who are certified to preach and to act as confessors; whereas the "common faithful," left with a simple, uncritical, and therefore somewhat credulous belief, are at least one step removed from an intellectual grasp of the realities of faith. Eventually this will lead in the Catholic tradition to reserving final verification of true belief to *official* teachers, with the implication that even professional theologians are not in immediate touch with the source of divine revelation. That, however, is a later development—quite different from the normative role played by theological faculties in the thirteenth century.

Duns Scotus

The third seminal thinker who shapes the sacramental theology of following centuries, Duns Scotus, picks up much of the Augustinian/ Franciscan viewpoint of Bonaventure; but he casts it in a more recognizably scholastic form. More than that, though he remains profoundly Augustinian in both philosophy and theology, Duns Scotus sees himself also as a faithful interpreter of Aristotle who disagrees basically with Aquinas's interpretation of "the philosopher."

Two basic elements in Scotus's synthesis had a profound effect on future explanations of Christian sacrament. Perhaps most tellingly, the metaphysical implication of Bonaventure's dictum that the power of sacramental signs to cause grace does not flow from the "nature" of those signs but derives from a divine "*ordinatio*" becomes confirmed as an instance of a much broader divine dispensation, through Scotus's famous distinction between the *potentia absoluta* and the *potentia ordinata* of God.[79] For Scotus the existential logic of all creation is grounded in divine volition rather than—as for Aquinas—in divine thought; and this principle finds an obvious application in Christian ritual, which according to centuries-old tradition receives its saving power from "institution by Christ."

78. By the power of the keys a person is made a mediator between the people and God. Suppl., 19, 3.

79. For a study of the historical consequences of this Scotist distinction see P. Vignaux, *Justification et predestination ai XIVe siecle* (Paris, 1934); also H. Obermann, *The Harvest of Medieval Theology* (Cambridge, Mass., 1963), 30–56.

Second, Scotus's theory of knowledge breaks both with the Augustinian tradition of "divine illumination" and with the symbolist mentality as it had come to expression, for example, in Hugh of St. Victor. Though apparently espousing Augustinian illuminationism, Scotus's position is quite different. In classic Augustinianism humans are directly illumined by God, all other objects of cognition are known in the light that is God, and human reason is the image within which God is known. For Scotus it is not God but the idea of "being as such" (*ens in quantum ens*) that is the primary object of knowledge, in terms of which all else is known. Participation is understood as participation in "being as such," which moves the discussion into the intentional rather than the existential order; for "being as such" is an intellectual abstraction whose comprehension embraces both finite and infinite being.[80] Such a view excludes the kind of divine presence that, at least implicitly, had been involved in the Augustinian explanation of human knowing and especially of faith. So sacraments, in expressing Christians' faith, cannot in Scotus's theory of knowledge reflect the divine saving activity as they do for Augustine and most medieval Augustinianism.

One cannot lay responsibility on Scotus for initiating the development, but with him it becomes evident that the late medieval explanation of sacramental causation excludes, or at least prescinds from, the effect of rituals *as signs* on the grace imparted in the sacraments. Aristotle's theory of causality had been used by Aquinas to interpret the effectiveness of sacramental liturgies: they are sensible signs that immediately cause the *res et sacramentum*, an "intellectual sign" which in turn helps effect grace. Both levels of *sacramentum* function as instrumental causes of grace; the precisely *symbolic* force of the ritual is not clarified.

With Scotus, Aristotelian causal theory, even though transformed by the Oxford Franciscan's view of the interaction of divine and created activity, impacts on the very heart of the Augustinian/Franciscan tradition, its soteriology. The symbol/mystery context of so much earlier Christian reflection on the divine saving activity has given way, at least in formal theological discussion, to more abstract controversy dealing with philosophical interpretations of grace/justification as conformity to and participation in divine being, or divine knowledge, or divine volition. Along with this, the Anselmian modeling of human redemption as atonement and satisfaction continues strong: there is increased discussion of justification in terms of legal remission of debt by God and debate as to whether such divine forgiveness can be merited in strict justice (*de condigno*) or whether there is only a certain appropriateness

80. For a short exposition of Scotus's view of "being as such" as the primary object of human knowing, see E. Bettoni, *Duns Scotus: The Basic Principles of His Philosophy* (Bresca, 1946; ET 1961), 25–46.

(de congruo) in God's forgiving those who have seriously sought to live a good life.

Importantly, too, interpretation of Christ's saving act is framed in terms of the "infinite merits" he gained; and humans' justification is explained as "application of Christ's merits." One of the clearest statements of this view comes in Scotus's defense of indulgences. An indulgence as he sees it is a remission of punishment granted by church officials who draw from the "treasure of the Church," that is, the merits of Christ and the saints.[81] The legal character of this transaction is confirmed by Scotus's statement that the power to grant indulgences is grounded in legitimate possession of jurisdiction.[82] Even in the literature of late medieval mysticism and in preaching, where explanation through use of symbols is still dominant, the impact of such scholastic abstractness can be felt.

FOURTEENTH CENTURY

William of Ockham

With William of Ockham one feels even more removed from discussion about the impact of symbols, specifically sacraments, on faith—this despite (or perhaps because of) the prominence in Ockham's logic of a theory of linguistic significance *(suppositio)*. With Ockham one feels the full force of the tension connected with the "problem of universals": Ockham's more radical empiricism, by challenging the relation between universal terms and reality, brings into question the function of symbols. For centuries philosophers had sought without satisfaction for an adequate way to explain the origin and use of universal terms. Even less satisfactory was the attempt to explain the actual similarity of things, both at the level of species and of genus. By and large, earlier medieval thinkers had followed the patristic adaptation of Greek philosophy and had located the source of such universality in divine creative thought.

But Ockham is not just a philosopher; he is a theologian concerned to clarify the Christian understanding of human life. Salvation is still seen as a divine grace; but like Scotus, whom he criticizes, Ockham focuses on human moral behavior as deserving or not deserving justification by God. This issue dominates Ockham's lengthy treatment of the Sacrament of Penance, and in his explanation of Eucharist it is linked with the notion of "applying Christ's merits."[83] For the most part,

81. *Quaestiones miscellaneae,* 4,4.

82. Ibid.

83. Aquinas among others had spoken about forgiveness of sin and granting of grace as flowing from the passion of Christ, but the model he uses is the traditional one of "spiritual nourishment" by eucharistic food rather than "vicarious legal satisfaction." See ST, 3, qq. 78

however, his eucharistic theology is centered on a metaphysics of "transubstantiation" with no attention given to the symbolic effects or the mystery context of the sacrament.

It appears that by the fourteenth century the effect that sacramental liturgies achieve through their action as sign had vanished from theological discussion. Instead, even more so than in the preceding century, theologians were debating various explanations for transubstantiation and discussing, particularly, the basis for the continuing existence of the accidents of bread after eucharistic confection. However, that judgment needs some qualification: as does Scotus before him, Ockham, without adverting formally to symbolic causality, recognizes that sacraments can alter people's psychological state, lead them to conversion, and thus condition them—at least *de congruo*—for justifying grace.

Much the same is the approach to salvation, grace, and forgiveness of sin in the writings of Gregory of Rimini. Questions about God's *potentia ordinata* or *potentia absoluta*, about predestination and freedom, about merit and grace dominate soteriological discussion. The abstractness of such reflection was obviously far removed from the approach of ordinary Christians to understanding their faith, but the distancing of the divine from human knowledge went even deeper. As Gordon Lepp has noted in his study of Gregory, the fourteenth century marks a sharp rejection of the preceding century's attempts to reconcile faith and reason. "The very essence of fourteenth-century thought is its discontinuity: its thinkers, at either extreme, from Ockham to Bradwardine, were operating on different territory from their predecessors; they expressed a different set of attitudes; and they sought for different solutions."[84] In particular, the so-called *moderni* stressed the infinite gap between divine and human and the consequent unknowability of God. Faith and theology, which is now denied the kind of knowing proper to either science or philosophy, deal with God on a different level. Moreover, theology is not meant to lead to intellectual clarification; rather it is a practical exercise aimed at strengthening people's belief in revealed truth and leading them to love of God.[85] While that consequence is only adumbrated in the fourteenth century, the wall set up beween faith/theology and empirical knowledge would increasingly distance Christian religious understanding from the emergence of modern science and lay the groundwork for the later hostility between much of Christianity and the Enlightenment.

Controversy

The 1340s witnessed a bitter controversy between the *via (theologia) moderna* and *antiqua*. John Buridan, rector of the University of Paris,

84. G. Leff, *Gregory of Rimini* (New York, 1961), 18
85. Ibid., 27, 233–34.

condemned Ockhamism in 1340; and a few years later Clement VI attacked as "pernicious" a long list of "novel" teachings. Yet, even champions of the *via antiqua* did not return to the optimistic trust of Aquinas or Bonaventure that faith and reason could be brought into synthesis. The stress on God's *potentia absoluta* had broken the link between created intelligibility and a knowable Creator; and with it went the possibility of arguing from the sacramentality of human experience, even liturgical experience, to the nature of God's saving activity in human life.

Perhaps the most striking indication that the observable symbolism of Christian sacraments is not seen as "supernaturally" causative is provided by Biel's commentary on the eucharistic action.[86] The obvious purpose of the work is to help people appreciate the meaning of the Mass, and so it would seem the logical place to explain to the faithful their basic human experience of the liturgy. Focusing on the canon, which by that time was pronounced silently and in Latin by the priest celebrant, immediately suggests that the people's activity is not a source of understanding. Biel's commentary bypasses the level of observable meaning and is instead a classic example of allegorical explanation of the liturgy: each detail is given a spiritual interpretation, and it is assumed that the true meaning of Eucharist lies beyond the immediately experienced sense of the sacramental symbol. Instructed by this hidden significance, the Christian will be stimulated to deepened faith and conversion and thus be a fit candidate for justification. It is worth noticing that the explanation is directed to individual attendance at Mass; the emphasis on the individual person that develops noticeably from Scotus onward and characterizes nominalistic thinkers works at obvious cross-purposes to the corporate nature of liturgy.

When he comes to more technical discussion of Eucharist, Biel, like his contemporaries, concentrates on the questions surrounding the transubstantiation of the bread and wine.[87] The principal issue that demanded some philosophical explanation was the ontological status of the accidents of the eucharistic elements after the consecration of the Mass.

What is doubly paradoxical about Biel's neglect of the immediate human level of sacramental meaning is the fact that he was closely identified with the *devotio moderna*, a movement that was so influential in the countercultural recovery of the human dimension of Christology and of Christian spirituality. Or perhaps it is a measure of the extent to which the mystery aspect of sacraments and of Christian existence

86. G. Biel, *Canonis Misse Expositio*, ed. H. Oberman and W. Courtenay (Wiesbaden, 1963).

87. *Canonis misse expositio*, lect. 39–48.

in general had been lost, to be replaced by a more didactic approach to evangelization and to the formation of faith.

No figure gives a more tantalizing glimpse of the strange conjunction of nominalistic philosophy/theology and the *devotio moderna* than does Jean Gerson. Chancellor of the University of Paris, key influence in the Council of Constance's resolution of the Great Schism, a pioneer in catechetics, Gerson also played a major role in the development of late medieval mysticism and in extending the influence of Pseudo-Dionysius into the period of the Renaissance and Reformation. Because of his important role in the crystallizing of mystical theology as a distinct mode of theological reflection, Gerson will be treated at greater length later in this chapter.

Tragedy

However, it would be a serious oversimplification to look only at the distancing that occurred because of the movement toward greater philosophical abstraction in late medieval theology. As Oberman has pointed out in his study of Biel,[88] it is difficult to overestimate the symbolic import of "the Babylonian Captivity" at Avignon and then of the Western Schism, of Tempier's condemnation in 1277 of the propositions drawn from Averroist thinkers and from Aquinas, or of John XXII's condemnation of the Franciscan Spirituals in 1317. European Christianity was painfully split from top to bottom as both the exercise and interpretation of Christian life became confused, in no little degree because the symbolically unifying function of church leadership faded with division and corruption at the highest level. To put it in theological terms, the sacramentality of the "holy orders" became increasingly countersymbolic. While the mediatorial role of ecclesiastical officials had been a major factor in distancing Christians in their relationship to the divine, it had also served to keep them in some contact with the divine, even if once-removed. Now in people's perception that sacramental link had proved itself untrustworthy if not nonexistent. Still, an almost blind trust in the divinely instituted saving role of the papacy persisted, finding expression in the expectation of an Angelic Pope who would preside over a new Golden Age.[89]

Equally if not more disastrous in its symbolic impact was the Black Death, which ravaged Europe in mid-fourteenth century and disrupted social processes for decades. Viewed as divine retribution for moral decay at all levels, the plague served to reinterpret people's understanding of sin and forgiveness, of divine justice and divine mercy, and of

88. See H. Obermann, *The Harvest of Medieval Theology* (Durham, 1983), 323–25.

89. On the link of this expectation to Joachimite circles, see M. Reeves, *The Influence of Prophecy in the Later Middle Ages* (Oxford, 1969), 395–415.

the efficacy of established rituals. Preoccupation with death was mirrored in the proliferation of artistic portrayals of "the dance of death"; and the fear attached to the plague may well have fed into the dread of witches and sorcery that gained momentum during the fifteenth and sixteenth centuries. To some extent, at least, the fundamental optimism of Dante's symbolism gave way to a darker view of human career on this earth. Apocalyptic expectation became stronger than it had been for almost five centuries.[90]

The Power of Prophecy

Feeding into this fear-filled preoccupation with the future was the widening influence of "prophecy."[91] Joachim, the Abbot of Fiore, was already in his lifetime a major shaper of the Christian interpretation of history; it was from the mid-thirteenth century onward that the full force of his eschatology impacted on people's image of space and time. Even after his prediction of definitive divine intervention in the year 1260 proved faulty, Joachim's vision of a new Spirit-dominated age found expression for centuries in any number of pseudo-Joachimite writings. Joachim's imaginative structuring of human history proved a source of social revolution, for it implied the inadequacy and transitory character of whatever was the established order in church and state. Besides, the Joachimite vision was susceptible of translation into numerous and quite opposing expectations of a golden age to come: it nourished the ultra-spiritual view of the *Fratricelli* as well as the imperial propaganda of the Hohenstaufens. Even though the orthodoxy of Joachim himself was frequently questioned, largely because of his trinitarian theology, the influence of his eschatological view of history continued on into the perspective of "renaissance" and into the social and religious revolution of the sixteenth century.

Since his lifetime there has been a dispute about the way Joachim relates the two earlier periods of history to the dawning age of the Spirit: do the old covenant age of the Father and the new covenant age of the Son continue on in fulfilled form, or are they replaced by the advent of the Spirit? This dispute itself, regardless of its resolution, points to the basic symbolic issue we have been studying. The expectation of a new entry of divine power and presence into human life reflects the loss of awareness of divine presence in the existing order. Present history is a battle between the antichrist and the Christian leadership of emperor and/or pope, with frequent anticipation that the penultimate situation

90. On the pervasive depression of the late Middle Ages, see J. Huizinga, *The Waning of the Middle Ages* (London, 1924).

91. On Joachim and subsequent developments of Joachimite thought, see M. Reeves, *The Influence of Prophecy*.

will be the temporal triumph of evil—the Christian leader will in Jerusalem forfeit both power and life, as did Christ himself.[92] Only with the final intervention of God will this victory of the antichrist be reversed and the death of the messianic ruler flower into the Spirit-life of the new epoch.[93]

THE WORLD OF DANTE

If the medieval symbolist mentality vanished for the most part from theological circles beginning with the final decades of the thirteenth century, it continued dominant in the fourteenth-century flowering of mysticism and literature. Nor were these two manifestations of Christian culture separated from one another; their intertwining is obvious in Dante's *Paradiso* and in Langland's *Piers Plowman*.[94]

It is clearly impossible to describe in short scope the symbol world either of later medieval mysticism, exemplified in Eckhart, Suso, Tauler, Lull, Catherine of Siena, Rysbroeck—to name only a few of the more prominent figures—or of the literary movements represented by Dante, Boccaccio, Chaucer, or Petrarch. For our purposes, it may be possible to identify certain general characteristics that reflect people's sense of the presence or absence of God, remembering that both literary works and mystical writings mirror the consciousness of a small educated portion of the Christian people. On the popular level there was an increasing decadence of symbolism, which we will have to examine shortly.

Dante provides a unique instance of late medieval Christianity's symbol world, for he synthesizes a mastery of literary techniques and critical methods with the heritage of biblical/theological use of the senses of Scripture and with an authentic prophetic charism that links him to the mystical developments of his day. Dante's use of poetic skills can be legitimately seen as the flowering and transformation of the courtly love tradition, as the crystallizing of a literary movement that had been germinating during the previous two centuries and that flowed into the literary explosion of the fourteenth century.[95]

92. Ibid., 300–301.
93. On the evolution of the imagery of the antichrist and its increasing influence from the twelfth century, see H. Rauh, *Das Bild des Antichrist im Mittelalter* (Munster, 1971), especially 528–40.
94. On the influence of liturgical symbolism in Langland, see M. Vaughan, "The Liturgical Perspective of *Piers Plowman* B, XVI–XIX," *Studies in Medieval and Renaissance History* 3(1980): 87–155.
95. To justify such a "theological" interpretation of Dante would require several volumes; fortunately, the research and insights of Dante scholars in the tradition of Auerbach, Singleton, and Hollander as well as of medievalists like Gilson have provided the basis for this justification.

But Dante's roots are more extensive, for his worldview is still ground-ed in the Bible and he absorbs the attempts of previous centuries to interpret Scripture as word of God and therefore guide for human life. Thus, in his writings, especially in *The Divine Comedy*, one finds what can be called either poetic theology or a theology of Christian symbolism. The appreciation of sacramentality in creation and particularly in human life which had never played a decisive role in professional theology's explanation of Christian sacraments is at the heart of Dante's poetic intuition.[96]

At the beginning of the fourteenth century there existed a highly refined theory of the senses of Scripture, tested by centuries of biblical exegesis[97] and described perhaps most systematically and succinctly at the beginning of Aquinas's *Summa Theologiae*.[98] But animating this more schematic approach, and going back at least as far as Origen, was the search for a spiritual sense of Scripture that cannot simply be equated with the allegorical meaning as that term is understood today.[99] Integral to this spiritual reading of the Bible was the typology so prominent in both Old and New Testament; and it is this typology that one finds everywhere in *The Divine Comedy*.

It is not just that Dante accepts and repeats the typological relations already found in the Bible, for instance, between Moses and Jesus. Rather, his own perspective is that from which typology flows: history is a divinely guided process by which God's revelation is progressively disclosed through persons and their actions and institutions. Because there is one ultimate meaning and purpose to this unfolding history, individual meanings participate in it, reflect and exemplify one or an-other aspect of it, and are linked with one another in their significance.

In such an outlook, actual persons can be portrayed in literature as personifying a particular characteristic—a technique that is quite dif-ferent from personifying an abstract quality such as justice or compas-sion. In the first instance, for example in Dante's famous treatment of Francesca da Rimini in Canto 5, a very real historical individual is involved but in terms of the universal implications of her situation. However, this literary device can be authentically used only if the poet believes that persons and their actions have a meaning that refracts

96. See E. Auerbach, *Dante: Poet of the Secular World* (Chicago, 1961); and *Mimesis* (New York, 1953); C. Singleton, *Commedia: Elements of Structure* (Cambridge, Mass., 1954) and *Journey to Beatrice*, 1958; R. Hollander, *Allegory in Dante's Commedia* (Princeton, 1969); and E. Gilson, *Dante the Philosopher* (New York, 1949).

97. See especially H. de Lubac, *Exegese medievale*, 4 vols. (Paris, 1959–64); and B. Smalley, *The Study of the Bible in the Middle Ages* (Oxford, 1952).

98. ST, I, 1, 10.

99. Attention was drawn to this patristic "spiritual" exegesis by de Lubac. In addition to *Exegese medievale*, see *Histoire et esprit: l'intelligence de l'Ecriture d'apres Origene* (Paris, 1950). See also, J. Danielou, *Sacramentum futuri* (Paris, 1950).

some cosmic logic—put in Christian terms, if the poet believes that God is actively present in human affairs and that, either positively or negatively, people's lives are "Word of God." What Dante does, then, is to suggest an integrated pattern of human history, grounded in his own faith in the reality of a God whose creative love is revealed in the two books of Nature and Bible.

Dante is at one and the same time the fullest expression of the medieval symbolist mentality and its most profound challenge. He is a challenge because he takes over Aquinas's (and Aristotle's) criticism of the Platonic downgrading of the sensible world. Like Aristotle in the *Poetics*, he finds universality in the depth dimension of the individual. Because Dante's use of symbolism is so firmly linked to the primacy of the literal, to the revelatory character of the observable, he does not go "behind the scenes" to find real meaning. Instead, he is dealing with the sacramentality, indeed, the Christian sacramentality, of human life.

The Divine Comedy is more than great literary skill manifested in discovering and describing the linkage in meaning of human lives. It is poetic/prophetic awareness of divine presence as the unifying source of this linked meaning. God is Dante's Muse. Nonetheless, Dante is a medieval man who takes for granted a hierarchical model of the universe; even the recurrent "voyage" theme of the poem is absorbed into the stronger imagery of the "ascent of the holy mountain"; and the Empyrean above is where God dwells in glory and where human destiny lies.

With all his appreciation of the intrinsic glory of human life in this world, there is never any question but that full existence lies beyond. Dante is much too Aristotelian to espouse the Dionysian ladder of theurgic symbolism, even though he grants a place of honor to Dionysius in the heavenly realms; but Dante's imagery follows the pattern of ascent and descent found in John's Gospel.

As the image of space is controlled by the location of heaven above and hell below, so is the imagery of time structured by biblical eschatology. Human life is a voyage reminiscent of the wandering of Ulysses, a pilgrimage to the final Holy Land. Only in the final arrival of humans at that goal, or in their failure to reach it, will the meaning of human historical experience be seen. In all this Dante is unexceptional. He accepts as divinely intended the clericalized hierarchical world in which he lives, even as he is sharply critical of its shortcomings. So, while he represents a unique breakthrough in perceiving the sacramentality of human historical experience, Dante still finds it necessary to move through dream and vision to the world beyond in order to understand and explain the nondream-world in which, never quite at home, he still dwells.

THE WORLD OF CHAUCER

Preeminent though he was, Dante was not the only witness to the fact that reflection upon Christian symbolism (sacramental theology, if you will) had passed in the late Middle Ages from the professional theologians to the poets. Chaucer certainly bears careful scrutiny in this regard. Like Dante he has a keen appreciation for all that is human, so much so that he could almost be considered "secular" or mildly cynical about religion. Yet, there is a deep current of Christian faith and culture that runs through his poetry and that provides the basic hermeneutic for interpreting his imagery.

In an intriguing essay on Chaucer's use of musical symbolism, David Chamberlain indicates five traditions—biblical, poetic, social, philosophical, and mythological—from which the poet draws but to which he adds his own creative use of metaphor.[100] Even though limited to the one area of musical symbolism, the essay makes clear the extent to which the resources of imaginative insight upon which theologians could have drawn have become instead the heritage of the arts. At the same time, in tracing through *The Canterbury Tales* the leitmotif of "melody," Chamberlain touches upon the overarching symbolic structures of medieval culture when he links Chaucer's poetic worldview to the "songs of the spheres" described in Cicero's *Somnium Scipionis* and the notion of cosmic harmony—an image of orderly space "Christianized" by Augustine and transmitted to the Middle Ages through Macrobius's commentary.[101] Centuries of Christian usage had drawn this classical imagery, non-religious in its origins, into the biblical idea that all creation sings a song of praise to its Creator—though sinful abuse of human freedom introduces at times a discordant note.

Like Dante, Chaucer uses flesh-and-blood humans as the key symbolic realities with which he works. Though they are richly symbolic of human nature and the human condition, the pilgrims of Chaucer's *Tales* and the characters in their stories are not personified abstractions. But perhaps because Chaucer remains within the confines of history and does not view things *sub specie aeternitatis*, the lives of humans are symbolic of moral virtues and values, signs even of divine activity in the order of grace, but are not—as in *The Divine Comedy*—sacramental of the divine saving presence.

What Chaucer's poetry does reflect is a pervasive acceptance of the

100. D. Chamberlain, "Musical Symbol in Chaucer: Convention and Originality," in *Signs and Symbols in Chaucer's Poetry*, ed. J. Hermann and J. Burke (Univ. of Alabama, 1981), 43–80.

101. Another source of this image of cosmic harmony was the writings of Pseudo-Dionysius, in which the notion of "harmony" was central. As we will see, Dionysius was a principal source of Renaissance fascination with cosmic harmony.

history-controlling role of Jesus' life and death and resurrection. Even a work like the *Book of the Duchess,* with its obvious links to profane love poetry, seems to have another layer of spiritual significance in which the healer is Christ.[102] *The Canterbury Tales,* obviously, would make no sense apart from the context of the Christian dispensation.

LATE MEDIEVAL MYSTICISM

Without going into the use of specific symbols by this or that mystic, one can notice certain aspects of the late medieval flowering of Christian mysticism which demonstrate a continued distancing of God. The term "mysticism" itself is misleading, since it can be used in a narrow sense to refer only to the highest attainments of religious contemplation, or more broadly to denominate any genuinely personal activity of religious faith. Even in the more narrow application, the term covers a wide range of experience and insight—from the almost pantheistic approach of Meister Eckhart and his disciples, Suso and Tauler, to the mathematical orientation of Nicholas Cusa, to the more down-to-earth devotion of *The Imitation of Christ,* to the common-folk but sublime world of "Piers Plowman." However, if one uses the term "Christian mysticism" to refer to out-of-the-ordinary conscious insight into and affective involvement with God as revealed in Jesus of Nazareth, there is little question but that the late medieval centuries witnessed a major development of Christian mysticism.[103]

Early on in this late medieval efflorescence of mysticism, Jean Gerson, himself gifted with unusual experiences of higher prayer, provided a systematic exposition of mystical experience and thus initiated "mystical theology" as a distinctive methodology and discipline of knowledge.[104] His explanation of the manner in which intellectual insight was intrinsic to intimate union with God—somewhat contrary to the view of Pseudo-Dionysius to whom he was otherwise very indebted—granted cognition a positive role in mystical experience and allowed for a theological investigation of this experience. Yet Gerson maintained that the highest power of the soul, by which humans reached God, was *synderesis,* an affective rather than cognitive faculty.[105] In terms of underlying symbolisms, Gerson's writings reflect a convergence of two metaphors of

102. See J. Wimsatt, "The Book of the Duchess: Secular Elegy or Religious Vision," in Hermann and Burke, *Signs and Symbols in Chaucer's Poetry,* 113–29.

103. It would be interesting to apply to the somewhat *ex lex* situation of many of these mystics the anthropological analysis that Victor Turner makes of *liminal* groups.

104. See S. Ozment, *Homo spiritualis* (Leiden, 1969), 49–83. A lengthier treatment is found in A. Combes, *La theologie mystique de Gerson,* (1963).

105. For earlier theological discussions of *synderesis* see O. Lottin, *Psychologie et morale aux XIIe et XIIIe siecles* (Louvain, 1948), vol. 2, 103–305.

the divine/human relationship that have run throughout Christian history: *enlightenment* and *the embrace of lovers*; and therefore a convergence of the influence of Bernard and Pseudo-Dionysius.

These two basic symbols, into which any number of subordinate images or anthropological viewpoints can be subsumed, run throughout the mystical literature of the late Middle Ages and beyond. However, even more fundamental than either of these two symbols as a "somewhat dark mirror" of the divine was that of which they were the metaphorical expression: the mystic's personal experience of divine friendship. Gerson's theology, though it does not formally address this sacramentality of deep faith experience, already structures mystical theology as a systematic reflection on the Christian experience of God. In this way, it already anticipates developments in systematic theology that in the post–World War II period are considered innovative—and that are innovative because for centuries "mystical theology" had been considered peripheral to the supposedly more central enterprise of a "manual" approach to systematic theology.[106]

The broader symbolic implication of this development is ambiguous, for the mystics use the most graphic metaphors of personal union in speaking of the soul's relation to the divine and at the same time dramatize in their own lives the relative impossibility of the ordinary Christian achieving such union in this lifetime. What the emergence of monasticism did in earlier centuries to deny to normal Christian life a full claim to discipleship, schools of late medieval mysticism did to deny "real prayer" to most Christians. It is not incidental that this same period witnessed the establishment of the Confraternity of the Rosary, whose purpose was to provide a conventionalized pattern of praying to the bulk of Christians, presumably incapable of loftier contemplation.[107]

Not that mystic developments alone reflected negatively on the faith of most Christians. Such a denigrating judgment had existed, with considerable justification, for centuries, because the great majority of people were exposed inadequately, if at all, to a level of understanding Christian belief capable of sustaining authentic contemplation. But the attention paid in the fourteenth and fifteenth centuries to those thought to be mystics, to say nothing of the cult directed toward some of the extreme ascetics of the age, only emphasized the separation of most Christians from an awareness of their union with Christ.[108]

106. Karl Rahner, in several essays in his *Theological Investigations*, has detailed the recent shift away from "manual theology"; see also his *Foundations of Christian Faith* (New York, 1978), 1–23.

107. On the origins and spread of this confraternity see W. Hinnebusch, *New Catholic Encyclopedia* s.v. "Rosary."

108. See the accounts in Huizinga, *Waning of the Middle Ages*, 160–80.

Religious Exhaustion

In the fourteenth and fifteenth centuries the accelerated popular obsession with extraordinary happenings, or supposed happenings—Jungmann calls it a "mania for miracles"—[109] meant that popular religious interest turned more and more to the periphery of Christian belief. Despite the exhortation of influential preachers such as Vincent Ferrer or Bernadine of Siena, more attention was paid to relics and more faith placed in worshipful devotion to the saints than was given to the celebration of the principal liturgical actions. Even in the liturgy, there was proliferation of special devotional masses to the detriment of the basic liturgical cycle. The result was a serious dislocation in most people's religious attitudes, as the distancing increased between the beliefs of the theologically educated and those of the mass of Christians—the first tending toward increased abstractness and the second toward greater credulity. But on both sides this meant increased distancing of people from the God professed in Christian faith, since abstract religious knowledge by its very abstractness sets up a barrier to faith as a personal bond to Christ and to the God whose Word he is, and credulity by definition denies to people an understanding of God as actually revealed in Jesus as the Christ.

No one symbol crystallizes the widespread depression and religious exhaustion that Huizinga describes as the pervading atmosphere of much of Europe from the late thirteenth century onward.[110] In studying the fourteenth and fifteenth centuries one becomes aware of a burdensome overload of religious imagery, an uncontrolled underbrush of devotional practices with their accompanying mythology, and an absence of dominant and integrating socio/cultural or religious symbols. For centuries a cosmology drawn from classical literature and adapted to Christianity by the Church Fathers had provided just such an integrating symbolic framework for the perception of human life. Now this cosmology was beginning to be challenged by mathematized science. With Galileo in the mid-sixteenth century the depth of this challenge became apparent, but it had already received its clear formulation by Copernicus some decades earlier. Religiously it had been foreshadowed in the fifteenth century by the idiosyncratic use of mathematical symbolism in the theological vision of Nicholas of Cusa.

DECLINE OF SACRAMENTAL LITURGY

What, during these centuries, was the effective symbolic power of the church's liturgy, especially of the Mass? If one traces the history in

109. Jungmann, *Missarum Solemnia* 1:130.
110. Ibid., 1–45.

western Europe of the forms of the Mass—as Jungmann has done in his classic *Missarum Solemnia*—one observes a striking homogeneity despite the socioreligious upheavals that marked the Middle Ages. This homogeneity was due to three factors: a continuing normative influence of Rome on liturgical forms in other parts of Europe; Charlemagne's earlier campaign to achieve greater uniformity in church practice; and the regularizing of monastic liturgy, particularly during the period of Cluniac dominance. Yet, this centuries-long external sameness hides the shifts that occurred in the actual symbolic impact of liturgy on the understandings and attitudes of European Christians. While the words and actions of baptismal and eucharistic liturgies remained remarkably constant, at least in their central portions, the people's experience of those liturgies underwent a basic shift.

As late as the eleventh century, the consecrated bread was still seen principally as food; the "eternal life" that people hoped to share in fully after death was already being nourished by the bread become body of Christ.[111] By the late Middle Ages reception of communion by the faithful had seriously declined for a variety of reasons, and the consecrated host took on a much different significance for the common faithful. It was considered by people to be an object of devotion, even of adoration;[112] and viewing it was thought to be the source of grace and healing. Because of demand to see the consecrated host, the elevation followed by special veneration of the host was introduced into the most solemn moment of the eucharistic action. Special eucharistic devotions, such as Corpus Christi processions and Benediction of the Blessed Sacrament began to overshadow the action of the Mass.[113] And in the later part of the Middle Ages, when the requirements presumed necessary for reception were greatly exaggerated, and ordinary Christians were therefore discouraged from sacramental participation, devout Christians were encouraged to practice "spiritual communion" instead—but with the desire for sacramental communion.[114]

In performance of the eucharistic action, the commemorative link with the sacrificial death of Christ, even more so with the resurrection, was dimmed; and instead of being mystery celebration the Mass became a devotional religious practice. Liturgy did not function as gospel proclamation that interacted with the word of people's daily life; it became instead—and then only in its more careful enactment—a beautiful

111. This viewpoint is retained in more abstract form in the theological explanations of Eucharist as late as the thirteenth century, but in the ordinary Christian's liturgical experience it has much earlier given way to "seeing Jesus."
112. See Jungmann, *Missarum Solemnia* 2:208.
113. See Iserloh in *Handbook of Church History*, (New York, 1965), 4:572.
114. See Jungmann, *Missarum Solemnia* 2:364.

religious performance governed by rubrical concentration on the exactness of external actions. In many instances the eucharistic liturgy was not carried out with either skill or care, attendance became viewed as a moral obligation explicitly prescribed by church law, and active participation of the laity dwindled to almost nothing.

An indication of how completely the Mass became the action of the celebrant priest instead of a community affair was the practice, which gradually became mandatory, of the celebrant quietly reciting the words being sung by the choir—it was his recitation that was "effective." And the celebrant's reception of communion was regarded as representative substitution for the people who did not communicate.[115] This concentration on the priest celebrant was most clearly and importantly expresssed in the emergence and eventual dominance of private masses. Sometimes such eucharistic celebrations would be said for important families by their "family chaplain," or for some other special group; more often, private masses would be offered in fulfillment of a funded benefice by men who were simply "Mass priests," ordained for no other purpose and without pastoral attachment or responsibility. The idea behind such a practice was that somehow grace was granted, the merits of Christ's passion were applied to the individual who established the benefice—usually this meant saying Mass for "the repose of the soul" of someone long dead.[116] Along with this, offering a priest a stipend to have a mass said for one's special intentions became common practice from the late thirteenth century onward.[117]

As for the liturgical forms themselves, though the basic structure of the Mass remained constant, votive masses proliferated, created for every conceivable special devotion. This illustrated the extent to which the Mass had been absorbed into a religious context of "devotions" instead of the earlier liturgical cycle with its anamnetic celebration of the central Christian mysteries. What further stressed the devotional context of eucharistic celebrations was the decoration of the apse wall— against which the altar was now situated—and of the altar itself. The pictures and statues on the wall behind the altar, or on the altar and dominating it, were images, not of the mysteries of Christ's life or death, but rather of patron saints or angels who had no relationship to the action of the Mass.[118] It became necessary to mandate that at least a crucifix be placed on the altar, but in most cases it was overshadowed by other devotional art.

With the emergence of private masses as the basic pattern of eucharistic enactment, an isolated role for the ordained celebrant became

115. See Iserloh, *Handbook of Church History*, 571; Jungmann, *Missarum Solemnia* 2:364.
116. See Iserloh, *Handbook of Church History*, 573.
117. See Jungmann, *Missarum Solemnia* 2:24.
118. See Ibid., 1:255–58.

even more generally accepted. Not only was his reception of communion seen as substituting for that of the faithful and his prayers seen as the effective verbal element of the action, his action by itself came to be identified as the Mass—what he did *was* the Mass. With respect to the symbolizing effect of the Mass, this meant that the meaning it now had for people became very different from what it had been in earlier Christianity. Mass was an action to be observed, people attended mass in fulfillment of a law of the church, the priest celebrant functioned to change the bread and wine into the body and blood of Christ.[119] Instead of the experience of mystery shared, the Mass became at best the experience of believing in God's saving presence in the hidden miracle of transubstantiation. Only the celebrant was immediately involved in "confecting" the Eucharist; the people were distanced both by their understanding (or lack of it) and by their liturgical role from the function appropriate to them as the community of the baptized. The symbolisms intrinsic to Christian sacramental liturgy had by the end of the Middle Ages become overlaid and screened from people's experience by other symbolisms that effectively conveyed the understanding that God and the Christ in whom God was revealed were distanced from ordinary human life.

The Shifting of Symbols

Beyond distinctively religious spheres of life, other basic shifts in symbolism were occurring—shifts that would indirectly have fundamental impact on religious imagination. The quest of philosophers for knowledge was shifting from "truth" to "certitude," which would later translate theologically, especially with post-Reformation polemic, into extensive attempts to prove Christian claims by appeal to miracles and prophecy. Again, the movement toward experimental science involving the shift from viewing numbers as internal theurgic forces to use of numbers as instruments of precise measurement meant that mathematics became a demythologizing methodology rather than a major area of mystification. However, in the arts, in literature, and in popular fascination with the occult, the "magical" character of numbers remained prominent for centuries.

As for social symbolism, the rise of a European bourgeoisie meant the gradual eclipse of aristocracy and, eventually, a denial of special sacrality and of a special religious role to those in positions of public power. Symbols growing out of agrarian existence dimmed as urbanization expanded and the experience of many people no longer involved

119. This led in later centuries, particuarly with the sacerdotal spirituality influenced by Berulle, to seeing the Mass as the private devotion of the ordained. This was foreshadowed by the much earlier practice of ordaining monks as a "reward for virtue."

immediately the rhythms of nature. While manifesting a striking survivability, the symbols attached to the Roman Empire slowly gave way before the ascendancy of national kingdoms and vernacular cultures. And the imagery attached to chivalry and crusaders found different resonances as European conquistadores set out to win the "new world" for God and king.

Whether it represents a prophetic forecast of this emerging new symbol world or an attempt to reclaim and save the significances of the past, the literature of the late Middle Ages contains much of history's most profoundly symbolic Christian writing. How one draws a line between this and the cultural flowering traditionally called the Renaissance has become less certain; perhaps it is impossible.[120] Certainly, the literary continuity that flows into and beyond the Elizabethan period bears witness to the enduring power of the symbolist mentality that so basically shaped the faith and life of medieval Christians. The questions our study will have to pursue are the extent to which traditional symbols were transformed or abandoned and to which new symbols emerged; and in this process, whether Christians in their faith awareness were drawn closer to or further alienated from the God revealed in Jesus of Nazareth.

120. See R. Benson and G. Constable, *Renaissance and Renewal in the Twelfth Century* (Cambridge, Mass., 1982), xvii–xxx.

8

Symbols of Renaissance
and Reformation

RENAISSANCE

No clear demarcation separates the late Middle Ages from the developments commonly referred to as the Renaissance.[1] At the same time, there did occur between the mid-thirteenth and the late fourteenth century the shift in worldview we have already seen. Particularly in the awakening humanism of Italy and the Low Countries, this takes forms that lead into what we have come to consider the modern world. In this cultural evolution a central role was played by changes in symbolism; this is immediately suggested by the fact that so much of the analysis of the Renaissance focuses on art and literature.

To a considerable extent the emphasis on the natural and particularly on the human,[2] generally conceded to be a hallmark of the Renaissance, continued the humanistic awakening of the twelfth century. However, this *esprit laique*—to use Lagarde's term[3]—having been denied or, at most, grudgingly granted a place within official Christian orthodoxy, went its own way and increasingly developed apart from the influence of traditional Christian thought and imagery. The profoundly religious spirit of Petrarch, even of Boccaccio, to say nothing of Dante, indicates the extent to which a faith-denying secularism was foreign to the early stages of the Renaissance. However, by the time of Giordano Bruno or Campanella one wonders in what sense the religion of many of the

1. L. de Rijk, *La philosophie au Moyen Age* (Leiden, 1985), 25–64, draws attention to the image of time that is involved in dividing history into periods—Middle Ages, Renaissance, etc.

2. P. Kristeller sees Renaissance thought as represented by Pico, Ficino, and Pompanazzi focusing on the dignity of the human and on humanity's place in the universe. *Renaissance Thought and Its Sources* (New York, 1979), 179.

3. See G. Lagarde, *La naissance de l'esprit laique*, 6 vols. (Paris, 1934–56).

leading cultural figures of the day can be called "Christian." Indeed, the prevalence in sophisticated circles of fascination with the occult suggests that the "faith" of many litterati of the fifteenth and sixteenth centuries may have had as much to do with underground religion as with mainstream Christianity.[4]

But to phrase the issue in this way is already to prejudge it; closer examination does not seem to indicate a clear either/or situation. Rather, figures such as Ficino or Pico della Mirandello retain genuine allegiance to their Christianity and accept it as the encompassing explanation of reality, but also believe that insights from ancient nonbiblical sources can be joined to traditional Christian thought to provide a richer and more universal human wisdom.[5] While it is chiefly to the great figures of classical literature and philosophy—Plato, Aristotle, Cicero, Seneca, Proclus, and so on—that Italian humanists turn for this complementary understanding, some, including Pico, draw also from Hermetic, Zoroastrian, and Cabbalist writings in their quest for some form of universal religion.[6]

Using ancient philosophy as an instrument for exploring the deeper meaning of Christian beliefs had been commonplace, of course, for centuries. As far back as Justin the patristic tradition embarked on just such a course, culminating in the syntheses of Augustine in the West and John Damascene in the East. Renaissance interest in and devotion to Fathers such as Augustine indicates that writers of the fourteenth and fifteenth centuries were well aware of this earlier synthesizing.[7] But they were, at least for the most part, involved in a different endeavor: rather than using "pagan" writers to seek understanding of faith, they were using, side by side, Christian sources and non-Christian sources to provide understanding of the human.[8] It is difficult in many instances to say whether this resulted in an eclectic assembly of insights, or whether real synthesis was achieved by interpreting one or another source, or both, allegorically. Perhaps tracing the use of some dominant symbols can help to sort out this ambiguity and, at the same time, to reveal the way in which this period of Western history understood the function of symbols.

4. See F. Yates, *Giordano Bruno and the Hermetic Tradition* (Chicago, 1964).

5. On the synthesis achieved by Ficino and Pico, See Kristeller, *Renaissance Thought*, 58.

6. Ibid.

7. On Augustine's influence on Petrarch see E. Cassirer, P. Kristeller, and J. Randall, eds., *The Renaissance Philosophy of Man* (Chicago, 1956), 24.

8. For example, in the same paragraph (n.11) of his *Oration* one finds Pico drawing from the story of Jacob's ladder and the myth of the dismembering of Osiris, then in the next paragraph using Empedocles to interpret the story of Job. *Oration*, 17 provides a good illustration of how Pico interprets classical sources both literally and allegorically to serve his pedagogical purposes.

Harmony

It is difficult to find a more encompassing symbol in Renaissance thought than "harmony." To a considerable extent the cosmology of previous centuries had become excessively structural and static. The Augustinian ideal of *ordo*, part of Latin Christianity's Roman heritage,[9] had gradually found expression in the medieval summas and Gothic art, in ecclesiastical and rediscovered Roman law, and in the bureaucratizing of church and civil government. And, in the view of its creators, this magnificent achievement of human ordering reflected the orderliness of the cosmos, even of the "heavenly court." But it was inevitably challenged by the historical developments of the late Middle Ages.[10] Indeed, the very forces of sociocultural ferment that led to the flowering of medieval genius continued on to challenge the adequacy of the patterns of thought and life that this genius had produced. To combine this restless social energy with the cherished security of *order*, fourteenth- and fifteenth-century thinkers turned to the notion of "harmony," order in the midst of movement.

Harmony was an obvious characteristic of the "book of nature" that religious-minded Renaissance thinkers, like their medieval symbolist predecessors,[11] read to understand both creation and the Creator. The cosmos was God's metaphor, that which God employed to convey the ineffable reality of divine existence; and the harmonious unity of complexity that was observable in the cosmos imaged, in inadequate but not distorting fashion, the coincidence in God of dynamism and immutable order.[12]

The unchallenged paradigm of cosmic harmony was the "song" of the heavenly spheres. "No other statement of cosmos conveyed its order and beauty with such imaginative completeness."[13] Cicero's *Somnium Scipionis* had provided the classic Latin description of this celestial harmony, and the widespread influence of Macrobius's *Commentary* guaranteed acquaintance with this Ciceronian source.[14] But to medieval and

9. See the analysis of Augustine's *De ordine* in V. Bourke, *Augustine's Quest of Wisdom* (Milwaukee, 1944), 75–6.

10. See E. Gilson, *The Spirit of Medieval Philosophy* (New York, 1936). His chapters on providence and on nature point out the way in which the medieval notion of order was rooted in God's creative ordering. Given the distinction, from Scotus onward, between *ordo absoluta* and *ordo ordinata*, which brought into question the grounding of divine providential ordering, a certain relativity was gradually introduced into the understanding of the order of nature.

11. For example, Pompanazzi, *On Immortality*, draws from both Aristotle and Pseudo-Dionysius. See the selection in Cassirer, Kristeller and Randall, eds., *The Renaissance Philosophy of Man*, 375.

12. See S. Heninger, *Touches of Sweet Harmony* (San Marino, Calif., 1974), 326–28.

13. Ibid., 179.

14. See *Macrobius: Commentary on the Dream of Scipio*, trans., intro., and notes by W. Stahl (New York, 1952); on its medieval influence see 39–55. For Cicero's text, see J. Kleist, *The Dream of Scipio* (New York, 1914).

Renaissance thought the harmony of the spheres was more than a poetic image, more even than a prime instance of cosmic order. The movements of the heavenly bodies determined the course of events throughout the cosmos, including human existence; and so cosmology was inevitably astrological—as it had been for centuries.[15]

However, this archetypal symbol did not remain as constant as appearances indicated, for over the centuries there was a shifting identification of the "forces" working in the movements and influence of the heavenly bodies. Whereas in its ancient classical forms astrology peopled the supraterrestrial spheres with gods or demigods, by the Middle Ages these gods had been demoted to the status of angels or devils who functioned in the space between earth and the empyrean and whose activity determined happenings in the cosmos. With the Renaissance another shift occurs, as ancient theories about occult forces, Pythagorean or Hermetic or Neoplatonic, once more come into prominence; though it is difficult in many cases to know whether a particular author's reference to magical powers is to be taken rhetorically or realistically.[16]

Linked with these influences was the continuing, even increasing, impact of the writings of Pseudo-Dionysius. While the Dionysian view of the cosmos is not one of magical forces, there is a strong link between the theurgic symbolizing that he attributes to the various levels of his "hierarchies" and the theurgy exercised by the various forces at work in a Hermetic or Neoplatonic universe. For this reason, it is not always easy to distinguish in some of the "mystical" currents of the Renaissance period between natural and specifically Christian mysticism.[17]

Actually, what seems to be occurring as the fourteenth century gives way to the fifteenth and sixteenth is a shift in the notion of "magic": there is a persistent theme of looking for hidden causes, but theorizing about these causes is steadily moving in the direction of the modern science of physics. There is a consistent distinction made by Renaissance thinkers between "natural" and "demonic" magic.[18] The "good magic" in question deals with forces such as inertia or bodies attracting one another, forces that can be systematicaly examined through mathematical measurement.[19]

15. See L. Spitz, "Classical and Christian Ideas of World Harmony," *Traditio* 2(1944): 409–64.

16. Pico's attack on astrology indicates that he thought many of his contemporaries took it quite seriously.

17. On Pseudo-Dionysius's impact on key thinkers of the Renaissance, see P. Watts, "Pseudo-Dionysius the Areopagite and Three Renaissance Neoplatonists: Cusanud, Ficino, and Pico on Mind and Cosmos," in *Supplementum Festivum*, ed. J. Hankins, J. Monfasani, and Fr. Purnell (Binghamton, N.Y., 1987), 279–98.

18. See Cassirer, Kristeller, and Randall, *The Renaissance Philosophy of Man*, 150–1.

19. Ibid., 246–49, contains a selection on this point from Pico, *On the Dignity of Man*, 32–33.

This does not imply an abandonment of the well-established idea of the Great Chain of Being, though—as we will see—the traditional position of humans in this chain is challenged. Hierarchy continues to be the basic image of cosmic and social order, with Cusanus being the one important dissenter prior to the seventeenth century.[20] For the most part, Renaissance thinkers do not include angels as a link in the chain between humans and God;[21] instead, some of them draw from Neo-pythagorean, Hermetic and Cabbalistic sources to describe the theurgic influences that establish and maintain the order of the cosmic hierarchy.[22] Accompanying this is a resurgence of the Greek (Platonic and Stoic) idea of a world soul that provides organic unity to a "living" cosmos.[23] One needs to wait for the sixteenth century and Galileo for the decisive break with these mythic and astrological views, and recourse instead to a purely mathematico-physical explanation. At the same time, both Pico and Nicholas of Cusa denounce astrology as false and incompatible with human freedom.[24]

Galileo does represent a revolutionary break with previous cosmology, but such drastic shifts do not happen without preparation; and probably nothing did more to prepare for modern mathematicized science than the heightened interest in numbers during the late Middle Ages and the Renaissance, an interest manifested in the Neopythagoreanism of the fourteenth and fifteenth centuries.[25] However, the sources of this mathematical impulse were more extensive than ancient Pythoragoreanism and Platonism. Many thinkers of the period were attracted to Augustine, and it is no surprise to see them fascinated as he was by the biblical statement that God created according to number, weight, and measure.[26] The image of a cosmos structured hierarchically according to mathematical patterns and the similar image of God the architect building the universe according to number, measure, and weight are to be found again and again in book illustrations of the period.[27]

20. For the uniqueness and influence of Cusanus, see E. Cassirer, *The Individual and the Cosmos in Renaissance Philosophy* (Philadelphia, 1972; heralter cited as *Individual and Cosmos*), especially its initial chapter.

21. Pico, for example, accepts the existence of angels but locates them as members of "the heavenly court," *Oration*, 7–8.

22. It is both interesting and significant that Pico says (*Oration* 34) that he works from these "secret revelations" to confirm the Catholic faith.

23. On Ficino's notion of a world soul, see P.Kristeller, *The Philosophy of Marsilio Ficino* (New York, 1943), 385–86 (hereafter cited as *Ficino*).

24. See Cassirer, *Individual and Cosmos*, 118.

25. For a detailed study of Pythagorean thought in the Renaissance, see Heninger, *Touches of Sweet Harmony*.

26. Wisdom 11:21.

27. See, for example, the reproduction (Heninger, *Touches of Sweet Harmony*, 208) of the frontispiece from Athanasius Kircher's *Arithmologia* (Rome, 1665). The universe, depicted as a series of concentric spheres, is flanked by angels carrying banners marked "weight," "number," and "measure"—and above, the triune God is symbolized in the sacred triangle.

While they do not yet break with the old view of numbers as invisible structuring forces,[28] some of the thinkers of the period are clearly pointing to the kind of mathematics and science that will come with the sixteenth and seventeenth centuries. When Pico in his treatise *On the Dignity of Man* distinguishes two kinds of magic, identifies "good magic" with philosophy of nature, and mentions Pythagoras as one of those who carried on this creditable reflection, his understanding of magical pursuits sounds very much like careful scientific study of nature.[29] Nicholas of Cusa goes far beyond his contemporaries: Cassirer points out that Cusanus has moved mathematics back into the realm of pure abstraction and is dealing with the image/idea of circle or square rather than with any actually circular object in nature.[30] There is considerable evidence that Leonardo has done the same thing in his reflection on the mathematical aspect of artistic proportion. Thus the symbol that leads to intellectual insight is less the external harmony of observed nature and more the internal Idea that provides the *logos* in both mathematics and artistic creation.

It is characteristic of Renaissance emphasis on cosmic harmony that the same basic laws of order and proportion that govern nature are seen to function also in art, architecture, and music. Renaissance humanism reaches back to the artistic canons of Greek sculpture and architecture and continues the traditional link of music with mathematics in the quadrivium. What is new is a detailed reflection on and self-conscious employment of the canons of artistic activity that characterize these centuries and that are concretized in Brunelleschi's dome for the Cathedral of Florence, Raphael's use of space in *The School of Athens*, and the balance of elements in the ceiling of the Sistine Chapel.[31] Probably no figure of that day illustrates better than Leonardo da Vinci the notion that some common laws of harmony function in nature, in human life, and in artistic creation.[32]

28. It seems that even Kepler in his earlier period still clung to number symbolism and astrology. See Kristeller, *Renaissance Thought*, 63.

29. Pico, *On the Dignity of Man*, nn. 32–33.

30. *Of Learned Ignorance*, trans. G. Heron, (London, 1954), chaps. 11–23. Also Cassirer, *Individual and Cosmos*, 166–72; M. De Gandillac, *La philosophie de Nicolas de Cues* (Paris, 1941), especially 38–56 (hereafter cited as *Nicolas de Cues*); and K. Volkmann-Schluck, *Nicolaus Cusanus: Die Philosophie im Uebergang vom Mittelalter zur Neuzeit*, 2d ed. (Frankfurt, 1968), 22–35.

31. "The perspective, geometric groupings, and total spatial arrangement make of *The School of Athens* a perfect example of Renaissance artistic theory and technique." L. Spitz, *The Renaissance and Reformation Movements*, vol. 1 (St. Louis, 1971), 217 (hereafter cited as *Renaissance and Reformation*).

32. The memorial volume published as a follow-up to the great Da Vinci exhibit in Milan in the years just before World War II gives in text and pictures a striking view of the scope of Leonardo's search for underlying laws/structures of reality. *Leonardo da Vinci* (New York, 1956), especially 19–31.

Figures like Leonardo—and one thinks also of Pico or Ficino or Michelangelo—who typify the notion of a Renaissance human, strove also for harmony in society. Admittedly, that harmony was an elusive goal. One who faced straight-on the social dynamics that caused or hindered harmony among humans was Machiavelli. Pessimistic about the natural tendency of people to live peacefully and with concern for one another, Machiavelli sees the effective and just use of *power* as the only real source of order in society. Such exercise of power is beyond what one can expect from democratic structures and processes; only a benevolent despot, by political skill and military strength, can achieve harmony among his subjects.[33]

Beyond the harmonious association of humans in the polis or the nation lay the worldwide family of peoples and the accompanying question, whether religion was to unite or divide the human race. Contrary to the view that Christianity, and Western Christianity at that, was the only true religion, and that all other claimants to that title were heretical or infidel or heathen, Renaissance thinkers cherished the idea of an all-embracing religiousness that could recognize the validity of many paths to God. While the symbol of "crusade" still lived on in the fifteenth-century reconquest of Spain from the Muslims and in Europe's frantic struggles to stem the advance of the Turks, one finds Pico and Ficino struggling to harmonize Christianity with Muslim, Cabbalistic, and Hermetic thought, as well as with ancient Greek philosophy.[34] So also, classic literature provided for the writers of the age a constant source of examples to illustrate "Christian" virtue. Indeed, the devoted churchman Nicholas of Cusa expressed as a Cardinal the view that some kind of universal religiousness underlay all the various formulations of religion.[35]

Humanity As Microcosm

But if the cosmos is a harmonious whole, governed by number and weight and measure, humans are the prime instance, more than that the epitome, of this harmony. Leonardo's frequently reproduced sketch of the human figure touching with outstretched arms and legs the circumference of a circle illustrates one aspect of that Renaissance view. What measures human bodiliness in its harmonious beauty is the perfect shape, the circle. At the same time, however, the outstretched limbs touch the sides of a square; and so the human figure is the ideal *resolutio oppositorum*, it accomplishes the theoretically impossible task of squaring

33. See F. Gilbert, *Machiavelli and Guicciardini* (Princeton, 1965).

34. On the entry of these currents of thought from the East as a result of the decline and fall of Constantinople, see Kristeller, *Renaissance Thought*, 53–54.

35. This is expressed in his *De pace fidei*. See Gandillac, *Nicolas de Cues*, 40–48.

the circle. For that reason, it is the human body that provides a dynamic canon, a living measure, for artistic creation of the beautiful.[36]

Beyond this preeminent bodily exemplification of physical harmony, the human, because it is spirit as well as body, catches up all the levels of being and form in the universe. Again and again in the writers of this period and in the diagrams that illustrate the early printed publication of their works, one finds the symbolism of humans as microcosm. This theme had carried straight through patristic and medieval Christian writings, but it is to the ancient Greek and Roman uses of this symbolism that Renaissance thinkers chiefly refer.[37] And if humanity is the principal theme of Renaissance thinking and writing, humanity as microcosm is probably the principal approach to reflection on humans' role in the world.

To identify the status and function of humans in this way is to make humans, individually and socially, the key symbol/metaphor for imagination and thought and communication. Moreover, it is to grant humans a unique dignity and value. Appropriately, Pico della Mirandello's little treatise, "a representative statement of the positive humanism of the Renaissance,"[38] is entitled "Oration on the Dignity of Man." But if this introduces a fundamental optimism about the human condition, and it does, we must also remember that a somber recognition of human frailty and of the ephemeral character of human existence also runs as a strong current through Renaissance consciousness.[39] Nothing so dramatically illustrates this ambiguity as does Pico's conversion from the exuberance of his early youth to the penitential outlook advocated by Savonarola.

Situated at the bridge between matter and spirit, humans combine in their own bodily capacities the characteristics of all that is material, vegetative, or sensitive; they are like all else in the bodily world, yet uniquely different. Thus, from the experience of bodiliness humans can gather insight into the nature and activity of other bodily beings. But a more far-reaching inclusiveness flows from human thought, that mysterious activity in which people can bring into their world of consciousness the entirety of the cosmos, thus becoming intentionally, though not physically, the entire extramental world. It is this inner representation of the outside world that makes each human's consciousness capable of becoming a "little universe."

36. See L. Barkan, *Nature's Work of Art, the Human Body as Image of the World* (New Haven, 1975).

37. As was indicated in chap. 7, this theme had been prominent in the Middle Ages; see the first chapter in M. D. Chenu, *Nature, Man, and Society.*

38. Spitz, *Renaissance and Reformation* 1:179.

39. See Huizinga, *The Waning of the Middle Ages,* 1–45.

Probably no one had greater influence in introducing into Renaissance attitudes this optimistic estimate of the human than did Petrarch, but for him as a believing Christian the dignity of humans goes even further. Describing his climb to the top of Mount Ventoux, he relates his admiration of the beauties of nature he beheld but goes on to tell how then, reading a passage from Augustine's *Confessions,* he became aware of how the human mind transformed by divine grace can as the object of contemplation lead beyond the cosmos to its Creator.[40] Thus the symbol of humanity as microcosm is transcended by the symbol of humanity as *imago Dei.*

It is, then, in the entirety of their being, soul as well as body, that humans exist as microcosm. To the chain of being drawn from classical thought is added the hierarchical vision of Christian Neoplatonism found in Pseudo-Dionysius, with humans sharing in and reflecting all the levels above and below them, even the divine. Thus, the unique dignity granted to humans by their Creator. Not all Renaissance thinkers view this complexity of humanness as positively as does Petrarch; Ficino, for example, will complain: "We seek the highest summit of Mount Olympus. We inhabit the abyss of the lowest valley. We are weighed down by the burden of a most troublesome body."[41] Even Petrarch does not totally accept the microcosm symbol; he remains troubled, like Augustine before him, by the attraction of the sensible world. Drawn as he is toward the world's beauty, he cannot break through to accept its sacramentality; it remains a temptation, a seductive invitation to neglect the "things of the spirit."

Perhaps the most innovative aspect of Renaissance use of the microsm symbolism is the idea that humans, while reflecting the entire chain of being, do not themselves have a determined position in that hierarchical arrangement.[42] What places them in this indeterminate situation is their freedom. Humans have the capacity to decide where they wish to fit into the hierarchy: they can choose to identify with the angels and live a life of contemplation and detachment from earthly involvements, or they can decide to abandon their spiritual dignity and live in hedonistic absorption with bodily pleasures. Augustine, centuries before, had acknowledged some such room for movement in humans' location on the ladder of being, but he had stressed the function of love rather than of freedom. *"Amor meus, pondus meum."*[43]

40. Petrarch, *The Ascent of Mount Ventoux,* text in Cassirer, Kristeller, and Randall, *The Renaissance Philosophy of Man,* 36–46.

41. Ficino, *Concerning the Mind,* 209.

42. Nicholas of Cusa represents a yet more radical departure, for his view of a centerless universe is a fundamental challenge to the very notion of hierarchy. See De doct. ignorantia, 2,2.; Cassirer, *Individual and Cosmos,* 28.

43. *Confessions* 13,9,10 (*Patrologia latina* 32, 849).

In the fourteenth century and thereafter, the emphasis was clearly on humans' distinctive power of free choice. The faith tradition of wounded freedom persists; Pico's praise of human freedom retains the limiting symbols of the Fall and of spiritual uncleanness.[44] As the Renaissance continues, however, the explanation of human choice becomes increasingly Stoic and less distinctively Christian.[45] Along with this, the mirroring character of humans as microcosm becomes related almost exclusively to nature, without taking account, as Petrarch had done, of the order of grace. Subtly but surely Renaissance symbolism was distancing humans' awareness from the divine, for increasingly it situated and interpreted the human situation without reference to the God of the Scriptures or to the revelation that occurred in Jesus.

Given the pervading influence of harmony as a symbol, it is not surprising that Stoicism should have had this strong an attraction for Renaissance thinkers. They did not, could not as Christians, accept the pantheism of classic Stoicism, though some of them did flirt with the notion of a world soul.[46] Nor did they accept the ultimate identity of spirit and body implicit in Stoic doctrine. It was Stoic ethical teaching, with its ideal of orderliness and balance, of harmonizing tensions through moderation, and of bringing humans into congruence with the underlying law of the cosmos, that they most unreservedly embraced. However, it is not just to Stoicism that they turned; the yet more ancient Pythagoreanism, undergoing a major revival in the Renaissance centuries, provided also a popular fund of ethical directives. The foremost collection of such Pythagorean teaching, the *carmina aurea*, went through numerous editions and was widely used as a school text during the sixteenth century.[47] Beyond ethics lay that further refinement of harmonious behavior, especially of human communication, that is, *style*. For Renaissance humanists the unquestioned exemplar of such style in expression was Cicero.[48] And it was here that the symbols of harmony and of humanity as microcosm meshed, for in the truly ethical human the orderliness of moral decisions and actions reflected and shared in the laws of harmony that governed the universe.

44. *On the Dignity of Man*, n. 20; in Cassirer, Kristeller, and Randall, *The Renaissance Philosophy of Man*, 237.

45. An interesting sidelight: in the Jesuit schools that exercised such influence during this period, Cicero was the author most widely assigned as study and Seneca was also included, thus exposing students to a considerable amount of Stoic thought. On the strong Stoic influence throughout both the Middle Ages and the Renaissance, see W. Bousma, "The Two Faces of Humanism: Stocism and Augustinianism in Renaissance Thought," in *Itinerarium Italicum*, ed. H. Oberman and T. Brady (Leiden, 1975), 3–60.

46. See P. Kristeller, *Ficino*, 92–120.

47. Heninger, *Touches of Sweet Harmony*, 63 n.41. The author refers to 137 different printings of the text between 1700 and 1747.

48. See Kristeller, *Renaissance Thought*, 29.

The Individual

It has been remarked that the Renaissance marks the emergence of the "ego" in European thought. Such a sweeping statement needs qualification—there had been clear recognition of individuality for millennia, though for the most part it was the individuality of prominent persons to which attention was paid. Moreover, as late as the thirteenth century the notion of "individual" related more to "species" than to "person."

The emphasis on the dignity of humans to which we have already referred was bound to draw positive attention to individuality, for it implicitly acknowledged the basic goodness of each human. More importantly, the focus on freedom and the consequent conviction that humans did not fit into some prearranged slot in the hierarchy of beings implied that each person possessed a radical autonomy. The tension between free choice and predestination, already given classic Christian formulation by Augustine, becomes a bitterly contested issue from the fourteenth century onward precisely because attention has been drawn to human personal freedom.[49]

In the attempt to express this awakened awareness of human personhood, Renaissance thinkers were well served by some of the ancient Greek symbols. While it would be an anachronism to read back into fourth- and fifth-century Athens the questions and aspirations of the Quattrocentro, the *Trilogy* of Aeschylus wrestled with the conflict between fate and freedom, as did Sophocles' *Oedipus Tyrannos*. One is not surprised, then, that the story of Prometheus is frequently mentioned in Renaissance writings, for it epitomizes the defiant struggle of a free person against the restrictive "will of heaven" that would deny to humans the possibility of cultural progress and personal autonomy.[50] Prometheus, of course, goes beyond bonds, must pay the ensuing penalty, and so becomes also a symbol of the tragic element in human existence.

Symbols of the Common Folk

The symbolism of Prometheus, however, had little if any impact on the vast majority of people during this period. "The gap that always exists between the highly educated intellectual elite and the great mass of the people was an enormous chasm in the fourteenth and fifteenth centuries."[51] Renaissance humanists may have used the Prometheus symbol to reinterpret the Christian motif of Adam,[52] but for popular imagery

49. On the way in which "modern" cultural individualism and religious individualism fuse in Petrarch under Augustine's influence, see Cassirer, *Individual and Cosmos*, 129.

50. See Ibid., 92; on the Prometheus symbol and the way in which it interacts with the Adam symbol. On the Prometheus symbolism and its connection with the "modern" move to secularity, see W. Lynch, *Christ and Prometheus* (Notre Dame, 1970).

51. Spitz, *Renaissance and Reformation*, 1:47.

52. See Cassirer, *Individual and Cosmos*, 92

and religious ideology Adam still functioned as a paradigm of human moral failure. Only a very small portion of the population was capable of sharing the Renaissance culture we have been describing, and it would take decades of gradual education, facilitated by the spread of printing and increasing literacy, to extend the influence of the symbols dear to Renaissance thinkers. Meanwhile, other forces and events were more influential in shaping the imagination and consciousness of most people in Europe. And in general, the message of that more popular symbol world was much less optimistic.

At what many would consider the high water mark of medieval faith, intellectual life, and church power, Innocent III had written a treatise *On the Misery of Human Life*.[53] That dour treatise had been answered by Pico della Mirandola's *Oration*, but it continued to speak much more meaningfully to the experience and outlook of all but the wealthy and privileged. As a matter of fact, when much the same viewpoint as Innocent's was voiced by Savonarola, Pico himself was converted from "worldliness."

If one were to seek a basic symbol that long before this period of history had conveyed the sense of human unworthiness before God, of the radical wounding of the human condition, and of the utter dependence of humans upon the unmerited mercy of God, it would be the notion of "original sin" (a notion, of course, that has continued into modern times). Ancient literature bears witness to an almost universal insight that "something went wrong" in some primeval situation. Somewhere between the beginnings of Christianity and the time of Augustine, original sin became a formulated element of Christian belief.[54] Augustine did much to crystallize the doctrine, particularly in his controversy with Pelagianism, and to pass on this theological heritage to the Middle Ages. But even in Augustine one does not sense the pessimism, the obsession with sinfulness, that marked later centuries. His *Confessions*, the classic testimony to his human frailty, is not basically a confession of sins but a confession of divine goodness.

The prevalence of artistic representations of Adam and Eve, often in "before" and "after" sequences, and the prominent depiction of the Fall in medieval morality plays both make it clear that the general populace was not only aware of but deeply influenced by the current understanding of the biblical account of human origins. That understanding was conveyed to them also by most of the preaching to which

53. *Lothario dei Segni: De miseria condicionis humane*, ed. R. Lewis (Athena, Ga., 1978).
54. See Pelikan, *The Christian Tradition*, 278–318. See also P. Schoonenberg, *Man and Sin* (Notre Dame, 1965).

they were exposed.[55] The depictions of Adam and Eve by Dürer and Cranach, and Michelangelo or Milton's *Paradise Lost,* prove the durability of the original sin motif throughout and beyond the Renaissance.

Reinforcement of this rather pessimistic view of human life was supplied by a number of elements in people's experience during these centuries. The great famine of the early fourteenth century and the scourge of the Black Death made omnipresent death a basic image of human existence for much of Europe. Renaissance courts might have their *dances figurees* representing cosmic harmony,[56] but for the bulk of people a much more appropriate and prevalent symbol of their worldview was the *danse macabre.*

The Papacy

Religiously, some of the most basic symbols changed in their significance; some even took on a contrary meaning. Perhaps the most important shift of this kind had to do with the way in which European Christians were impacted symbolically by the papacy. For centuries, before Europe became Europe, the pope had been a unifying symbol, a norm for truth and judgment. Toward the end of the Middle Ages this perception of the papacy began to change.

The accumulation of papal power in the Middle Ages had in large part grown out of the appeal of cases to Rome for decision, a practice rooted in the trust that just judgment resided in the successors of Peter.[57] This was shattered by the Avignon Captivity and the Great Schism. With two and then three claimants to the papal throne, European Christianity became bitterly split for almost forty years. The papacy itself proved incapable of healing the breach and it took the Council of Constance, brought together by the Holy Roman Emperor and animated by theologians such as Gerson and D'Ailly and canonists such as Zabarella, to provide unified leadership for the church. While the papacy quickly regained much of its political power because of the failure of Basel and Pisa as effective councils, damage had been irreparably done to the symbolic role of the pope. Popes functioned as Renaissance princes, were drawn from influential Italian families, and along with other rulers of the day, played the political game through military power and diplomacy and intrigue. Scarcely a symbol of "the vicar of the poor Christ"!

But the damage went deeper: with the moral decadence of the Renaissance papal court, Rome came to be seen as "Babylon," and the papacy

55. See J. Longere, *La predication medievale*. The need to arouse people to overcome their tendency to sin is the underlying assumption of the book that exercised unparalleled influence on medieval preaching, Gregory the Great's *On Pastoral Care*.

56. See Heninger, *Touches of Sweet Harmony*, 178.

57. On the gradual accumulation of papal power, see R. Southern, *Western Society and the Church in the Middle Ages*, Penguin edition (Harmondsworth, 1970), 91–133.

that in earlier centuries had been the source of church reform now became the principal target of demands for "reform in head and members." With the Reformation of the sixteenth century, the papacy symbolized the controversy that split the Church; accepting or rejecting it was the decisive issue that linked Christians with the Reform or with Trent. Thereafter, up to the present, the papacy became a dominant symbol of unity within the Roman Catholic Church but the key symbol of that Church's separation from the rest of European Christianity.

For Christians of the Late Middle Ages the papacy was linked also with the symbolism of the Inquisition, though the Grand Inquisitor acquired a fear-inspiring image of his own. Apart from the question of its actual conduct, though that certainly fed into popular perception, the Inquisition came to be seen as the epitome of cruel and fanatical enforcement of official orthodoxy. Moreover, the abuse of the Inquisition in cases such as the persecution, torture, and execution of the leadership of the Knights Templar during the first two decades of the fourteenth century established the Inquisition as a symbol of arbitrary and tyrannical ecclesiastical administration.

It was not only the papacy that became religiously countersymbolic during the fourteenth and fifteenth centuries. The heavy taxation levied by church authorities, the unscrupulous exploitation of simple and uneducated people by roaming friars with their preaching of hellfire and their sale of indulgences and relics, and the financial wheeling and dealing of the Avignon papacy all conveyed the image of an avaricious ecclesiastical establishment. Linked with the breakdown of religious life in many monasteries and convents, this led to frequent representation of "the monk" as a symbol of irresponsible and licentious behavior. Boccaccio's *Decameron* is but one of the literary testaments to this prevailing view.

Accompanying this shift in papal symbolizing was a broader symbol change that occurred gradually and somewhat imperceptibly between the thirteenth and sixteenth centuries. Margaret Ashton speaks to this change at the beginning of her book on the fifteenth century. "In 1500 Europe existed. For the world of a century or so earlier such a proposition is altogether more doubtful. In the latter part of the fourteenth century Christendom was more meaningful than Europe . . . In the fifteenth century Christendom was giving way to Europe; it became possible to be 'European'."[58] The overarching sense of being the *societas (civitas) christiana* which pervaded medieval Christian consciousness faded before the beginnings of what would be national and European identity. And with this came more sharply the distinction between the two "perfect societies," church and state.

58. M. Ashton, *The Fifteenth Century* (London, 1968).

Eucharist

In the midst of all this, what was the role in people's life and worldview of that which was claimed to be the key symbol in Christianity, the celebration of Eucharist? Generally, things continued much as they had been except that liturgical malaise and abuses became more pronounced.

The principal symbolizing impact of the eucharistic liturgy probably was that of a performance; for the bulk of Christians, the Mass was something to be attended, something they did not understand and saw no need to understand, an action performed by the ordained that provided a source of God-derived power against a range of evils. The fascination with seeing the consecrated host, which had already assumed major proportions in the Middle Ages, continued unabated; as a matter of fact, it took more structured official expressions in devotions directed to the host exposed in a monstrance. Perhaps the strangest liturgical anomaly that originated at this time and continued in Roman Catholicism until Vatican II was the practice of celebrating the eucharistic action itself, with appropriate changes in rubrical prescriptions, before the consecrated host displayed above the altar in a monstrance. In such a situation it seems clear that the exposed host rather than the action of the Mass was the dominant symbol that drew the attention of the attending community. The Eucharist had been frozen into an icon.

In the more public celebrations of the Mass the trend toward performance intensified. Nowhere was this more noticeable than in the development of church music. Medieval liturgical chant had already become more complicated with the use of lengthy melismas, but it was the introduction of polyphony that marked the decisive appropriation of liturgical music by a group outside the sanctuary. Even spatially this change was reflected in the migration of the choir and the organ toward the rear loft of the church building.

People's interpretation of the liturgy they were observing was based, of course, on the explanation they had been given, an explanation that was devoid of any reference to the role of the attendant community—or for that matter, of the Church as a whole. The Mass was seen as a divinely instituted action through which certain benefits, the "fruits of the Mass," could be obtained by those present or by those who had paid a stipend to the ordained celebrant. Earlier medieval explanations described these benefits along more spiritual lines—as one source has it: "more like God, less a sinner, strengthened against the devil, more blessed than before."[59] But by the fourteenth century the list of "fruits" had grown to include such things as the fact that after mass one's food

59. Jungmann, *Missarum Solemnia*, 1:129.

tasted better, one would not die a sudden death, during attendance at mass one did not grow older.[60]

Along with expecting such rewards through a hidden action of God, those observing the liturgical celebration were taught to interpret the various actions and even the liturgical vestments in allegorical fashion. Essentially, the allegorical approach that had been developed by Amalar and Alcuin and had remained central to medieval instruction about the Eucharist continued on, indeed was expanded, in the fourteenth and fifteenth centuries.[61] While a very few theologians, such as Albertus Magnus in the thirteenth century and Nicholas of Cusa in the fifteenth, attacked these imaginative interpretations, scholasticism had practically no effect on people's understanding of the Mass.[62] While some of these allegorical explanations paralleled the elements of the Mass to the ceremonies performed by the high priest in the Jerusalem temple, the principal approach was commemorative of the suffering and death of Jesus.[63] This allegorical linking of the liturgical actions to the life and passion of Christ was detailed in *De sacro altaris mysterio* of Innocent III, which became the basis for many of the late medieval explanations of the Mass.[64]

Much of the allegorical explanation dealt with the vestments worn by the ordained celebrant and depicted the celebrant as portraying the suffering Christ.[65] This led to increased emphasis on the Mass as somehow the sacrifice of Christ, but it also conveyed symbolically and emphatically the notion that the priest was acting *in persona Christi*. The liturgy of the Mass was experienced as a dramatic presentation of the saving mystery of Jesus' passion and sacrificial death, but the people had no sense of being part of that mystery. Indeed, the understanding of mystery was not that of Ephesians, where it refers to what is *revealed* in Jesus, but instead views mystery as that which is *hidden* and unknown.

What centuries earlier had been a shared experience of Christian *communio* developed, by the beginning of modern times, into an individualistic experience of exposure to an awe-inspiring action of God hidden behind a rubrically controlled ritual. Even for the priest celebrant a sense of "the sacred" that bordered on the fearsome was reflected in

60. Ibid.
61. See Ibid., 1:115–19.
62. "As for the development of the Mass-liturgy, or for all that, the development of an understanding of the Mass-liturgy, Scholasticism left scarcely a trace—a rather surprising thing." Ibid., 1:115.
63. Ibid. 1:110–111.
64. Innocent III, *De sacro altaris mysterio*, *Patrologia latina* 170, 11–13. Jungmann, *Missarum Solemnia* 1:111f.
65. Ibid. 1:280–81.

various "perils" of which the rubrics warned, for example, spilling the consecrated wine. Religious reverence passed into taboo.[66]

Excluded from any active participation in the liturgical action, even from regular reception of communion, the bulk of the faithful were increasingly distanced in their faith relationship with God by their understanding of and attendance at mass. This awareness that liturgical activity did not belong to them—they probably did not feel deprived, since they had no understanding that it should be otherwise—was confirmed by the basic shift of eucharistic celebration to private masses. The fact that most masses were now said without any community in attendance, said by a "Mass priest" to fulfill the contractual responsibility of a stipend or benefice and so bring "the fruits of the Mass" to the person for whose intentions the Mass was being offered, inevitably strengthened the notion that the liturgy was solely the priest's action. Whatever this action achieved, it came through the instrumentality of the priest, independent of the people's profession of faith, and without reference to the intrinsic significance of the human action being performed.

So instead of being effectively sacramental, a situation in which Christians deepened their awareness of divine saving presence in their lives, the liturgy was a cause of distancing the faithful from God. The liturgy was a screen behind which God was hidden, the Mass was mystification and for many magic, the people were reduced to ignorance and inactivity. Doctrinal focus on transubstantiation added to people's isolation from the reality of Christ's presence, for both in theology and in popular explanations of the Mass it diverted attention from the ancient belief in the risen Lord's presence to the people, his body, the Church. And reducing Eucharist to a devotion fed into the privatization and individualization of faith and religion, which distanced people from one another and obscured the symbolism they were meant to have for one another in eucharistic communion. In short, the eucharistic liturgy was becoming more and more countersymbolic.

REFORMATION

More than one voice was raised against this decline of liturgical worship and especially against the abuses that seemed to grow with the decline of medieval culture.[67] Innocent III's treatise had been aimed at curbing the extravangances of allegory, but it had not broken with the basic

66. Ibid. 1:128–29.
67. On growing lay discontent with the state of the church in the late Middle Ages, see S. Ozment, *The Reformation in the Cities* (New Haven, 1975), 15–46.

pattern. The *devotio moderna* produced some profoundly spiritual re-
flection on the Mass, above all the fourth section of the *Imitation of Christ*,
but this touched only the better educated and theologically sophisti-
cated. Even in these circles, Gabriel Biel's lengthy explanation of the
canon is a classic example of allegorical interpretation. Nicholas of Cusa
attempted unsuccessfully as papal legate to root out the superstition
and simony he encountered. It was not, however, until the religious
revolution of the sixeenth century was triggered by Martin Luther that
effective reform began.

To detail the sacramental theology of any of the principal Reformers
is a major undertaking in itself, but some of this has been done.[68] A
thorough comparative study of the highly diversified liturgical revo-
lution that began in the sixteenth century, however, has yet to be done
and is far beyond the goals of this present volume. Some of the principal
shifts in both the theory and the implementation of Christian symbols
can be identified; and these shifts illustrate both the continuity and the
discontinuity that occurred in the distancing of Christians from the God
of their faith and worship.

The Reformers and Eucharist

It would be a serious oversimplification to identify liturgical discontent
as the basic force behind the religious movements associated with the
great sixteenth-century Reformers. Still, if one accepts the premise that
the Reformation was essentially a religious phenomenon,[69] there was
no element of Christian belief and practice that was more central than
the Mass to the disputes of that century. Luther devoted several of his
key treatises to attacking Roman explanation and celebration of the
Lord's Supper;[70] Calvin did so even more drastically;[71] Zwingli advocated
radical recasting of the celebration of the Lord's Supper.[72] In Elizabethan
England it became a penal offense to offer or share in a "Romish" Mass.

At the heart of the disputes about Eucharist was the question of the
efficacy of liturgical ritual. For several centuries, explanations of the
Mass had focused on the changing of bread and wine into the sacra-
mental body and blood of Christ; the ability to effect this change was

68. See K. McDonnell, *John Calvin, the Church, and the Eucharist* (Princeton, 1967);
(hereafter cited as *Calvin*); J. Raitt, *The Eucharistic Theology of Theodore Beza* (Chambersburg,
Pa., 1972); V. Vajta, *Luther on Worship* (Philadelphia, 1958); P. Althaus, *The Theology of
Martin Luther* (Philadelphia, 1966), 294–403.

69. See H. Hillerbrand, in *The Protestant Reformation* (London, 1968), xix–xxiv.

70. Three of the most important are printed together in Vol. 36 of *Luther's Works*
(Philadelphia, 1959).

71. See McDonnell, *Calvin*, 177–284.

72. See the epilogue to his *Commentary on True and False Religion*, in Hillerbrand, *The
Protestant Reformation*, 116–21; also in J. Courvoisier, *De la reforme au protestantisme* (Paris,
1977), 21–23.

seen as the principal empowerment bestowed in presbyteral ordination. Since Lateran IV the term "transubstantiation" had privileged status as the orthodox name for this eucharistic transformation, though use of this common term did not guarantee common understanding.[73]

On the popular level the technical understanding of the term was totally absent; in its place there existed a vague notion of something miraculous happening. And the widely circulated stories of bleeding hosts or apparitions of Jesus in the host testify to the increasing credulity of the late medieval centuries.

Luther

Frequent criticism of this superstitious approach to Eucharist, even official condemnation of the devotional excesses, proved unavailing. What made official criticism less credible was the widepread abuse of peddling indulgences, a practice that had become in some instances a major economic enterprise. So when Martin Luther in the first quarter of the century began his attack on the exploitation of popular credulity, his criticisms were neither novel nor isolated. What made these criticisms particularly effective, in addition to Luther's passionate rhetoric, was the theological insight with which he appraised the problem and suggested a positive remedy. Triggered by Erikson's study of Luther as *homo religiosus*, considerable attention has been directed to the authenticity and depth of the religious faith and commitment out of which he spoke; but inseparable from this prophetic aspect of his career was his eminence as a theologian.[74] And nowhere is his theological stature more manifest than in his understanding of the symbolic dimension of Christian life and worship.

Basically, Luther's understanding of Christian sacramental rituals remained quite traditional, despite the widening disagreement with Roman explanations and implementation of sacramental liturgy. His insistence on the indispensable role of faith in people's participation in sacrament stands in the mainstream of the sacramental theology of the Middle Ages.[75] His discontent with the use of "transubstantiation" to explain the real presence of Christ in the Mass, which he steadfastly accepted, did not put him in contradiction to orthodox teaching—Trent

73. See G. Macy, *The Theologies of the Eucharist in the Early Scholastic Period* (Oxford, 1984).

74. J. Todd in his two studies of Luther, *Martin Luther* (London, 1964) and *Luther, A Life* (London, 1982) stresses Luther's creative role in theology.

75. For a detailed study of Luther, Melanchthon, and Calvin on the relation of faith and sacrament, see A. Villette, *Foi et sacrement* (Paris, 1964), 2:83–205.

some years later will state only that use of the term "transubstantiation" is "most appropriate" (*aptissime*).[76]

What Luther does is to move discussion of the eucharistic action and of other sacramental activity, even in areas such as ministerial ordination, to which he denied the name "sacrament," in the direction of liturgy being effective through its perceived significance.[77] With the Zwinglian wing of the Reformation this will deny to the observable actions of public worship anything other than didactic effect, but Luther will continue to oppose Zwingli and insist on the reality of Christ's eucharistic presence. Between these two opposing positions lay the view of Bucer, which, after some vacillation, ended quite close to Luther; and that of Calvin, which still maintained a genuine presence of Christ at the same time that it moved away from a "physical" explanation of this presence.[78] What distinguished these understandings from one another and from the understandings of Catholic theologians was not the question, "Is Christian ritual symbolic?" but the question "Symbolic in what sense?" The responses ranged from reduction of ritual symbol to homiletic sign, an enacted sermon, to insistence that the external ritual cloaks but also embodies and reveals the saving action of God.

Controversy about the role of symbols in Christian faith and life focused logically on the liturgical rituals that for so long had provided the basic structure of popular religion. But disagreement about Christian sacramentality was broader; it was yet another expression of the recurrent challenge of iconoclasm. The statue-breaking enthusiasm of Karlstadt as early as 1521 and the more programmatic iconoclasm of Zwingli's followers in Zurich illustrate the inner logic of the issues raised by the evangelical character of Christian symbols.[79] Ultimately what is at stake is Christian belief in the Incarnation, the rejection or acceptance of Docetism. It should come as no surprise that the disputes that began with the universally recognized need to move toward liturgical reform led to the very heart of Christian faith, for (as we will see in greater detail) Luther—and in varying degrees other Reformers—continued the Christocentrism already prominent in Tauler, Gerson, and the *devotio moderna*.[80]

Seen from our point in history, much of Luther's agenda for liturgical

76. See Denziger-Schonmetzer, *Enchiridion symbolorum*, 33d ed. (1965), no. 1652 (hereafter cited as *Enchiridion*). On present Catholic theological understanding see K. Rahner, "The Presence of Christ in the Sacrament of the Lord's Supper," *Theological Investigations* 4 (1966), 287–311.

77. This is part of his (and Calvin's) stress on the role of the proclaimed word in effecting faith. See Villette, *Foi et sacrement* 2:93–105.

78. See K. McDonell, *Calvin*, 206–48.

79. See Todd, *Martin Luther*, 205.

80. On their influence on Luther see M. Lienhard, *Luther: Witness to Jesus Christ* (Minneapolis, 1982).

reform makes good sense. He called for simplification of the ritual, restriction of private masses and their sustaining benefices, use of the vernacular, more active involvement of the people, in short, for a return to basics and adoption of measures to make the Mass understandable and significant for ordinary Christians. Yet, when he proposed it in *The Babylonian Captivity* there was less than sympathetic attention by Rome. Certainly, the strident rhetoric of the treatise, not unusual in writings of that time, and its attack on the notion of the Mass as a "sacrifice" did nothing to encourage acceptance of Luther's suggestions for liturgical change. As the same message was reiterated, with increasing passion, in *The Misuse of the Mass* and *The Abomination of the Secret Mass,* it received even less acceptance. In the atmosphere of polemic, the critically important theological issue was obscured: namely, for sacramental ritual to shape and deepen faith, to give grace, it must function according to its own proper character, that is, as an actually communicating symbol.

Radicalism and Response

As the rapid evolution of Reformation thought moved from Luther to Zwingli, there was increased insistence that worship should shape the religious awareness of the congregation. Along with this came a gradual loss of belief in a mystery-presence of Christ in Eucharist; at most the Mass was a memorial service, reminding people of the saving death of Christ. Since the Mass is not a sacrifice, not even a privileged icon, it should give way in its traditional form to an evangelical gathering of Christians aimed at stimulating and shaping faith by the proclamation and explanation of the Word of Scripture. The ultimate expression of Zwinglian iconoclasm was not the statue-smashing that marked the 1520s in Zurich but the rejection of Eucharist as sacrament of Christ's presence.[81]

When the Roman Catholic Church finally did get down to responding officially to the Reformers' challenge to the efficacy of sacramental liturgies, the Council of Trent (Session 7 in 1547, and Session 13 in 1551) quite predictably concentrated on a defense of traditional doctrine, the intrinsic efficacy of the liturgical action, the reality of Christ's presence in the consecrated elements, and on the sacrificial character

81. Despite the Wittenberg Concord of 1536, through which Zwingli and Bucer entered into a truce with Luther, with whom they had quite contentiously feuded about the doctrine of eucharistic presence, and in which they accepted a presence of Christ at celebration of the Lord's Supper, the Zwinglian wing of the Reformation continued to move away from a sacramental interpretation of the liturgy. On the Wittenberg Concord see Todd, *Martin Luther,* 244–45. On Bucer's view of liturgical reform see G. Van de Poll, *Martin Bucer's Liturgical Ideas* (Assen, 1954). On Zwingli's position as worked out in debate with Luther, see G. Potter, *Zwingli* (Cambridge, 1976), 287–315.

of the Mass.[82] While repeating the centuries-old teaching that faith played an essential role in sacramental activity, Trent did not deal in any depth with the question whether community faith and understanding affected the "objective" efficacy of the sacramental sign. This allowed popular understanding in subsequent centuries to misinterpret in a semimagical vein the council's statements about the *ex opere operato* effect of sacramental rituals. And it passed on to Catholic theological reflection a view of the ritual's causality as almost purely instrumental, with the result that the distinctively symbolic character of the liturgy received practically no attention.

Trent left to Roman Catholic reflection the firm statement that "sacraments contain and give grace,"[83] leaving open the nature of the grace given and the kind of causality exercised by the sacramental liturgies. Moroever, in the area of symbolism, the Council and its mandated liturgical reform, carried out for the most part by Pope Pius V,[84] handed on to later generations of Catholics the model of *homogeneity* as the ideal for Christian unity. The doctrinal homogeneity formulated in the lengthy decrees and canon that dealt with Bible and tradition, original sin, grace, grace/justification, and sacraments, and the disciplinary homogeneity that tightened up structures and processes to provide a much-needed reorganization, found a parallel in the rubrical homogeneity imposed on Roman Catholic communities throughout the world. Homogeneity became the criterion of unity and Rome the paradigm for the homogeneity.

Reformation Symbolism

At first glance, the Reformation and Catholic response do not represent much of a change in the cultural symbols that shaped people's cosmology and conditioned their understanding of Christianity. The evolution from the medieval symbol world to the Renaissance recovery of ancient classical symbols and toward the beginnings of modern science went on in relative independence of religious developments. In Reformation and Counter-Reformation there were both progressive and reactionary trends. However, a closer look reveals several areas in which the religious upheavals affected the basic images that operated in people's worldview.

Family and Sexuality

Though it took some decades to take effect completely, in Protestant regions of Europe "family" replaced "monastery" as a symbol for ideal

82. See Denziger-Schonmetzer, *Enchiridion*, 1635–1661, 1725–1759.
83. Ibid., 1606–08.
84. For a detailed explanation of this reform, see Jungmann, *Missarum Solemnia* 1:133–41.

Christian life. When one reflects on the extent to which monasticism had been a dominant interpretative symbol for centuries of medieval Christian self-understanding, the proportions of this symbol shift become evident. Moreover, the fact that it was "family" which now served to model people's understanding of being truly Christian meant that an accompanying shift was occurring in the symbolism of human sexuality. Mature and loving exercise of sexuality rather than celibate renunciation of sexual activity took on overtones of virtue and sanctity. Paradoxically, while Protestant churches denied to marriage the title of "sacrament" and Catholicism defended its place among "the seven sacraments," it was in Reformation circles that the fundamental sacramentality of Christian marriage gained new acceptance.[85]

Clerical celibacy had by the sixteenth century lost a great deal of its positive symbolism; instead, widespread abuses had made it almost a countersymbol. In many circles the Reformation repudiation of the ecclesiastical discipline of celibacy as it then existed was regarded as a purification of the Church's life. The Catholic response to the obvious need for some reforming measures was to attack the abuses rather than reject imposed clerical celibacy, to tighten ecclesiastical discipline so that the clergy, both diocesan and regular, could again be a sign of dedicated Christian life. As a result, the post-Reformation centuries witnessed a dialectic of Christian views regarding the symbolic role of sexuality in human life. In the climate of controversy that followed the Reformation, this dialectic was prevented from becoming fruitful because the two views were generally considered opposed rather than complementary.

"Turning from the symbolism of the monastery and underlining the Christian significance of marriage was only part of a more basic symbol shift in which Luther played a major role. This broader shift comes with new emphasis on the importance of Christians' daily ordinary activities.

> If you further ask whether they [Luther's critics] consider it a good work when a man works at his trade, walks, stands, eats, drinks, sleeps and does all kinds of works for the nourishment of his body or for the common welfare, and whether they believe that God is well pleased with them, you will find that they say no, and that they define good works so narrowly that they are made to consist only of praying in Church, fasting and alsmgiving. The other things they consider as worth nothing and think that God attaches no importance to them. And so through their damnable unbelief, they deprive God of his due and despise faith, though God is served by all things that may be done, spoke, or thought in faith." [Treatise on Good Works, in *Luther's Works*, vol. 44 (Philadelphia, 1966), 24]

85. See W. Lazareth, *Luther on the Christian Home* (Philadelphia, 1960).

Ironically, this passage from the 1520 treatise *On Good Works* runs counter to a simplistic understanding of the reformer's insistence on faith rather than on good works. Picking up the theme of Rom. 8:28 and 1 Cor. 10:31, Luther rehabilitates ordinary human activity as meaningful, even exemplary, implementation of discipleship. Though the Reformation churches would not succeed in reversing the manifold distancing we have been studying, the significance given by Luther to the Christian living out of "the everyday" would remain as a seed to bear fruit gradually in the centuries ahead.

Papacy and Empire

Another instance where the impact of a symbol bifurcated was the papacy. Long before Luther and then other Reformers began to attack the corruption of the papal court, the pope's significance for Christians had already become ambiguous. From Gregory VII to Boniface VIII, the Pope had been a privileged symbol of the unity of medieval Latin Christianity. But with the Avignon Captivity, the Great Western Schism, and the worldliness of the Renaissance popes, this symbolic power eroded.

Perhaps the fracturing of the European church could have been prevented until almost mid-sixteenth century by a forthright effort at reform and response to the changing sociocultural context, but Rome was in no mood to respond to the challenge of the Reformers by such compromise. Instead the official solution implemented at Trent was to cut off all dissent as heretical or at least schismatic, and systematically to restate traditional doctrine, particularly in the area of sacraments. While the Council of Trent did not detail the role and power of the pope—that would be the central agenda of Vatican I three centuries later—it was clear that the doctrinal and disciplinary homogeneity decreed by the council was to find its norm and source of enforcement in the papacy. The Tridentine Church became very much the *Roman* Catholic Church. Thus, the pope in modern times has been the prime symbol of unity within the Roman Catholic Church and the prime symbol of the division between it and the other Christian Churches.

Accompanying this was the full disappearance of "The Roman Empire" as a lingering cultural symbol of unity. While the sixteenth century still had Holy Roman Emperors, some of them—Charles V—quite influential, the basic geopolitical reality of Europe had become a struggle among emerging national states and of dynastic conflict within these states. The papal states had by the fifteenth century figured among these competing territorial governments, which scarcely reinforced the image of the pope as unifying symbol of all Christians. Already in 1324

the *Defensor pacis* of Marsilius of Padua had shifted discussion of conflicting political power to a nonreligious context, though until the eighteenth century divine legitimation remains a presupposition to claims made by rulers such as Louis XIV. This inevitably deprived the "Holy Roman Empire" of the symbolic power it had earlier possessed.[86]

The Crusade

One of the ideas/images associated with the earlier papal role, namely that of the crusade, did not fade with the advent of the Reformation; indeed, in many ways it was reinforced. The sixteenth and seventeenth centuries saw a full-scale rehabilitation of the notion of "holy war." Not only was Rome in conflict with the Reformers, Reformation churches were often in open and bitter conflict with one another. These conflicts coincided or at least overlapped with the political divisions in Europe, and the result was a long and draining period of actual warfare fueled by religious enthusiasm. Aggression and hatred directed against one's religious enemies came to be viewed as virtue, as a symbol of one's devotion to the cause of God.

Spain, of course, was still engaged in the classic form of Christian crusade throughout the fifteenth century; it was only in 1492 that Ferdinand and Isabella were able to drive the Moorish armies from their last stronghold in Granada. Well into the next century the atmosphere and imagery of medieval chivalry were alive and strong in the Iberian penisula. But this quickly took on a new flavor with the military and political involvements of Charles V and Philip II in the rest of Europe, involvements that aligned them against the supporters of the Reformation and which Philip in particular interpreted in a religious light.

Perhaps the "purest" instance in the sixteenth century of the old ideal of crusade being used to interpret a military undertaking was Pius V's formation in 1570 of the Holy League. This alliance with Venice and Spain, though short-lived, enabled the Christian forces to defeat the Turks in the decisive naval victory at Lepanto the following year. In a sense the struggle against the Turks was the final crusade and the eventual victory of the Christian forces symbolized for most Europeans the saving power of God being exerted on their behalf against the infidels. The endurance of this symbolism into the twentieth century can be seen in the crusading enthusiasm of G. K. Chesteron's "Lepanto."

But it was not only political rulers who helped reinforce the holy war symbolism as they legitimated their military undertaking by placing them under divine patronage. Luther—and he was not alone—saw the

86. On the "secularization" of the notion of government, its impact on the earlier notion of "empire," and the alternative suggested by Cusa, see M. de Gandillac, *Nicolas de Cues*, 38f.

entire undertaking of Christian life as a battle, a war against the forces of Satan, among whom he included some of his religious opponents. On the Catholic side, Ignatius of Loyola in one of the key meditations of his *Spiritual Exercises* uses the imagery of two armies, that of Christ and that of the devil, lined up for battle. Erasmus's guide to Christian behavior bore the title *Manual for the Christian Knight* and one of the most influential ascetical writings of the age was Scupoli's *Spiritual Combat.*[87]

Beyond the European struggles for political ascendancy, the "holy war" imagery functioned to interpret and legitimate military adventures around the world. As the Spanish and Portugese explorers, and shortly thereafter the English, French, and Dutch, "discovered" the Americas and established trade routes to the Far East, the conquering armies of the conquistadores were accompanied or very shortly followed by the evangelizing missionaries who conquered the defeated natives for the kingdom of God. The joint venture "for God and king" created for both conqueror and conquered the experience of religion established through aggression; but it is doubtful that the exploited natives joined the Europeans in interpreting the aggression as "holy." To the credit of most of the missionaries involved in what they understood to be the conversion of the heathen, it must be noted that they often fought against the cruel exploitation of the native peoples by unscrupulous colonization. Still, most of them seem to have shared the view that the conquest of the world by Europeans was a victory of good over evil, of God over Satan, a holy undertaking.

While it never was an unambiguous notion nor an unmixed social blessing, *chivalry* had played an important role in the Middle Ages as a tempering influence on violence and a norm of aristocratic exercise of might. Though the sociocultural context in which knighthood had flourished gave way in the fifteenth and sixteenth centuries to post-medieval Europe, and the conduct of warfare changed with the advent of professional armies and the use of gunpowder, chivalry remained in literature and popular memory as a romantic idealization of violent behavior undertaken in the name of virtue and beauty. In much of the literature in question—for example, the various versions of the Arthurian legends—the religious dimension was central; the knight hero retained an almost-Messianic aura.

Given his military background and his service at court as a young man, it is not surprising that Ignatius Loyola imbibed and retained the symbolism of chivalry. His *Spiritual Exercises,* in the imagery attached to Christ the King and to his mother, enshrined and passed on to thousands

87. See L. Cognet, *Post-Reformation Spirituality* (New York, 1959), 53.

in subsequent generations the idealism of fighting for the honor of Christ the King or the honor of Our Lady. By the sixteenth century, however, the view of knighthood as a glorious institution had passed into romanticizing literature and religious metaphor; the Hundred Years War conveyed none of the glamor of chivalry, either to the soldiers who waged it or to the poor who were its hapless victims, and it proved disastrous to the feudal nobility.

The one instance where the retention of chivalrous imagery played a continuing and subtly influential symbolic role was in the attribution of kingship to Christ.[88] This found a theological expression in the post-Reformation prominence of discussion about the threefold office and authority of Christ—prophet, king, and priest; in emphasis on the monarchical episcopate as implementing this kingly role of Christ in history; and in devotional celebration of Christ's kingship, which culminated in Roman Catholic circles with the twentieth-century establishment of a liturgical feast of "Christ the King."

This inclusion of Jesus in the symbolism of king-leading-crusade played an ambivalent role in the process of distancing. On the one side, it infused a certain idealism and dedication into the understanding of discipleship to imagine the risen Christ fighting at one's side against the forces of evil. On the contrary, it worked to obscure the Gospel view of Jesus' Abba, a God not aligned with royal, much less military, power but instead working in the enigmatic role of a servant—as had Jesus himself—to overcome the evils of violence and domination.

CHRISTOCENTRIC SYMBOLISM

However, the devotional and liturgical attention to Christ as king was a relatively minor aspect of a growing Christocentrism that was gradually transforming the symbol world of Christianity. As early as the twelfth century there were clear signs that the anti-Arian diverting of attention from the human Jesus was being reversed. Bernard of Clairvaux and then Francis of Assisi were key but by no means isolated figures in nurturing popular devotion to the mysteries of Jesus' life and death. The Christmas crib, the Stations of the Cross, recollection of the events in the life of Jesus and Mary as people recited the rosary, focus on the Holy Land with the Crusades, honor given to what were thought to be relics of Jesus such as Louis IX's building of the Sainte Chapelle as shrine for the crown of thorns—all these and more fed into the shift

88. J. Leclercq, in *L'idee de la royaute du Christ au Moyen Age* (Paris, 1959), has provided a careful study of the development and centrality of the symbolism of Christ's kingship in the Middle Ages; no comparable study exists for the modern period.

in image of Christ that is graphically illustrated by comparing the Pantocrator of eleventh-century Romanesque art with Giotto's painting of the crucifixion or the scenes of Jesus' life in the stained glass of Gothic cathedrals.[89]

This recovering of the Jesus of history as the object of Christian faith and love marked the spirituality of the *"devotio moderna"* and of Jean Gerson, who was not only Chancellor of the University of Paris, one of the leading spokespersons for conciliarism at Constance, and a major influence in developing the mystical theology of his day, but a pioneer in providing catechetical instruction for the mass of Christians.[90] The classic expression of this Christ-centered devotion was Thomas à Kempis's *Imitation of Christ*, which was destined to have enormous effect for centuries. It was the *Life of Christ* of Ludolph of Saxony that Ignatius of Loyola read during his convalescence from battle wounds, and the *Imitation of Christ* that he discovered in his retreat at Manresa. The *Imitation* remained as a source of meditation for the remainder of his life.

The Christology of the *Imitation of Christ* would be an intriguing and revealing study in late medieval spiritual theology. There is no question but that the author—whether Kempis or Groote—treasured and advocated a very personal attachment to Christ and specifically to aspects of Jesus' historical life and death. And there is no question but that the "Lord" to whom he addressed his prayer is that same Christ. But at the same time, the constant phrasing of this address as "Lord, God . . ." indicates that the relationship he felt to Christ was that of a devoted but weak and needy creature to a mercifully loving *divine* friend. Even in the volume's fourth section on the Eucharist, with its profoundly trinitarian theology and a personalistic understanding of the *sacrifice* of the Mass that unfortunately was lost sight of in most Reformation and post-Reformation debate, it is clearly the divine dimension of Christ that makes it possible for him to be a figure of the present and not simply of the past. Theological understanding of the resurrection of Christ had not yet provided a formulation adequate to the deeper currents of Christian experience.

The *Imitation of Christ* was but one of the indications of a turn toward

89. To keep a balanced historical perspective, however, it is important to note the strong current of *theocentric* mystical experience that continues through Eckhart and the Flemish mystics and Suso into modern times, a form of spirituality that tends to move directly to union with the divine apart from explicit mediation of the Christian's relationship to Christ. The *Cloud of Unknowing* and *The Pearl*, both of them anonymously authored, are sixteenth-century classics that witness to this tradition. See Cognet, *Post-Reformation Spirituality*, 116–17.

90. A helpful listing of the characteristics of the *Devotio moderna* is provided by R. Garcia-Villoslada, *New Catholic Encyclopedia*, s.v. "Devotio Moderna."

Christ-centered spirituality. Luther's temporary attraction to Tauler's writings and his enduring appreciation for Bernard of Clairvaux, despite his aversion for much of late medieval German mysticism, seems quite clearly related to their devotion to the human Christ.[91] That a devotion to Christ was not a peripheral element in either the theology or the personal religious experience of Luther seems clearly indicated by the central role in his thought of the *theologia crucis*.[92] Luther may be the most striking example of Reformation emphasis on devotion to the human Christ, but he is by no means the only example. Insistence that Christian faith is a Christ-directed rather than a church-directed attitude runs throughout Reformation literature.[93]

On the Catholic side, one can point to the way in which the *Spiritual Exercises* of Loyola focus on contemplation of the mysteries of Jesus' life, passion, and resurrection. For Ignatius himself, Christian faith was inseparable from a personal relationship with Christ. He went to great lengths to realize his ambition of traveling to the Holy Land so that he could see the places where Jesus had lived and preached. And one of the key mystical experiences that shaped his spirituality was the La Storta vision of the suffering Jesus.[94]

Loyola is but one indication of the extent to which sixteenth-century Spanish mysticism is colored by a warmly human, even passionate, love of Christ. One thinks immediately of Teresa of Jesus and of her disciple and co-reformer of the Carmelite Order, John of the Cross. But the movement they represent was much broader, and its influence was exerted in the late sixteenth and early seventeenth century on two figures of great influence in the shaping of modern Catholic religious attitudes, Francis de Sales and Pierre de Berulle.[95]

Unquestionably, then, the remembered earthly career of Jesus functioned as a prominent symbol for Reformation and Counter-Reformation. Re-created in people's imaginations through the revival of preaching in both Catholic and Protestant circles, and through the emergence of widespread catechetical formation that printing made possible, the Jesus of history—though it was a somewhat uncritical

91. See Todd, *Martin Luther*, 93.

92. See A. McGrath, *Luther's Theology of the Cross* (Oxford, 1985), 148–81; also Pelikan, *The Christian Tradition*, 4:155–67.

93. On the "high Christology" of Lutheranism and the criticisms it received from other wings of the Reformation for supposedly endangering the true humanity of Christ, see Pelikan, *The Christian Tradition*, 4:350–62.

94. For a theological appraisal of the La Storta vision, see Hugo Rahner, *Ignatius von Loyola als Mensch und Theologe* (Freiburg, 1964), 53–108. In the same volume, 251–311, Rahner studies the Christology of the *Spiritual Exercises*. An interesting confirmation of the Christocentric orientation of Ignatian spirituality was the symbolism Loyola attached to two cities: it is Jerusalem and not Rome that is for him the "holy city."

95. See Cognet, *Post-Reformation Spirituality*, 51–54.

version of the Jesus of history—became increasingly both object of devotion and model of behavior.

However, a crucial qualification needs to be made. While Christian imagination and consequently Christian devotion were being formed by memory of Jesus' life and death, that devotion was not being directed to a historical figure of the past in the way that some Renaissance philosophers were devoted to Plato. Rather, the language used by the great religious figures of that age make it clear that they were conscious of relating personally to someone of the present. The Jesus to whom their prayer and devotion is directed is not someone removed from their lives; he is the Lord who lived and died centuries ago in Palestine but who now reigns in glory "at the right hand of the Father"; they feel that he works with them in their endeavors to establish God's kingdom. Their preaching and writing are aimed at bringing the Christian faithful to a loving relatedness with Christ.

Actually, though their theological explanation of Jesus' resurrection is inadequate, even misleading, and though their religious imaginations still place the risen Lord "up in heaven," their religious experience is involved with the risen Jesus who is present to them. Thus, Christian relatedness to God in the risen Christ is visibly working in these centuries as a counterforce to challenge the distancing of God that continued to function in ritual, in doctrinal formulation, and in ecclesiastical structures. It will take another four hundred years, until mid-twentieth century, for a critical theology of Jesus' resurrection to emerge out of scholarly New Testament studies; but that theology was already implicit in the Christology of Christian contemplation in the sixteenth century.

THE SITUATION AFTER THE REFORMATION

Central as it is, the shift of religious experience toward a more personal relationship with Christ needs to be seen as one wing of a broader development, the use of individual religious experience as a symbol of God's action and being. Augustine's *Confessions* were a classic example of God known through reflection on one's life experience, and the literature of mystical theology throughout the Middle Ages always presumed that God was known in contemplative awareness, and the sixteenth and seventeenth centuries produced widespread systematic examination of religious experience as a revelation of God's dealings with humans. Teresa of Avila, John of the Cross, Catherine of Genoa, Ignatius of Loyola—to name but a few—look to their own experience in prayer as a primary source for understanding what it is that grace is working to accomplish in their lives. Luther's "tower experience," while it probably should not be seen in isolation, is another example of

personal experience functioning as the key symbol that interprets God's dealings with humans.[96]

Still, though they represent a major reaction against the distancing of God that had been in progress almost from the beginning of Christianity, neither Reformation nor Counter-Reformation put an end to the processes we have been tracing. For the most part the theological explanations of this period are either directed to defending consecrated formulations (the *via antiqua* reasserting itself against the *via moderna*) or are moving toward a theodicy that can deal with the changes in science and philosophy. From what we have already seen, it is clear that the principal currents of medieval and Renaissance thought, Aristotelian, Platonic, or Stoic, still focus on the issue of *participation*, whether that of creation in the Creator or of the microcosm in the macrocosm. Nicholas of Cusa, a prophetic forecast of post-Renaissance reflection about the divine, is wrestling in all his writings with the fundamental issue of the participatory relationship of a finite creation to an infinite Creator.[97] Framing the relationship of humans to God in terms of the philosophical problem of participation means the understanding of that relationship is distanced at least one level of abstraction from people's religious experience. What is happening is not a movement away from the question of participation, but a greater use of mathematics than of language or logic as a model for this participation.

Despite the revolt against ecclesiastical structures that stood in the way of Christians' direct dealing with God, the period of late Middle Ages and Renaissance did not essentially diminish the distancing implicit in structures and processes that mediated, that is, stood between, the divine/human relationship. Rather, to some extent this was increased because of the extended authority granted civil rulers in religious affairs as an "established church" pattern became part of the political compromise between Catholics and Protestants. Psychologically the distancing was bound to be intensified, because civil rulers did not lay as much stress as did religious leaders on being sacraments of the divine

96. The famous "tower experience" that helped break Luther's obsession with guilt and make trust in God's mercy a source of inner peace and not just a piece of advice from his spiritual counselor, no doubt emerged from the long process of painful reflection and theological study that preceded it. The critical intellectual probing of faith and justification seems to have come in the years 1513–1518 when Luther was lecturing on Romans and the Psalms. What is important for our point here is that it remained in Luther's memory as a key "word of God" that effectively revealed to him the reality of divine forgiveness. For a critical description of this experience see Todd, *Martin Luther*, 78–79; R. Theil, *Luther*, (Philadelphia, 1955), 145–50; M. Lohse, *Martin Luther*, (Philadelphia, 1986), 149–52.

97. This is the fundamental issue that runs throughout his *docta ignorantia*. See De Gandillac, *Nicolas de Cues*, 357–378. Interestingly, Cusa's argumentation is reminiscent of Plato's *Philebus* and anticipatory of Spinoza's *Ethics*—which may say something about using mathematics as a model for philosophical analysis.

saving presence in history. At the same time, Louis XIV's claims to rule by divine right make clear the extent to which the image of the king standing between God and ordinary humans was alive in the seventeenth century.

Just as the Reformers' radical questioning of mediating ecclesiastical structures could have led to a lessening of the institutional separation of the faithful from God, so also the reaction against abuses and misunderstandings of Christian ritual could have remedied the long-standing distancing between believers and God caused by countersymbolic cult. But here, too, the gap was not closed, even by the anticultic stance taken by the Zwinglian wing of the Reformation. Instead, along with sacrament (as in Lutheranism) or instead of sacrament (as in the Reformed tradition), a cult of the Bible grew up in Reformation circles. And in Catholic circles, the result of the rubrical homogenization of the liturgy and of Trent's focus on the sacrificial character of the Mass was to reduce even further the perceived connection between sacramental ritual and the faith of the people.

Ideally, both Scripture and liturgy could have functioned sacramentally to effect an awareness of the divine saving *presence*—such was the understanding and goal of the more theologically sophisticated and religiously dedicated leadership on both sides of the Reformation. Concretely, this was not the case. However, the problem had been identified, even if insufficiently, and the polemic of the next four centuries would slowly move the Christian churches toward an insight into sacramentality. But this would require more than purely religious reflection; it would need the critical clarification of symbol which has come with twentieth-century scholarship. Under the surface, though, a religious ferment was at work and it would keep driving doctrine and theology toward closing the gap between the faith of ordinary Christians and the God revealed in Jesus as the Christ—and the heart of that ferment was increased attention, both positively supportive and negatively critical, to the originating belief of Christianity: Christ's resurrection.

9

Modernity, Science, and Religion

Among the more influential studies of modern history one must certainly list Paul Hazard's *La crise de la conscience europeénne*. Since its appearance in 1935, a number of other studies of the late seventeenth-century "crisis" have reinforced the judgment that a basic shift in worldview occurred within a few decades on either side of 1700. While it would be foolhardy to attempt a simple definition of this shift, or to suggest one or other single cause as its source, some of the changes in symbol which we have been studying were close to the center of the change. By 1750 the signs of the times were quite different than they were in 1650, and they pointed unmistakably to what we think of as the modern world.

THE RELIGIOUS SITUATION

Attitudes toward religious faith and practice were central to Europe's and America's radically shifting outlook on human life, so it is not surprising that the distancing of God was significantly influenced. As we will see, what happened was a basic transposition of the distancing process among intellectuals and in the widening circle of those influenced by movements such as the Enlightenment. At the same time, a large segment of the population tended to reject modernity and clung to the established patterns of religious belief and practice and to the distancing of the divine they involved. A basic split between traditional and modern approaches to religion became evident and increased until well into the twentieth century, when a partial reversal occurred. Thus, two processes of distancing were in tension with one another as well as with deep currents of religious experience which were preparing new grounds for reasserting divine *presence*.

Culturally the earlier part of the seventeenth century seemed truly

to merit the title of *"le grand siecle,"* particularly in the France of Racine and Corneille, and a Bourbon monarchy about to find its apogee in the reign of Louis XIV. Theologically, the early 1600s were still largely an attempt to regain the heritage of the late Middle Ages and use it selectively and polemically to confirm the diverse religious positions taken in the Reformation. The late sixteenth century had seen a resurgence of scholasticism that rivaled the developments of the thirteenth century; this continued on for several decades as a creative development in ecclesiastical circles. But in the broader cultural context there was a decided shift away from medieval patterns, as Gothic gave way first to Renaissance and then to Baroque in music, art, and architecture. The symbolism embodied in people's lives was changing at a different pace and in different ways than was the formalized theology of early modern Europe.

Revitalizaton of Catholic theology, which already had taken shape in mid-sixteenth century with the great Thomists Melchior Cano and Francis Vittoria, found its most penetrating and extensive expression at the turn of the century with the work of Robert Bellarmine, at one and the same time the greatest polemicist of the Counter-Reformation and one of Aquinas's most perceptive commentators. Two contemporaries of his, Gabriel Vasquez and Francis Suarez, were eminent theologians in their own right and perhaps more than others served to link scholasticism with modern philosophy. Suarez, in particular, influenced Leibniz and Wolff as well as Descartes, who had been introduced to him in his studies at La Fleche. Perhaps Suarez's most lasting influence on the thought of later centuries was his separation of philosophy from the theological context in which it was embedded in classic scholasticism, and his pure philosophical reflections on "human nature" and "natural law."[1] In its own way this prepared for a mitigated reception in Catholic theological circles of the Enlightenment's rationalistic explanation of nature.

In Anglican theology, Hooker's monumental *Laws of Ecclesiastical Polity*, written as the sixteenth century was ending, passed on to Jeremy Taylor and Lancelot Andrewes in the following decades a systematic theology reminiscent of Aquinas.[2] On the continent, the last decades of the sixteenth century saw a contentious development of Lutheran theology that often drew more from Melanchthon than from Luther himself. The explanation of Lutheran belief during that period took a highly systematized, scholastic form in the writings of Chemnitz or

1. On this late Renaissance scholasticism, see A. Maurer, *Medieval Philosophy* (Toronto, 1962), 347–71.

2. For Hooker's influence on the Caroline Divines, see J. Marshall, *Hooker and the Anglican Tradition* (Sewanee, 1963). See also B. Cooke, *Ministry to Word and Sacrament*, 600f.

Selnecker; and this renascent scholasticism was reflected in the 1580 *Formula of Concord* and more so in its classic theological explanation by Johann Gerhard in the first two decades of the seventeenth century.[3]

Reformed theology had already been cast in somewhat scholastic form by Calvin's *Institutes*, but for Calvin as for Luther there is an uncontested primacy granted the Bible. As Reformed theology develops, particularly in the controversy with Arminianism,[4] there is increasing emphasis on orthodox formulations of belief. This option for orthodoxy in doctrine was made official in the Synod of Dort (1618) and elaborated in the consequent development of Reformed scholasticism. "Theological formulations became the norm of Christian truth, including that of the experience of God through the Bible. Whereas Roman Catholicism insisted that the church was the interpreter of the Bible, orthodox theology now tended to be the custodian of biblical truth. Theology came before the Bible, as the key to its interpretation . . ."[5]

Within the thought-life of the mainline Christian churches and in the faith awareness of their constituents, official theology continued to formulate belief in an abstract fashion that contributed to the same intellectual distancing of God that had been taking place for centuries. At the same time, it was becoming clear by the end of the seventeenth century that ecclesiastical officials and academic theologians would no longer enjoy undisputed teaching authority among Christian believers in Europe. Pietism, established as a major movement by the efforts of Spener and Francke, spread widely in Lutheran circles and found a distinctive expression from early eighteenth century onward in the Moravian Brethren.[6] For a large part of Christianity the heart came to challenge the head as a symbol of orthodoxy, a development that was not without roots in Luther's emphasis on the fiducial dimension of faith.[7] While this emphasis on the affective side of Christian devotion found these influential expressions on the continent, it was Methodism,

3. See Walker, Norris, Lotz, and Handy, *History of the Christian Church*, 4th ed. (New York, 1985), 526–29.

4. Basically a reaction within Reformed circles against a rigid interpretation of Calvinist predestination, Arminianism remained largely confined to Holland but it triggered a broader reaction within the Reformed Church that led to the synod of Dort. For a brief summary of Arminianism, see W. Walker, *A History of the Christian Church*, 538–42; for a longer treatment see C. Bangs, *Arminius: A Study in the Dutch Reformation* (Nashville, 1971).

5. John Dillenberger and Claude Welch, *Protestant Christianity Interpreted through its Development* (New York, 1958), 97. The authors point out (97–98) the difference between this Protestant scholasticism and medieval scholasticism. The former, forced by its historical location to debate with modern rationalism, absorbs into its own methodology a considerable amount of the appeal to natural reasoning.

6. On the development of Pietism, see L. Bouyer, *Orthodox Spirituality and Protestant and Anglican Spirituality* (New York, 1969), 169–83.

7. Though some of its views have been rightly contested, Ronald Knox's *Enthusiasm* (London, 1950) traces in suggestive fashion the history of this more "enthusiastic" wing of Christian spirituality.

in both its English and American forms, that became the most wide-spread Protestant movement of evangelical enthusiam. In Catholic circles much the same impulse produced a concentration on devotions such as that toward the Sacred Heart of Jesus. To some extent, at least, this religious attention to feeling was a reaction to the more general shift to abstractness in worldview that marked the beginning of the modern world. Emphasis on religious experience blossoms in eighteenth- and nineteenth-century theology. The seventeenth century is still absorbed in the polemics of post-Reformation Christianity, polemics that had sifted down into the attitudes of ordinary people who had no real insight into the convictions they so belligerently espoused. To a degree this begins to change with the end of the Thirty Years War and the Peace of Westphalia in 1648. Even though bitter conflict would last throughout the century, for example, in Louis XIV's revocation of the Edict of Nantes and the suppression of the Huguenots, neither "Reformation" nor "Counter-Reformation" appropriately names the situation after 1648.

ASCENDANCY OF SCIENCE

Nothing can lay greater claim to being the hallmark of modernity than can science. And within the realm of science, whose gates gradually opened beyond the physical and life sciences to admit structured study of human psychology and of human society, nothing is more distinctively characteristic of the new way of viewing the world than its use of mathematics. Already foreshadowed, as we saw, in Cusanus and Leonardo da Vinci, the use of number as an *abstract* instrument of measurement gains the field from Galileo onward. With the discovery and employment of analytic geometry and calculus, mathematics irreversibly moved into a new context, leaving behind the heritage of Pythagorean mystification.

But if mathematics as used by modern science broke its links with earlier systems of magical insight, it acquired a new aura of "magic" as it became the key symbol of science's claimed preeminence in human knowing. Verification by mathematical measurement became central to scientific research, above all to controlled experimentation; but beyond that, it became a privileged criterion for "truth" and "certitude."[8] It was not accidental to his philosophizing that Descartes was a mathematical genius and that, in his search for an unassailable basis for certitude, he fixed upon attributes that are uniquely distinctive of mathematical thought: clarity and distinctness.

8. See Hazard, *Crise de la conscience européene* (Paris, 1935), 301–12.

The Machine

Intertwined with this new role of number was the gradual dominance of mechanics in the explanation of the physical world. While a magical/mystical understanding of the universe carried over from medieval times, especially in religious circles, and a view of the world as a living entity surfaced during the Renaissance and finds some resonance as late as Darwin, it was the mechanical view that gained the field.[9] From the late seventeenth century at least—Newton's *Principia mathematica* appeared in 1687—science was clearly identified with mathematically expressed mechanics. This had major impact on the symbolism of Europeans, for no symbol became more prominent in modern centuries than *the machine*, humans' technological application of mechanics. Within the world of machines, one of the most complicated, intriguing, and culturally important was the clock, which, as it became a common element of people's experience, structured the very perception of time in measurable mechanical fashion. Hours and minutes, precisely indicated by timepieces, became in most people's awareness "objective realities."

The symbol of the machine became and still remains omnipresent. In theodicy the image of the machine underpinned a supposedly convincing argument for the existence of God: certainly a machine as complicated as the world required a master watchmaker. Locke, Clarke, and the Latitudinarian preaching of the eighteenth century would appeal to this indication of the existence of God;[10] Hume would not accept the proof but would see it as the principal argument with which he had to contend.[11] Even Darwin in his younger years seems to have accepted this reasoning as he found it in William Paley's *Natural Theology*.

The pioneering theorists who established the patterns for analyzing humans' economic behavior and created scientific economics—Adam Smith, Ricardo, John Stuart Mill—may have disagreed about the precise mechanics of production and distribution, but they all worked with an implicit machine model in their theories.[12]

Even in the study of human consciousness, to say nothing of study of the human body, the machine symbol was to be found. One of the better known and influential works of the French Enlightenment was

9. On the character of the "scientific revolution" and the ascendancy of mechanics over the other two trends, see H. Kearney, *Science and Change, 1500–1700* (New York, 1971), 17–76.

10. On the accompanying loss of "mystery" in worship and preaching, see H. Davies, *Worship and Theology in England* (Princeton, 1961), 3:19–75.

11. See Part 2 in *Dialogues,* in *The Natural History of Religion and Dialogues Concerning Natural Religion,* (ed. A. Colver and J. Price (Oxford, 1976), 158–72.

12. On Adam Smith, whose *Wealth of Nations* set the pattern within which his successors worked, see R. Heilbroner, *The Worldly Philosophers* (New York, 1953), 55–64.

De la Mettrie's *L'Homme Machine* (1748), a thoroughly mechanistic ex-
planation of human psychology. Up to the present time, some psy-
chologists understand human consciousness and appetition as nothing
more than highly complex physical mechanics. Freud himself started
with the view that psychological reality could be explained by mecha-
nistic physiology, but his own creative therapy gradually weaned him
from this earlier way of modeling human consciousness.[13] The advance
of scientific research has done nothing to diminish the prominence of
mechanics and of the machine model in human thinking. To some
degree the objective reality of the physical world lends support to this
approach. The development of physical chemistry and of biochemistry
illustrate the way in which the intrinsic continuity of nature allows for
insights, theories, and accompanying models utilized in mechanics to
find applicability in other areas. There have been impassioned reactions
against the dominance of the machine in the modern imagination,
perhaps most strikingly by William Blake, but the link between tech-
nological use of machines and improvement of humans' life-style seems
to safeguard the privileged image of the machine for some time to
come.[14]

The System

Closely linked in early modern thought with the symbolism of the ma-
chine was that of the *system*; actually, one could see machine as a par-
ticular kind of system, a mechanical system that produces a desired
practical effect. That human thought was systematic was not an inno-
vative insight of the late seventeenth and early eighteenth centuries.
As a matter of fact, many of the *philosophes* of the Enlightenment, in
the name of tolerance for divergent opinions, attacked the systems of
metaphysical reflection that preceded them.[15] For centuries thinkers
had implicitly considered human knowledge a unified and organized
system. It was taken for granted that a person's ideas and opinions
should, at least ideally, be consistent with one another. Plato's later
dialogues, especially the *Sophist*, are an almost painful struggle to main-
tain such consistency. And the great medieval summas are magnificent
instances of immense amounts of learning gathered together and cor-
related into logical unity.

For the latter half of the seventeenth century, under the influence of

13. For a description of this evolution in Freud's thought, see P. Ricoeur, *Freud and
Philosophy* (New Haven, 1970).
14. See N. Frye, *The Critical Path*, 90–92; also T. Roszak, *Where the Wasteland Ends*
(Garden City, N.Y., 1972).
15. Voltaire was probably the most obvious instance of an intolerant attack on intol-
erance; see P. Gay, *The Enlightenment* (New York, 1966), 1:382–86.

Descartes, the system becomes explicitly the ruling goal of philosophical and scientific reflection. Whatever is and is known must fit into the system. Research and discovery can be triggered and guided by noticing lacunae in the system. The coherence and completion of the system serve as a criterion for judging the truth and certitude of any element of knowledge or the practical worth of any thing or any activity. The physical universe is a system on the basis of the view of Galileo and Newton that the same set of mathematically mechanical laws functions throughout the universe. Because this is so, theoretical physics must itself be a unified system of thought; the accuracy of any element of understanding is measured by its congruence with the system as a whole.

Understanding in terms of system finds a much wider application than physical science; moderns will speak from the seventeenth century of philosophical systems, economic systems, political systems, and so forth. In theology Christian rituals will be referred to as "the sacramental system." In spheres of knowledge where the influence of mathematics was not so apparent, it was logical consistency that provided coherence of thought and a criterion of truth and certitude. Yet even here the ideal of mathematical order and clarity lurks beneath the surface and comes to expression in twentieth-century developments of mathematical logic. The philosophers' dream of creating the all-embracing system of thought remains an enticing goal at least until Hegel's monumental, but not quite definitively successful, achievement.

Earlier centuries had looked on reality as consistently structured; the very notion of "cosmos" implies this. And as far back as Thales, philosophers had proposed one or other theory to explain this consistency. However, it was almost universally accepted that whatever unity a given theory about the cosmos possessed was due to the fact that it reflected rather accurately the objective reality of the sensible world or of some world of Ideas. Truth consisted in the conformity of thought to an external reality; it was that reality which judged human thought. With the modern age, particularly with the Enlightenment's worship of human reason, human thought finds within itself an alternative source of evaluation, namely, its own conformity to the absolute relationships that bind logic and mathematics into a system.

However, before such a system would find a revolutionary and immensely influential expression in Kant's *Critique of Pure Reason* at the end of the eighteenth century, the notion would be subjected to severe criticism by the first two generations of Enlightenment thinkers.[16] The frequency and sharpness of their attacks pay tribute to the early modern

16. Ibid., 134–37. On the reemphasis on "system" in late nineteenth- and twentieth-century discussion of language and literature, see Jameson's *The Prison-House of Language* (Princeton, 1972).

prominence of the system as a symbol of truth and certitude. However, the criticism was directed at philosophical figures like Leibniz, not so much because their thought was systematic, but because it was "metaphysical," because it did not have the grounding in empirical evidence that Locke or Hume or Newton stressed, and because on principle it ruled out the eclecticism that characterized much of the Enlightenment.[17]

Less polemic was generated by the notion of *method*, though it symbolized much the same thing as the notion of system to which it was closely joined. Perhaps this was due in part to the fact that the Enlightenment critics of system themselves stressed sceptical suspension of presuppositions and verification through empirical evidence as *methods* of careful thought. Even among those critical of it, Descartes' *Discours* continued to have widespread influence as a paradigm of logical argumentation proceeding out of initial scepticism. Despite the continuing stress on empirical verification, especially by the philosophes of the eighteenth century with their verbal assaults on systems of thought, the underlying quest for a method that would produce in a system can be glimpsed in the reliance upon mathematics and logic. In both these modes of thought, relationships exist a priori, built in before any human discovery or convention, waiting only to be discovered by some ultimate method that, by appearing heuristic rather than deductive, could claim the cherished attribute of "scientific."

Perhaps it is in the nascent social sciences where one can see most clearly a search for methods that would and could produce an explanation systematic enough to provide the basis, if not for accurately forecasting, at least for structurally planning the future of human behavior.[18]

Abstractions

It is when we observe the ideal of systematic measurement applied to human activity, economic or social or political, that we can begin to identify the heart of the revolutionary shift in symbolism that occurs at the crisis in European thought. As thought itself becomes the dominant object of thinking, subjected to criticism and to patterns of verification, methods of thought become formalized, and people's understanding of themselves and of their world becomes more *abstract*. More than this, the ideals to which, from the late seventeenth century onward, Europeans hitched their dreams are *abstractions*: freedom,

17. Ibid., 135. In the light of "harmony" having been a dominant Renaissance symbol, it is interesting to see its prominence in the thought of Leibniz. See Hazard, *Crise*, 221.
18. See P. Gay, *The Enlightenment* 2:319–96; also R. Heilbroner, *The Worldly Philosophers*.

equality, efficiency, productivity. These abstract symbols stirred revolutions, motivated capitalistic development, guided the organization of large corporate ventures, and animated the establishment of constitutional forms of government. Certainly, such abstractions were suggesting concrete forces at work in people's lives—they would not have been so powerfully symbolic had it been otherwise—but it is amazing to realize the social power of a rallying cry such as *"liberté, egalité, fraternité."*

But the power of such symbols may well have derived, at least partially, from the fact that they dealt with *human* activity rather than divine. These were goals that epitomized human effort, ideals that for all their abstractness and vagueness could, it was hoped, find down-to-earth realization through the dedication and ingenuity of human beings. Just as truth was to be reached by critical reasoning and verified discovery rather than by revelations from God, so also beatitude was to be gained gradually by human scientific progress. Men and women were no longer to wait for divine liberation, for equality to come with the establishment of the kingdom of God; they now could understand the forces that shaped their thought and their lives and they could themselves devise methods to attain truth and freedom and well-being.

This emphasis on human ingenuity and hard work was in stark contrast with the stress on *obedience* so eloquently advocated by Bossuet.[19] However, as Gay has suggested as the key shift in worldview that occurs at this time, the world of the eighteenth century is no longer the "enchanted" world of the Middle Ages.[20] The "world behind the world," the activity of countless good or evil spirits which explained the course of human events, that had already been challenged in the twelfth century now vanishes for the "moderns." They could now go about the task of establishing "a political system without divine sanction, a religion without mystery, a morality without dogma."[21]

Perhaps to compensate for the abstractness of these goals, the literature of seventeenth and eighteenth century embodies these ideals in certain paradigm humans, the Gentleman, the Hero, and so on. The sequence of one after another of these paradigms coming into fashion provides an interesting reflection of the sociocultural evolution taking place during these decades.[22]

19. See Hazard, *Crise*, 200.
20. "The philosophes saw the Renaissance as the first act of a great drama in which the enlightenment itself was the last—the drama of the disenchantment of the European mind," Gay, *The Enlightment* 1:279.
21. Hazard, *Crise*, xviii.
22. Ibid., 319–24.

The Ideal of Nature

But if such symbolically idealized figures allow us to observe the rapidly changing intellectual landscape of this period, the symbolic ramifications of "nature" take us deeper into the evolution of early modern thought. Nature has always intrigued humans. The earliest myths of which we have record were attempts to explain, or at least deal with, the order and the power of nature; and all such attempted explanations revealed the ambiguous character of nature. It took two Greek divinities to personify the two faces of nature: Apollo for the orderly predictability and harmony of nature's laws, Dionysius for the wild, unruly power of life that resists confinement within law.

This dialectic intrinsic to nature becomes the dominant theme of eighteenth-century thought. Basil Willey has detailed the centrality of nature as a symbol in literature, particularly English literature, of the period,[23] Hazard has pointed out the same focus in continental writings.[24] What is distinctive about eighteenth-century focus on nature is not the fact that there is such emphasis, nor even the fact that one finds it present in such diverse areas as science and poetry and preaching and philosophy. Rather, what one notices as different from previous outlooks on the created universe is that in "enlightened" circles the *created* character of the world is dimmed or disappears; nature is viewed as much more autonomous, as a law unto itself and therefore as an ultimate norm for human behavior and human progress.[25]

To quite an extent the symbols of reason and nature reinforce one another, even overlap; for the philosophers of the Enlightenment will see rational thought as that which alone befits true humanity. Nature and reason are in harmony; what is according to nature is according to reason; the rational, that is, enlightened, person will think and act in accord with the nature of the physical world and with human nature.[26] The symbolism of light, which for centuries had been used to describe the activating influence of God on human thought, is now taken over by human reason itself. As a matter of fact, the notion that a special revelation from the divine provides understanding or guidance for humans is seen by the philosophes as being part of the obscurantism inherited from "the dark ages."

23. " 'Nature' has been a controlling idea in Western thought ever since antiquity, but it has probably never been so universally active as it was from the Renaissance to the end of the eighteenth century." B. Willey, *The Eighteenth Century Background* (London, 1940), 2.

24. P. Hazard, *La pensee europeénne au XVIIIeme siecle* (Paris, 1946), 1:151–210 (hereafter cited as *Pensee europeéne*).

25. Ibid., 151–59.

26. Montesquieu develops this extensively in his *L'Esprit des lois* (1748); see Hazard, *Pensee europeénne*, 1:208–11.

Even in the last half of the seventeenth century, this rationalistic view of nature was still matched by eloquent presentations of the long-standing Christian view that nature and history were being constantly directed by a providential God, whose character and will could therefore be discerned in the nature of things and in the events of history. Louis XIV ruled, until well into the eighteenth-century, as a vicar of God and champion of true religion. Bossuet's *Discours sur l'Histoire Universelle* provides the framework for so interpreting human happenings even as John Locke in England is laying the ground for the naturalism of the next decades. It is Locke, more than any other, who establishes nature in its position of autonomous governance of reality and of thought.[27] Newton's *Principia mathematica*, appearing in 1687, provided a scientific explanation of a universe operating on immutable laws intrinsic to itself. But it is Locke, beginning with his *Essay on Human Understanding*, published only three years later, who generalizes the domain of nature and includes under it all the reality that enters into human experience, that is, all that for practical purposes exists. Locke himself remains a devoted Christian, though actually in his outlook much more a Deist. He sees the precise workings of the physical universe as an argument for God's existence—how could there be a watch without a watchmaker?—but the God in question is safely removed to heaven and sealed off from interference with the laws of nature.[28]

Natural Law

It is this idea of nature that underpins the extensive development of a theory of "natural law" that will coincide with a resuscitated Stoicism to produce an "ethic without religion."[29] Despite surface appearances of identity, this notion of natural law is different from that developed by scholasticism in one important aspect: though the scholastics, especially late scholastics such as Suarez, taught that human reasoning could arrive at the natural law, this natural law was always seen as an expression of the will of God, the divine law implanted in nature by

27. "The state of Nature has a law of Nature to govern it, which obliges every one, and reason, which is that law, teaches all mankind who will but consult it, that being all equal and independent, no one ought to harm another in his life, health, liberty or possessions." Locke, *On Civil Government* (book 2, chap. 2 in *Two Treatises on Government*, ed. P. Lazlett (Cambridge, 1960), 311.

28. "The Divine was relegated to a vague and impenetrable heaven, somewhere up in the skies. Man and man alone was the standard by which all things were measured." Hazard, *Crise*, xvii.

29. H. Rommen, *The Natural Law* (St. Louis, 1946), 70–74, sees Grotius as the turning-point in the changing view of "natural law." For a brief but provocative description of the movement from classical and medieval views of natural law through Grotius and Hobbes and then Kant to modern views, see E. Bloch, *Natural Law and Human Dignity* (Cambridge, Mass., 1986), 36–118. See also A. d'Entreves, *Natural Law: An Historical Survey* (London, 1951).

creation; and so this view of natural law fitted without difficulty into the notion of divine providence. The concept of natural law as found in Locke or Grotius is an expression of the autonomy of nature, a denial of an immanent providence.[30]

This will have a disastrous effect on people's attachment to religion. To a great extent most people's religion had long before that been reduced to a pattern of morally acceptable behavior; and revelation was viewed as God's providing humans this pattern. If it is now determined that such a pattern can and should be discovered by human reasoning, why believe in a revelation that has now been proved unnecessary? Moral behavior is no longer seen as "fulfillment of God's will" but as "accord with reason." Even religious groups will come to teach the precepts of Christian behavior under the canopy of natural law.[31]

In this connection it is interesting to reflect on Frye's contention that in the eighteenth century the previously prevalent Christian myth of concern starts to give way to a more secular myth of concern.[32] If revealed religion is threatened by recognizing reason's capacity to discover the dictates of natural law and so to direct human morality, it is undermined more drastically by the emergence of "natural religion." As understood by Locke, Clarke, and by the Latitudinarian movement of the eighteenth century, this is something quite different from the universal religion Nicolas of Cusa had proposed three centuries earlier.[33] It also is something different from the traditional view that before the advent of revelation with Israel and then Christianity there existed some natural recognition of divinity among insightful humans. What Deism and Latitudinarianism are teaching is that the only religion deserving of that name is reduceable to human conformity to what is natural. Instead of following the revealed will of God, a good Christian is one who follows the dictates of nature—which in effect means living like a respectable member of the upper classes. Instead of working for the establishment of the kingdom of God, one should work for the building of heaven on earth.[34]

30. See Gay, *The Enlightenment*, 315; he quotes Dryden's remark that "almost a new Nature has been revealed to us."

31. It is interesting to study the dynamics of the problems this raises for the Catholic church at Vatican I—when it says that revelation helps those who without it cannot grasp those truths reachable by human reason; or when, in extending magisterial authority to faith *and morals*, it raises the question of religious authority functioning in the realm of philosophy.

32. See Frye, *The Critical Path*, 50–51.

33. On Cusa's view see Gandillac, *Nicolas de Cues*, 41–43. Linked with this for Nicholas was his idea of cosmic harmony existing because the Word is the basic pattern/principle by which all things do their own work well. (Ibid., 52–56).

34. The classic study of this theme is Carl Becker's *Heavenly City of the Eighteenth-Century Philosophers* (1932). Its thesis has been seriously questioned, particularly by Peter Gay's essay "Carl Becker's Heavenly City," in *Carl Becker's Heavenly City Revisited*, ed. R. Rockwood, (1958), 27–51.

THE "HUMANISM" OF THE ENLIGHTENMENT

The obvious emphasis on "the human" in the naturalism of the late seventeenth century, already a long step beyond the humanism of the Renaissance in claiming the independence of humans vis-à-vis the divine, becomes even more pronounced in the eighteenth century with the Enlightenment. While some of the philosophes of the mid-1700s could still be classified as Deists, the movement is toward atheism. Some, like Holbach, openly espouse atheism; and Kant at the end of the century, while finding a moral usefulness for God, is intellectually agnostic and prepares for the atheistic humanism of the nineteenth century. This rapid abandonment of "divine providence" as an explanation for the happenings of nature and history is the flip side of the Enlightenment's insistence on the activity and resources of humans themselves. Unlike the fourteenth and fifteenth centuries, when humanism was grounded in a recovery of the ancient classical culture, the humanism of the eighteenth century sees itself as a recovery of the ancient wisdom but is also intentionally modern.[35] "In short, the philosophes saw the Renaissance as the first act of a great drama in which the Enlightenment itself was the last—the great drama of the disenchantment of the European mind."[36] Voltaire, Diderot, and their associates viewed themselves as the prophets and high priests of a new epoch, even as they were painfully aware of the inadequacies, even the barbarities of their age. Clearly, the connotations, that is, the symbolism, of the human underwent major shift as medieval culture gave way to the Renaissance which in turn yielded to the world of Newton and Locke, Voltaire and Kant.

One could object that the Enlightenment as a formal intellectual movement was restricted to a very small group of prominent figures, self-declared philosophers for the most part; that it did not represent the broader reality of European life at that time; and that most people continued to live with the outlook and according to the patterns that had prevailed for centuries. This contention is partially valid, but the attitudes of skepticism and irony, the acceptance of nature as an ultimate norm for practical decision, the reverence for science and its technological applications spread with amazing rapidity into Europe's popular culture. Modernity seemed to be contagious. "The word itself, the mere word *modern*, had suddenly become a sort of wonder-working shibboleth, a magic formula which robbed the past of all its power."[37]

35. On the Enlightenment's return to the classics, see the early chapters of Gay's *The Enlightenment.*
36. Ibid., 279.
37. See Hazard, *Crise*, 29.

Revolution and Progress

Any number of factors can justifiably be mentioned as causing this embracing of modernity, but certainly part of the reason lies in the prominence and symbolic power of the notion of "revolution." Toward the end of the eighteenth century, "revolution" became a catalyst in the series of violent sociopolitical realignments that stretch well into the twentieth century. Beginning with the American Revolution, animated and guided by "enlightened" Deists such as Franklin and Jefferson, through the bloody overthrow of the old aristocratic order in France and the wildfire revolutions of 1848, the notion of revolution excited and motivated people to take their destiny into their own hands and build what they hoped would be a world of justice, peace, and well-being. These hopes were often disappointed, something that is attested to by the recurrent symbol of "restoration," but the world of the late twentieth century is still the scene of massive geopolitical activity fueled by the attraction of revolution.

Revolution was not understood in early modern times as exclusively or even primarily political. Instead, the term was applied to intellectual and cultural shifts; and the basic notion was operative, if not formally expressed, in much of the Reformation. Copernicus himself does not speak of his theory as a revolution, but from Galileo onward one considers heliocentric astronomy as a revolutionary break with the past—as it was.[38] Descartes felt that a revolution in thinking was needed, and d'Alembert understood the task of the Enlightenment as that of completing the revolutionary overthrow of religion that had been begun in the preceding decades.[39] Kant will describe his own critical method, which in many ways distills the philosophical developments of the preceding century, as a "new Copernican revolution."[40] Revolution was in the air; people prided themselves on being revolutionaries in science, in politics, in mores and manners, in the arts, and—to a lesser degree—in religion. What supported hope in the benefits of revolution was the trust that human *reason* would be able to find the path to a better world, that human progress was inevitable even if somewhat slow and unpredictable. Paris in the French Revolution would witness the "goddess of reason" enthroned on the high altar of Notre Dame Cathedral.

Looking back on the unaccomplished agenda that faced the philosophies of the eighteenth century, it seems a bit strange that "human progress" should have become a dominant social symbol in the circles they influenced. Yet even Voltaire, for all his scepticism, looked for a

38. See T. Kuhn, *The Copernican Revolution* (Cambridge, Mass., 1957).
39. See Gay, *The Enlightenment* 1:319.
40. See Ibid., 1:137, on the character of Kant's revolution in philosophical method.

continuing betterment of the human condition because of the new freedom of thought. Pierre Bayle already in 1684 had spoken of the age as becoming ever more enlightened.[41] Condorcet in the midst of the Revolution, hiding from the Reign of Terror that would bring about his own death, ends the literature of the Enlightenment with his *Sketch for a Historical Picture of the Progress of the Human Mind*, in which he clings to the dream of progress even as he is uncertain about the eventual outcome.[42] The key to this expectation of human progress was the emergence of science; science was the great promise of human independence and future well-being. "Science was becoming an idol, an object of worship. Science and happiness were coming to be looked upon as one and the same, as also, were moral and material progress."[43]

From the point of view of symbols' effect on people's worldview, it is illuming to notice the extent to which the great Lisbon earthquake of 1715 shook the trust in human progress through science. Lisbon at the time was one of the great centers of European commerce, an example of prosperity and culture resulting from human enterprise, directed in its politics and diplomacy by Pombal, one of Europe's most powerful statesmen. The devastating earthquake, which killed thousands and from which Lisbon never recovered to regain its previous eminence, made it clear that human science was not yet able to protect people from the destructive power of nature. Besides, for large portions of the populace—not the "enlightened," who attempted to deal with it as an argument against providence—the catastrophe was interpreted as divine punishment, an interpretation that revealed the limited extent to which Deism and the Enlightenment had at that point changed popular understandings of divine providence.

The Golden Age

There were not many things on which all the thinkers of the Enlightenment agreed, but they were unanimous in rejecting the Christian doctrine of original sin, the notion that there was some basic wounding of human nature as a result of which humans inclined to do what was injurious to themselves and to others and because of which they were dependent upon divine help.[44] History was not for the Enlightenment

41. See P. Hazard, *Crise*, 317. For a fascinating account of the history and an analysis of the metaphor of "progress," see R. Nisbet, *Social Change and History* (New York, 1969).

42. See Guy, *The Enlightenment*, ed. Gay, 800ff.

43. Hazard, *Crise*, 318.

44. Hobbes, of course, was an exception, not in the sense that he espoused a religious teaching about original sin, but because he took a basically cynical view of human beings as aggressively unprincipled and therefore in need of coercion if social relationships were to be maintained. See J. Hampton, *Hobbes and the Social Contract Tradition* (Cambridge, 1986), 6–11.

the story of a fall from earlier blessedness; yet paradoxically, one does find frequent references to an earlier "golden age"—as a matter of fact, to two such situations when human life was more as it should be.

One of these was the situation of the "noble savages," those recently discovered humans of the Americas, for example, who enjoyed a life close to nature, uncomplicated as yet by the restrictions of civilization, following in native freedom the way to blessedness that nature itself taught them.[45] For all their rejection of the biblical account of Adam as "mythical," there is something strangely reminiscent of Eden in this age's glorification of "primitive man."

The other golden age was ancient Rome. The extent to which this age yearning for modernity hearkens back to the achievements and "the glory that was Rome" is truly striking. "Every major writer of the Enlightenment turned to the ideas and information provided by Roman culture."[46] Rome, of course, had crumbled; but Gibbons will make the case in his *Decline and Fall* that a principal cause of that decline was precisely that which Voltaire described as "the accursed thing which must be crushed," that is, Christianity.[47] The future of modernity's resurrection of Roman models can be assured only if that ancient enemy of natural humanism can be eliminated from human history.

It is interesting to speculate on the reasons why "Rome" (and that means *ancient* Rome) became such a powerful symbol in the eighteenth century. To some extent it was due to fascination with Stoicism in its Roman form that had continued on from the Renaissance, a Stoicism that glorified the rule of nature. To some extent it was a by-product of the Enlightenment's rejection of a Middle Ages that it scarcely knew and did not wish to know. To some extent it came from the search for a historical model of individual and corporate morality that was grounded in nature rather than in religion.[48] Whatever the sources of its prominence, the symbol of ancient Rome added nostalgic overtones to rather abstract Enlightenment dreams of human progress.

The Response of Experience

Enlightenment thought and Enlightenment hopes proved too abstract and too unrealistically optimistic to pass unchallenged. They were attacked or at least reacted to on both counts. Swift's biting satire cut at

45. N. Capaldi, *The Enlightenment* (New York, 1967), 25.

46. Ibid., 24. For a detailed treatment of the Enlightenment's fascination with ancient civilization, see the first three chapters of Gay, *The Enlightenment*, vol. 1.

47. On Voltaire's campaign against "l'infame," see R. Pomeau, *La religion de Voltaire* (Paris, 1969), 314–60. For a recent reevaluation of Gibbons's thesis see J. Pelikan, *The Excellent Empire* (San Francisco, 1987).

48. Such a "natural reason" grounding for morality was already emerging in sixteenth-century scholasticism. For the key role of Suarez in this development, see A. Maurer, *Medieval Philosophy* (New York, 1962), 356–71.

the assumption of humanity's native goodness, and did so more effectively because he portrayed abstractions such as greed and incompetence through symbols of Lilliputians and Yahoos and Liputians. Most readers of *Gulliver's Travels* passed the social judgments Swift desired before they became aware what these imaginary creatures symbolized.

The broader reaction to the Enlightenment's glorification of reason as nature's guide to morality and progress, and to science's explanation of nature in terms of mathematics and mechanics, came from within the symbolism of nature itself. "Natural" describes law and religion and morality, that is, what is orderly and reasonable; but it can also point to that "primitive" state of human existence and awareness that precedes formulated thought. It includes the instinctive, the emotional, what demands poetry rather than prose, what at times transcends ordinary limitations of law because it is a law unto itself, the imaginative out of which thought itself flows and without which it cannot exist. Paradoxically, it was scientific rationalism demanding verification by empirical evidence that drew attention to immediate experience, and it was experience that embodied these very anti-abstract characteristics. So Romanticism in its turn laid claim to nature.

The distance was not as great as it might seem between the Romantics' appeal to nature as justification for their emphasis on feeling, instinct, and freedom from restriction and the Enlightenment attitude toward nature. By and large the philosophes expressed in thought and life the same reluctance to have human behavior be hemmed in by outside authority, specifically by religion. Where the two views differed was in their respective approaches to discovering the dictates of human nature. Rousseau epitomizes in his own intellectual journey the tension and the overlap of the two: starting out as an associate of the Encyclopedists, especially of Diderot, he drifts toward the antirationalism of his *Emile* and comes to be regarded by some of the philosophes as a traitor to the movement. At the same time, he is a critical step in the philosophical process that leads up to the Enlightenment's culmination in Immanuel Kant. Perhaps even more importantly, his views of what it means to be human and to be human in society were destined to have a major impact on pedagogical and political theory for more than two centuries.

Beyond such explicit philosophizing about nature there was the extensive development of Romanticism in literature and the arts that stretches throughout the modern period and recurrently peaks in dialectic with a more canonical attitude to music and art and literature. In a later chapter we will discuss present-day literary and artistic criticism of Romanticism's claim to nature; suffice it for now to indicate the dominance of Nature as a cherished symbol of modernity. The emphasis on the human and on nature had an ambivalent impact on the process

of distancing people's consciousness from the divine. On the one hand, it more and more suggested that no reference to God was required to make sense of human experience or to guide human activity; on the other hand it was a move away from understanding human life too exclusively in terms of its relation to an otherworldly realm quite apart from people's lives on this earth.

THE RELIGIOUS RESPONSE

How did religion—and in the context of early modern Europe that meant one or another form of Christianity—react to all this? Were its symbols reinforced, weakened, reoriented, or simply left untouched and reduced to irrelevance by the seventeenth- and eighteenth-century crisis in European culture? As might be expected, established Christianity's posture to the new science, to the Enlightenment, and to the rush into modernity was mixed; but it was not only mixed, it was hesitant and unclear and often fearful. There were pockets of continuing growth in the most authentic traditions of the past, and some of these would prepare for a religious resurgence in the future;[49] but there was an understandable lack of insight into the character of the cultural change taking place, and a reluctance in official circles to move with it. Still, the deepening involvement of church officials in politics, due in large part to the pattern of established churches that followed in the wake of the Reformation, absorbed the attention and energies of religious leadership in secular conflicts and developments. This meant that many of the higher clergy in the churches were caught up in whatever was the symbol world of the political party in power; whereas many of the lower clergy along with their people were often living with another set of socioreligious symbols. One of the most striking instances of this split within the church was the division between higher and lower clergy that came to light in the French Revolution; *"liberte, fraternite, egalite"* sounded quite different in episcopal and presbyteral ears.

Where accommodation of churchmen to the reigning public ethos occurred, for example in Latitudinarian circles, church officials by and large thought and "believed" like Deists or philosophes, even when this was out of harmony with the religious symbols they used as celebrants of liturgy or teachers of doctrine. Many of them thought of themselves as believing and dedicated Christians, as did prominent laypersons such as Locke or Newton, who wrote in defense of religion. The question, however, was the meaning of the term "Christian"; and the response,

49. Gay, *The Enlightenment*, 1:338.

as we have seen, was that the term had become synonymous with re-
spectable living in accord with the moral dictates of human nature.

However, even among those who clung with tenacious devotion and
considerable understanding to the traditional external expressions of
Christian faith—for Catholics this meant the sacraments—the symbols
of modernity made major and often unchallenged inroads. The sym-
bolism of truth as verifiable by logical reasoning led to the development
of an apologetics that claimed to make faith itself an assent to incon-
testable arguments. Descartes was praised for providing the church with
the method of safeguarding people's belief in the existence of God.[50]
Apologists and teachers alike felt the need to explain how Christianity
was everything that "natural religion" was—and hopefully more. This
sets the stage for Baius, who introduced the modern theological un-
derstanding of "supernature,"[51] and for the still unsettled disputes about
the relationship between philosophical and theological ethics.

Relatively few observably new symbols marked seventeenth- and eigh-
teenth-century European religion. Despite Baroque embellishments to
the setting and ceremonies of liturgy, Roman Catholicism remained and
would remain very much a Tridentine church, scrupulously observing
the doctrinal formulations, liturgical patterns, and disciplinary arrange-
ments of the Council of Trent—at least on the surface. Much the same
could be said about the various Protestant communities after the end
of the sixteenth century. One major exception, however, needs to be
mentioned: "religious conversion" emerged as a prominent symbol of
Christian faith.

"Religion of the Heart"

In reaction both to the abstracted neoscholasticism of the latter sixteenth
and early seventeenth centuries and to the rationalism of eighteenth-
century natural religion, a powerful backlash of evangelical awakening
moved in waves through Europe and North America. Methodism in
England and America, Pietism and the Moravian Brethren on the con-
tinent, Quietism in France—all attest to the swing toward a more af-
fective approach to religion. This "religion of the heart" did not originate
in official church circles; it emerged from the grassroots under the
stimulus and guidance of charismatic figures such as the Wesleys or
Zinzendorf, and Madame Guyon, and not infrequently it ran afoul of
church officialdom.[52] It was very much a matter of individuals "finding

50. I recall seeing, in the mid-1950s, a plaque on the wall of Saint Germain-de-Pres in
Paris that read "To Rene Descartes who by the rigor of his method saved the faith for
France."
51. See H. de Lubac, *Surnaturel* (Paris, 1946), especially 15–37.
52. See Hazard, *Crise*, 335–434.

God" in their own religious experience; and while there was a sharing of individual experience of spiritual awakening in small communities such as the Pietist conventicles or larger gatherings such as Methodist evangelical meetings, the principle of community and the credential for being Christian was that of personal *conversion*. So, for large numbers of devoted Christians it was conversion rather than a distinctive body of doctrine or participation in a specified ritual or even membership in a particular denomination that symbolized for them what it meant to be Christian. No place was this more widespread than in the United States; it made possible that somewhat unusual phenomenon of millions of people being generically "Protestant" in their faith and, especially in small town U.S.A., attending whatever Protestant church happened to be available. Over the centuries, conversion has lost little of its power as a religious symbol. The present-day prominence of "born again Christians" attests to this.

Quite a different emphasis on individual religious experience was to be found in the largely French development of Quietism.[53] Even though its immediate effect touched a relatively small group of upper-class Catholics, it was symptomatic of the reaction against the notion that human effort and human reason could replace divine grace and revelation. The spiritual ideal it preached—utter self-emptying and openness to divine self-giving—quickly exerted an influence in circles of "mysticism" throughout Europe. To some extent, its spread was fostered by the notoriety given the dispute between Fenelon and Bossuet and by the consequent papal condemnation of Quietism. Though officially condemned, this French expression of "religion of the heart" passed on to modern Catholicism the symbol of *emptiness*, emptying oneself of all but God as a goal of asceticism, prayer, and personal devotion. Most devout Catholics, however, did not follow this route; instead, like the majority of their Protestant counterparts, they experienced their relationship to God through family and local religious customs, through the heritage of festivals and rituals and family prayer that still made up a large part of the pattern of their lives.

Loss of Meaning

Religious experience continued to play a key role in the lives of millions, but there is considerable evidence that for many more millions the experience of being "Christian" was largely emptied of religious meaning. If the eighteenth-century reduction of Christianity to some form of natural religion spread so widely and with relatively little challenge,

53. On the struggle between exponents of quietist abandonment to God and advocates of a resurgent asceticism, see H. Bremond, *Histoire littéraire du sentiment religieux en France* (Paris, 1928), vol. 8.

it was because religious faith and practice had meant little more than this in most people's lives.[54] There was an emotional and cultural attachment to celebrations of Christmas and Easter, to christenings and church weddings and Christian burial, even to churchgoing with singing of familiar hymns and listening to familiar moral exhortations; but this involved little, if any, understanding of or interest in the mystery level of Christian faith.[55] Yet, one has to be careful in making too simple a judgment in this regard, because beneath these appearances there seems to have lurked a deeper spiritual sense and deeper spiritual longings that preachers such as Whitefield or Jonathan Edwards could tap during the Great Awakenings of the eighteenth century.[56]

Ritual languished, and official teaching in the churches did little to bridge the growing chasm between established forms and people's actual religious experience. Most academic theology was of even less help, for theological faculties found themselves either bogged down in confessional polemics, or providing explanations of the reasonableness of Christian belief and practice, or trying to counterattack the Enlightenment through rational "proofs" for the existence of God and the verity of Christianity. In academic circles religion and theology were increasingly looked on as irrelevant remnants of medieval obscurantism; before long, theology found itself exiled from most university faculties of arts and forced to take refuge in divinity schools or independent seminaries. Lip service was paid to the importance of theology as long as it stayed in its assigned place and did not interfere with "the intellectual life." The symbolic import of "theology" in academe was radically changed from what it had once been.

EARLY MODERN DISTANCING OF GOD

Before going on to a closer look at the way in which Christian symbolisms develop in the nineteenth and twentieth centuries, it might be helpful

54. On the widespread secularization of life in the eighteenth century, See Gay, *The Enlightenment*, 338–41.

55. See Gay, Ibid., 353, where he links the ebb of religious fervor to estrangement from the medieval heritage of symbolism.

56. Peter Gay's observations are worth quoting: "To speak of the secularization of life in the eighteenth century is not to speak of the collapse of clerical establishments or the decay of religious concerns. The age of the Enlightenment, as the philosophes were among the first to note, was still a religious age . . . In country after country social and political conflicts were still fought out on religious issues, and there were many thousands of educated Europeans, Protestant and Catholic alike, who believed in the efficacy of prayer, the blessings of monastic life, or the Thirty-Nine Articles . . . To speak of secularization, therefore, is to speak of a subtle shift of attention: religious institutions and religious explanations of events were slowly being displaced from the center of life to its periphery (ibid., 1:338).

to relate the symbol shifts of the seventeenth and eighteenth centuries to the distancing of God from Christian religious experience.

The shifts were truly revolutionary; the entire context of the problem was altered, the very nature of the distancing became different. Obviously, no cultural transformation of this magnitude occurs without a previous period of germination; and in this case one can point to a long period of gradual preparation. However, the rapidity and the breadth of the change that happened around 1700 is remarkable. What occurs with modernity is no longer a blockage of human approach to the divine by *moving in* ritual or ecclesiastical officials or philosophical/theological reflection as necessary mediators between people and God; rather, God is *moved out*, quite literally put at a distance in people's imaginations. In Deism the divine existence is not denied but divine presence is rendered unnecessary by nature's governance of the physical universe and human affairs; as atheism grows more prevalent, even metaphorical understandings of the divine are rejected along with acceptance of God's existence, and religous symbols obviously have no function to perform. Hazard has aptly entitled a chapter of his study of the eighteenth century "God on Trial."

New Meanings, New Experience

New symbols did emerge in these centuries, but the more profound change came through old symbols taking on a radically new significance. By the middle of the eighteenth century nature, law, and science all came to mean something very different from what they had meant to medieval or Renaissance thinkers; by the end of the century that new meaning was rapidly becoming part of the worldview of women and men at all levels of European sociey. Though it would take some decades to become apparent, the most radical shift was taking place at the very heart of religious belief, in the connotations attached to "divine providence," that is, in the meaning of "God-for-us." Instead of discussing the character of God's saving activity in human life, much of the educated populace of Europe and America began to argue about the effect of thinking about a saving God. Kant's reduction of human awareness of God to a transcendental Idea would bear fruit in a succession of claims about the "death of God"; and it would also prepare for the attack of Feuerbach and Marx on "God" as an alienating symbol.

Concomitant with this intellectual threat to Christianity, another path to the divine survived and seemed to grow stronger in reaction to Deist and Enlightenment attacks on revealed religion; this was the path of faith experience in which believers relate to a God who is *present*. Throughout Christian history, along with developments in liturgy or doctrine or church institutions that contributed to make the divine

distant, Christians' relationship to God, when it was genuinely personal and not just routine religious practice, involved some sense of God being "with us." This obviously did not completely square with images of God being up in heaven, but for most people an unformulated sense of divine omnipresence kept this inconsistency in "divine geography" from becoming a conscious problem. However, there was a sense at times such as the late Middle Ages that the externals of religion somehow blocked the immediacy of God in Christ; this spiritual uneasiness animated the *devotio moderna* and much of the thrust of both the Reformation and the Counter-Reformation. With the rationalism and natural religion of the eighteenth century, the sense that familiar relatedness to God was being threatened led in some circles to increased emphasis on God's presence to people of faith. However, consciousness of the proximity of a caring God found much, if not most, of its nurture apart from the traditional ecclesial structures of doctrine or liturgy; "genuine" faith became more individualistic. The question then becomes unavoidable: why bother with such things as dogmas and liturgy and bishops? For that matter, why bother with the church?

The Meaning of Eucharist

A specific element of this question dealt with the impact of liturgy, and especially eucharistic liturgy, in post-Reformation Europe. Eucharistic celebrations had been from Christianity's inception the primary context for Christians' experience of divine presence—the Matthean saying, "where two or three are gathered together in my name," probably has for its referent the primitive Christian assemblies for "the breaking of the bread." The sixteenth century, however, saw a break with the tradition of Eucharist. Particularly in Reformed and free church communities, there was a deliberate movement away from sacramental liturgy and toward Bible-centered worship services. The Mass became a symbol of division between Catholics and Protestants; and even though much of Anglican and Lutheran worship still retained eucharistic liturgies, the general trend of modern Protestantism has been away from ritual.[57]

For believing Catholics and, mutatis mutandis, in other Christian churches where the Lord's Supper was celebrated, there remained in modern times a strong consciousness of Christ being present in eucharistic gatherings. At the same time, the evidence suggests also that for Catholics this presence was associated almost exclusively with the consecrated elements of bread and wine. As we saw already, the consecrated bread had come to function as an icon, and the liturgical action

57. On the disastrous results in today's world, particularly in the educational enterprise, of this loss of ritual, see E. Fromm, *The Sane Society* (New York, 1967), 298–305.

of the Mass was performed in order to provide this icon for the community to worship. The very word "Eucharist" had come to designate the consecrated species rather than the liturgical celebration, and theological explanation of the liturgy focused on the moment of transubstantiation. External ceremonies of the liturgy had been to a large extent shaped by patristic and medieval culture, but "by the eighteenth century unbelievers and believers alike had lost the key to the symbolic language of medieval Christendom."[58]

Logically this reinforced people's perception of the Mass as a spectacle, and Baroque developments in church music and art and architecture reflected and intensified this perception. The complexity and artistic profusion of Baroque altars is such that the essential element of the table almost escapes notice. People's attention in Baroque churches is drawn by the ornate decorativeness of sanctuary furniture and by the cupola painting that was designed to carry the experience of people up beyond the building itself to a contemplation of heavenly reality. Protestant architecture in its relative austerity escaped such Baroque and Rococo distraction but clearly moved the congregation's attention from altar to pulpit. Protestant churches in large part were meant for hearing rather than seeing. Even the development of religious music reflected the bifurcation of Christians' experience of worship services: either into attendance at a liturgical performance by professional celebrants and professional musicians, or into a context where hymns reinforced the call of sermons to conversion or intensified devotion. In many ways, creation of sacred music that was intrinsically integrated with liturgy ended with Palestrina in Catholicism and with Bach in Protestantism.

For most Catholics the Mass was experienced as something that had to be attended as a grave religious obligation—in fulfillment of a law of the church. For a minority it functioned as a privileged occasion for coming into relationship with Christ. Even for these latter, however, much of their religious devotedness was channeled into other devotional practices. The extent and importance of such devotions, for example, to the Sacred Heart or the Precious Blood, can be seen in the fact that new religious congregations came into existence bearing these names. Competing with these Christic devotions, and often overshadowing them, was a proliferation of devotions to Mary and other saints. Such veneration had, of course, long since come to dominate the liturgical calendar, and was so entrenched in folk religion that celebration of saints' feast days continued on in some Protestant regions long after the Reformation. What was distinctive about modern developments was a broad attention paid such devotional practices in *official* teaching and

58. Gay, *The Enlightenment* 1:352.

exhortation and subsequently in theological reflection. Along with this there emerged a new public role for private revelations; this was witnessed to most dramatically in the nineteenth and twentieth centuries by Lourdes and Fatima. Devotional practices continued to be a major factor in distancing believers from the divine, for all too often people's prayer stopped at this level without going further to contact the God revealed in Jesus.

There remained the alternative avenue of personal contemplative prayer. For the most part, though, this was considered to be reserved for "professionals," the ordained and the members of religious congregations. The laity were considered to be incapable of such a mystical approach to God; they were to find their path to God through the mediation of these professionals, through observance of church laws, and through devotional practices of one kind or another. In such a context it is difficult to see how sacramental liturgies could have other than peripheral symbolic impact. For the most part these rituals had a tenuous experiential link with the remainder of people's lives; religious practice was something additional, an "extra" obligation rooted in one's family and cultural inheritance. Theoretically the Christian churches clung to the notion that public liturgy possessed a certain primacy in people's life of prayer; the public nature of such prayer was said to bestow a special efficacy. Yet, the theory found scarce verification in reality; even among the ordained there were many who performed the rites with little insight into their nature or meaning and who were therefore little affected by them.

With liturgy no longer providing the cultural context in which people's experience was interpreted and its apparent meaning either challenged or confirmed, what did fill this role? As we will suggest a bit later, the *theater* became increasingly the mirror and even an arbiter of society's moods and questions and worldview. Certainly, the great Greek dramas, the medieval morality plays, and the classic French theater of the seventeenth century both reflected and shaped the ethos of their day, but a new symbolic function, a more direct relationship of theater to life emerges in the nineteenth and twentieth centuries with the emphasis on "realism" in dramatic presentations.

NINETEENTH AND TWENTIETH CENTURIES

By the beginning of the nineteenth century institutionalized Christianity, both Catholic andProtestant, was clearly imperiled. Not only was it staggering under revolutions of various kinds, it gave signs of being an outdated shell of doctrines and practices divorced from inner meaning and faith. To many people's surprise and to others' chagrin, the

churches rebounded rapidly in the course of the nineteenth century. In the light of history one can see that the apparent revitalization did not occur, at least for the most part, through creative interaction with modernity. Instead, it sprang from many people's sense that things had gone too far in Enlightenment and Deist attacks on Christianity, that something precious was endangered by rationalistic naturalism and by the critical methodology and mentality of modern philosophies. Traditional circles embraced Chateaubriand's *The Genius of Christianity* as the response to the *Encyclopodie* and as reassurance that all was well with the churches. But what was most well and what promised most for the future, for example the insights of Moehler or Newman, was not yet recognized by official church leadership. Ecclesiastical reaction to intellectual, cultural, political, and economic developments tended to be defensive and unimaginative.

In many respects the nineteenth century was for most Christian thought a time for sorting out and coming to terms with the radical shifts of the previous two centuries. Science and modernity established themselves even more deeply in European intellectual circles as symbols of humans' capacity to deal with life rationally and autonomously, and conversely connoted the irrelevance of Christianity as an historical fossil. Professional historians refined their efforts to free the memory of the past from legendary and mythic accretions and to discover rational patterning in the happenings of past and present. Progress continued to be a pervasive symbol in such historical accounts, a thread of integrating intelligibility in attempts to explain human affairs.[59]

Despite its toll of suffering and degradation, the Industrial Revolution was interpreted by most chroniclers of the modern world as progress toward a new promised land, as the beginning of unprecedented well-being created by the machine. Dickens's novels might draw a different picture for perceptive readers, and *The Communist Manifesto* might sound the summons to workers to overthrow the oppression of capitalistic exploitation; but even Marx's critical analysis of history was grounded in an almost naive trust in a progressing and inevitably successful dialectic. Matthew Arnold could see development of "culture" as a bright hope for progress in the modern world, even if he then balanced that with the pessimism of the final lines of *Dover Beach*.[60] Spengler's *Decline of the West* would appear only in 1918 and Toynbee would follow in 1939 with *A Study of History* and its theory that extensive bureaucratization, such as that taking place in the industrialized West, was a symptom of civilization on the way to extinction. But it would take the trauma

59. On nineteenth-century literary expressions of "progress" and their link with Darwinian evolution, see Frye, *A Critical Path*, 85–91.

60. On the ambiguity of Arnold's hope for culture as a revolutionary force, see ibid., 72–73.

of the Spanish Civil War, Nazism and the *Shoah,* and two World Wars to make such sugggestions credible.

Schleiermacher and Liberal Protestantism

With two major exceptions, nothing innovative emerged during the 1800s to alter the symbols by which the Christian churches lived and understood themselves—the two exceptions being the development of Liberal Protestantism and Darwin's formulation of a theory of evolution. Liberal Protestantism brought into being a new context *within Christianity* for the use and interpretation of classic Christian symbols.[61] Its beginning is generally associated with the name of Friedrich Schleiermacher. This formulation of Christian faith and practice was hailed by some as the wedding of Christian faith with modern thought and decried by others as the betrayal of authentic Christian faith. However one wishes to judge it, Schleiermacher's *On Religion: Speeches to Its Cultured Despisers* was an epoch-making intrusion into the agnostic world of early nineteenth-century German intellectuals. To these "cultured despisers" Schleiermacher proposed—and continued to propose in later writings—a new *humanistic* justification for religion. Though considering himself a faithful Moravian, Schleiermacher was not proposing an argument for accepting any specific form of Christianity; he was not even suggesting acceptance of Christianity. The religion he was advocating for his unbelieving fellow-academicians—and for anyone else who wished to listen—was more generic; indeed, it was universal, for it was each individual's honest response to his or her "religious feeling." This had all the universality of Locke's "natural religion" and so an aura of respectable rationality, but it was grounded in religious *feeling* and so could resonate with the attitudes and aspirations of Romanticism.[62] It could honor the primacy of religious experience but give that the respectability of an essentially philosophical explanation, and in this way exclude undisciplined and unreflective religious enthusiasm. One could embrace both Kant and the Christian gospel, for one now realized that the gospel really announced a God who was the fulfillment of humans' religious sense and who was revealed as such in the subjective experience

61. On Liberal Protestantism see C. Welch, *Protestant Thought in the Nineteenth Century* (New Haven, 1972).

62. Few terms have been more debated and received more divergent interpretation than Schleiermacher's notions of "feeling" and "piety"—from R. R. Niebuhr's rather sympathetic interpretation in *Schleiermacher on Christ and Religion* (New York, 1964, especially 180–96) to Karl Barth's rather prickly, questioning explanation of Schleiermacher's introduction to *The Christian Faith* (in *The Theology of Schleiermacher,* ed. D. Ritschl [Grand Rapids, 1982], 211–24), to the trenchant critique by Max Scheler, in *On the Eternal in Man* (London, 1960), 284–90. On Schleiermacher's own attempts to clarify some of the ambiguity, see his two letters to Locke in *Friedrich D. E. Schleiermacher. On the 'Glaubenlehre,'* trans. and ed. J. Duke and F. Fiorenza (Chico, Calif., 1981).

of religious belief. Authentic humanism and authentic religion were allies, not opponents. Religion could once more have positive symbolic value for a modernity bent on progress through autonomous human creativity.

The French Situation

However, Liberal Protestantism was but one facet of the nineteenth century's response to the Enlightenment and to the revolutionary spirit that carried over from the preceding century. A somewhat different scenario unfolded in France. After swinging from Louis XIV to the Revolution and Napoleon, the pendulum of social change moved back to attempts at restoration of the *ancien regime*. Ecclesiastical institutions proved a bit easier to reestablish along prerevolutionary lines than was the case with civil structures. The latter had been irrevocably altered by the upheaval at the turn of the century, in their external forms but even more in the underlying national mythology and symbols that supported them. Even the imperial symbols of the Napoleonic era were devoid of the sacrality attached to earlier monarchy. Monarchist restoration was a losing cause.

National symbolism pointed now to the power of the people's choice, to a social contract rather than to selection by God as a chosen people, with a leader who was God's vicar. Napoleon found, through the political blunder of dragging Pius VII to Paris for his imperial crowning, that among the general populace the powerful symbolism of the sacred attached not to him but to a pope who was politically powerless. The cultural divorce of church and state had been quite effective; but this had not meant that the former had ceased to exist. Catholicism continued on very much as "holy *mother* Church," even when her motherly directives were benignly neglected by much of the upper levels of French society.

By and large Catholicism, not just in France but in other traditionally Catholic countries as well, continued to live and prosper through the symbols it had inherited from the Middle Ages and Trent. Slowly, however, the questions raised by liberal research and theology, most of which was taking place among Protestants, would confront Catholic thought and lead to the modernist crisis of the early twentieth century.

Darwin and Development

Before that crisis occurred, another major challenge—for all the Christian churches—appeared with the publication in 1859 of Charles Darwin's *Origin of Species*. Darwin was not the first to propose a theory of evolution—Lamarck for one, in his *Philosophie zoologique* (1809), had suggested an evolutionary explanation for the appearance of various

species. But the rejection of teleology and of a plan that was intrinsic to Darwin's theory of "natural selection" involved a radical denial of Christianity's interpretation of *time*. Evolution as explained by Darwin merged with the symbol of autonomous nature developed in the preceding two centuries; and natural selection rather than divine providence rapidly became the symbol by which the sequence of physical and human existence was understood. No other notion has exerted greater influence from mid-nineteenth century until now than has evolution; it has found application far beyond biology and it has modified cosmic, psychological, and anthropological symbol systems.[63] While it was the apparent conflict of Darwin's theory with the Bible that drew the attention of religious leaders in the decades after the publication of *Origin of Species* and *The Descent of Man*, the more lasting challenge of Darwinism lies in its impact on the symbolic dimensions of human experience of time. It is important to bear in mind, though, that evolution itself emerged within a broader awakening to the notion of "development." At roughly the same time as Darwin, Schleiermacher and Moehler in Germany were using the notion of development in their explanation of Christian doctrine, and Newman was writing his *Development of Dogma*.

Not only evolution but development was suspect in religious circles—for one thing, because it raised the threat of relativism in doctrine and in ethical norms. In reaction there was a noticeable increase of official emphasis on the unchangeableness of dogma, ritual, and ecclesiastical institutions. "Stability" and "permanence" became important elements in the symbolism attached to the church, especially to Roman Catholicism.

The Power of the Papacy

If there was not much introduction of new religious symbols in the nineteenth century, this does not mean that the situation was stagnant. Some of the centuries-old symbols conveyed quite a different message by century's end than they did in 1800. For Catholicism particularly, the symbolism of the papacy, and concomitantly the symbolism of "the Church," underwent dramatic change. A symbol of impotence during the decades when the Gallicanism of Louis XIV and the Josephenism of the Austrian Emperors threatened to sever much of Catholic Europe

63. Probably no one has more imaginatively suggested the synthetic power of "evolution" as an interpreting and organizing idea in contemporary thought than Pierre Teilhard de Chardin. His breakthrough writings have now received widespread acceptance as orthodox, and he is commonly regarded as a pioneer in bringing together scientific and theological reflection about human origins; but in his lifetime he faced condemnation and ostracism from church officials—a sign of the fear aroused in religious circles by the notion of evolution.

from its ties to the papacy, a symbol of persecution by rampant forces of evil during the pontificate of Pio Nono, popes had again become by century's end a strong guiding force in the Roman Catholic church worldwide and respected moral spokesmen in judging the modern world. The pope remained a sign of division within Christianity; the papacy as an institution continued to be a standard object of Protestant theological attack. But Protestant Christians could no longer consider the papacy the prime enemy; the eighteenth century had irrevocably shifted the debate from the legitimacy of this or that particular church to the more basic questioning of Christianity as a whole.

Because of its clear and constant claims to ultimate religious authority and power, crystallized in the decrees of the First Vatican Council that dealt with the jurisdictional primacy and the infallibility of the bishop of Rome, the pope has become a paradigmatic figure in the whole modern realignment of power and authority in human society. Two different models of the human search for truth had been in tension from at least as far back as the twelfth century, but modernity's insistence that truth can be gained only by a process of *discovery* through careful use of scientific methods was an open attack on the traditional view that religious truth came through acceptance of authoritative teaching. Vatican I's confirmation of the latter model served to harden the division between the two views and to isolate official Catholic thought still further from much of modern scholarly research. But it also left unanswered questions about the relation between the teaching roles of official leadership and theologians in the Catholic church itself. Though mitigated somewhat by Vatican II, the symbolism of the papacy in the area of religious teaching remains that of a God-given authority ultimately beyond challenge by scientific research.

Less intrinsic and less blatant is the continuing symbolic link of both papacy and episcopacy with aristocratic power. Not that remnants of the older claims to temporal power still remain; but not all the aura and trappings of "princes of the church" have vanished, particularly from the Vatican. Beyond all this is the basic claim to the power of mediating salvation, a claim directly opposed to the naturalistic humanism coming from the Enlightenment, a claim that draws for its effectiveness upon the symbolic power of sacrality. In a world where kings were disappearing and aristocracy was losing most of its prestige and privileges, the pope endured as a "sacred" personage. The mix of sacral power and temporal powerlessness was nowhere better illustrated than in Pio Nono.

"Miracle"

Despite Vatican I's reassertion that authoritative teaching was sufficient justification for the truth of Christian doctrine, Catholic fundamental

theology had accepted the eighteenth-century contention that religion had to justify itself rationally and in the nineteenth-century controversies with "rationalism," the theologians developed a detailed argument to establish the claim that Jesus was God-sent as savior and final revelation and that the Church was the divinely established bearer of his gospel and his mission. Central to the entire structure of fundamental theology was the argument from miracles, particularly the culminating miracle of Jesus' resurrection. Attacks on religion's appeal to miracles flowed logically from science's view of the absolute character of the laws operative in Newtonian physics—the world of Newton leaves no place for miracles, if one views a miracle as a suspension of the laws of nature. In addition, increased modern attention to the subjectivity of human perception led to the contention that experience of the miraculous was only a faith interpretation of a normal happening.

So, until at least mid-twentieth century, the notion of miracle became a key symbol of the controversy over Christianity's claim to divine institution. It functioned symbolically to distinguish positions within Christian belief as well as to separate Christians from the "cultured despisers of religion." Within the theological world of liberal Protestantism there developed very early a criticism of biblical accounts of miraculous happenings; while the term was not used, a demythologization of miracles was under way decades before Jonas or Bultmann. Very early in the controversy, the resurrection of Jesus took center stage; quite obviously, it was the critical miracle upon whose actuality Christianity's claims seemed to stand or fall. What was not realized at the time, largely because New Testament exegesis had not yet advanced far enough, was that the "the resurrection of Jesus" as understood by those involved in these nineteenth and twentieth century arguments was an *interpretation* (actually several differing interpretations) of the event that began Christianity. In modern polemics resurrection had come to symbolize something other than what it had symbolized for the earliest Christians. This has become evident very recently through scholarly research into the nature of "the Easter experience" of the earliest Christians, with the result that the entire context of discussion is shifting.[64]

"Jesus Christ"

As one looks back on nineteenth-century developments in the Christian churches and more specifically on developments within theology, it

64. One of the most detailed instances of this recent reexamination of the "Easter event" is found in E. Schillebeeckx's two volumes *Jesus* and *Christ*. The breakthrough shift occurred a bit earlier, in mid-twentieth century, exemplified in Kunneth's *The Theology of the Resurrection* (London, 1965), F. Durrwell's *The Resurrection* (New York, 1960), and Schillebeeckx's *Jesus, the Sacrament of the Encounter with God* (New York, 1963).

becomes apparent that the symbolism associated with miracle was pointing to something deeper, to the changing symbolism of Jesus Christ and God. This was at the very center of the tension between Liberal Protestantism and more traditional mainline Christianity; no challenge to the enduring truth of Christian belief was more basic or more threatening.

Sooner or later, the results of careful textual and historical studies were bound to challenge Christian theologians to reexamine their understandings of Christian origins. The Reformation had already represented some movement in this direction, as Catholics and Protestants worked to shore up their respective positions by differing readings of the New Testament literature; but most of this and of subsequent post-Reformation polemic dealt with ecclesiological issues. These debates about the Church did implicitly involve christological issues, but it was only with the eighteenth century that the divinity of Jesus was widely and explicitly questioned.

Obviously, those who espoused atheism did not see Jesus as more than an admirable human teacher; but a rapidly widening circle of public figures and influential thinkers who identified themselves as good Christians no longer attributed anything beyond purely human wisdom or virtue to Jesus. The "lives of Christ" of Strauss (1835) and Renan (1863) were strident instances of attack on the belief that Jesus was either Christ or Lord; but many of the more moderate New Testament scholars who rejected Strauss and Renan worked with critical methodologies that raised questions about the mythic or legendary character of the New Testament depiction of Jesus. Subtly but consistently, the figure of Jesus of Nazareth became for a large segment of Christianity a symbol not of a revealing God but merely of human life lived idealistically and in relation to the transcendent. More generally, even among those who retained belief that the appelation "Son of God" had divine implications when applied to Jesus, there was increasing acceptance of the full humanity of Jesus with the result that humanness played a more prominent role in the symbolism connected with the name Jesus Christ. To a very limited extent, for many religiously practicing Christians the symbolic resonance of Jesus Christ was touched by shifts in liturgical forms and understandings and by theological/exegetical research into the meaning of the resurrection—but by and large this is a shift that began less than a half-century ago and is still too new to assess. Perhaps the most revealing symptom of the symbol shift that has occurred with regard to Jesus is the dramatic reversal in the symbolism of his mother, Mary, in the past two decades.

"God"

This changing symbolism of the name Jesus Christ inevitably affected the meaning conveyed by Christian use of the term "God." However,

another development rooted in the philosophy of Immanuel Kant has had for the past two hundred years a more far-reaching influence on philosophical and religious views of God. Intellectually agnostic about the noumenal reality of the divine, God-outside-my mind, the *Critique of Pure Reason* gives God, along with "world" and "self," the status and role of an overarching structure of thought, a "transcendental Idea." Not just in the German idealism derivative from Kant but in a wide range of European thought influenced by him this meaning of God has become an unchallenged assumption. As a result much of the discussion about God, and much of the attack against religious faith in God that has been labelled atheistic has really been directed against the *idea* of God. Feuerbach and Marx are striking illustrations: each points in his distinctive way to the psychologically destructive impact of a particular understanding of God on people's individual and social consciousness, and it is clear that what they are talking about is the symbolic force of God as preached and believed in by the churches.

CHALLENGING THE FOUNDATIONS

Though very few people perceived it, criticism of Christian symbolism had already in the 1800s touched the very foundations of Christianity and forecast the shifts in faith and worship and life-style that would emerge in the post–World War II churches. Much of European and American life in the 1800s was far from tranquil, but by century's end things seemed to have settled into a pattern of peaceful progress. However, forces of drastic cultural upheaval were straining to break out of old forms that still restricted them. As often happens, the earliest manifestations of this new spirit had come in the arts; in the architecture of Gaudi, in impressionist and abstract painting, in the symbolist poets in France, both classicism and romanticism were being transcended as a new socially creative thrust began to find symbolic expression.

One might expect the liturgy, because of the symbolic character of ritual, to have prophetically reflected this cultural ferment. For the time being, however, there was no perceptible movement on this front. Catholic liturgy remained frozen in its Tridentine forms; Protestantism remained for the most part attached to a post-Reformation indifference or even hostility to ritual.

Theater

Instead, the theater filled part of this lacuna and, even more obviously than other art forms, pointed to the ferment in Western society. At several points in history the theater of the day gives us an important insight into the forces shaping a human culture: the great Athenian

dramatists wrestled with the questions of fate and evil and wisdom as these were being raised in the context of Greece in the sixth to fourth centuries B.C.E. Medieval miracle and morality plays provide an irreplaceable glimpse of the imagery and understanding that functioned at the popular level of a culture that was pervasively religious. Shakespeare's plays are a window on Elizabethan England, as are the plays of Racine and Moliere for the France of Louis XIII and XIV. But in several aspects the modern theater has played an unprecedented role in reflecting and molding the underlying dynamics of society.

Modern theater's distinctiveness as a cultural force is rooted in the emphasis on realism that surfaced in France of the 1820s and 1830s, with Victor Hugo as chief spokesman, and has continued to the present time. This break with the theatricality of traditional theater, especially with the classic French drama of the seventeenth century, found confirmation in Emile Zola's advocacy of naturalism in his preface to *Therese Raquin* (1873) and in Strindberg's 1888 introduction to *Miss Julie*.

Yet, realism did not take over as an unchallenged approach to theater. It was balanced by the neoromanticism of Wagnerian productions at Bayreuth (from 1876 onward) and by a symbolist movement in theater that emerged from the symbolist school in France but quickly spread to other countries. Interaction between the various trends was widespread, so much so that it is almost impossible to situate many of the major playwrights in one or another school. Strindberg, for example, published his symbolist-expressionist *The Dream Play* in 1902, only fourteen years after *Miss Julie*. "The modern stage has not reached any noticeable equilibrium: conflicts and confusions have abounded, an almost continuous state of crisis has existed in the theatre, and the search for new forms of dramatic art has gone on both with and without fanfare."[65] Still, throughout this constantly fluctuating development the basic pattern is a dialectic between realism and one or another symbolic approach, whether the latter be symbolist theater as such or impressionism or Wagnerian opera or Brecht's epic theater.

Both sides of the debate seem to be seeking the same goal: to provide a deeper and more accurate insight into the meaning of the lives of modern humans. Though many plays and their staging—scenery, lighting, costumes, and so on—were impressionistic, with little easily recognizable resemblance to reality, their elimination of all but a few salient details was a *selective* realism intended to direct attention to some key element of contemporary experience. Even in those cases where plays and their staging were abstract in form, or when the play as a whole was treated as a metaphor for some element of individual or social

65. J. Gassner, *Directions in Modern Theater and Drama* (New York, 1965), 128.

experience, the goal was to touch upon a deeper level of reality, to lay open "the soul of the play." On the other hand, more traditionally representational plots and staging frequently accentuated symbolic elements in order to convey social or psychological interpretation of the "passing scene."

In the theater, as in other artistic ferment, one can sense a studied effort to avoid artificiality in use of symbols at the same time that there is an eagerness to experiment with new and possibly more communicative symbols, an effort to get beneath the surface of life, to question the authenticity of inherited artistic conventions. With the twentieth century two new media, film and television, will offer a new range of theatrical expression, above all, undreamed-of possibilities of realistic dramatic environment; but the theatrical tension between representation and presentation will remain largely unresolved.

However, in the late nineteenth and early twentieth century, creative theater, along with impressionist painting and abstract sculpture and innovative architecture, influenced directly a relatively small portion of the population. Broader recognition of the basic cultural struggle in the making came only with the two great World Wars, which themselves became major symbols by which twentieth-century people interpreted their rapidly changing world. Tragically, it was the experience of these two wars that catalyzed the recognition that the various nations form together one interdependent world. Christianity itself was caught in this dialectic of cultural continuity and discontinuity, and the ambiguity of its reaction can be seen in the of the churches' attitude to militant political developments like fascism.

Modernism, Communism, and Fear

However, a more pointed indication of the churches' inability or unwillingness to come to grips with the forces of change was the modernist controversy. Most explicitly formulated in Roman Catholicism, the basic issues touched (and to some extent continue to touch) other mainline Christian churches as well. It has now lost much of the emotional freight it carried in the early decades of the twentieth century, but prior to World War II modernism was one of the key symbols used to distinguish opposed schools of thought regarding Christianity's role in the modern world. Even though little if any uncertainty was professed by those who considered themselves the guardians of orthodoxy and used the label of modernism to describe the presumed errors of their opponents, the controversy as a whole betrayed official Christianity's unpreparedness to cope with the explosive developments in human life.

One of the factors contributing to this uncertain posture was fear: fear that the influence of critical disciplines of knowledge would corrode

faith, fear that the loss of long-standing privileges would be accelerated until the church would be stripped of special consideration and perhaps even of basic freedom to operate, fear that new forces of evil had been unleashed in the world. Fears always find symbolic translation, and twentieth-century religious fears have converged with the political fears of the capitalistic countries of the West in the symbol of *communism*. Apart from how Marxist theory has actually been applied or modified in various parts of the world, for millions of people communism has come to signify everything that is oppressive, militantly antireligious, opposed to human freedom and basic rights—in a word, Godless. Grounded in fear that itself was grounded in ignorance, this symbol for that very reason has been an instrument for widespread manipulation of public opinion and public policy. In many situations it has forged a new alliance between religion and governments that had abandoned the older pattern of establishment of religion.

On the contrary, in much of the world it is capitalism, more often than not characterized as capitalist imperialism, that has become a symbol of the source of social evils. In much of the Third World it is capitalism that is feared and hated as the enemy. Thus, two symbols have become standards under which millions are gathered in opposing forces, in an East-West conflict that threatens the very exisence of humanity on the planet.

ELEMENTS OF A POSITIVE RESPONSE

It would be a caricature to describe twentieth-century Christianity and its reaction to secular cultural developments in essentially negative terms. If modernity received acceptance slowly and hesitantly, it may have been because not all that was modern represented genuine progress or safeguarded the most valuable elements of historical tradition. More than that, many of those who advocated caution about adopting modernity perceived the radical implications of what was taking place better than did those enthusiastic about change.

At any rate, a new world was coming to birth. No place were the dynamics in this tension between continuity and discontinuity more manifest than in the Second Vatican Council that took place in the mid-1960s. Gathering together bishops from the diversity of cultures that make up today's world illustrated the task that faced the Christian churches, the task of discovering symbols that have enough universality to unify a worldwide community of believers and yet are able to resonate with the very distinctive cultures of Asia, Africa, Europe, and the Americas. Out of that highly complex process, which we are only beginning to understand, we might quickly mention four important elements that

bear directly on cultural and religious symbolism and on the distancing or making present of the divine: authority, sexuality, discipleship, and citizenship.

Symbols of Authority

Authority, in every sphere of human life—national, familial, professional, religious—has come under scrutiny, often under attack. Not only have there been the familiar criticisms of abuse of authority and struggles as to who will possess and exert authority; the nature and need for authority, at least authority as it had long existed, was seriously questioned. For millennia, cultures both East and West had assumed that *hierarchy* was the natural and therefore unquestionable model of authority. The unity and harmony of human society flowed, it was believed, from observance of this God-given order of things political, economic, social, and religious. Now the appropriateness of that hierarchical model began to be questioned.

Science had gradually become a sometimes competing but more often cooperating authority. By the beginning of the twentieth century scientific methodologies had established themselves as normative in practically all areas of human knowing and human decision-making. Scientists were sought out by civic, social, and, to a lesser extent, religious leadership to provide authoritative insight into important issues.

With World War I, and even more World War II, widespread disillusionment with civic leadership set in. Understandably this was felt first in the conquered nations, but by the 1960s it had spread worldwide. Much of the world's population was ruled by dictatorships kept in place by military oppression; and in the free world there has been an often-remarked vacuum of leadership. The symbolic power of official authority has been seriously diminished, to the point where other powerful forces in a society such as the United States have been able to manipulate public opinion in opposition to political leadership. Yet, as the Reagan phenomenon has demonstrated, there is still a widespread willingness to accept civic authority if it promises to be effective.

Religious authority suffered some of the same eclipse since church officialdom was tarnished by considerable weakness or collaboration in dealing with fascist regimes. In large portions of the population, other figures have laid claim to the saving authority once monopolized by religion. Science, too, has suffered a diminution of the unquestioned authority it once enjoyed. Atomic weaponry, fears of undisciplined genetic engineering and medical experimentation, supposedly scientific social planning that produced disaster rather than human betterment, have made people wonder how much science can be relied upon to produce genuine progress.

Still, if the mantle of authority has slipped somewhat from the shoulders of science, it has very quickly been conferred on science's technological offspring, computers and communications media. In almost all spheres of human activity, computer technology has become the new magic and computer experts have rapidly become the new "magi." The latest machine symbol, the computer, has already assumed a power over human life that no previous technology enjoyed. One consequence of proliferating computer use may be a major shift in the nature and location of power. Power may be spread among the the masses, as they gain access to what previously has been information and know-how reserved for the few. Or on the contrary, power may pass into the hands of a very tiny minority, those skilled in creating computer technology.

Radio, film, and television have within a single lifetime assumed a worldwide influence over people's thinking, imaginations, and motivations which would have been unimaginable in previous ages. Television in particular has become an indispensable instrument in seeking, exercising, and legitimating civil or religious power. Becoming a celebrity in the world of film or television, and to a lesser degree in radio, endows one with an authority that parallels and at times overshadows the authority possessed by those in the highest civil offices. Many of the social functions that the symbolic power of ritual provided for simpler societies are now being carried out by television.[66] One need only think of the way in which television has transformed the electoral process in the past two decades.

Along with the spread of television, and to some extent dependent upon it, has been the power of the symbol of "the city." While the city has always had important and ambivalent symbolic power, the advent of radio and television has extended urban culture far beyond the actual physical limits of the city. Much of television, especially commercials that are geared to make urban affluence attractive, gives a picture of city life that subtly connotes pleasure, excitement, and achievement— despite constant news reports of urban violence. The fictional movie *El Norte* made clear the fascination of First World city life for the economically deprived populations of the Third World. And within countries such as Brazil or Mexico, the incredible migration to the city testifies to the attraction it exercises. Much of this is grounded in the unquestioned authority of the communications media.

While many of the more traditional symbols of authority, for example the presidency or the papacy, still maintain much of their power, they have more and more been forced to draw from the symbolic force of

66. See G. Goethals, "TV Faith: Rituals of Secular Life," *Christian Century* (April 23, 1986), 414–17.

the communications media to shore up or even reground their own authority. Political candidates and officeholders are packaged by public relations experts and "sold" to the public; what becomes important is not what really happens in official circles but what is perceived to happen. The authority being exercised by public officials is increasingly that of media-conditioned popularity.

Symbolism of Human Sexuality

In any culture, the outlook on human sexuality is a key to grasping that culture's understanding of what it means to be human. Nothing in people's experience is more profoundly and pervasively symbolic than their sexuality; and probably for that reason few if any dimensions of human life have been the subject of more divergent interpretations. Recent decades have seen an unprecedented public examination of sexuality in all its varied manifestations.

Much of this open discussion has been beneficial; but some of it has been adolescent obsession with the topic, some of it shared voyeurism, some of it faddish and shallow "pop psychology." In addition, the new public tolerance of realistically portrayed sexual activity and sexual attraction has often resulted in abuses, especially the exploitation of women's bodies in advertising. The ambiguity of the new frankness is reflected in the heated debates about the dividing line between pornography and truly artistic portrayal of nudity or erotic behavior. Clearly, what is at stake is the specific symbolic impact of each.

If the new frankness about sexuality is a mixture of maturity and immaturity, it has had the benefit of permitting positive investigation of the distinctively symbolic character of human sexuality. Particularly in religious circles, this has shifted attention from the biological to the personal aspects of sex. Thus new avenues have been opened for reflecting on the sacramentality of marriage and more broadly, on the sacramentality of human friendship.

More far-reaching and more lasting has been the shift at the level of sexual identity: what does it mean to be female or male? So much of people's present gender self-identification has been culturally conditioned that it is difficult to decide what, apart from such social interpretation, the significance is of being either a man or a woman. However, that cultural conditioning is being vigorously studied, and with that study has come a serious challenge to some of the most longstanding symbols in human culture—for one the symbol of hierarchy as conveying an acceptable understanding of the authority structures that should govern human life.

It is not accidental that the feminist movement has had special impact in religious circles. For the most part, religious groups have been almost

paradigmatically patriarchal, with their patriarchal presumptions grounded in the notion of divine paternity. In the Roman Catholic church this has been intensified because of the exclusion of women from the "sacred" realms of the church's life presently occupied by celibate males. Historically, religions have oscillated between viewing sexuality as divine and viewing it as diabolic; while in theory Christianity has rejected both these extremes, it has yet to formulate in doctrine, ritual, and life-style a truly balanced perspective. Ironically, its own sacramentality as body and bride of Christ is dependent upon such a development.

Symbolism of Discipleship and Citizenship

There are numerous byproducts of the disestablishment of religion in recent centuries. One of the most controversial results has been a shift away from the subordination of discipleship to citizenship that the established church arrangement had demanded. Even in the United States, where people prided themselves upon the separation of church and state enshrined in the Bill of Rights, political disestablishment did not prevent a cultural establishment of Protestantism throughout the nineteenth and much of the twentieth century.[67] There is still a widely shared opinion that citizenship means supporting one's government, be it right or wrong, and that religious fidelity, that is, true discipleship, calls for support rather than challenge of the government.[68]

For a variety of reasons, this wedding of civic and religious fidelity, already weakened somewhat by the abolition debates of the 1800s, began to dissolve early in the twentieth century. The view became more common than what one did in public or professional life was independent of one's religious commitments. Religion had to do with people's relationship to God; it was properly exercised in such things as prayer, not in business or professional life. Nor should church personnel interfere in public affairs. Religious leaders were well-equipped to speak authoritatively about religious matters and ill-equipped to provide directives for people's secular activities. What one did or believed as disciple was walled off from what one thought or did as citizen.

Such views were challenged by relatively few voices, Reinhold Niebuhr's being one of the more noticeable; but they were shaken by the rise of Hitler. Suddenly it became all too evident that Christian discipleship could not calmly coexist with compliant citizenship in a nation

67. For a detailed description of this historical process, see M. Marty, *Righteous Empire* (New York, 1970). On the more recent shifts toward pluralism see *Religion and America*, ed. M. Douglas and S. Tipton (Boston, 1982).

68. On the interplay of "citizenship" and "discipleship" see the two companion volumes, *Education for Citizenship and Discipleship*, ed. M. Boys and *Tensions between Citizenship and Discipleship*, ed. N. Slater (both New York, 1989).

under Nazi rule. Bonhoeffer's *The Cost of Discipleship* left no comfortable middle ground to which Christian conscience could retreat. Yet, when the war was over that middle ground was quickly reoccupied—until Vietnam.

Whether one identified the issues as religious or simply as matters of conscience, controversy over the legitimacy of the United States' intervention in Vietnam focused on the question of whether there is some higher criterion by which civic loyalty should be measured. Put into a religious context—and much of the opposition to the war was formulated in explicitly religious terms—did discipleship require a kind of citizenship other than that expected by the government and by a large portion of the country? Was vocal opposition to the war disloyalty or the most authentic fulfillment of citizenship?

The debate is far from over and continues to find more recent application to Central America and the Middle East. What is over is an unchallenged subordination of religious belief to political arrangements or a complacent compartmentalizing of civic and religious responsibilities. The symbolic dimensions of discipleship and citizenship are unavoidably intertwined. For a Christian, engagement in public life should share in the sacramentality of discipleship.

SELF-CONSCIOUS USE OF SYMBOLISM

To some extent the three "new" situations of symbolic influence mentioned above reflect modifications or intensifications of forces intrinsic to the human situation and therefore present in some form throughout history. What is more distinctive of recent use of symbols is the self-consciousness with which they have been employed. Because of the development of social sciences since the eighteenth century, the explosive growth of research and interest in psychology, and technical analysis of symbols through linguistics and artistic/literary criticism, we now have an unprecedented insight into the operation of symbols, with a consequent ability to nurture them knowingly and to use them effectively to alter people's worldview or values.

This is too extensive and complex a development, and too filled with implications for a theological study of religious symbols, to be described in summary fashion. The next four chapters will, then, attempt a more detailed look at the way in which recent technical study has opened up new avenues for study and possible revision of Christian ritual, doctrinal, and institutional symbols.

Part Two

AMBIGUITY OF SYMBOL

What insights, then, can one draw from the historical interplay in Christian experience of divine *presence* and divine *distance*? And what may be new possibilities of dealing theoretically and pastorally with Christian faith in the saving presence of God?

STRUCTURED ECCLESIASTICAL MEDIATION

Perhaps the easiest form of distancing to understand, though not necessarily the easiest to deal with practically, is that connected with the appearance and institutionalizing of church officialdom. That some structured governing group should have emerged is not surprising; once the church grew in size, it was a necessity. However, it is not the bureaucratic role of ecclesiastical officials that has been our concern in this volume; rather, it is the symbolic function they have served by placing themselves as an agency through which—and necessarily through which—the rest of the people deal with God. This has "removed" the bulk of the faithful from immediate contact with God.

Since very early on, the ordained have been "the holy orders" whose activity was looked upon as sacramental of God's graciousness to humans, whose laws and directives were proposed as expressions of God's will, whose special sacredness enabled them as liturgical leaders to perform the sacred rituals and communicate grace to the laity. Their role and life-style, particularly in the Roman Catholic tradition, the discipline of clerical celibacy, signified clearly that they were the *active* element in the church's life and that the remainder of the church was passive. The presumed special sacredness of their status and ministry implied, again by contrast, the secular character of "ordinary" Christian life in the world.

Unavoidably, such symbolic implications of the structures and functions of ordained ministry fitted into the overall cultural symbols. The overarching worldview, which for the most part ecclesiastical institutions shared and even reinforced, was that of patriarchy with its cosmology of a hierarchical universe. Precisely because it laid claim to being the top step in the ladder of graded beings, the step that touched the divine and through which the divine power passed to touch the lower levels, the ecclesiastical hierarchy was seen as symbol of the way God, the supreme patriarch, dealt with humans.

Since human religious thought, from its earliest mythic forms, has attempted to explain and deal practically with the *power* that shapes human affairs, the hierarchical ideology that accompanied the growth of official church structures gradually developed an explanation of the power exercised in the church. While this explanation dealt in increasing detail with administrative arrangements within the church and so claimed jurisdictional authority for church leaders, it dealt more distinctively with both teaching and ritual celebration.

Before the end of the second century, as we have seen, bishops were already claiming teaching authority, claiming to be *the* guardians, interpreters, and transmitters of apostolic tradition. At the beginning this claim was based on a succession of teachers—as Irenaeus put it, he had heard Polycarp, Polycarp had heard John, John had heard Jesus. Before long, however, teaching authority became attached to office itself, so that one was supreme teacher by virtue of possessing the episcopal office.

Over the centuries this rooting of magisterial power in episcopal office faced occasional challenge, as it did with the rise of professional theologians and canon lawyers in the high and later Middle Ages and more starkly in the Reformation. Still, the link of teaching authority with jurisdictional power has been asserted even more sharply in modern times, particularly in Roman Catholic circles where the trend culminated in the first Vatican Council. In the decrees of the council the logic of the deliberations on the papacy proceeds from the claim to jurisdictional primacy to the claim to infallibility in teaching.

Whatever the theological grounding for such official teaching authority, church leaders over the centuries have consistently believed themselves capable of passing judgment on any teaching being carried on in the church, and responsible for thus safeguarding orthodoxy. As early as the third century, bishops gathered together in synods to examine and appraise teaching they considered suspect. Some such procedure has continued up to the present, in Protestant communities that do not recognize episcopacy as well as in churches with an episcopal polity. Whether it is presumed that those in charge should understand

best the traditional faith of the community, or that such understanding is a criterion in the selection of officials, or that a special charism of insight is given along with selection for leadership, there is a continuing claim by those in high ecclesiastical positions that they are the pre-eminent teachers in the church.

Distinctive of religious groups is the rooting of both ruling and teaching authority in the claim of officials to possess special sacred power. Christianity is no exception; so strong is the notion that sacrality attaches to the "holy orders" that more than one civil ruler has tried to claim for himself a place of eminence within the Christian priesthood. The ordained are the keepers of the mysteries; they have privileged access to God; it is through them that divine saving power is extended to the lives of those who receive their religious ministrations. Thought to have at their disposal divine power to counteract the evils that threaten to keep humans from their destiny, ecclesiastical officials are an indispensable bridge to God—to ignore or refuse their mediation is to court final failure and damnation. Moreover, as God's chosen legates they merit the respect of those who acknowledge God. This respect is due them by virtue of their office, even if their own personal lives and religious infidelity are a scandal. Jurisdictional power attached to office grounds even the power of sacrality; the hierarchy of sanctifying ministers coincides with the hierarchy of ecclesiastical rulers and is characterized by bureacratic structure.

Yet, along with all this, history has also witnessed for centuries a countervailing claim to immediate access to the divine on the part of all believers. Not even the most autocratic hierarch has contended that the least powerful of Christians could not pray directly to God or denied that God could bypass structures to intervene directly in the life of any person—though they may have doubted that God would do such a thing or that such private prayer could possess the efficacy of official prayer.

In fact, such claims to immediate access to God were often acknowledged and nurtured by many of the very church leaders whose official status was part of the institutional distancing of God. Pastorally concerned for their flock, and understanding in faith that salvation and sanctification were divine accomplishments, these bishops and presbyters were concerned to bring their fellow Christians into as close a relationship with God as possible. Most importantly, church leadership in its better representatives has worked consistently for an increased level of popular religious education and understanding, recognizing that only this can root a large-scale awakening of authentic faith consciousness.

As the level of education has slowly risen, both in secular society and

in the Christian churches, Christians have become more aware of their own abilities, rights, and responsibilities. For a variety of reasons, the growth in awareness and the exercise of new understandings has been slower in religion than in other spheres of life; but recent centuries have witnessed an undeniable movement toward discovery of the dignity and importance and religious potential of each person, and a consequent movement toward "democracy" in the church. Until very recently this movement has been very gradual, at times well-nigh indiscernible; but since World War II there has been an almost explosive questioning of any autocratic rule, even in the church. The explicit recognition at Vatican II that it is the entire people to which the name "the church" should be applied, that the church is "the people of God," is but one symptom that there is a changing mindset toward the institutional aspects of Christianity.

A radical shift has been occurring in the realm of Christian symbolism, a shift that is only recently finding observable expression. For one thing, the monopoly of the organizational/political model in ecclesiology has been challenged by return to two very early Christian models for the Christian community: the family and organic life. When the latter model is applied to Christian faith as a special form of consciousness-life and then, in combination with the family-model, is applied to the people of God, a new perspective on communication and community—humans to humans, humans to God—is created.

Vatican II also voiced the renewed awareness in the Christian churches of the mystery dimension of Christianity. This it did by applying to the Church, the Christian community, another model: that of *sacrament*. The Church is meant to be a symbol both of the world and of God's saving presence to the world. However, adopting this model has many implications and the council took a long step in confronting them: It is the *people* who are the Church, who are meant to be the sacrament of God's saving presence in the midst of the world. These people cannot, then, remain aloof from the world which is theirs but like leaven can only be a challenging and transforming force if they accept and work with the historical situation in which they find themselves. For theology this has demanded a critical absorption of contemporary thought as a medium for interpreting the word of God. Theologies of liberation, and in a special way feminist theology, have responded to this demand; but the incorporation of social and psychological analysis into theological reflection is still quite limited.

What this touches is today's profoundly revolutionary and worldwide social development, in which the patriarchal culture that has been dominant throughout recorded history is giving way to patterns and processes of human society that are as yet too new to be clearly described.

Part of this shift is the abandonment of hierarchy as privileged image of cosmic and societal order, and the accompanying reappraisal of the nature of power and authority.

CULTIC DISTANCING

If the question of authority in the church—its nature, extent, and grounds—is being raised today as seldom before in Christian history, there is also a questioning of the cultic distancing of God, less abrasive but no less basic. There has been in almost all the churches one or other form of "liturgical movement," a recognition that the present patterns of public worship leave a good deal to be desired, and that a considerable amount of the drift away from religious practice has resulted from discontent with the meaninglessness of traditional ritual. Analogy with nonreligious instances of human ritual has not yet suggested viable alternatives—nothing comparable to the way in which democratic forms of social organization have contested religion's adherence to hierarchical arrangements.

As we saw, the shift in early Christianity to ritual that was distanced from ordinary life was quick and largely uncontested, because it appeared so traditional and religious. In a matter of only a few generations the revolutionary proximity of the divine to the human which had characterized the career of Jesus himself and much of earliest Christianity had been replaced by religion. Whereas sacrality attached to ordinariness of human experience in the first few decades of the church, and designations of places or times or persons as sacred was eschewed, the attribute of special sacrality very early became associated with "removed" places and actions and persons, and belief grew that divine saving presence was to be encountered through involvement with these sacred realities.

Not that this cultic distancing of the divine was totally accomplished by the end of the second century, nor that the nature of this distancing remained constant throughout Christian history. Indeed—to describe developments in the broadest terms—there have been two major epochs, each lasting approximately a millennium, in the history of official cult seen as the preserve of divine presence.

During roughly the first millennium of Christianity's existence there still prevailed a sense of entering into the mystery of Christ, though this had already grown rather thin, especially in the West, by Carolingian times. What led to this weakening of the original sense of celebrating the ongoing redemptive mystery of the risen Christ was the community's reduction to silence and passivity as the liturgy became increasingly the action of an ordained celebrant, performed in separated-off space in

an alien tongue. Liturgy degenerated into a spectacle whose intrinsic meaning became foreign enough to need explanation by allegory. Even the anamnetic significance of the rituals came to be seen as recollection of past happenings—the life and death of Jesus—rather than a process of making those mysteries present.

Because simple Christian believers never ceased clinging to the conviction that Christ was somehow with them, especially in Eucharist, questioning and conflict arose about the link between sacramental symbol and "the real presence." Chronologically, the sharp focus of this issue in the debate between Berengarius and Lanfranc coincided with the reentry of Aristotle into European thought and the increasing use of Aristotelian understanding of causality to explain the action of sacraments.

It was this scholastic mentality, in which sacraments were reduced to their ritual moment and the ritual seen as an instrumental cause of supernatural effects, that by and large controlled the second millennium of Christian liturgical history. Liturgical celebrants became even more the doers of the sacramental rituals, since only they were seen to possess through ordination the powers of absolving sin and transforming the eucharistic elements into body and blood of Christ. In a way that they did not understand and that they were not meant to understand, the faithful *received grace* through priestly-performed rituals they accepted as indispensable for salvation.

Increasingly the liturgy, particularly the Eucharist, became a clerical spectacle that the faithful were commanded to attend in order to become freed from their sinfulness and strengthened to face the evils of life. Along with this, the practice of private masses proliferated, and they intensified the impression that religious rituals were effective through some hidden supernatural force, their effectiveness rooted in official approval added to ordination. Sacraments were *the* sacred actions in the midst of otherwise secular daily life. While popular explanations of Eucharist continued to be allegorical, theological explanation became increasingly scholastic and centered on two issues: the Mass as a sacrifice, and transubstantiation.

Late medieval discontent with this liturgical emptiness grew into the Reformation's evangelical reaction against ritualism and the Counter-Reformation's campaign against liturgical abuses. Neither movement, however, broke through to a grasp and implementation of the intrinsic evangelism of Christian sacramentalism, the sacramentality of Scripture as interpretative of the sacramentality of people's Christian lives, and the inseparability of Scripture from liturgy as distinctively Christian anamnesis. Though there always remained the conviction that in some way the entirety of life was meant to be Christian, in both Catholicism

and Protestantism this was translated in terms of appropriate moral behavior; for most people religion remained a special sector of life that itself was seen as fulfillment of a moral obligation.

The deepest levels of discontent remained and found expression in a variety of movements—Methodism was a striking instance—aimed at awakening Christians' faith. In the twentieth century this flowed into a felt need for liturgical renewal in the communities that had retained a sacramental tradition, and an awareness of the need to recover ritual in the communities that had largely abandoned it. Able to draw from the higher level of popular education, the Christian churches launched efforts to acquaint the faithful with the meaning of ritual celebration and to initiate reforms in practice that would nurture people's prayerful participation. For the most part, though, this proceeded slowly, to a large extent because the nature of Christian ritual was (and is) still inadequately understood by those charged with its celebration. What became increasingly apparent is the relative lack of a sacramental theology capable of guiding and animating the kind of liturgical reform demanded by Christian life in a post-Enlightenment world.

At present, the signs are both positive and negative: on the one hand, for millions of people the practices of religion have lost much of the aura of sacred power and as a result many at least nominal Christians now content themselves with being "good people" without any participation in recognizably "religious" activities. On the other hand, such leakage from the mainline Christian churches combined with the remarkable attraction of pentecostal groups and television evangelists has made clearer the need to animate and humanize traditional liturgical forms, and to remain open and imaginative with regard to creation of new forms. Again, it is now widely if not yet generally perceived that genuine ritual celebrations cannot be divorced from community and individual involvement in social justice. This is leading to an increased awareness of the basic sacramentality of Christian life and to the role of ordinary human life as the fundamental word of God.

PHILOSOPHICAL DEMYTHOLOGIZING

In the course of the past two millennia the Christian "myth," that is, its explanation of human existence, has been challenged successively by the explanations proposed by philosophy and by science. Often these alternative explanations, which presented themselves as objective, as the true understanding of reality, appeared to believers to threaten the survival of Christian faith. Actually, while superficial philosophy and superficial science at times claimed to have replaced religious faith, and

while genuine philosophy and science have been a real threat to su-
perficial belief, the careful pursuit of insight, whether philosophical or
scientific, has proved to be an inestimable benefit for authentic Christian
belief.

This benefit has become more apparent in recent decades, as formal
study of the process of "demythologizing" has indicated how critical
understandings can work to purify religious faith and belief from magic
and superstition. Accepting even a limited amount of demythologizing
has not been easy for Christians, especially for those entrusted with
safeguarding the orthodoxy of belief, for it inevitably has involved the
acknowledging that the traditional formulations of belief—biblical, li-
turgical, or doctrinal—were the products of humans in a particular
historical/cultural context and therefore limited and relativized by that
situation.

It has helped to discover that all human knowing is to some extent
"mythic," that it is a use of interpretative models to give shape to the
perception of extramental reality; and that science and philosophy
themselves must be subject to constant demythologizing. It has not
helped to have some scientists and philosophers, particularly uncritical
heirs of the Enlightenment, proclaim that their intellectual empire had
replaced "the kingdom of God." However, a balanced epistemology and
a careful study of intellectual history make it clear that there is no
intrinsic incompatibility between philosophy and science on the one side
and religious belief on the other, provided each remains faithful to its
own character.

There is, though, a deeper issue that arose with the development of
a Christian theology through the instrumentality of Greek philosophical
thought. The link of Christians to God through grace and revelation
came to be considered in abstract terms of ontological participation
rather than in terms of experienced personal relationship. Not only was
the abstractness of this way of thinking a distancing of the God revealed
in Jesus, but the very notion of participation presupposed the under-
standing of God as the Supreme Being, thereby placing the divine
somehow within the same order of being and denying the transcendence
intrinsic to true monotheism. Over the centuries the greatest of Christian
thinkers wrestled with this, not infrequently turning to an apophatic
theology that recognized the inadequacy of language but not that of
the underlying philosophical worldview.

Although the average person during these centuries was innocent of
any philosophical reflection about participation, there was a broader
cultural impact that touched everyone. The reason for this was the
imaginative model that accompanied the intellectual category of par-
ticipation. This was the model of a *hierarchical ladder* stretching from

God to the lowest of created beings. On such a ladder there were several steps that distanced the ordinary Christian from the God who dwelt "at the top."

Modern thought, particularly from mid-seventeenth century onward, challenged the theological worldview of the Middle Ages without thoroughly challenging the philosophical cosmology and anthropology of Greece that it had absorbed. Instead of remythologizing the prevalent religious understanding of divine providence, modern science and its accompanying philosophy have moved toward intellectual agnosticism about the divine and have created explanations of the physical universe and of human existence that are devoid of any reference to a transcendent.

What this has done, though perhaps it need not do so, is to go beyond distancing God and to remove the divine entirely from the thought-world of millions of people in recent centuries. More than abstract thought was involved here; all the subtle desires of humans to reject dependence, to be free of answering to a provident Creator, and to be completely masters of their own destiny played a major role; what claimed to be purely scientific was to some extent ideology. Yet, there can be no denying the profound modern challenge to Christianity of honest and inquiring sceptical thought.

Fortunately, the past few decades have seen an important response to this challenge by philosophers who were Christian. Names such as Maritain, Gilson, Blondel, Marcel, Marechal immediately come to mind along with others—Lonergan, Tillich, Rahner, to name only a few—who, though generally classified as "theologians," were creatively involved in philosophy. Many of the best elements of earlier Christian philosophizing were retrieved, clarified, and deepened by being brought into confrontation with modern philosophy. Surprisingly—or perhaps not so surprisingly—these fairly abstract currents of thought were influential in drawing attention to the key role of concrete human experience.

Introducing philosophy into Christian thought had another and continuing influence on the distancing of God. As these more abstract ways of thinking about the divine, and about humans in relation to the divine, fashioned the official formulations of Christian faith, the average believer was reduced to religious assent to what she or he did not understand. Profession of faith became an obedient agreement with church authorities, rather than a conscious commitment to live out the revelation that occurred in Jesus' life, death, and resurrection. This should not lead to the conclusion that theology as a more sophisticated explanation of belief is a barrier to faith and discipleship; rather, it says that theology is an indispensable ministry to the community's faith and not

an end in itself and that it must, therefore, work out of and remain in constant interaction with the religious experience of the Christian people.

A NEW SITUATION

My contention is that the distancing we have sketched need not continue, indeed that it is already being reversed, and that Christians can today glimpse the dawn of a new era of Christianity which is grounded in a changed understanding of God's providential presence to human life. Central to this new stage of faith and belief is an appreciation of the sacramentality of all human life, including the distinctive sacramentality of Christian life, that was not possible for previous generations.

To make such a statement is not to pass judgment on the personal faith of Christians of the past—there is a basic dimension of faith that transcends the limitations of historical context precisely because it is a personal relationship to the divine. Instead, it is to point out that the scholarly study of symbols in recent decades has opened up the possibility of a new level of human experience, the possibility of living symbolically—which humans have always done—but now with critical awareness of the symbols that are shaping and communicating human consciousness.

This second section of *The Distancing of God* is an attempt to indicate the impact of modern research and scholarly reflection on our understanding of symbolism and therefore on the shift in religious understanding. Out of the immense intellectual and cultural productivity of the past century or so, all of which has had some bearing on our deepened insight into symbols, I have chosen only a few instances to suggest the task that lies ahead for Christian theology as a guide to renewed Christian life.

Probably as important as suggesting what I will attempt is stating what I will not attempt. I will not review all or even most of the relevant scholarly contributions to our present-day insight into symbols. Major areas of study, for example art criticism and aesthetical theory, are barely mentioned; each of them deserves a separate book. Instead, I have selected three key areas of research and critical reflection—anthropology, psychology, and literary criticism—because they represent diverse though overlapping disciplinary approaches to study of symbolism. Nor will I attempt a systematic review of the scholarly study of symbol in these three disciplines; such an endeavor lies beyond the scope of this volume and would, if done satisfactorily, be a multivolume, multiauthored enterprise. Instead, I will point to those developments

within each of the three disciplines that appear most germane for theological investigation of Christian symbolism.

I hope that the following chapters will illustrate the basic thesis that a new level of understanding and employing Christian symbolism is provided for today's Christians by the insight into the nature and function of symbols that has come from recent critical research in the social, behavioral, and communications fields. In addition, I hope to show that the more conscious appreciation and use of appropriate symbols opens up for both Christian theology and Christian belief an understanding of the divine saving presence in human history that can rehabilitate for a post-Enlightenment world the notion of divine providence.

10

Anthropological Study
of Symbol

There are intriguing indications that the distancing of God from or-
dinary human experience is being reversed. Indeed, the evidence seems
to indicate that this reversal has for several centuries been slowly growing
as a countercultural development, but has accelerated and become clear-
ly noticeable since the middle of this century. Such a revolutionary
cultural development, if it is happening, is not taking place in isolation
from the overall context of contemporary human life, and specifically
from the functioning of symbols in today's world. So, to help determine
whether such is actually the case, to specify more clearly the nature of
the shift if there is one, and to discover some orientations for creative
contribution to the increased humanization of Christian symbolism, it
will be helpful to examine recent research into symbolism in three
areas—social sciences, psychology, and language study both linguistic
and literary—and to suggest the implications for deepened insight into
Christian symbolism. To a considerable extent it is scholarly advances
in these disciplines that have made possible more profound and more
exact theological reflection on Christian symbols.

The present chapter will treat the social scientific research into ob-
servable symbols, their social origin and function and interpretation.
The following chapter will study modern psychology's contribution to
understanding the role of symbolism as a structuring principle of human
consciousness, and the succeeding chapter will briefly describe how the
distinctive character of language as a symbol system has been examined
by recent linguistic and literary analysis.

Within the social sciences, sociological and anthropological research
overlap quite a bit; this chapter will focus on anthropology. Application
of sociological insights into the social functioning and religious use of
symbolism has been formally addressed by Robert Bellah in a number

of his writings and especially by Gregory Baum in *Religion and Alienation*.[1]

Setting any date as the starting point for current discussion of symbolism by social scientists is artificial; however, the end of World War II is a convenient choice. The war was a major watershed in people's reflection upon their shared existence as "human society," and the colonial context for so much of the anthropological field work was drastically altered in the aftermath of the war. "The experience of World War II certainly altered both the social organization and the intellectual materials of the anthropological profession in the United States. Many of the trends toward change were already under way before the war; but most of them showed a qualitative change, as well as a quantitative increment, after it."[2]

Perhaps the most notable change was the new focus on methodology, on discerning or devising models to be used either heuristically or for correlation, and on formal analysis rather than simple description or cataloguing of field research. Eric Wolf complained in the mid-sixties that anthropologists had come to think like engineers,[3] and the growing influence of psychoanalysis and of structuralism to some extent justified his charge. Since this shift dealt precisely with the role of symbols, the postwar years have provided a wealth of sociological and anthropological discussion about symbolism.

Formal discussion of symbols is not, of course, something new; in Western thought it goes back as far as Plato.[4] But two things at least

1. "Christian doctrine refers not to a sacred reality apart from history, but to the deepest dimension of historical reality as its matrix, elan, and horizon . . . What is being discovered is that Christian truth is salvational doctrines that communicate salvation only if they are understood as derived from symbols and leading back to symbols. Dogmas make sense only if we find the place they occupy in the telling of the Christian story and the symbols revealed in Jesus Christ . . . The symbolic approach to Christian theology acknowledges that something marvelous and unaccountable really happened in history which, when accompanied by a new word, revealed to people the meaning of their lives and enabled them to re-create their social existence. And this happened through symbols." G. Baum, *Religion and Alienation* (New York, 1975), 252–53. See also R. Bellah, *Beyond Belief* (New York, 1970) and *The Broken Covenant* (New York, 1975).

2. E. Wolf, *Anthropology* (Englewood Cliffs, N.J., 1964), 6–7.

3. "Increasingly we find ourselves using not the language of subjective involvement with the primitive, but the language of the engineer. The image of man projected by current anthropology is indeed an engineer's image. To a consideration of this image we must now turn, for such images are not neutral. The meaning of meaning lies in its uses, and the uses by anthropologists and others of this new projection of man and his capabilities is fraught with serious consequences both for its users and those upon whom it is used." Ibid., 7.

4. For a review of earlier work in anthropology see A. de Waal Malefut, *Images of Man* (New York, 1974), a popular presentation of anthropology (in the broad sense) from the Greek philosophers to the present; and T. Penniman, *A Hundred Years of Anthropology*, 3d ed. (London, 1965), a more technical review with emphasis on European developments prior to the early 1960s.

distinguish the social scientific activity of the past few decades: an attempt to relate specific symbol systems, such as those of religions, to other symbol systems within the broader context of human society[5] and a growing integration of the structural and content dimensions of symbols with their societal function.

During the decades prior to World War II there was relatively little explicit analysis of symbolism, and relatively little correlation of the immense amount of data being gathered about symbolic realities such as religious or cultural rituals. By and large the goals and hermeneutic governing anthropological and sociological research were furnished by a few key figures, notably Weber and Durkheim and Levy-Bruhl, who had ventured into more theoretical discussion. Both the research and the theorizing were still governed by the two-pronged search for the "origins of religion" inherited from Hume's *Natural History of Religion* and Kant's *Prolegomena*.

If, for example, one peruses the volumes of *The American Anthropologist* for the five years prior to the U.S. entry into World War II, there is almost no formal attention to theories about the intrinsic nature or social function of symbols. What one does find is an incredible wealth of detail about various societies and cultures, and imbedded in this empirical data some implicit hints about the social role of symbols in these societies. Most of the essays are field reports describing the activity and institutions and mores of a wide range of societies; a few discuss more formally the social scientific methods for carrying on field research; and one or two articles report and comment upon the approaches of Malinowski and Boas.

Almost the only explicit treatment of symbols comes on two pages of A. Blumenthal's essay on a new definition of culture.[6] In another essay H. Barnett discusses cultural processes and wrestles with the issue of *meaning* in social relationshps, but does not do so in terms of symbols.[7] Yet this absence of articles dealing with social symbols is a bit misleading; for as Katherine Luomala points out in a 1938 review, the descriptive treatment of various cultures often contained what she characterizes as "the pedestrian plodding of American anthropologists in the field of mythology, their pre-occupation with myth elements, and their cautious and modest generalizations."[8] The interest in myths continued, even intensified, and—at least to some extent in response to European social

5. "The anthropological approach . . . links the occurrence and interpretations of symbolism to social structures and social events in specific conditions." R. Firth, *Symbols, Public and Private* (Ithaca, N.Y., 1973), 25. (Hereafter cited as *Symbols*).

6. A. Blumenthal, "A New Definition of Culture," *American Anthropologist* 42 (1940): 574–75.

7. H. Barnett, "Cultural Processes," Ibid., 21–48.

8. From a review of Lord Raglan's *The Hero*, in *American Anthropologist*, 40 (1938): 518.

theorists—the generalizing blossomed into full-blown reflection about the origin and function of social symbols.

FOUR USES OF SYMBOL

How to describe in some structured form the very extensive and complex recent development of anthropological and sociological study of symbol? One of the most useful organizing patterns is that provided by Raymond Firth in his 1973 book, *Myths, Public and Private*, where he discusses the role of symbols as instruments of social interaction in four areas: expression, communication, knowledge, and control.[9] While adopting this scheme may tilt the discussion too much in the direction of a functional approach to symbols, complementing it by examination of more structural views should help retain balance.[10]

Expression

That symbols are common and at times powerful means used by individuals or groups to express their judgments, attitudes, or emotions is rather evident. Firth cites several examples, especially political or religious symbols, and indicates how symbols such as a flag can serve to establish or intensify a group's identity or be a force to unify its actions. A symbol that originally was powerfully significant can over time or because of certain circumstances (such as the end of a war) lose its relevance and become an "empty word." Contrariwise—and probably not too commonly—events such as the outbreak of war can revitalize a symbol, like a flag, that had lost most of its effective expressiveness. However, when this latter happens, the symbol gains from people's experience significances it had not previously had.[11] It becomes important, then, for one who wishes to evaluate or help nurture effective religious symbols to grasp the process by which symbols come to give expression to human consciousness or intentionality.

Wide-ranging anthropological studies of primitive cultures, particularly into their rituals of passage, have furnished rich evidence for the

9. Firth, *Symbols*, 76–77. Not that they are directed at Firth, but the observations of Kingsley Davis in "The Myth of Functional Analysis as a Special Method in Sociology and Anthropology," *American Sociological Review* 24(1959):757–72 are worth noting. He argues against functional analysis as a distinct method; he sees it rather as a logical approach to social analysis developed by sociology and taken over by anthropologists to interpret their field research.

10. To some degree any study of symbols as a structure of consciousness, whether individual or societal, involves psychological reflection. For that reason, though formal discussion of psychology's insights into symbol will be reserved for the next chapter, the present chapter, in dealing with the influence of thinkers such as Freud upon anthropological analysis, will inevitably touch upon psychological matters.

11. Firth, *Symbols*, 77–78.

fact that a people's deepest attitudes and insights, their wisdom, find expression in symbols prior to any rational explanation. Recent studies of culture and societal patterning in developed countries confirm the view that symbols function in essentially the same fashion universally.[12]

For the most part, symbolic expressions of an underlying ideology are not immediately recognizable. Generally, the influence of a people's symbolisms is scarcely adverted to by the general public, often not even by the professional practitioners of ritual. Anthropologists regularly complain about the difficulty of interpreting the symbols of a given culture when the natives themselves cannot explicitly articulate the symbols' meaning. Indeed, most researchers in the field, anthropologists or sociologists, point to this density of implicit significance as a characteristic of genuine symbolisms. Symbols give voice to feelings or perceptions or social commitments that are too "deep-down" and rich in connotation to be transmitted by reasoned explanation. At this deeper level of shared societal consciousness, symbols interact with one another in a world of germinating but often not-yet-formulated metaphor, in what Turner has called a "forest of symbols."

Symbol as expressive of an individual's psychic world falls to some extent within the social scientist's purview, for society is composed of individuals; but it is more properly the object of psychological research. So, also, clarifying the role of linguistic symbol in humans' formulation and communication of thought is the special domain of linguistic and literary study and of communications theory.[13] For social scientists the formal object of reflection is the function of symbol in expressing the shared worldview, the common attitudes, the controlling motivations, and the behavioral arrangements that hold a group together as social entity.[14]

Because it claims to be an ultimate explanation of reality, religion uses its myths and rituals to express the worldview within whose framework a given group experiences human life. This is more evidently the case in primitive cultures, where the religious explanation of the world has not yet been replaced by the demythologizing that accompanies the advent of science. Not surprisingly, then, anthropological study of socio-religious symbols has focused on these less sophisticated societies. However, there has been more recently a marked carryover into the study

12. See E. Muir, *Civic Ritual in Renaissance Venice* (Princeton, 1981), a fascinating study of the myths and rituals of Venice in its days of glory. See especially 54–61, his analysis of the social power of patriotic rituals.

13. Developments in the theory of communication and of semantics, of signs and their meanings, have focused attention on the interpretation of those elements of behaviour where the meaning of the sign has often seemed most complex and obscure." Firth, *Symbols*, 27.

14. See Turner, *Forest of Symbols* (Ithaca, N.Y., 1967), 36.

of symbols as expressing the underlying worldview of industrialized societies—the work of Robert Bellah on "civil religion" or of Mary Douglas on the "bog Irish" are notable examples.[15]

One of the more interesting and instructive pieces of research into the expressive function of religious symbols in a modern context is Paul Friedrich's research study of Naranja, Mexico, during the early decades of this century. Describing the concomitant and interacting shift of political ideology and religious rituals in the village of Naranja around the turn of the century, Friedrich details the process by which the basic pattern of religiocultural celebration was altered because of economic and political upheavals and the change they caused in people's understanding of the forces that worked in their lives.[16]

As the economic changes of the first decade of the century raised the issue of agrarian reform, and the second decade brought revolutionary political upheaval and an anticlerical questioning of the civic role of religious leaders, the traditional cycle of religious festivals was shattered by the collapse of its supporting worldview. By the 1930s Naranja had become a center of anticlericalism and revolutionary ideology, and a radically changed pattern of religious practice, or lack of it, marked the life of the villagers. With the 1940s came a weakening of the political hostilities, particularly of the anticlericalism, and with it a partial recovery of the old liturgical festivals.

Not only have the celebrations of the religious fiestas shrunk appreciably, the reason for holding them has shifted as religious and political attitudes have mixed. For one thing, Independence Day, with its purely secular symbolisms, has entered the cycle of fiestas. Even more significantly, there is an annual commemoration of the assassination of Primo Tapia, a local revolutionary hero of the tempestuous 1920s who was the key figure in destroying the old sociopolitical structures. Though quite clearly distinguished from religious fiestas—Tapia was bitterly and outspokenly anticlerical—this yearly celebration of his political assassination, popularly understood as martyrdom, expresses the people's altered interpretation of their life. "His memory, fused with its mythical penumbra, has come to play a more vital role in local culture than any saint or complex of Catholic dogma."[17]

Most cultural rituals are not tied to such a distinctive social change and used to interpret and adjust to it. Rather, they deal with the basic

15. See R. Bellah, *Beyond Belief: Essays on Religion in a Post-Traditional World* (New York, 1970), Bellah and P. Hammond, *Varieties of Civil Religion* (San Francisco, 1980). On civil religion see also J. Coleman, "Civil Religion," *Sociological Analysis* 31(1970):67–77.

16. P. Friedrich, "Revolutionary Politics and Communal Ritual," in *Political Anthropology*, ed. M. Swartz, V. Turner, A. Tuden (Chicago, 1966), 191–220.

17. Ibid., 218.

rhythms of the human life cycle that people experience in any age or culture.

Every society faces the need to induct its young people into the understanding of life that underlies the community's existence. Every group must have, then, some process of ritualized initiation; and dependent upon the efficacy of this process and in a special way upon the symbolic power of its ritual, the society is marked by a greater or lesser generation gap. Such rites of passage provide a concentrated expression of a people's shared outlook on their life and on the world around them. Not surprisingly, there have been numerous and detailed anthropological investigations of such initiation rituals, particularly since Arnold Van Gennep's pioneering study in 1909.[18]

Such rituals convey a society's understanding of the cosmic forces that shape its experience; in addition the rituals, as well as the myths that accompany and explain them or that in some instances function independently, are intended to explain the relationships and patterns of behavior into which the initiate is expected to fit. This is markedly the case in the marriage rituals of a given culture. Not only does the society express in its marriage ceremonies the respective roles of the two persons in their relation to one another; at least in less urbanized cultures, the rituals of marriage state the new arrangements of husband and wife vis-à-vis their respective families and society as a whole.[19]

Within an overarching worldview and the "master symbols" that formulate it, a complex of subordinate symbols reveals the values that influence a people's motivations and consequent activity. And because symbols express a people's value system they provide an insight into the social dynamics of a society. Though their purpose is not that of empirical academic research, experts in the advertising industry, especially the producers of television commercials, may well be today's most insightful students of this particular function of symbols.

Communication

Not all the expressiveness of symbols is intended or even recognized by people; hence the symbolic aspect of actions, even of words, is not always used consciously and intentionally to communicate. Symbols have to some extent a life of their own; they have a unique multi-layered power to communicate; they are a medium of shared awareness among persons that embraces and extends beyond the communicative power of language.

18. Arnold Van Gennep, *The Rites of Passage* (London, 1960).
19. See J. La Fontaine, "Ritualization of Women's Life-crises in Bugisu," in *The Interpretation of Ritual*, ed. J. La Fontaine (London, 1972), 159–86; and Monica Wilson, "The Wedding Cakes: A Study of Ritual Change," ibid., 187–201.

It is obvious that symbols make it possible for people to share understandings. They are bearers of meaning from one person or group to another; and for that reason they are able to embody and create a view of reality that is commonly shared and therefore able to sustain a human community. In their significance, however, symbols go beyond simple identification or description; they communicate more than clear and distinct ideas. They carry with them overtones and unformulated implications.

Symbols, specifically the more basic and complex symbols that are broadly used in a culture, express in condensed form the goals of a people. They have the power to communicate desires and motivations in addition to understandings. As the medium by which such desires and hopes are shared, symbols help bring about a common purpose without which no group can long retain its unity or even its existence. Mutatis mutandis, the same need for communication of goals applies to any grouping of people.

The numerous anthropological studies of initiation rites illustrate this communicative role of symbol. Unless a new generation of young men and women are led into seeking the common goals that have held the tribe together—be they as immediate as providing food and protection from enemies or as long-range as safeguarding the link with the tribal divinities—the tribe has no future.

However, these rituals do not state and advocate in some rationalized and detached fashion the purpose of a group's existence. Rather, both the knowledge of and the desire to share in the group's finality occur in the broader context of the symbols' transmitting a total culture. A people's wisdom, that is, the insights and judgments and dreams and practical "know-how" that have been distilled from generations of experience, become linked with symbols that thus acquire the power to transfer the culture from one generation to another. Symbols are at the heart of the process of tradition.

Symbols have this power because they function in conjunction with human memory, both individual and social. It is only because humans are able to retain remembrance of past happenings and because emotional resonance still attaches to this memory that a shared meaning and motive power can be contained within a given symbol that is used by a cultural group as an instrument of tradition. Knowingly or unknowingly, a group banks the treasures of its acquired wisdom in its symbols. And it shares these treasures with its young through a complex process of socialization that finds its focal moments in some rituals of initiation. It would be a mistake, however, to identify such initiatory symbols solely in terms of the more obvious and public tribal rituals that anthropologists ordinarily investigate. At present there are numerous indications, particularly in more technologized societies, that

much of the socialization of the young is carried on within their own peer group through symbols that may be neither familiar nor acceptable to their elders.

In speaking as we have been about "culture," we have used as the term's principal referent the shared *inner* awarenesses and attitudes and images and impulses that make up a people's worldview. The past half century of social scientific reflection on symbol has emphasized this more psychological understanding of culture. However, there has been a continuing insistence, especially among British anthropologists with their strong empirical tradition, that the proper object of scientific study of societies and cultures is the external activity that expresses and transmits a group's worldview. Any such emphasis relates us to the long-standing research into and debate about artistic symbols—poetry, painting, music, architecture, sculpture—and their social situation and function.

Cultural Impact

Whatever one's position on the debated question—whether communication is an intrinsic purpose of artistic creation or whether production of the artifact is its own self-sufficient purpose (*ars artis causa*)—it seems undeniable that artistic creations are powerfully commmunicative symbols in any culture. The enduring impact of Shakespeare's *Hamlet*, Bach's *Brandenburg Concerti*, the Athenian Acropolis, or Michelangelo's *David* testifies to the power of artistic classics to communicate cultural attitudes and insights in a way that transcends the relativizing bounds of time and geography. In a somewhat mysterious way, an artistic symbol is able at once to express and to create a people's ideals. Genuine art has the symbolic power to lead the human spirit to unanticipated understanding of its own existence and, by extrapolation, to imagination of an even broader spirit world.

It should come as no surprise, then, that in a religious culture such as ancient Israel it is poets who function as the great charismatic prophets, as oracles through whom the God of Israel communicates with the chosen people.[20] Apart from the religious truth claim about the "objective" reality of the prophet's experience of the divine, the empirically observable fact open to social scientific study is that the poetic symbolism of Israel's prophets communicated a unique worldview, encompassing both created and uncreated reality, that formed Israel into a distinctive theocratic society and culture.

At the same time, it would be a mistake to see symbols that effectively shape a group as emerging *ex nihilo* from the creative genius of the

20. See W. Brueggemann, *The Prophetic Imagination* (Philadelphia, 1978).

artist. As Victor Turner argues from his African field work experience, there is an underlying *communitas*, more noticeable in liminal groups but not confined to them, a sense of corporate identity that is not modeled through hierarchical imagery but that sees the cosmos "possessing a common substratum beyond all categories of manifestation, transcending divisible time and space, beyond words, where persons, objects, and relationships are endlessly transformed into one another."[21] It is this communitas, a social antistructure of universal friendship, that Turner sees "raised to metaphysical power by symbolic action" and, we might argue by extension, that finds expression in the universality that is characteristic of all true art.[22]

This convergence of interest in language, art, and communication theory has attracted special attention from a distinctively American approach to symbol which stretches from Pierce through Dewey to Mead and crystallizes in the "dramatistic" view developed by Kenneth Burke and Hugh Duncan.[23]

This movement continues to influence recent social scientific study of symbol, for example, Turner's and Glockman's use of the concept of "social drama"; and it illustrates the intertwining of anthropological with psychological and literary studies of symbol.[24]

Knowledge

Present discussion of the role that symbol plays in human knowing has been importantly enriched by the major development in social science that followed upon the work of Claude Levi-Strauss and that is generally referred to as "structuralism."[25] Whether one judges as successful or unsuccessful the attempt of structuralist analysis to interpret cultural myths, particularly those of primitive peoples, by laying bare some underlying patterns of relationships, this methodology has again attracted critical attention to the complex process in which human thought employs symbols to structure experience. Actually, the project in which Levi-Strauss and his disciples have been engaged is a combination of epistemological analysis and anthropological data-gathering. While there is always danger in this kind of procedure that observation of cultures and correlation of data will be unduly guided by philosophical

21. V. Turner, *Revelation and Divination in Ndembu Ritual* (Ithaca, 1975), 21–23.

22. The classic insight into this universal dimension of art is still that of Aristotle's *Poetics*. It is interesting to find the resonances of Aristotle in David Tracy's treatment of "the classic" in his *Analogical Imagination*.

23. For a description of this lineage see D. Duncan, *Communication and Social Order* (Oxford, 1962).

24. See Firth, *Symbols*, 194.

25. For a brief exposition of Levi-Strauss's positions, see G. Kirk, *Myth* (Berkeley, 1970), 42–50; see also E. Leach, "The Structure of Symbolism," in *The Interpretation of Ritual*, ed. J. La Fontaine, 239–75.

presuppositions—and such an accusation has been leveled at Levi-Strauss,[26] structuralism has proposed in sharper detail the basic question as to whether humans the world over have a common approach to symbolizing their experience of self and of society.

Despite its contribution, structuralism is far from being embraced by all social scientists. For one, Clifford Geertz in his recent collection of essays, *Local Knowledge*, expresses his reservations and provides a healthy reminder that the particularities of specific human experiences should not be obscured in the effort to find common patterns of thought or action.[27] That is not to suggest that the questions about cultural commonalities are irrelevant; what anthropologists such as Geertz underline is the resistance of concrete data to any one explanation. This obviously presents a profound challenge to any worldwide religious group that strives to maintain a common ritual that has existential meaning for very diverse cultural groups.

Use of structuralism in social science cannot, of course, be divorced from the use of the same techniques in literary studies; and one can notice in the debate about Levi-Strauss's work the classic question disputed by literary critics: what is the relation between content and form in a piece of literature? It is not quite satisfactory to say that "the medium is the message." The epistemological interest of structuralist reflection shifts the question somewhat, with obvious implications for any study of symbols: is human consciousness (including its less-than-explicit levels) shaped more by the underlying structure of a symbol, particularly the narrative structure of myth, or by its content?

Apart from technical discussion about the validity of a structuralist approach, it is obviously important to clarify the function of symbols in catalyzing and shaping human consciousness. The history of philosophy, at least in the West, has been to a large extent a sequence of attempts at just such a clarification. From Plato's effort to explain the relation between paradigm ideas and human common ideas, to medieval discussion of the nature and role of the *verbum internum*, to Kant's a priori categories, to phenomenology's attempt to reconcile scholastic and critical insights, the purpose has been constant: to discover within the dynamics of human thinking the interaction of the psyche's self-objectification and the formative influences coming from outside.

If one includes language as the key symbol system, it seems clear that at any given moment a person's inner consciousness has been shaped, at all its levels, by symbols. Moreover, it is constantly being shaped by these symbols as they are retained and interact in memory and imagination. Psychoanalysis has helped us discern this process and educators

26. See Kirk, *Myth*, 46–50, 198–99.
27. C. Geertz, *Local Knowledge* (New York, 1983).

try to take account of and utilize it. What recent developments in the social sciences have helped us grasp more accurately is the reciprocal influence of this inner world of symbols and people's experience of and participation in the symbols shared by a society.[28] While psychological study tends to focus on the individual, "it is the symbolism of collectivity—of myth, of ritual, of social structure—with which anthropologists are mainly occupied."[29]

Much of the anthropological study of this interaction has focused on religious rituals and on the distinctive shaping power of what is claimed to be revelation. A culture's dominant symbols serve as instruments for revealing the depth of human and cosmic existence. And within a culture it is religion (and modern nonreligious ideologies) that claims to provide a revelation of what is ultimately important and otherwise hidden and unknowable. It is not surprising, then, that the myths and rituals of the world's religions have been the earliest and constant object of social scientific study of symbols. Comparative research into religion by Fraser, Tylor, and Weber prepared the way for the broader cultural studies of Durkhein, Boas, and Malinowski, which still gave place of honor to religion as the home of myth and symbol; and this in turn led to the more recent studies of symbol by Evans-Pritchard, Firth, Turner, and Douglas—to mention only a few more prominent names—in which increasing attention has been paid to the symbolic continuity between religious and secular spheres of life.

One thing that has been firmly established by social scientific research is the key role played by "master" or "dominant" symbols in any given culture.[30] Most of these "master symbols" are linked to basic life experiences—birth, marriage and establishment of family, sustenance of life (by agriculture or hunting), sickness and death—but some—and the symbol of "exodus" in Israelitic society comes immediately to mind— are rooted in historical events. Whereas psychologists, most prominently Abraham Maslow, have pointed to the symbolic power of "peak experiences" in an individual's psychic life, social scientists have given extensive clarification of the manner in which the symbolic dimension of certain shared experiences, a symbolic dimension that is re-presented in condensed form in ritual, influences the outlook and activity of groups. Such "master symbols" constitute, then, a powerfully integrating force in a culture.

What still remains to be studied in greater depth is how private and

28. See particularly chap. 6, "Private Symbols and Public Reactions" in Firth, *Symbols*.
29. Ibid., 207.
30. "Dominant" is the term used by Turner in *Forest of Symbols*, 45–46, perhaps the most influential recent study of the power of these key symbols to integrate both the consciousness and the social relations of a group.

public symbolisms impact upon one another.[31] The influence of prominent public symbols on the imagination and understanding of individuals in any society can be evident, even when the precise manner and extent of this influence is not clear. By contrast, there is much less clarity about the process of individuals' symbols coming to be shared, interacting with already established public symbols, and in some instances attaining status as socially influential symbols. Considerable light would be shed on this question if we had more detailed study of the manner in which charismatic prophets in a religion such as Israel's or pioneering figures in the arts come to gradual acceptance after, in most cases, an initial period of social rejection.

Another thing that appears beyond dispute is the centrality of ritual. While much recent study has criticized the earlier view that all myth springs from ritual, that myth and ritual are but two sides of the same coin, ritual certainly shares with myth the role of shaping the deepest levels of a people's culture.[32] What is a new and valuable contribution of recent social scientific research of ritual is extension of study to include "secular" rituals.[33] It is too early yet to say how analysis of these (at least apparently) nonreligious rituals will correlate with study of other influences such as urbanization, but there is every indication that considerable light will be thrown on the process of secularization and concomitantly on religion as a social force.

Control

Discussion of the power of symbols to shape society can no more be separated from their role in expression, communication, and thought than these three can be separated from one another. More than four decades ago Malinowski had stressed this interrelation in his treatment of myth.

> Myth fulfills in primitive cultures an indispensable function: it expresses, enhances and codifies belief; it safeguards and enforces morality; it vouches for the efficacy of ritual and contains practical rules for the guidance of man. Myth is thus a vital ingredient of human civilization; it is not an idle tale, but an active force; it is not an intellectual explanation or an artistic imagery, but a pragmatic charter of primitive faith and moral wisdom.[34]

31. Ibid., 215.

32. See Kirk, *Myth*, 12–26. He is particularly critical of Malinowski and Kluckholm and more recently Leach for their contention that myth is always associated with ritual.

33. In this regard it is interesting to note how Firth devotes the latter half of his book *Symbols* to nonreligious symbols such as ritualized acts of parting and greeting.

34. Malinowski, *Magic, Science, and Religion* (New York, 1948), 101. See F. Harwood, "Myth, Memory and the Oral Tradition," *American Anthropologist* 78(1976):784–85, who faults Malinowski for downgrading the cognitive function of myth.

It is helpful, though, to focus more sharply on the manner in which symbols act as the "motors" of a culture.[35] Basically, symbols have this kind of motive power because they embody and express the goals that motivate a given group, they enshrine the value judgments that animate the traditional wisdom that a people transmits from one generation to another, and they resonate with radical emotions, such as fear, that drive people to action. Moreover, they do this at the deep levels of the implicit and the subconscious as well as at the level of explicit awareness and rational judgment.

Field research by anthropologists has provided abundant evidence for the way in which the myths and rituals of primitive, more simple, societies not only express but confirm various social arrangements. It does not take a great deal of imagination to compare this with the role of formalized schooling in today's so-called developed countries, where the legitimating myths of society are promulgated as a way of socializing the young. It takes a bit more insight to perceive the extent to which new social alignments are being created in countries such as the United States by the symbolic power of the "image makers" who control the communications media.[36]

Karl Marx's highlighting of ideology as a shaping force in society, and the resultant attention paid by students of society to the interpretation of social experience by powerful special-interest groups, has strongly stimulated and specified study of the social structuring power of symbols.[37] Through this study we have become increasingly aware of the extent to which all experience, individual and shared, is socioculturally interpreted experience. Some of this interpretation comes to us as formulated explanation provided by pundits of various sorts; but much of it, and perhaps the most powerful portion, comes through interconnected political and cultural and religious symbols.[38] In this process religious symbols, or what are perceived to be religious symbols,

35. Robert Bellah has drawn attention to the role of symbols, such as "covenant," that are attached to civil religion; see R. Bellah and P. Hammond, *Varieties of Civil Religion* (San Francisco, 1980) and R. Bellah, *The Broken Covenant* (New York, 1975). On symbols' role in society, see also T. Parsons, in *The Social System* (New York, 1951), 384–427. Parsons begins his treatment with the remark that "the field of expressive symbolism is, in a theoretical sense, one of the least developed parts of the theory of action" (384). He returns to the topic in his *Societies, Comparative and Evolutionary Perspectives* (New York, 1967).

36. As far back as Vance Packard's *The Hidden Persuaders* (1958), social analysis has drawn attention to the powerful manipulative potential of the media. For a recent discussion of the social power of television see "Print Culture and Video Culture," Daedalus III (Fall, 1982), and "The Moving Image," *Daedalus* 114 (Fall, 1985).

37. See Peter Berger, *The Sacred Canopy*, for the way in which the institutions and power structure of a society are legitimated by such symbols.

38. A number of recent studies, such as Robert Bellah's writings on "civil religion" or Martin Marty's *Righteous Empire*, have illustrated this interpretation of religious and cultural symbols.

have shown an unexpected ability to counteract secularizing tendencies in present-day society. Perhaps the most striking instance, at least on the North American scene, is the resurgence of religious fundamentalism.[39] This suggests that we need careful research into the use of symbols by fundamentalist groups, not just to discover the sources of the power exercised by these groups but to discern more broadly the power of symbols to shape social attitudes, institutions, and activity.

Again, given present-day tensions regarding the nature and exercise of power/authority in religious communities, there is special value in anthropological research into the different functioning of words as one moves from a society ruled by a "divine king" to a *polis* in which decisions arise out of public discourse. In the latter case, speech used in open debate is elevated to "preeminence over all other instruments of power, speech no longer the compelling ritual word pronounced from on high, but an argument to be judged as persuasive in the light of wisdom and knowledge verifiable by all as something called truth."[40] This touches, obviously, on the extent to which in any religious (or civil) grouping the authority attached to official statements is linked to the sacrality surrounding office and grounding the power to govern. What is difficult to situate into this dialectic between divine king's decree and discovered truth is the word of the charismatic prophet which is presumed to be God-given and which challenges both kingly utterance and public consensus.

IMPLICATIONS FOR CHRISTIAN SYMBOLISM

In the light of this quick sampling of recent social scientific research into symbol,[41] what transfer of understanding can we make to the field of Christian symbolism?

Sacraments Are Symbols

Perhaps most importantly, the very fact that social scientists have studied religious symbolism so intensely for decades has inevitably drawn attention to the functioning of Christian symbols *as* symbols. This may well be one of the reasons why more recent theological discussion of

39. For an interesting group of essays on this phenomenon see the September 27, 1986, issue of *America*.

40. M. Sahlins, "Other Times, Other Customs: The Anthropology of History," *American Anthropologist* 85 (1983): 517.

41. For a summary description of leading theories on symbol—social scientific, philosophical, artistic, etc.—see F. Dillistone, *The Power of Symbols in Religion and Culture* (New York, 1986); his summary of Gombrich's *Symbolic Images* (147–51), is particularly relevant to our present study. See also Dillistone's earlier book, *Christianity and Symbolism* (New York, 1955).

Christian sacraments has abandoned the fruitless attempts to reduce sacramental effectiveness to either "physical" or "moral" causation.[42]

Anthropologists and sociologists have certainly recognized symbols as powerfully causative, but they have also honored the distinctiveness of this causation, even as they have differed quite noticeably regarding its precise nature. In general, they agree that symbols, and specifically religious myths and rituals, play a role in the shared consciousness that underlies human culture and society. Their specific research and theories, whether structuralist or functional or psychoanalytic or whatever, suggest strongly that technical study of Christian sacramentalism should concentrate on the role of symbols in the shared religious consciousness that shapes a believing Christian community. In a sense, this would be a return to the perennial question of the relation between faith and sacrament, in particular the role in sacrament of the faith of the world-wide Christian Church;[43] but a return informed and refined now by the critical analyses of social science.

Demythologizing Sacrament

One of the greatest benefits coming to religion in modern times is the purification resulting from the demythologizing effect of modern science. In the area we are discussing, the attention that anthropology and sociology have drawn to the concretely observable effects achieved by a ritual inevitably challenges previous claims about some hidden unknowable "supernatural" effect.

While careful theological explanation of the causality of Christian liturgies has avoided implications of magic, the popular understanding of terms such as *ex opere operato* has often skirted the edges of magic and superstition. Even if one wishes to maintain, as most mainline Christian traditions do, that there is a level of sacramental effect that transcends ordinary symbolic causation, scientific studies of ritual suggest that this "supernatural" effect occurs within the human dynamics of the action and not on some other suprahuman level.[44] This insight promises, not the secularization of the theology of Christian symbol but a deeper and more accurate explanation of such symbols as causes and not merely occasions for a divine grant of "grace."[45]

42. For a thorough discussion of such theorizing about "sacramental causality," see B. Leeming, *Principles of Sacramental Theology* (London, 1955). One can notice the changing perspective on sacramental effectiveness by comparing W. Van Roo's *The Mystery* (Rome, 1971) with his earlier theological manual *De Sacramentis* (Rome, 1957).

43. On the history of debate about this relation, see A. Villette, *Foi et sacrement*.

44. See Firth, *Symbols*, 192–94, where he differs with Turner's stress on the sacral aspect of ritual.

45. It is too large a question to pursue at this point, but the twentieth-century dispute about and reconsideration of "grace" and the "supernatural" are closely related to this revised notion of sacramental causation. See the final chapter in my *Sacraments and Sacramentality* (Mystic, Conn., 1983).

Achieving Presence: Others and the Other

Social scientists have not explicitly used "presence" as a distinct object of study. In explaining symbols as processes of social expression and communication, however, they have clarified the dynamics of people's presence to one another. It requires little additional reflection on the anthropological research of a Turner or a Firth to see how the new interpersonal relationships that are established in rituals such as initiation make the participants present to one another in a new way. In the attempts, then, to understand how Christian rituals can function to make members of a faith community more personally present to one another, to make them more genuinely a *communio*,[46] data and insights provided by the social sciences should be a rich resource.

Belief in a presence other than that of the worshipers to one another, however, has always been basic to theological investigation of Christian ritual: the presence of the risen Christ and through him the saving presence of God. It is difficult to think of any element of Christian belief and practice that has been more hotly and divisively debated than the "real presence" of Christ in Eucharist; and over the centuries, beginning with the earliest Christian generation, a range of explanations has tried to cope with the enduring belief that in some fashion the Jesus who had passed through death into new life was present with Christians as they celebrated the eucharistic mystery.[47]

Social scientific research has been suggestive but not very satisfying in its treatment of people's experience of symbol as the "place" or "instrument" of a *personal* divine presence. The assertion that there is such presence is a religious truth claim; and the social scientist as such can neither admit nor deny such a claim. However, the charge could be made that some contemporary anthropologists have reduced to social phenomena the "mystery aura" of ritual to which earlier field observation and theorizing had paid respect.[48]

Even if one takes account of the experience that Rudolph Otto highlighted in his essay on "the Holy" or that Mircea Eliade has recurrently

46. For a recent examination of the church as *communio*, see the double issue of *The Jurist* 39 (1976). Significantly, the final presidential address of Bishop Malone to the 1986 meeting of the U.S. Catholic bishops (published in *Origins* 16[1986]:393–98, stresses *communio* as the basic model for the Church.

47. The diversity of views became a major source of the religious divisions in the sixteenth century; however, the preceding centuries had seen anything but theological unanimity. For a study of early medieval disputes about eucharistic presence, see G. Macy, *The Theologies of the Eucharist in the Early Scholastic Period* (Oxford, 1984).

48. Victor Turner is a notable exception. His interest in retaining the unifying force of common liturgy led him to an important and profound warning to Catholics to proceed cautiously in liturgical reform. See his "Ritual, Tribal and Catholic," *Worship* 50(1976):504–26. Firth, for one, had been criticized on this point. Without responding directly to this criticism, Firth proposes (*Symbol*, 192–96) a more nuanced position in his evaluation of the way in which Victor Turner deals with "the sacred."

described in his studies of "the Sacred,"[49] there is still a basic question: are such studies dealing with the experience of *power* or the experience of *person*? Not that these two need be separated, for exposure to an eminent person is its own form of experience of power. Still, there does not appear to be anything in the social scientific research into ritual, nor for that matter in comparative religious study of ritual, that provides a parallel to the anamnetic dimension claimed for Christian Eucharist, namely the personal presence of the risen Christ and therefore contact with the continuing mystery of his death and resurrection.[50]

Symbols and Meaning

However, not all present-day Christian theology sees the need to deal with a personal eucharistic presence of the risen Christ. One prominent explanation of Jesus' resurrection understands it, not in terms of Jesus' passage through death into a new form of continuing human existence, but rather as a transforming extension in history of the *meaning* of Jesus' death.[51] Whether or not one agrees with the reduction of Christian belief in the resurrection to this enduring significance, it is undeniable that Christian ritual has from the beginning focused on retaining and communicating this death/resurrection significance with the purpose of relating it to the significances of believers' lives.

In this context, Christian sacramental theology has much to learn from social scientists' investigation of the impact that the meanings of rituals have on individuals and groups. Structuralist analysis has intensified interest in meaning precisely because it has drawn attention to the implicit meaning conveyed by the underlying structure of myth or ritual. But those also, such as Turner or Geertz, who are critical of structuralism point to the *meaning* as that which a symbol expresses and communicates and that by which it exercises its influence on social structures and behavior. After all, the various methods employed by anthropologists and sociologists in their study of symbols are directed essentially toward discovery of the symbol's *meaning*.[52] These same methods, when applied to Christian rituals or to the broader spectrum of Christian symbolism, could enrich and make more accurate both the

49. See R. Otto, *The Holy* (New York, 1958); M. Eliade, *Patterns in Comparative Religion, Images and Symbols* (New York, 1961), *The Sacred and the Profane* (New York, 1959).

50. For a brief discussion of the distinctive application of *anamnesis* to Eucharist, see my *Christian Sacraments and Christian Personality* (New York, 1965), 134–35.

51. See W. Marxsen, *The Resurrection of Jesus of Nazareth* (Philadelphia, 1970). Marxsen's treatment emphasizes the role of the phrase "Jesus is risen" as an expression of Christian faith and hope rather than as a reference to a "historical happening."

52. "We hope to use the insights we gain from symbol interpretation as we use what we gain from aesthetic appreciation—to deepen our sensitivity of relationships and provide us with fresh ways of conceiving of meaning." Firth, *Symbols*, 196.

interpretation and the nurture of this symbolism. This would not sup-
plant the liturgist or the theologian by the social scientist; rather, it
would draw from social scientific expertise to clarify the reality with
which the theologian and the liturgist must deal.

What is of great importance to Christian sacramental theology is social
scientific discrimination between *signs*, in which the meaning conveyed
by a sensible symbol pertains only to an external referent of the symbol,
and *symbols*, in which the significance is intrinsic to the symbol itself.
More precisely, if one is dealing with religious symbols such as a ritual,
is "sacrality" characteristic of the symbol itself? Is "the sacred" present
in the symbol? Or by contrast does the symbol merely point to a sacred
reality extrinsic to and beyond itself? The importance of this distinction
becomes clear when one asks whether or not the participants in a ritual
themselves take on a new (sacred) significance and as a result are on-
tologically different.[53]

One could contend, and with some justification, that the distinction
being made by these present-day social scientists is nothing new, that
it simply repeats the classic explanations of sign and symbol.[54] While it
is true that basically the distinction being made is the same that has
long been recognized, what today's social researchers have done is to
probe more critically the process by which shared experiences or shared
imagery or shared language acquire growing resonance, the process to
which some have referred by the term "condensation." More specifically,
they have examined in considerable detail the sociocultural influences
that feed into the connotative enrichment of a particular symbol. One
of the more helpful methods employed in this regard is that of "field
theory," proposed in 1949 by Kurt Lewin[55] and employed so fruitfully
by Victor Turner in his *Forest of Symbols*.

Ritual and Social Structure

Another area in which theological understanding of sacramental lit-
urgies and other Christian symbols can draw from current social science
has to do with the role of ritual in expressing and creating social struc-
ture. To take but one example, the very term "holy orders" that came
to denominate the levels of officialdom in Christianity and, somewhat

53. See Turner's discussion in *Dramas, Fields, and Metaphors* (Ithaca, N.Y., 1974), 23–
57, of "the metaphor of change" in terms of the ritual acting as a social drama that effects
changes in character, structures, and relationships. When applied to ritual activity in
sacramental liturgy, Turner's insights throw light on the change effected, that is, the
"grace caused," in individuals and in communities. The social dimension of this change
has by and large been neglected in post-Reformation debate about grace and justification.
54. For a review of this classical discussion, see W. Van Roo, *De sacramentis in genere*
(Rome, 1957).
55. K. Lewin, *Field Theory in Social Science* (London, 1949).

later, the liturgical actions by which individuals were established in one or other of these levels, reflects the link between symbol and social structure in the church. Though conventionalized legal effects are clearly established in rituals such as ordination and these effects have become crystallized in church law and custom, there has been very little study of the deeper symbolic impact on the sociopsychological structuring of the Christian community. It would be instructive, for example, to examine the unifying and religiously self-defining symbolic power of the papacy within Roman Catholicism between Vatican I and Vatican II, the shifts in that symbolic effectiveness as John XXIII was succeeded by Paul VI and then by John Paul II, and the conscious employment by John Paul II of the power attached to papal symbolism.[56]

At a time in history when the Christian Church is on the verge of becoming truly a "world church" and not merely European Christianity transplanted worldwide, the institutional patterns rooted in Greco-Roman civilization which have structured Christianity until now will probably prove inadequate. If so, more truly universal sources of human community will need to be sought; and it is here that Christian symbols can function if in the symbols themselves, and specifically in Christian rituals, diversity and commonality can find place.[57]

Process

Finally, the whole movement of modern scientific thought, including the social and behavioral sciences, has been in the direction of increased awareness of *process*. Since it surfaced in mid-nineteenth century, the notion of evolution has infiltrated and revolutionized almost every discipline of knowledge. Everything, even at the subatomic level, is now recognized as being in constant change. In the realm of the human, elements such as language and law and dogma and liturgy that had appeared "eternal" and unchanging have been unmasked and revealed as subject to the changeableness of the context in which they existed. At the same time, beneath the changing circumstances of human existence a profound continuity has been glimpsed; and it is this glimpse

56. In his review essay of Kung's *Infallible: An Inquiry* (New York, 1971), Charles Davis pointed to the scholarly weaknesses of the book but then went on to indicate the deeper problem. "Moreover, a religious problem arises over infallibility which is not touched. Religiously what has been primary for Catholics, I should maintain, is not the doctrine of infallibility but the papacy as a religious symbol. The doctrine is derivative from the symbolic force the papacy acquired in the structure of the Catholic religion . . . If this symbol is now losing its force, as is indeed the case, what if anything is now replacing it symbolically? From the point of view of religious typology, what is now happening to the Roman Catholic religion?" C. Davis, "Kung on Infallibility," *Commonweal* 93 (1971): 445–47.

57. The need for common symbols is not restricted to the religious sphere. Mary Douglas in *Natural Symbols* (London, 1970) has pointed to the dangerous lack of effective common symbols in human society today.

of a common humanity that has spurred on much of the study of symbol that we have described.

The underlying process of the interplay of continuity and discontinuity, especially in human affairs, is clearly of central importance for the ritual behavior of religious communities. Increased study of social groupings (e.g., the family) as systems of interlocking relationships has thrown light on the manner in which the formation of community by sacramental significance is a systems process. Operative sacramental symbols nurture alienation or reconciliation, foster group identity, transmit inherited wisdom. What is not quite that evident is that symbol itself, if it is a living symbol, is a process. It is of the very nature of a central social symbol that it retain a large measure of sameness, otherwise it cannot function to transmit meaning and value over time; and religious rituals are notoriously slow to change, at least in their observable shape. This can obscure the realization that the concrete reality of any symbol is as fluid as is the meaning of human life that it exists to express and communicate. A living symbol is always becoming, both shaping and being shaped by the social group it animates.[58] This dynamic reality of symbol demands a flexible application of the distinction currently made in semiotic circles between synchronic and diachronic aspects of symbols.

In summary, recent social scientific study of symbols has provided theology both insights and questions regarding the role of sacraments in forming a community of believers and conversely the influence of the community on the effectiveness of sacramental symbolism. However, two of the classic areas of theological reflection about sacraments remain relatively untouched by the results of recent social scientific study: 1) the process, internal to the consciousness of individuals, of symbol shaping religious cognition and response—the classic issue of the relation between faith and sacrament; and 2) the function of language in specifying the precise here-and-now significance of a symbolic act—in Aristotelian terms, the function of words as "the form" of sacramental ritual. For the first of these we turn to psychology; for the second to current language and literary study.

58. One area of present scholarly research that throws light on this process dimension of symbol is the discussion among biblical scholars about the manner in which a canonical text is used by a constantly changing community of believers.

11

SYMBOLISM AND MODERN PSYCHOLOGY

The history that we have traced shows that Christianity from its inception has sought by the use of symbols to shape the understanding and activity of its adherents, to instill and nurture and inform faith in Jesus as the Christ. Through creedal formulations, liturgical rituals, community structuring, and distinctive life-style patterns, Christian communities and eventually the "great Church" employed a broad range of human symbols. Basically, it could not have been otherwise, for humans have no other means than symbols to create their individual and shared worlds.

Today this radical human dependence on symbols has become so widely recognized by various scholarly disciplines that an overarching specialized field of semiotics has emerged in the past century and become increasingly prominent since the end of World War II. In a refreshingly candid and straightforward article in which he pokes a bit of fun at the mystification that often accompanies discussions of hermeneutics and allied topics, Walter Kendrick saves a specially caustic remark about semiotics's "grandiose claim that all human endeavor should be explored under a single rubric, the interpretation of signs."[1] However, without denying the tendency of academics to see everything in terms of their own specialty and to drift into esoteric conversation that is totally opaque to ordinary intelligent folk, one does have to recognize the very important epistemological advances made by semiotics.

Basically, the notion of semiotics is quite simple; it is the study of all the various kinds of signs and signifying that enter into and structure

1. W. Kendrick, "What Is This Thing Called Hermeneutics?" *Voice Literary Supplement* (June, 1983): 7–8.

human experience. While linguistics forms its most technically refined element, semiotic study has reached out to influence research in all the social and behavioral disciplines and even research in the physical and life sciences.[2] Indeed, semiotic study has provided much of the impetus for development of the broader field of communications analysis.

For the most part, Christian liturgical studies and sacramental theology have been little touched by these recent developments.[3] As we saw in the previous chapter, social scientists have been engaged in extensive study of religious rituals, and Levi-Strauss's influential structuralist approach has converged with semiotic analysis—but most of this anthropological research has dealt with primitive societies. Despite the major renascence of Christian liturgical studies, application of semiotic research to reflection upon the sign-functioning of Christian sacramental rites has been almost nonexistent.[4]

The situation may not be as bad as it appears. For decades there has been large-scale and fruitful use by biblical scholars of the techniques and perspectives of semantic research. As a matter of fact, some of the more intriguing advances in semiotics language analysis today are taking place in biblical circles.[5] At the same time, the research methods and insights of biblical scholarship have increasingly affected the procedures and issues of Christian theological reflection. More pointedly, the attention to hermeneutical factors in recent foundational theology represents another important convergence with semiotic interests. So we can expect increased impact of semiotic study on sacramental theology. That such is desirable is obvious: the very term "Christian sacraments" indicates that the life and experience of Christianity and its adherents are radically and distinctively *significant*. Growth in the understanding and in the practice of Christianity rests on a more profound and more accurate insight into the role that *signs* play in human existence.

PSYCHOLOGY AND RECENT
LINGUISTIC STUDY

While recognizing pre–World War II contributions to semantic studies— the pioneering struggles of Pierce, the seminal work of Saussure, the

2. One of the more intriguing endeavors of semiotic analysis is the attempt to apply its methods to history—an endeavor that is especially relevant for research into anamnetic ritual. See Peter Haidu, "Semiotics and History," *Semiotica* 40 (1982):181–218.

On the attempts to discover semiotic structures and processes common to various disciplines of knowledge, see J. Piaget's essay in Piaget, ed., *Main Trends of Research in the Social and Human Sciences*, part 1 (Paris, 1970), 513–27 (hereafter cited as *Main Trends*).

3. For an exception to the general rule see E. Kilmartin's references to communications theory in his *Alternative Futures for Worship* (Collegeville, Minn., 1987).

4. An exception is the work of David Power, especially his *Unsearchable Riches* (New York, 1984).

5. For instance, the ongoing Society for Biblical Literature seminar on the Gospel parables provided a focus of structuralist study of New Testament texts.

philosophical insights of Wittgenstein and Husserl and Heidegger—
one can justifiably concentrate on the extensive development of lin-
guistics that has marked the second half of this century.[6] In these past
four decades there has been increased mastery of method, an integration
of a mass of new research with the accumulated backlog of previous
study, and a growing "ecumenism" that honors and profits by an in-
teraction of different approaches rather than a polemic insistence on
one theory to the exclusion of other views. For all their originality and
personal convictions, scholars tend to treat with respect the contribu-
tions of those with whose theories they disagree. One of the valuable
aspects of this openness has been the increased interest in interacting
with semiotic developments in other fields such as anthropology or
psychology. Substantively what has emerged is a greater recognition
that language *forms* cannot be adequately analyzed apart from language
content. A key instance of this movement away from an almost purely
formal approach was the development in Wittgenstein's own position
toward a more functional understanding of the phenomenon of human
language.[7] Another instance has been the increased interest in metaphor
and in images that model thought, that is, in underlying thought/lan-
guage processes that cannot be reduced to the structures of mathe-
matical logic, a development that has helped bring into question the
appropriateness of mathematics as the privileged paradigm for scientific
study.[8]

Actually, in the technical study of language the very notion of "lan-
guage" has taken on increasing breadth, becoming in some discussion
almost equivalent to "thought" as commonly understood.[9] Recognizing
and studying this "internal word" of human cognition is not, of course,
completely new. Medieval philosophers dealt extensively with the reality
and function of the mental word, its relation to the spoken word as well
as to extramental reality; and they extended this reflection to the nor-
mative universals (the *rationes aeternae*) that they located in the mind of
God. As we saw in an earlier chapter, a key element in such medieval
reflection was interest in the divine Word, where the eternal intelligi-
bilities controlling the truth of all reality and all cognition were thought
to reside.

6. For a concise review of the state of linguistic study, see Roman Jakobson's essay
"Linguistics," in Piaget, *Main Trends*, part 1, 419–66.

7. See A. Caponigri, *History of Western Philosophy* 5:314–19, where he describes the shift
between the *Tractatus* and *Philosophical Investigations* as a move toward appreciation of
the *use* of language.

8. Much of the following chapter will be devoted to present-day research and reflection
about the metaphorical aspect of language. For a semiotic approach to classic topics such
as metaphor, sign, or symbol see U. Eco, *Semiotics and the Philosophy of Language* (Bloom-
ington, Ind., 1984). Eco places semiotics within the history of the philosophy of language
and in so doing recasts that history.

9. See Piaget, *Main Trends*, 512–13.

Not surprisingly, much recent linguistic research (repeating the intrinsic logic of twelfth- and thirteenth-century questioning) has once more been driven back to the age-old problem of the origin of ideas. Theories of universal archetypes recall Plato's world of Ideas, Kant's a priori *forms* constantly lurk in the background of structuralist theories, phenomenologists exploit the notion of *intentionality* derived through Brentano from scholastic discussions, and attempts at sheer physiological and deterministic explanations have proved futile. Like previous generations that probed the derivation and nature of human consciousness, today's scholars have come to increased appreciation of the unity of the human person as an embodied spirit and of the inseparability of the subjective and the objective.

All this has immense implications for the study of symbols, for it is now becoming clearer that symbol is not something that humans use occasionally and for the most part aesthetically, even artificially. Rather, symbol is of the essence of all thought and all language.[10] Even more basically, the very mode of existing which is distinctive of humans is symbolic; we are more than "symbol-making beings" as Cassirer and Langer have insisted.[11] We exist symbolically because the spiritual dimension of our being "speaks" itself—though never with complete satisfaction—in our bodiliness. Speech and gesture are but two elements of this more inclusive reality of "body as language." Body is the most basic symbol and the root of all other processes of symbolizing.[12]

Within this broadening view of symbol, linguistic analysis has continued its role of examining critically and systematically the uses and structures of language. Because of the careful and persevering efforts of scholars such as Jakobson[13] and Chomsky there has been a continuing and rich flow of linguistic insights into the epistemological dimension of the human sciences and the humanities. As we strive to understand better the phenomenon of human cognition and discover that structural analysis cannot by itself provide the adequate explanations that we seek, the precision of linguistics has helped us avoid a pendulum swing toward vague generalizations and ungrounded theorizing. Accurate understanding of the origin, structures, and function of spoken and written

10. See M. Foss, *Symbol and Metaphor in Human Experience* (Princeton, 1949).

11. See S. Langer, *Philosophy in a New Key*, 2d ed. (Cambridge, Mass., 1951), which lays down the basic principles of her position, and *Feeling and Form* (New York, 1953), which extends this into a theory of aesthetics.

12. Jungian psychology, despite insistence on a body/spirit unity, is still deeply touched by Platonic idealism and would basically reject assigning this basic a role to bodiliness. See T. Sebeok, ed., *Psycholinguistics* (Bloomington, 1965); also J. Nelson, *Embodiment* (Minneapolis, Augsburg, 1978), a volume that explores from a Christian viewpoint the symbolic dimension of sexual bodiliness.

13. For an appreciative description of Jakobson's seminal contribution, see E. Brown, "Roman Osipovich Jakobson 1896–1982. the Unity of His Thought on Verbal Art," *The Russian Review* 42(1983):191–99.

language is a requisite for accurate insight into the nature and function of human consciousness, since language is the primary and most comprehensive symbol system through which our thought and feelings and decisions find expression. As a result, sacramental theology, if it ignores the advances of linguistic and semiotic studies, will do so at the risk of ambiguity and mystification.

RECENT PSYCHOLOGICAL RESEARCH

Inevitably, study of language leads to study of the human psyche which language symbolizes. Consequently, the remainder of this present chapter will concentrate on recent psychological insight into symbols and the implications this has for theological reflection on Christian sacramentalities.

Recent decades of psychological research have been marked by developing insight in three areas of dialectical tension.

Emergence of a "Life" Model

The earlier more mechanistic, chemicophysiological explanations of mental structures and functions have been challenged, modified, and to some extent supplanted by an approach to psychic activity that uses a "life" model and views consciousness as an organic *process* of emerging self-identity (Erikson), self-realization (Jung), or self-esteem (Becker).[14] One can see this dialectic exemplified in the movement from Freud to Erikson, or even in the evolution of Freud's own insights and explanations as he discovers psychic phenomena to be a distinctive reality that defies reduction to physiological explanation.[15]

Much of recent discussion about development or healing of the human psyche has moved toward a "constructionist" view, that is, a person is constantly (and perhaps more sharply in early years) involved in constructing his or her psychic existence. It is the function of the teacher or the therapist to assist the student/patient to make their own conscious life. However, the "construction" in question can be interpreted according to either of the two models we are distinguishing: construction

14. However, there has been large-scale continuation of what often is called "experimental psychology," and research in this area provides both insight and challenge. Our treatment does not deal with it precisely because it does not work with symbolizing but with more measurable organic concomitants of consciousness.

15. On the evolution in Freud's thought see P. Ricoeur, *Freud and Philosophy* (New Haven, 1970).

can be thought of in a more structural/organizational fashion or it can be thought of as the emergence of life.[16]

Implications for Theology

Dependent upon which of the two models one adopts, one's entire approach to studying or explaining Christian rituals, as well as other less obvious instances of Christian sacramentalism, is governed by an instrumental or organic symbolism. If one adopts the "life" model, one inevitably deals with human existence and activity (and therefore realities such as salvation and destiny) as radically symbolic, the distinctively human mode of being is seen in terms of symbolic self-expression and self-realization, and symbols (sacramentalities) are studied as the key to the communication that grounds community, religious or "secular." If the "life" model prevails, theological anthropology in its explanation of the soteriological "reconstruction" of a person will inevitably focus on the emergence of the self-image as the central dynamic of personal development; and this can then be extended to the development of a community or a culture.

Emphasis on Social Forces

The second instance of dialectical tension deals with the emphasis *either* on drives, impulses, structures, and so on, within the individual psyche as the root explanation of psychic phenomena, *or* on social forces— shared values and attitudes, social acceptance or rejection, prevalent ideas and intellectual presuppositions, language itself—as shapers of the individual's psychic situation.

Debate in this area, inseparable from the root epistemological issue of the relation between subjectivity and objectivity, is ancient and endless; but the specific shape it has taken in recent decades is largely in terms of differing psychological schools. Becker's *Revolution in Psychiatry* details, for example, the movement away from Freud's early stress on the individual's consciousness as the projection of unconscious impulses.[17] Instead, there is increasing acceptance of the impact of social forces, beginning with the shaping of awareness by language, and beyond that acceptance of the extent to which an individual psyche develops within the context of the corporate psychic processes of society.

Educationally the dispute has taken the form of "nature or nurture," of debate over the relative influence of genes or environment. If nothing

16. Piaget, *Main Trends*, has an interesting transposition of this dialectic into a semiotic context, in which he describes the "uniformity or variety of relationships between diachronic and synchronic factors depending on different types of structure" (492–93). He then goes on to apply this to the study of history and to suggest an imposing agenda for historical research.

17. E. Becker, *The Revolution in Psychiatry* (Glencoe, Ill., 1964).

else, serious questions have been raised about the source of basic psychic powers. Are they innate or do they originate from the influence of certain external agents? It is clear that much of what empowers and structures a person's conscious existence is learned; it is much less clear what learning is, what inner resources it draws from and actuates, how external forces elicit or form or inject not only images and ideas but the very capacities of imagination and thought.[18] Paulo Freire's well-known attack on the "banking concept" of teaching is but one of several theories that stress the interdependence of subjectivity and objectivity in all psychic activity.[19]

All this impinges strongly on the study of symbols, for inner consciousness, even on the level of the subconscious, is shaped and animated by symbols. More than that, the entire process of consciousness being translated into communication as a basis for society is a process of symbolizing. And conversely, the shaping influence of culture and society upon an individual's inner existence is exerted through symbols of one sort or another. As we saw earlier, some social scientists have underlined the need to understand more accurately and thoroughly the interaction of public and private symbols.[20] This is the domain of social psychology which so far has been studied by relatively few psychologists.[21]

Implications for Religion

The resonances of all this with the relationship between religion as a social institution and religion as an experience are almost limitless. Not only are the classic questions about "the origin of religion" seen to be questions about the source of people's symbols of "the sacred"; they are questions about the very possibility of symbols dealing with transcendence. This was, as we saw in an earlier chapter, the radical question of the iconoclast controversy, and the question has found several new formulations in recent decades, perhaps most observably in linguistic analysis of "God-talk."[22]

18. Recent advance in learning theory is probably connected more with Jean Piaget than with any other figure. See *The Child's Conception of the World* (London, 1929); *The Construction of Reality in the Child* (New York, 1954); *The Language and Thought of the Child* (New York, 1955).

19. See especially his *Pedagogy of the Oppressed* (New York, 1976).

20. "The serious problem for social anthropologists is not so much to demonstrate how one arrives at a general statement of any piece of public symbolism, as to work out how public and private symbolisms impact upon one another." Firth, *Symbols*, 215.

21. One can mention as pioneers in this area, B. Roheim, *The Origin and Function of Culture* (New York, 1943); R. May, *Power and Innocence* (New York, 1972) and *Politics and Innocence* (New York, 1986); E. Fromm, *The Sane Society* (New York, 1955).

22. For a review of the debate and a substantive dealing with the issues, see J. Macquarrie, *God-talk* (New York, 1967); see also L. Dupre, *The Other Dimension* (New York, 1972), 202–42.

At the present time, there is in this regard a critical tension in the traditional religious communities; for both the efficacy and the appropriateness of time-honored symbols—doctrinal, liturgical, and institutional-structural—are being appraised; are these symbols able appropriately to "translate" people's actual religious consciousness? This is acerbated by the challenge of the major Eastern religions to the claim made by Western religions that their faith and therefore their religious symbol system are unique and ultimate.

Conscious, Unconscious, and Language

The third dialectic concerns the relative importance and "reality" of the conscious and unconscious levels of the individual and social psyche and their interrelationship; this is tied in with the recent reemphasis on language as a key symbol system. Understandably, Freud's discovery of the powerful influence of the unconscious, coming as it did in contrast to the rationalistic heritage of the Enlightenment, tended to overshadow the role of conscious elements in human awareness and activity.

Strong currents of nineteenth-century Romanticism had already reacted aesthetically to the classical rationalism of the preceding century;[23] the Dionysian dimension of human consciousness and motivation, in contrast to the Apollonian, was honored as the source of creativity and heroism.[24] But it was the Freudian revolution that provided this enthusiasm for the prerational with the validation of science. Apparently, if one wished to understand why humans thought and acted as they did, it was *eros* rather than *ratio* to which one should direct attention.

However, as contemporary psychology absorbed and applied Freudian insights, there has been growing appreciation of the conscious level of awareness and affectivity. Interaction, interdependence, and mutual enrichment of the various levels of consciousness rather than of their conflict has more and more drawn the attention of psychologists.[25] Still, the relative contribution of conscious and unconscious forces to the psychic structure and existence of individuals or groups remains a debated and only inchoatively studied area.

With the acceleration of scientific research and technological development there is increased awareness of the need for creative thought and imagination if there is to be continuing advance. Perhaps even more importantly, creativity is needed to discover how scientific and technological progress can serve truly human goals. Yet, attempts to grasp

23. For a theological approach to this development see T. O'Meara, *Romantic Idealism and Roman Catholicism* (Notre Dame, 1982).

24. See N. Brown, *Life against Death* (Middleton, Conn., 1959), 170–76.

25. "It is this building of the structures of the intelligence that enables us above all to analyze the study of psychogenesis in the child. It is at present the subject of intense study in a number of countries." Piaget, *Main Trends*, 260.

the nature of the creative process and to provide some guidelines for nurturing creativity through the established academic processes have proved at best tentative.[26] There is mounting suspicion that our present methods of education are ill-suited to prepare people for the task of creating a human future, in large part because formal education does little to tap the resources lodged in the imaginative and emotive levels of the psyche.

Without detailing the implications that this debate about the relative importance and interaction of conscious and unconscious levels of the psyche has for the understanding of symbols, it is enough to remember that it is symbols that bridge the two psychic realms. It is in discovering the significance that symbols bear that humans discover the deeper psychic resonance of experiences like birth and death, but it is in the sharing of these same symbols that the pattern of unconscious response to experience is shaped. Ritual symbol, religious or other, provides therefore a privileged situation for tapping the resources of people's unconscious at the same time that it gives it shape and direction.

PSYCHOLOGICAL ORIGIN OF SYMBOLS

For anyone interested in nurturing the influence of ritual symbols in people's religious experience and development it is of major importance to understand the origin of symbols in a person's psychological life. The past decades of psychological research have contributed substantially to such understanding, not just of symbols in general but specifically of religious symbolism. There exists, then, a large body of psychological insight that needs to be incorporated into sacramental theology.

For several centuries Western intellectual history has been characterized by increasing awareness of humans' consciousness. At least as far back as Descartes, the philosophical search for a basis of verifying knowledge has focused on humans' interior life. This approach found in Kant's *Critiques* a formulation whose influence continues to be felt in every discipline of knowledge right up to the present. The fundamental character of the impact of Kantian thought upon our understanding of symbols is suggested by the fact that in his *Critique of Pure Reason* the basic contextual symbols of space and time are attributed to subjective formulation in sensation, and the three transcendental Ideas

26. See *Daedalus* 94 (Fall, 1965), on "Creativity and Learning." In theological circles there are beginning attempts to deal with imagination's role in theological reflection. See G. Kaufman, *The Theological Imagination* (Philadelphia, 1981); R. Hart, *Unfinished Man and the Imagination* (New York, 1979); D. Tracy, *The Analogical Imagination* (New York, 1981).

(self, world, and God) provide the overarching symbolic integration of knowledge.

From the Enlightenment on, human consciousness has been the central object of research and reflection. Yet, the intensification of this interest in the last hundred years has been so great that one can legitimately speak of a psychological revolution. Today there is an explicit awareness by people of their various psychological states which borders on the obsessive, and technical terms such as neurosis, Oedipal complex, or sublimation have become part of everyday language at the price of being often misunderstood.

What makes the term "revolution" appropriate is the fact that recent psychology is not just a heightened appreciation and more accurate understanding of the processes of human reason, such as marked the eighteenth and nineteenth centuries—or for that matter, of the twelfth and thirteenth centuries. Rather, psychology, especially since Freud, has revealed the world of the unconscious, the energies of the affective and emotional that seem to work in tension with the rational. And in this realm of the unconscious or semiconscious, psychic reality is structured by symbols with all their connotative ambiguity rather than by the precise laws of logic or mathematics.

Psychologists, guided for the most part in their research and philosophizing by a therapeutic goal, have concentrated on the inner drives that source people's actions. Whether it be Freud's explanation of the "id" as an erotic impulse toward pleasure, or Adler's focus on the "drive to power," or Rank's will toward individuality, or even Maslow's hierarchy of needs, the root of psychological states and activity has been identified with an energy prior, at least causally, to any ideational or imaginative formulation. This has challenged the classical "order of response" which viewed affective impulse as resulting from perception. Symbols do elicit affective impulse, but only because they have emerged and exist as the translation of impulse. For that reason symbols are the therapist's clues to the psychological disorders that need treatment in any given case; therapy consists very largely in interpretation of symbols.[27]

While the earlier stages of modern psychology tended to deal with various "drives" in somewhat fractured fashion, more recently there has been more emphasis on the integrated "outward drive" of the person as a whole.[28] This has coincided with the recognition, for example in

27. See P. Ricoeur's *Freud and Philosophy*, which describes Freud's method as basically a hermeneutic.

28. This is particularly true of the "humanistic school" of psychology. See, for example, A. Maslow, *Towards a Psychology of Being*, 2d ed. (New York, 1968) and *The Further Reaches of Human Nature* (New York, 1971); G. Allport, *Pattern and Growth in Personality* (New York, 1961); S. Maddi and P. Costa, *Humanism in Personology* (Chicago, 1972), a short introduction to the work of Maslow, Allport, and Murray.

the post-Freudian view of Erikson, of the intertwining of internal psychological development with socialization into some community. Humans exist relationally, constructing their own internal world by both interpreting and responding to the broader outside world.[29] Symbols do spring from the depths of the unconscious, they do give expression to the drives that move a person to feeling and decision and action, but they do not come into being independent of and untouched by the symbolic influences of the context in which the person exists.

Toward a Holistic View

The movement of much psychological theory toward this more holistic view with its emphasis on the relational character of human consciousness has been profoundly influenced by the philosophical currents of phenomenology and existentialism, especially by the notion of "intentionality." Rollo May, for example, in his masterful *Love and Will*, uses the notion of intentionality as the key to explaining the whole span of of psychic activity.[30]

One of the most recent and most thoroughly revisionist contributions to this relational current of developmental theory has come from the study of women's psychology *by women*. To take but two examples: Carol Gilligan, reacting to the moral developmental model of Lawrence Kohlberg—which she considers a one-sided masculine model—has described a different pattern that is more characteristic of women's movement toward maturity, a pattern that stresses *relational* existence;[31] much the same emphasis is found in the work of Jean Baker Miller (and her associates at Wellesley College's Stone Center) where psychological growth is viewed not as achievement of autonomy that is gained by separation from earlier relations (e.g. mother/daughter) but as intensified relatedness grounded in openly recognized and freely chosen interdependence.[32]

What this implies is the existence of a fundamental and (in first act) unrecognized symbol of the self as outward directed, a symbol that underlies all exercise of human intentionality, that gradually finds formulation as that intentionality is expressed in activity, a symbol therefore

29. In Preface 2 (1979), written for the second edition of *Identity and the Life Cycle* (New York, 1980), 10–13, Erikson indicates the way in which his own thought had moved to a greater coincidence of ego development and socialization, the "complementary interplay of life history and history." Piaget, *Main Trends*, 251, singles out Erikson's work on children's symbols as contributing to the constructionist view.

30. R. May, *Love and Will* (New York, 1969), especially chap. 9 on intentionality.

31. See Carol Gilligan, *In a Different Voice* (Cambridge, Mass., 1982).

32. J. Baker Miller, *Towards a New Psychology of Women* (Boston, 1976). The profound role played by symbols in this whole process is highlighted in the essay of Patricia Ries, "Good Breast, Bad Breast. This is the Cuckoo's Nest," *Journal of Feminist Studies*, (1987):79–96.

that implies the objective reality of "the outside" to which the intentionality is directed. This is not a Kantian transcendental Idea to integrate consciousness—though it does that too—but an imaginative structure that encompasses and animates both cognition and affectivity. It is a living and constantly changing symbol that reflects at any given moment a person's Gestalt, that embodies one's hermeneutic of experience.[33]

Without being described in precisely this fashion, the notion of a basic self-image that is the center of psychological development has become a commonplace in recent psychological literature. This is particularly true since Erikson's explanation of the process of self-identity, his focus on the role of an identity crisis, and his description of the cumulative emergence of a mature self-identity. All this reflects the extent to which a "life model" of the human self has come to modify much of the earlier mechanistic model of interacting psychic forces. As Ernest Becker describes this development—perhaps with excessive optimism— "the earlier functional psychology and the psychoanalytic and existential psychology are now one. This is a crucial historical achievement not only as a linkage of the history of ideas but also as a secure platform for future work."[34]

The Importance of "Meaning"

Connected to this stress on the basic intentionality of the human self is recent attention to "meaning." Perhaps in response to the evaporation of naive trust in meaning that came with the two great world wars, the currents of philosophical and artistic reflection linked with the term "existentialism" have drawn attention to the importance of meaning in human life. Paul Tillich's most existentialist work, *The Courage to Be*, described the loss of meaning as the most dire threat to humans in our century. In psychological literature one thinks immediately of Frankl's *Man's Search for Meaning* or of the focus on acquiring self-meaning in much developmental psychology.[35] And one can view the Jungian process of individuation as establishment of one's meaning.[36]

That meaning is central to the establishment of self-identity needs

33. At first blush this would seem to coincide with the Jungian archetype of the self, but as we will see shortly in treating Jung's view, I suggest a greater existential autonomy for the individual self-image than does Jung.

34. E. Becker, *Birth and Death of Meaning* (New York, 1971), ix.

35. See V. Frankl, *Man's Search for Meaning* (Boston, 1963). For a review of twentieth-century reflection on meaning's role in human life see J. Morgan, *In Search of Meaning: From Freud to Teilhard de Chardin* (Washington, D.C., 1977); also R. Stevens, *James and Husserl: The Foundations of Meaning* (The Hague, 1974). Developmental psychology has been a major source for recent religious educational theory; see *Faith Development and Fowler*, ed. C. Dykstra and S. Parks (Birmingham, 1986).

36. See A. Jaffe, *The Myth of Meaning* (London, 1970), 76–94.

no argument, for meaning has to do precisely with the question of a subject's conscious relationship to a happening; how does it affect me? Today's widespread concern with meaning, accentuated by the current interest in self-fulfillment and reflected in the constant evaluation of things in terms of their "relevance," betrays the extent to which the individual exists in relationship to the *Umwelt*—the circumstances in which she or he is situated—and draws self-identification from this relationship.

But this raises a question: Where does meaning come from? To what extent does the knower discover the meaning intrinsic to the experienced happening; or to what extent does the knower read into the happening a subjective interpretation? Undoubtedly both discovery and interpretation play a role, and these roles do not function in independence of one another. Symbols are intrinsic to this acquisition of meaning, for images within the individual or societal psyche become more densely symbolic as increased meaning is attached to them.[37] And it is through meaning-bearing symbols that a society tries to transmit from one generation to another the significance it has found in human existence.

Without denying a great deal of validity in Freud's discovery of the extent to which symbols, especially dreams, emerge in the psyche as a translation of underlying impulses, more recent psychology has moved in a different direction. For one thing, this is due to the shift in emphasis from examination of psychic pathology, understandably stressed in theories such as Freud's that are controlled by a therapeutic goal, to study of normal psychic processes. There has been a proliferation of research and reflection on human learning and psychic growth, the emergence of various schools of development psychology (Piaget, Kohlberg, Erikson, etc.), and numerous theories of personality growth and enrichment of experience.

While much of the insight gained by the research of Piaget and others into the processes of learning probably had always been intuitively possessed by "born" teachers and to some extent was passed down in traditions of teaching, it has been helpful to have those processes delineated and clarified. For one thing, the establishment of correlations between physical maturation and the ability to learn various things, between emotional states and learning, between stereotyping and "objective" observation, between powers of observation and imagination and reflective thought, has helped us appreciate and understand the

37. In his *Birth and Death of Meaning*, especially 118–29, Ernest Becker draws attention to the role of the hero-symbol, to the largely fictional development of this and other key symbols, and to the need to bring governing social systems into increased congruence with reality—at the price of human survival.

complexity of human intellectual and affective development and to devise means of educating people more effectively and holistically. This certainly has not brought about a utopian advance in our educational institutions; but if nothing else it has helped us appraise more accurately the all too apparent deficiencies in our pedagogical efforts. Knowing what could and should happen is a needed step in working toward betterment. One of the key imperatives of the educational enterprise today is to help people discern, understand critically, and then utilize with intelligent freedom, the symbols that now shape our individual and shared human lives.

The symbolism attached to education itself (as being a good thing, carrying a certain prestige, etc.) has been influenced by developmental psychology. While it is not an element of technical advance, one of the important byproducts of contemporary psychology has been a broader acceptance of the principle that it is good for people to understand what they are doing. Given the large-scale manipulation of information by governments and the implied disdain for the critical powers of the general public, one cannot naively overestimate the opportunity that people today have to discover what is going on in their world. Yet, increasing educational opportunity is a key element in the "rising expectations" of disadvantaged populations and "conscienticization" has become a widely desired goal in much of the world. Cries for free exchange of information are based on this assumption, and the movement in many quarters toward consensus rather than authoritarian direction of communities rests on the presupposition that those working toward consensus have sufficient understanding of the issues under discussion. Though it is still far from being rejected in practice, the notion that "the masses" are better off left to their ignorance and directed by a powerful elite is no longer acceptable as a raw enunciation of social behavior. Psychology has contributed to this shift in perspective: development of people (which every "decent" person is now expected to espouse) involves as an indispensable and high-level goal the nurture of critical and autonomous consciousness.

This implies that people need to understand the import and impact of the symbols they employ—their language, their gestures, their artistic forms, their styles of housing and dress, their social rituals, their ethnic and national myths. Much of what appears to be operative symbol may well be empty and noncommunicating, much of what is actually shaping people's attitudes and lives may be relatively hidden, much of what is considered just ordinary and not particularly significant may have greater symbolic power than the symbolic forms perpetuated artificially in educational curricula or in routinely performed religious rituals.

Basically, people need to be alerted to the reality that they exist

symbolically, and that if symbols are to contribute to their advance and happiness they must be understood and creatively fostered. Once alerted and desirous to move in this direction, people need to know *how* to live symbolically in a way that furthers psychological advance and maturation. This is much more than simple acquisition of information; it is learning to control their symbol system rather than be unconsciously controlled by it. It is here that developmental psychology and learning theory can make an indispensable contribution by clarifying the process through which formative symbols, individual and social, emerge and function. The need for sacramental theology and liturgical practice to profit by this contribution is obvious.[38]

What may be one of the major contributions of contemporary developmental psychology is its symbolizing of human psychic existence through a "life model." Rather than describing human maturation in mechanistic terms or simply as acquisition of habits or modification of certain powers of action, psychoanalysts such as Erikson as well as humanistic psychologists such as Allport or Maslow have dealt with it as an organic life process.[39] Establishing self-identity, setting goals and values that are grounded in a basic option, moving toward increased personal freedom—this is most basically what life means for a self-aware being. And while an analytic or structuralist approach to the study of symbols does much to clarify their intrinsic logic, and semiotic study of the diachronic dimensions of symbol throws light on symbolic evolution, seeing symbols as integral to the life-process that is human consciousness provides a distinctive insight into their genesis and their function.

Symbols and Human "Commonness'"

Throughout the entire discussion about the origin of symbols there lurks the perennial question: how does one explain the universal aspect that makes a symbol applicable to different people, even to different cultures and historical periods? Basically, one is asking what grounds the commonality that binds men and women into the human race. But one is specifying the question to human psychological existence: how is it that humans across the globe can use symbols to share their consciousness with one another? And it is here that some of the most valued and provocative suggestions are found in the Jungian currents of modern psychology.[40]

38. An instance of what needs to be done is the recently published project of Liturgical Press, *Alternative Futures for Worship*, in which current social and behavioral science are explicitly used as basis for suggested liturgical revision.

39. See *Handbook of General Psychology*, ed. B. Wolman (Englewood Cliffs, N.J., 1973), 819–21.

40. One of the best explanations of Jung's view of symbols and of their social and religious function is Wallace Clift's *Jung and Christianity* (New York, 1982).

Humans have always been intrigued by the suggestion of some underlying ultimate reality of which they are really only a manifestation and to which, in the final analysis, they will be reduced. In the East this has tended to be the general view associated with Hinduism and its Buddhist offshoot, with variations ranging from unmitigated monism, to a more subtle nondualism, to an acceptance of some distinctive though dependent existence of the sensible world.[41] In the West this tendency has been offset by the biblical notion of a truly transcendent divinity, the corollary being the genuinely distinct reality of creatures. However, in Greek thought Plato entertained the notion of a world soul.[42] It is not clear that for Aristotle there is more than one agent intellect for the entire human race;[43] and Hegel in his *Phenomenology* does more than suggest that human consciousness is self-expression of Spirit.

Thus there is widespread historical support for the Jungian theory that not only maintains the existence of certain universal archetypal symbols but views this as a manifestation of an underlying common consciousness in which all humans share. This "collective unconscious" is not to be understood, however, as a denial of individuality; rather, Jung describes a process of cumulative psychological inheritance, an evolving heritage shared by all humans. Nor are the archetypes to be thought of as ready made and fleshed-out symbols; rather, "the archetype in itself is empty and purely formal, nothing but a *facultas praeformandi* . . . In principle, it can be named and has an invariable nucleus of meaning—but always only in principle, never as regards its concrete manifestations."[44] It is from this collective unconscious that archetypal symbols emerge to form and give teleological orientation to the psychic experience of an individual.

Whether or not there is solid ground for accepting a collective unconscious such as Jung describes it, he has certainly highlighted the issue of "commonness" in humanity's myths, fables, and rituals and concomitantly the issue of the origin of religious mythology and ritual.[45] And he has done so not only by drawing from the Kantian insight into a priori forms but by absorbing some of the arcane views of the gnostic

41. The classic explanation of Indian religious thought for Western readers is still H. Zimmer's *The Philosophies of India* (New York, 1951). A more popular but insightful presentation is that of H. Smith, *The Religions of Man* (New York, 1965), 71–158. On Jung's relation to Eastern thought, see H. Coward, ed., *Jung and Eastern Thought* (Albany, 1983).

42. *Timaeus*, 34a–37c. See F. Cornford, *Plato's Cosmology* (London, 1952), 57–97.

43. See *De anima*, 430a. See also F. Brentano's lengthy discussion in *The Psychology of Aristotle* (Berkeley, 1977), 106–61 of the active intellect—which he does not see as separate.

44. Jung, "Psychological Aspects of the Mother Archetype," in *The Archetypes and the Collective Unconscious*, Collected Works 9, part 1 (New York, 1970), par. 155.

45. For Jung's view of religious symbolism see *Psychology and Religion* (New Haven, 1938).

and hermetic traditions that had passed for centuries through the underground literature of the alchemists.[46] Jung has already exerted widespread influence on comparative study of religions and on the various currents of structuralist analysis; and his influence shows no signs of waning.

There is an interesting link in the history of ideas if one compares the Jungian archetypal form, particularly as worked out in his later works and extended somewhat beyond the purely psychic realm,[47] to the Aristotelian *enteleche* ("substantial form"). While this substantial form as Aristotle explains it does not exist as a being, it is a structuring principle of being that finds existential realization only in its dynamic shaping of matter. In a sense what Jung has done is to move this insight into the psychic realm where the archetypes are the formative dynamism of the symbols that most deeply shape and direct an individual's psychic life.

Connected to Jung's theory of the collective unconscious and of the archetypes that manifest it is his explanation of the origin of meaning in human experience. It is in the influence of the collective unconscious in the individual's attempts to establish identity that the deeper meaning of experience is conveyed. More precisely, it is the archetype of the self, the focus of an individual's discovery and creation of personal meaning, that is *imago Dei*, a reflection of ultimate meaning. Ultimate meaning, divinity itself, remains impenetrably shrouded in mystery, beyond direct human knowing; but at the same time, there is validity to the symbolizing of the divine that springs from the collective unconscious. Jung's explanation, though basically apophatic, is not iconoclastic.[48]

Pushing a bit further than Jung himself, one can seek the implications of his theories for a theology of divine presence. What Jung does intimate is a pervading divine influence on human consciousness and affectivity—the dynamism of the archetype both shapes and directs theologically—as both Word and Spirit. This is, of course, different than a truly *personal* presence of "someone"—or is it, when one examines the manner in which humans make themselves present to one another through symbols that catalyze and shape consciousness? Jung's formulated response comes most directly in his understanding of religious experience. But before examining his and others' view of religious

46. One of Jung's last major works, *Mysterium Coniunctionis,* is devoted to interpretation of alchemical symbolism. See also J. Singer, "Jung's Gnosticism and Contemporary Gnosis," in *Jung's Challenge to Contemporary Religion,* ed. M. Stein and R. Moore (Wilmette, 1987), 73–92.

47. For the overlap of Jung's reflections on the archetypes and some contemporary scientific theories, see Jaffe, *The Myth of Meaning,* 29–42.

48. Jung himself was attracted by Christian mystics, particularly by Meister Eckhardt; see Ibid., 138–53.

experience, it is necessary to review various psychological explanations of the *function* of symbols.

THE FUNCTION OF SYMBOLS

In examining various explanations of the way symbols function in the human psyche, one becomes aware of how differently the term "symbol" is used and therefore how different are the understandings of the referent of the term. Indeed, comparing differing views can be misleading if one assumes that the theorists in question are talking about the same reality—there usually is overlap, but often little more than that.

Another caution: there are several categories of things that function symbolically for humans, but they function quite distinctively. Probably the most basic and most influential of symbol systems is language, particularly a person's mother tongue. Language formulations play a key role from early infancy onward in shaping people's perceptions, in giving people an instrument for identifying and classifying things experienced, a mold into which to cast their understandings and emotions and goals, and a means of communicating their insights and feelings to others.

Another very broad category that to some extent overlaps language is that of symbolic artifacts. Painting, sculpture, architecture, music, dance—along with poetry and theater—provide the artist not only a mode of expressing inner consciousness (including the less than fully conscious) but a medium in which that consciousness itself takes shape. For the observer of the art, the psychological impact of the art symbol is complex and diversified according to one's aesthetic sensitivities; but the artifact clearly acts to shape both conscious and subconscious levels of the psyche.

Less apparently symbolic, but no less effective, are the life-styles and social institutions that people share with others in a given culture or that they adopt to distinguish themselves from others. Such patterns of behavior reflect people's goals and structure their priorities. As modern advertising so strikingly illustrates, society's life-style is itself molded by symbols—for example, the symbol of "youth" that has such influence on the American way of life.

Another broad grouping of symbolic actions can be gathered under the notion of "ritual." Here by a more or less conscious social convention, actions take on a meaning beyond themselves, a meaning that touches the shared dimensions of their lives, a meaning into which "initiates" need to be introduced by acquainting them with the significance the group has attached to the ritual.

Each of these types of symbol has received detailed and distinctive

study from a number of disciplines. Psychology's contribution has to a large extent been one of probing the role of these symbols on the more hidden levels of the human psyche, though there are indications—as we have suggested—that attention is shifting to the domain of consciousness. Theories about this role continue to be differentiated by the researcher's use of either the mechanistic or the organic model, though there is general agreement that one is dealing with a constructive process through which an individual establishes his or her inner world of awareness along with a distinctive identity.

Three precise questions face psychology's investigation of the function of symbols in this constructive process. First, to what extent, if at all, do symbols (e.g., the Jungian archetypes) or some psychic directedness towards symbol-making precede and mold psychic existence? Second, to what extent do symbols function as the intrinsic shaping principle (*enteleche*) of both conscious and unconscious? Third, in what ways do symbols function to express various levels of psychic existence, to express understandings and intuitions and emotions and motivations and underlying psychic energies? How does this happen within the psyche so that passage and integration can be established between these levels? How does it happen as people communicate their inner world to the outside world so that human community can result? Fourth, to what extent do symbols make human psychic existence possible by formulating hope of a truly personal future?[49]

Upon psychology's ability to deal with this immense agenda will depend much of sacramental theology's future development, for understanding the concrete effectiveness of Christian sacramentalities (whether in rituals or in the broader context of Christian life) will be a specialized segment of the understanding of the psychological function of symbols. What psychology has already achieved in addressing this agenda provides a major challenge to both theology and liturgical practice, for it forces a reassessment of the classic belief that "sacraments give grace."

PSYCHOLOGY OF RELIGIOUS EXPERIENCE

Within the broader psychological study of symbols, there has been attention paid specifically to religious symbolism as part of the expanding field of psychology of religion.[50] While valuable insights have

49. For discussion of these issues a good introduction is *The Dialogue Between Theology and Psychology*, ed. P. Homans (Chicago, 1969). One of the most insightful approaches to the psychoreligious role of symbols is that of William Lynch, particularly in his *Images of Hope* (Notre Dame, 1965).

50. For a systematic psychology of religious experience see A. Godin, *The Psychological Dynamics of Religious Experience* (Birmingham, Ala., 1985); see also D. Browning, *Religious Thought and the Modern Psychologies* (Philadelphia, 1987).

been gained by psychological reflection on particular symbols, the controlling insights have come in terms of psychological research into religious experience, research that has been strongly influenced by two early twentieth-century classics, Otto's *Idea of the Holy* and James's *Varieties of Religious Experience*.

Freud combines the view that people's experience of religion is rooted in and controlled by their fears and desires (an explanation that goes back at least as far as Hume) with the theme recurrent in nineteenth-century German philosophy that people's experience of "God" is a projection of their own self-perception. What people experience in religion is not a "God actually out there," but a divine Father-figure created by their own psychological need for security.[51] "God" is a powerful symbol that helps the individual cope with the anxieties of life and on the social level provides a normative principle for civilized human existence. In calling such experience "illusion," Freud is not directly attacking religious truth claims about divine revelation; he remains agnostic regarding the existence of a transcendent, but sees the symbol "God"—which would operate in the same way in the human psyche whether or not there is a transcendent reality—as a powerful force, for good and ill, in individual and social experience.[52]

While not subscribing to Freud's view that God is only a psychological projection, mainline religious communities have already been forced to take serious account of the relationship that does exist between people's hopes and anxieties and the way in which they perceive the divine. This impact of Freudian thought has been more evident in the instance of pathology that touches religious experience, such as scrupulosity; but it has begun to touch as well the examination of healthy religious experience and drawn attention to the subjective interpretative dimension of people's beliefs about the divine.

Freud's view of religious belief as psychological illusion takes on added importance because of its partial coincidence with Karl Marx's depiction of religion as illusory ideology that results from the needs and interests of both oppressed and oppressors in capitalist society. However, Marx locates the source of people's subjective religious experience in the maladjustments of the economic order rather than (as with Freud or Feuerbach) in psychological tendencies intrinsic to humans.

With Erikson's move toward a more positive estimate of religious faith, seeing it as a key contribution to the process of maturation, the

51. For a critique of Freud's theory of the origin of religious experience, see J. Bowker, *The Sense of God* (Oxford, 1973), 116–34. See also J. Scharfenberg, *Sigmund Freud and His Critique of Religion* (Philadelphia, 1988).

52. On Freud's view of "God" and on recent appraisals of Freud's atheism, see P. Gay, *A Godless Jew* (New Haven, 1987).

ground was prepared for the kind of developmental psychology approach to religious experience that one finds in James Fowler's *Stages of Faith*[53] or in Walter Conn's books on conscience and conversion.[54] While such developmental theories allow for unusual religious experiences, particularly in instances of "conversion," they stress the continuing role of faith and belief in the core process of maturing individuation.[55] However, to a considerable extent they leave unanswered the question of the source of an experience of transcendence. One of the more insightful responses is provided by John Bowker, who develops the notion of "compound of limitation" in reference to the awareness of contingency and limitation acting as a "reality principle." Bowker then argues that such an awareness could be caused by an "outside" object and is not necessarily a projection of inner impulses.[56] That leaves open as a possibility the kind of awe-inspiring intrusion into human consciousness of "the Holy," which Rudolph Otto described and which comparative studies of religions, particularly those of Mircea Eliade, chronicle as a widespread human experience.[57]

If there is such religious experience of an "outside" transcendent reality—and there is plentiful evidence that this is what millions of people experience—then the theological question arises: how does this experience (or these experiences) function as overarching symbol of divinity? The final chapter of this book will attempt a tentative answer by analyzing the manner in which people's basic experience is privileged "Word of God."

Jung has, of course, an appealing theory to answer the question: It is the energizing and shaping presence of the archetype of the self, from which springs the sense of divine presence. However, when examined closely the Jungian solution presents profound problems. Like all other forms of Platonic idealism, that of Jung betrays sacramentality by denying to sensible reality its own intrinsic meaning; meaning must break through from the "unseen" world of spirit, of the unconscious,

53. J. Fowler, *Stages of Faith: The Psychology of Human Development and the Quest for Meaning* (New York, 1981).

54. W. Conn, *Conscience: Development and Self-Transcendence* (Birmingham, Ala., 1981); *Christian Conversion* (New York, 1986).

55. T. Groome in *Christian Religious Education* (New York, 1980) provides a detailed analysis of the manner in which ongoing experience of faith is integral to the process of education and subject to the analyses proper to educational methods. His book incorporates into cognitive development the insights of Piaget as well as the emphases of "Liberation Theology," on *praxis*. For a treatment more centrally focused on sacramental symbolism see R. Browning and R. Reed, *The Sacraments in Religious Education and Liturgy* (Birmingham, Ala., 1985).

56. See J. Bowker, *The Sense of God* (Oxford, 1973).

57. R. Otto, *The Idea of the Holy* (London, 1936); among the many writings of M. Eliade that touch on this topic, see especially his *Patterns in Comparative Religion* (New York, 1958).

and *sensibilia* project meaning only by being mirror or shadow and not by their own ontological significance. But does not meaning come out of the discovery of the meaning "deep down [but not behind] things"? Is it not the meaning of things themselves that the poets discover and lead the rest of us to see? Is not the meaningfulness intrinsic to human embodiment the source of dance's symbolic power and of artistic fascination with the beauty of the nude?

Before turning to theological reflection on these psychological developments, there is one particularly intriguing psychological insight that touches on our theme of "distancing." In his essay "Towards a Psychology of Religion," Peter Homans draws from Rorschach research to link vista responses to self-evaluation. If a person projects self in relation to the spatial world with a heightened sense of distance, this is "associated with feelings of inferiority, guilt and loss of the capacity for confident and positive self-appreciation . . . the imagery of distance is also, therefore, the imagery of the super-ego."[58]

IMPLICATIONS

In summary, what elements of recent pyschological understanding of symbol provide either resources or challenges to the task of sacramental theology?

Remythologizing

Perhaps modern psychology's most basic and permanent effect on Christians' understanding of sacramentality comes through its demythologizing of the in-between world of "spiritual" realities—angels, devils, graces—that centuries of religious understanding had placed between God and humans. Clearly, this notion of a world of "persons" and forces that either linked or blocked Christians in their attempt to reach union with the divine was part and parcel of the distancing of God that the earlier chapters of this book tried to trace.

Demythologizing is always a process of remythologizing, and in this instance psychology "removed" the imagined second layer of created reality by transferring it to the second layer of the human psyche, by developing an alternative mythology of the unconscious. Temptations of the devil, "actual graces" that were special helps directly infused at critical moments into human decision making, hidden powers of good or evil that worked in such feared phenomena as witchcraft—these

58. P. Homans, "Towards a Psychology of Religion," in *Dialogue between Theology and Psychology* (Chicago, 1968), 78–81.

were now interpreted as impulses, energies, and unconscious symbols at work in the subconscious.

Christian theologians, however, need to assess not only the somewhat mythologized world of religious belief but psychology's remythologizing of this world. Christian belief, for example, in the communion of saints, which involves acceptance of a human life beyond death and some community between those in glory and faithful still in this world may well have been envisaged in too mythic a form. It may unjustifiably have given a spatial location to "heaven" as part of the distancing of the kingdom of God. And it probably interpreted the helpful intervention of these "blessed souls" by projecting the mediatorial role played by ecclesiastical mediation in the church. This does not deny reality to "the communion of saints," a reality that psychology's critique has forced theology to discover and in so doing has enriched rather than diminished Christian belief.

This theological remythologizing has been particularly important with regard to human understanding of and coping with evil. Simplistic psychology can, of course, give the impression that there is no such thing as good and evil; but responsible psychology has become increasingly aware that moral evil, sin, is a basic element in human life that cannot be reduced to psychic disorders even though it is intimately intertwined with them.[59] On the other hand, simplistic catechesis or theology can neglect the rooting of evil in human psychic deviation, can make it a mystery of God allowing diabolic forces to disrupt human life rather than a mystery of humans' own foolish abuse of freedom.

Given this need to reconsider, in the light of both faith and psychological research, the dynamics of human awareness and motivation and freedom, the sacramental theologian has a special task because of psychology's clarification of symbols' role in insight and motivational energy. To the extent that the demythologized "second level" really constitutes an intrinsic part of the human psyche, sacramental theology must reflect on the way in which Christian ritual communicates an understanding of realities such as sin and grace and the communion of saints.

Symbols Transform the Psyche

But psychology challenges theology also to examine the manner in which symbols, and specifically the sacramentalities of Christian life and ritual, touch and transform the human psyche—that is, "give grace." One could see this as a continuation of the Reformation challenge to

59. A turning point in current psychology's acceptance of moral evil was Karl Menninger's *Whatever Became of Sin?* (New York, 1973).

give more serious attention to the role of faith in sacramental rituals. One could also see it as a bypassing of that challenge: by interpreting the causal power of sacraments in terms of the psychic changes effected by symbols, one can transpose the sixteenth-century controversy into another dimension and say "yes" to both sides of the controversy.

It will not be enough for contemporary theology to explain somewhat the generic statement that Christian sacramentality has symbolic impact on people's psychic existence. Rather, there will be endless need to study the way in which specific cultural and Christian symbolisms impact on one another—endless because neither symbol system remains static, but each is (as we suggested earlier) a living and changing reality. Being this ongoing engagement with individual and social symbolizing, sacramental theology will have to exist as an intrinsic constituent of Christian *praxis*, particularly (but not exclusively) of liturgical *praxis*.

Symbols and Personal History

By dealing with psychic activity as a process of the individual's construction or reconstruction of his or her own inner world, as an organic process of individuation that involves the emergence of an all-important self-image, recent psychology leaves sacramental theologians with the task of discovering how Christian symbolisms can positively enter into this process and how, in turn, this process individualizes Christian sacramentality in each person's life. How, for example, does the symbolism connected with "the imitation of Christ" interact with a person's self-image as "a disciple," and how does this interaction occur in sacramental liturgy?

Since the organic development of psychic symbols embraces the totality of a person's experience, theological reflection on Christian symbolisms cannot be confined to study of sacramental rituals as isolated cultic events. And it may be that as a byproduct of this broadening of theological perspective, the ritual celebrations of Christian sacramentality will be revised to take account of this process aspect of people's lives. Touching on this is today's emphasis on the role of "story," on narrative theology: a person's story is the process form of that person's self-image, it is the (somewhat interpreted) account of the process of individuation that has brought the person to their present state of self-awareness. That story is told within the context of the larger community story; and it is the continuing influence of these two stories upon one another that is meant to be critically challenged and nurtured in ritual. It is already clear that a major element in this process will be the stories of women, previously untold, with perspectives that will not only complement but also challenge traditional theology.

Not only is there the coincidence of Christian self-identification and

Christian socialization. The anamnetic dimension of liturgy as it is repeatedly celebrated in a person's life is an important fleshing out and "correction" of one's historical consciousness. This interacts with the effects of psychological insights on one's personal history. "The method of psychoanalytic therapy is to deepen the historical consciousness of the individual ("fill up the memory-gaps") till he awakens from his own history as from a nightmare. Psychoanalytical consciousness, as a higher stage in the general consciousness of mankind, may be likewise the fulfillment of the historical consciousness, that ever widening and deepening search for origins which has obsessed Western thought ever since the Renaissance."[60]

CONCLUSION

Basic to all this is the insight, reinforced and fleshed out by modern psychology, that symbols exist and act in a distinctive way that cannot be reduced to physiology or logic or semiotic energies or sociological principles—though all these provide enriching vantage points from which to study symbols. Put into classic theological language, this implies that it is unjustified and misleading reductionism to think of Christian symbolisms, and specifically of sacramental rituals, as instrumental causes of some entity called "grace" or as situations of establishing semi-legal claims to "salvation" or as religious contexts that appropriately occasion divine favor.

Already in the thirteenth century Thomas Aquinas had pointed to the fact that sacraments were effective precisely as signs,[61] and modern psychology has apparently driven theology back to this insight. Not really driven "back," for modern psychology has studied the functioning of symbols in an analytic fashion quite foreign to the mentality of a medieval world, fascinated as it was by the symbolic. Today's theologians, in probing the causality exercised by sacramental rituals, need to draw from modern psychological insights about the origin and function of symbols.

No matter what position one takes on Jungian archetypes or on other theories of a priori forms of consciousness, modern psychology has clearly underlined the creative/interpretive role of the subjective matrix of experience into which any social communication through symbols is received. Sacramental theology must, then, take into account these receptive psychological influences that condition the effectiveness of Christian symbols.

60. N. Brown, *Life against Death* (Middletown, Conn., 1959), 19.

61. *Summa theologiae* III, 62, 1. At the same time, his basic model for the causation of sacramental rituals is that of an *instrument* and it is this model that controlled discussion of sacramental causality in later Thomistic theology.

Actually, a limited precedent for such investigation existed in reflection upon the phrase *ex opere operantis*. In contrast to the effectiveness of sacramental rituals *ex opere operato*, that is, the effect intrinsic to the liturgical action as an expression of the Church's faith, somewhat independently of the faith or sanctity of the minister or community involved in a particular liturgical action, *ex opere operantis* was meant to highlight the role played by the receptive dispositions of those to whom the liturgy was directed (e.g., those attending Mass); dependent upon his or her good intentions, devotion to God, and so forth, a person would receive more or less grace through the sacramental ritual.

What modern psychology provides is detailed, scientifically examined understanding of the manner in which symbols are interiorized, rejected, modified, interpreted, amplified by factors already operative in a person's psyche. This provides a rich resource for theologians to study the way in which already-present psychological structures condition the way in which sacramental symbolisms convey meaning, and the way in which already espoused structures of meaning can be challenged and altered by effective Christian symbolizing.

Finally, modern psychology has suggested—and anthropological research drawing from psychology has confirmed (as we saw in the previous chapter)—that ritual is the situation in which psychological individuation and socialization uniquely coincide. Indeed, this is the precise purpose of key ritual actions, at important moments of passage to inject into the process of self-identification the identifying role that the person is to play in a community.

However, the communication of such symbols by a society to its initiates—whether this be one generation to another or established residents to an immigrant group or full-fledged members of a community to novices—is a complex process that may focus on ritual but embraces much more. So, sacramental theology must addresss the question of how the Christian Church, both as an institutionalized body and as a human community of shared belief, can effectively use symbols in its entire social existence as well as in its liturgy to communicate its story and its wisdom and its mission to people in a way that can be synthesized with these people's individual self-creation.

Inevitably, then, we are drawn to the present-day reality of human communications. It is this to which the following chapter is addressed in a study of symbols as they function in literature and other artistic media.

12

Linguistics and Literary Criticism

No other area of scholarly research has witnessed during the past half-century as intense and wide-ranging a discussion of symbolism as that which has occurred in the study of language and literature. To a considerable extent this has been triggered by the developments in anthropology and psychology we have just examined; it resulted also from the cross-fertilization that occurred when leading European experts in language and literature fled German-speaking Europe before and during World War II; more immediately, it has been influenced by the extensive development of semiotics; and to an extent that is not yet clear it has been a response to the theories of communications that have accompanied rapidly changing communications technology.

One could add to this list of influences the impact of contemporary philosophy, especially in France and Germany; but actually it has become impossible to distinguish much less separate much of present-day literary criticism from dominant currents of philosophical reflection. The mention of Ricoeur or Derrida, Foucault, or Gadamer makes clear this coincidence.

For the past few decades literary studies have been careening from one movement to another at a breathtaking pace: New Criticism gave way to structuralism, which in turn has been critiqued by post-structuralism and deconstruction; but as successive theories came to prominence, the older theories remained in the field to contest and modify the new arrivals. The result is an extremely complex body of competing theories, most of them expressed esoterically enough to block any understanding by ordinary educated people. By and large literary criticism today is an insider's conversation that does not directly touch the general understanding or use of symbols; but the issues being discussed are central to the advance or decline of culture. Despite the erudite form in which they are for the most part proposed, the various theories have

ultimate importance for sacramental theology precisely because they deal with the *meaning* of literature, that is, with the symbolic function of literature; and sacramental theology is intent on uncovering as far as possible the manner in which enacted symbols (rituals) and verbalized symbols (myth and narrative) convey meaning. Moreover, great literature deals with the same basic key experiences of human life to which Christian sacraments are meant to give transcendent meaning.

Fortunately, for those who must venture into this academic maze there are careful studies that detail the evolution and the nature of current literary study. Kermode's *Romantic Image* and *Sense of an Ending* and Lentricchia's *After the New Criticism* have traced analytically the course of modern criticism;[1] William Ray's *Literary Meaning* provides a not-too-technical introduction into the views of a broad spectrum of contemporary critics and philosophers[2]—and one might go on to mention any number of other recent studies, including those of Robert Scholes.[3] Consequently, there is no purpose in attempting yet another survey, even an abbreviated one, of prevailing critical theory; instead, I hope to identify some of the basic issues or implications of this literary study that touch with particular impact on Christian sacramental symbolism and on the distancing of God that we have been tracing. The relevance of reflection on contemporary literary criticism to our topic is clear from the contention of some literary critics that there can be no reference in human thought or language to a transcendent frame of reference. That is, symbols can never lead humans to knowledge of the divine.[4]

LINGUISTIC ANALYSIS

Discussion of present-day literary criticism is appropriately prefaced by a brief indication of what has been occurring in the field of linguistics. This may complement our previous chapter's examination of the relation between linguistic and psychological research. Contemporary

1. F. Lentricchia, *After the New Criticism* (Chicago, 1980); F. Kermode, *Romantic Image* (London, 1964) and *The Sense of an Ending* (London, 1967).

2. W. Ray, *Literary Meaning: From Phenomenology to Deconstruction* (Oxford, 1984).

3. See Scholes' three interrelated volumes, *Semiotics and Interpretation* (New Haven, 1982), *Structuralism in Literature* (New Haven, 1974), and *Textual Power* (1985). Another helpful guide through developments prior to 1960 is *The Modern Critical Spectrum*, ed. G. Goldberg and N. Goldberg (Englewood Cliffs, N.J., 1962); this anthology provides descriptions by leading critics (Brooks, Eliot, Tate, Babbitt, etc.) of a wide range of critical methods. Probably the most comprehensive historical survey of modern criticism, and one that provides essential background for understanding the issues underlying the present-day controversies, is Rene Wellek's four-volume *History of Modern Criticism, 1750–1950* (New Haven, 1955–1986).

4. On the other hand, there is need to probe more deeply the reasons for the emergence toward the end of the nineteenth century of the symbolist movement in France—what does it say about the self-conscious use of symbolism by poets such as Mallarme? How does this tie in with the subsequent "New Criticism"? See the chapter on this symbolist development in Rene Wellek's *Discriminations* (New Haven, 1970), 90–121.

development of what can be called broadly the "structuralist" wing of criticism found its beginnings in the pioneering work of the Swiss linguist Saussure, and research in linguistics has continued to influence or even overlap with critical studies up to the present.

Until World War II, linguistic study was dominated by a mathematical/mechanist model. If "forest" was an apt metaphor for anthropological study of ritual, and "jungle" for literary criticism, a more appropriate figure for linguistics would have been "assembly line"—language seemed to be broken into innumerable bits and pieces, waiting to be reassembled into a unified machine for human communication. For several decades, however, this mechanistic model has been giving way to a more organic approach, somewhat the way that the entire scientific community has been moving since around the turn of the century toward greater concentration on *power* and *process* models. At the same time, interdisciplinary research, for example psycholinguistics or structuralist anthropology, has been broadening the horizons of linguistic study.[5] Early in the post–World War II period one can observe increased conversation among scholars involved with different aspects of language study—for example, the 1958 Indiana University Conference on Style, at which literary critics such as Wellek and I. A. Richard challenged the rigidities of linguistics. It was here that Richards made the oft-quoted remark: "The printed words of a poem are only its footprints on paper." Such disciplinary cross-fertilization increased interaction of scientific precision and aesthetic insight and, at least in some circles, a greater attention to the piece of literature itself rather than excessive concentration on historical/psychological/sociological sources.[6]

Even within the field of language study there has been increased awareness that linguistics cannot be limited to a search for internal structuring relationships of syllables or words; the reality of language is its use in discourse among people.[7] It is an individual language event that in the last analysis accounts for the syntactical arrangements, selection among alternative expressions, and so on, that give each situation of discourse a somewhat distinctive meaning. "Linguistics, then, deals with communications events between emitters, senders, or speakers and

5. A systematic review of the state of psycholinguistics in 1965 is provided by *Psycholinguistics: A Survey of Theory and Research Problems*, ed. C. Osgood and T. Sebeok (Bloomington, Ind., 1965). This review reflects the swing away from static, abstract linguistics and toward a more organic view. A fascinating aspect of the linkage of language structures with "life" has been the discovery that the genetic code in DNA functions much like a syntactic language.

6. *Style in Language*, ed. T. Sebeok (New York, 1958): papers from the conference on Style sponsored by the Social Science Research Council's Committee on Linguistics and Psychology, University of Indiana at Bloomington, April 17–19, 1958.

7. See P. Ricoeur, *Interpretation Theory: Discourse and the Surplus of Meaning* (Fort Worth, Tex., 1976) (hereafter cited as *Interpretation Theory*); also J. Macquarrie, *God-talk*.

receivers or listeners. The structure of the language communicated offers the speaker a particular choice of patterns which he selects to fit his intention. The patterns are picked up by the listener from his own knowledge of the structure."[8]

Out of this more recent linguistic study several insights emerge, insights whose implications extend beyond technical study of language.

First, analysis of the identifiable structures of speech can throw considerable light on the elements common to all languages, or at least to language families, and so illumine our understandng of the process of human communication. That in turn provides added understanding of the way in which humans formulate images and ideas. What has come to the fore is the realization that the process is a *life-process*, somewhat distinctive in each individual as is human life itself. As a life-process it has a principle of unification, the integrating consciousness of the person, that is more basic than the logical unity of the "pieces" of speech or thought.

Second, in studying this process, for example, as it takes place in the emerging language usage of a child, we can see the interaction of perception and interpretation: "teachers," especially parents, guide and help structure the interpretation by providing names that can be used to distinguish and interrelates elements of the experience; at the same time, that naming is always contextualized by the child's experience and cumulative memory.

Third, in the process of naming, "things" are positively identified and classified and interrelated; but other "things" are overlooked, and many other ways of identifying the things that are recognized are denied. One's mother tongue, then, acts to situate the knower in certain cultural boundaries and to limit the capacity to communicate with those of another culture. This raises the question: what medium of communication (that is, symbol) can be used to effect cross-cultural sharing of human experience.

Fourth, as linguistic symbols are resituated in the context of actual human awareness and expression, it has become clearer that words communicate more than their denotation—even as a child is being helped to identify "things," the words provided are value-laden. Words such as "dangerous," "good/bad," even "yes" and "no," carry judgments of social or moral acceptability and help to shape the child's affective

8. E. M. Mendelson, "The 'Uninvited Guest': Ancilla to Levi-Strauss on Totemism and Primitive Thought," *The Structural Study of Myth and Totemism*, ed. E. Leach (London, 1957), 120. One of the best-known schematic structures is that presented by Jakobson at the Indiana University conference referred to above, "Linguistics and Poetics," in *Style in Language*, 350–77. Ricoeur provides a summary and appraisal of this schema in *Interpretation Theory*, 34–37.

response to and interpretation of the experienced "world." This process, which begins in infancy, continues through the entirety of a person's life; language is constantly modifying one's hermeneutic of experience.

Fifth, not all words that a person hears are retained as part of that person's operative vocabulary; retention requires that the word refer to some meaning that the person grasps. However, as any teacher knows, there can be memorization of words and their relation to one another, and learning of abstract formulations, that is independent of a real understanding of the realities to which the words or the formulations relate. There is some pedagogical advantage to this: the memorized structures can help shape a subsequent process of search and discovery, at which point the words then begin to operate as genuine meaning-bearing symbols. Religious catechesis of the young is a prime example of this development of understanding; unfortunately it has all too often remained frozen at the level of empty verbalization.

Sixth, what this suggests is that there is a basic inseparability of language and experience: without language to help one discriminate and identify, experiences remain relatively unintelligible and therefore unmanageable; but without experience language remains groundless, abstract, and humanly irrelevant.

Seventh, comparative study of human and animal communication has sharpened awareness of the uniqueness of human language. Something very different than "signalling" takes place in our use of language—though they do not use that terminology, what researchers seem to be pointing toward is the experience of humans being *present* to one another, being aware of that presence, and using language to establish, modify, or intensify presence. In this way, language underpins (or if improperly used, blocks) *community*; linguistic communication is the sine qua non of any vital and enduring community, from the family to the church or human society as a whole.

LITERARY CRITICISM

As far back as we can trace, there has been in each culture a privileged body of language-use that played a special role in shaping people's worldview and in setting the pattern for their communication with one another—what is named "literature." I will not enter into a full discussion of how some works become "literature" and endure as such, or into a description and appraisal of current attempts to establish the nature of literature; my purpose here will be the more modest one of examining a few key presently debated issues in literary criticism, to see how this debate intersects with theological reflection on the symbols that influence Christians' faith and life.

SUBJECT/OBJECT

Since at least as early as Plato, the relation between the knowing subject and the object that is known has been a focus of philosophical reflection. However, with Descartes' *Discours* and even more since Kant's *Kritik* it is the knower's knowledge itself that has become the known object studied by philosophers and more recently by literary critics. Mainstream modern philosophy has been epistemology rather than metaphysics.

The Poet/Author

Discussion by literary critics of the subject/object relation must deal with two linked but distinct knowing subjects: the *poet/author* and the *critic/observer*. The attempt to explain the poetic process must deal with the basic alternatives of "intuition" versus "creation." To what extent does the work originate in the poet's own imagination, to what extent is it imitation (*mimesis*) of the extramental world whose beauty the poet has intuited?

Responses to this question range from a radically idealist view that the form of the literary work originates solely in the world of mental structures, to a romantic view of the poet's consciousness and act of literary creation merging with the symbolic dimension of Nature itself. By and large, present-day literary criticism falls within the parameters set by Immanuel Kant's identification of "the object" with the phenomenal world of human perception.[9]

What this has meant in many cases is that the process of poetic creativity is seen only in terms of the poet structuring consciousness and language according to patterns already existent in his or her own mind/imagination, or (as seen by structuralist criticism) according to certain archetypal structures common to human awareness.

In the more extreme statement of this position, the poet exists and creates in isolation from the outside world; from it he can gather no form, no *logos*, since it is essentially chaotic. The poet draws artistic inspiration and insight from within the world of poetic forms and produces the poem as literary self-expression, prescinding from any communication with a potential audience. Many of the literary critics writing today would modify this view, admitting that some stimulation from beauty in the outside world enters into the poetic production and admitting also that some intent to communicate brings the poet to

9. This is not to ignore important anti-Kantians like Kermode, whose distinction between the mythic and the fictive throws considerable light on the literary use of metaphor and symbol. If applied to ritual celebration, there are obvious implications for the kind of educated awareness of a ritual's symbolism that is needed for authentic ritual effectiveness. See Kermode, *The Sense of an Ending: Studies in the Theory of Fiction* (New York, 1967). See also Lentricchia, *After the New Criticism*, 36–37.

actually concretize the work in spoken or written form. Some contemporary critics would go further and root the artistic elements of the poem in the poet's creative insight into the symbolic character of the extramental world, granting that poets then re-form these symbols in their own creative activity.

Among those who see the poet creating in essential independence from "outside" influence, a basic split has developed—not limited to but generally associated with the two movements of "structuralism" and "deconstruction." The former, drawing from the psychological notion of archetypes, sees certain basic narrative and/or mythic structures underlying and setting limits for all literary productivity. The latter, rejecting any limitation on the creative freedom of the poet, refuses to acknowledge any reference to "the outside" that would provide a centering stability to the creative act.

All this has obvious implications for any study of religious literature or ritual. To what extent, if at all, can literary texts be considered communication and therefore the basis of community? Does the author wish to share her or his aesthetic experience and employ literary symbols to achieve this goal, or is such sharing an incidental byproduct of the poet's creative self-expression? And if the poem is a communicating symbol, does it function by virtue of the author's communicating intent or by virtue of its own communicating structure?

Such questions, which stand at the center of today's technical study of literature, have sharpened analysis of the role of symbols and renewed debate about the distinctive character and relative merits of metaphor, symbol, and allegory. Some critics, such as Coleridge or Kermode, would hold that symbols close the gap between the knower and outside reality and involve human consciousness in the meaning of nature itself, whereas allegory sets up a level of artificiality that distances one from reality.[10] (Such a view recalls immediately what we saw earlier about the ritual distancing that took place from Carolingian times onward because of the allegorical meaning attached to liturgy.) But critics who describe the poet's activity as one of autonomous creativity carried on in lonely isolation view symbols much differently; for them symbols, specifically poetic symbols, form an esoteric language that can be interpreted only by an aesthetic elite, by literary scholars of their particular persuasion. In this context a symbol functions to objectify the poet's creative subjectivity and, perhaps at the same time, to give particularized form to more general archetypal structures of the poet's consciousness. With such forms the poet is able to make a world out of the extra-mental chaos that surrounds and impinges upon the human knower.

10. See Ibid., 6.

It would be folly to suggest any easy resolution to these contradictory theories; it seems that there is much to learn from both. Clearly, there is some process by which any human knower and especially the poet adds his or her meaning to whatever is garnered from immediate experience. As a matter of fact any such experience is already an unrepeatable intepretation of the happening to which one is exposed. So creativity is already present in the poet's awareness, and additional creativity is manifested in the mental symbols that give shape to the experience. At the same time, it seems difficult to maintain that the consequent translation of this poetic consciousness into language, above all into metaphors, is devoid of all intent to communicate. Granted that creation of the artistic work may be required for the poet to realize artistic self-awareness, linguistic utterance seems inescapably directed to communication.

Inevitably, discussion of the poet's independence from the outside world raises the issue of art as *mimesis*. One can immediately reject an application of that term in the sense of the artifact being ideally a mirror that reflects "nature" as it is. But, taking into account the artist's interpretative experience of the outside and the creative reinterpretation introduced by the artistic use of symbols to bring into being a new object of beauty, there is a sense in which the poem does hold up a mirror to reality—a mirror, however, that reflects obliquely the deeper truth/ beauty which the artifact reveals. In a sense the artist is imitating nature's function of disclosing truth and beauty; but one could see the artist as the final and finest agency of nature in performing this function.[11]

A special issue arises in the case of narrative: is there a paradigmatic function governing literature that deals with the temporal sequence of human experience? It is apparent that there is some similarity, some logic internal to human experience, that allows for our common involvement in vicarious experience. But the basis for this is less clear. While there is an obvious progression of human life from birth through growth into maturity and finally death, it is debatable whether there are certain paradigms such as "quest" or "journey" that underlie all narrative literature.

One of the more satisfactory analyses of narrative understanding and structure is Paul Ricoeur's theory of the dialectic between what he terms "innovation" and "sedimentation."[12] Applying to literature the basic historical interplay of continuity and discontinuity, Ricoeur points to

11. See Ricoeur, " 'Anatomy of Criticism' or the Order of Paradigms," *Centre and Labyrinth*, ed. E. Cooke et al. (Toronto, 1983), 7–9. "Even within that state of suspension wherein fiction holds the poem, there subsists an oblique reference to the real world, either as a form of borrowing or as a subsequent resymbolization of it" (8).

12. Ibid., 2–3.

the manner in which elements of experience retained in memory act as interpreting structures for subsequent experience, but are in turn confronted and modified by the newness that comes from these later experiences or from creative reinterpretation. Neither sedimentation nor innovation occurs without the influence of the other. "Paradigms that are generated by some previous innovation in turn provide guidelines for further experimentation in the narrative field. These paradigms change under the pressure of new innovations, but they change slowly and even resist change by virtue of the process of sedimentation."[13] The applicability of this theory to biblical and liturgical typology is unavoidable, for the modeling connected with use of a type, (e.g., the exodus) shapes the interpretation of later experiences and texts and thereby safeguards tradition.

The Critic/Observer

It would seem logical to extend the title "critic" to any perceptive reader of literature or observer of other artistic creation, but a fair amount of current literary critical discussion seems to assume that only those possessing finely honed technical skills of interpretation are capable of dealing with a piece of literature. At first sight that might seem to be simply professional elitism—Kermode for one has so described it[14]— but for the most part it is related to the sophisticated methods of "unpacking" a text that are connected with theories like phenomenology, structuralism or deconstruction. Confining ourselves to the literary critic, but assuming that much the same could be applied to a well-educated perceptive reader, we discover roughly the same spectrum of opinions we noticed in descriptions of "the poet."

Those who hold that there are some deep paradigmatic mythic or narrative structures will see the discovery of these within the literary piece as the key to grasping the meaning of the text. The object with which the critic deals is then not the text out there but the understanding garnered from application of his or her methodological tools to the piece of literature in question.

This raises the question of the autonomy or dependence of the critic in dissecting and appraising the poem. What norms, if any, restrict or guide the critic in dealing with a piece of literature? Or, to put the question in a less provocative context: how would one educate a student to approach critically a piece of literature?[15]

13. Ibid., 3.

14. Kermode, *Romantic Image* (New York, 1964), 161.

15. One of the elements that recent criticism has tended to downgrade in the reading of a text is the intention of the author. For an attempt to retain this along with the "objective" meaning of the words of the text—specifically in leading students to insightful interpretation of a poem—see I. A. Richards, "Poetic Process and Literary Analysis," *Style in Language*, 9–23. A somewhat similar plea to keep the various elements together in literary analysis is made by R. Wellek's concluding essay, "Retrospects and Prospects from the Viewpoint of Literary Criticism," Ibid., esp. 416–19.

Just as in questions about the role of the poet, several divergent schools of thought exit. Basically, it is a matter of emphasizing the social situation and conditioning of the observer/critic or of emphasizing the autonomy of the critic.

Unless one maintains the view that the poem (or at least elements of the poem) expresses some universal patterns of thought that transcend cultural and historical differentiations, and that the critic's hermeneutic is completely free from social conditioning, it is difficult to see how interpretation of a piece of literature can occur in some kind of splendid literary isolation. The notion of "intertextuality" that has recently been stressed in some critical circles points to this issue: there is a web of interrelated literary production and sociocultural significances within which any literary production occurs. An exhaustive grasp of any one poem would necessitate insight into this entire context—obviously an impossible task. What we need to pursue realistically is an approximation to this goal. Attempting to divorce literary creation from the circumstances in which the poet lives and writes is to fly in the face of the insights provided by modern sociology of knowledge.

Objectivity/Subjectivity in Human Knowing

Literary/critical theories fit within the larger context of debate about the relative subjectivity or objectivity of human knowing. Fundamentally, there are two basic opposed positions, though it is rather clear that neither can be held absolutely. Is human knowledge derivative, a question of *discovering* the intelligibility of extramental existents, including the thinking of other humans. Or is knowledge, at least in its more logical and verifiable elements, a matter of the knower *creating* a world within consciousness itself, a world that is truly the object of knowledge? Clearly, we are still grappling with the Kantian heritage; even if one does not accept Kant's basic position, there is no avoiding his challenge to any presumed objective knowledge of the extramental world.[16]

One could, not too accurately, apply the term "faith" to what is today called naive realism, that is, to accept human experience as a discovery, even though partial and inadequate, of how things actually are. Rather than faith, it is common-sense acceptance of what to some extent is

16. One of the more intriguing studies of contemporary poetry's wrestling with Kantian and neo-Kantian aesthetics is Frank Lentricchia's *Robert Frost: Modern Poetics and the Landscape of Self* (Durham, N.C., 1975). "Robert Frost occupies a position somewhere between the neo-Kantian, object-oriented aesthetics of the New Critics and the proto-phenomenology and existentialism of William James which focuses almost exclusively on the uniqueness and privacy of person—what James somewhere called the 'self of selves' " (124). Lentricchia then goes on to suggest that John Dewey succeeds better than anyone at formulating an aesthetic theory that "tied together in indissoluble unity the creative act of expression, the expressive object itself, and the revelation of selfhood" (125).

unavoidable. Extramental reality is thrust upon us and even manages occasionally to contest the truncating or distorting interpretations of it that we call immediate experience.

On the other hand, there can be no denying that whatever experience a human has is subjectively interpreted. The only really debatable issues are the extent and the manner of the knower's molding of the input in a specific instance and the verifiable accuracy of a particular interpretation. Previous knowledge and experience, developed or undeveloped powers of observation, analytic and heuristic skills in particular areas of science, aesthetic sensitivity—all these enter into the actual experience an individual has of the outside world. That means that the *perceived* outside world is the world of this or that particular person. Besides, into any given experience there flow also the fears and expectations and prejudices and desires of the knower. Truly honest straightforward confrontation of reality is hardly possible.

So it seems safe to say that human knowing is a mixture of influence from outside and interpretation from inside and that objectivity has to be judged both by the intrinsic consistency of the knowledge and by its congruence with the actuality of that which is known. One cannot, however, avoid the suspicion that a yet more ultimate issue lurks in the depths of this question: namely, acceptance or refusal of the creaturely status of human knowing. At least some of present-day theorizing about the production and criticism of literature appears to lay claim to a freedom and autonomy incompatible with human creaturehood.[17]

Behind this tendency to glorify the creative self as an autonomous center of awareness lies the Cartesian *cogito*. Indeed, Descartes's attempt to give the thinking subject's self-awareness absolute logical priority finds an even starker formulation in Poulet's insistence on the cognitive ultimacy of the *cogito*. Self-awareness and self-identification, then, do not come in a process of personal interaction through self-disclosing communication with others; somehow, prior to all this the self is present to self in the transcendence of the present.[18]

With the conscious self enjoying such independence from symbol in its grounding moment of self-awareness, the function of experience as well as of symbol in self-identification is brought into question.

17. Claude Bruaire provocatively links "humanism" with the attempt to remove from human identity and activity any restrictions whatsoever, even those of giving "humanity" any specific definition. Freedom in this context is seen as absolute spontaneity, which Bruaire sees as a self-defeating desire to be divine. See "Negation et depassement de l'humanisme," in *Homo, homini, homo*, ed. W. Beyer (Munich, 1966), 270–75, (hereafter cited as "Negation").

18. See Lentricchia, *After the New Criticism*, 72–75, who reviews Derrida's penetrating critique of this autonomous *cogito* as he finds it in Poulet and in Husserl, and indicates the negation of phenomenology that is implied.

This discussion obviously impacts on attempts to explain the manner in which human selfhood is attained. Theories of developmental psychology have proved helpful; but reflection on the processes of human linguistic expression also provides valuable insights and raises basic questions regarding the way in which the self emerges both from a distinctive sequence of experiences and from the creative decisions connected with those experiences. One's self is shaped and one shapes one's self, just as one makes one's world and one's world is given; and use of language, the most basic of symbol systems, is located at the very center of this interaction.

AESTHETIC EXPERIENCE

Not all experiences have the kind of self-shaping power we have just described. The ordinary course of our daily experience is a rather prosaic affair. There are relatively few "peak experiences"; but certainly among them must be included those moments of special awareness of beauty. Such aesthetic experience has always fascinated people and led to attempts at explanation that range from Aristotle and Longinus to Kant and Malraux.[19]

One of the intriguing things about the experience of beauty in which the poet as an artistic creator is caught up, is its similarity to the experience of a great prophetic figure like Jeremias. Perhaps the coincidence of these two experiences should not be surprising; Walter Brueggemann has convincingly argued that the great Israelite prophets were that because they were Israel's poets. That would seem to lead to the conclusion that there is something prophetic about all real poetic/artistic production.[20]

In pursuing this line of reflection we must face, of course, the diversity of recent literary theories, above all the emphasis in some circles on the poet acting independent of outside influence. Yet, being cautious about romantic overemphasis on feeling, a solid argument can be made that the truly creative artist is a person possessed, gripped by an inner vision that ultimately defies articulation but that drives the artist to attempt it through forms of expression that break out of ordinary patterns of discourse or representation.

So, also, history's great religious prophets. If one explores empathetically the experience pointed to by the opening verses of the book

19. On the role of *values* in aesthetic experience, something often missing from analyses of the experience, see J. Rosenfield, "The Arts in the Realm of Values," *Daedalus* 105(1976): 837–43.

20. See Brueggemann, *The Prophetic Imagination* and *Hopeful Imagination* (Philadelphia, 1986).

of Jeremias, it seems impossible to claim that at its heart the experience is simply the product of the prophet's psyche.[21] Just the opposite: the consciousness of Jeremias is invaded, swamped by an inescapable presence that is terrifyingly strange and yet consolingly intimate and familiar.[22] The awareness transcends and shatters all imaginative, categorical and linguistic molds; yet the prophet has an irresistible impulse to communicate the experience, even with the painful realization that language will prove inadequate to the task and people's hearing of language even more inadequate. And so the prophet, like the artist, searches for symbols that can less distortingly convey to himself and to others the meaning of what has occurred.

One fundamental problem facing the prophet/poet is intrinsic to human knowing. In giving shape to the experience one must bring into being a formulation, mental and then verbal, that stands at a distance from the intiating experience and is a distinct object of knowledge. This artistic creation of the prophet/poet represents inevitably a one-step removal, a distancing, from the presence that permeated the initiating experience. The goal of discourse is to overcome this loss, to share through the process of vicarious experience the consciousness of presence.

But achievement of this goal is always limited, sometimes quite severely. Religious believers see the prophet as one who has been seized by God.[23] The ancient Greeks held a not too different view of their artists and poets, though Plato by way of exception had a somewhat jaundiced view of the divine inspiration of the poet. In more recent centuries, if there is the notion that poets are seized it is more often associated with Nature. Romanticism (with religious overtones) sees the creative artist as caught up in a transporting awareness of Nature's beauty, as driven to give shape to that experience in a work of art that can also serve to witness this beauty to others. The work of art, while an expression of Nature is also for the artist an expression and a discovery of self. When one turns from the prophet/poet to the observer/

21. Not only religious prophets claim divine inspiration for their experience. In *The Critical Path*, 76–81, Frye has an interesting reflection on the way in which much modern poetry since the Romantic movement has laid claim to an oracular function, to prophetic authority.

22. This is not to deny that the details of seeing and hearing as described in this and similar texts spring from the prophet's memory and imagination. But these are not the distinctive element of the experience; rather, they are that into which the awareness of presence is very inadequately translated. An insightful discussion of the parallel instance of "private revelations" is provided by C. C. Martindale in *The Meaning of Fatima* (New York, 1950), 4–11. For a more detailed analysis of the prophetic experience, see J. Lindblom, *Prophecy in Ancient Israel* (Oxford, 1962).

23. One is reminded of Otto's association of the *"tremendum"* with the experience of "the Holy," something that recurs as a theme in Mircea Eliade's studies of "the Holy."

critic one encounters an aesthetic experience that is more than just a mirror of the artist's. While the poem serves as its own perceived object of beauty and communicates some of the poet's own awareness of beauty, it does so within the perceptual world of the observer and its effect is conditioned by the observer's aesthetic sensitivities, memory, imagination, and so forth. The *meaning* of the poem, in the full sense of form and content, is appropriated by each reader in somewhat distinctive fashion. Beyond the *understanding* of the poem, which is enhanced by technical skills of criticism, lies the *appreciation* of the poem, which draws in addition from the reader's aesthetic empathy that allows him or her to resonate vicariously with the originating aesthetic awareness.

Intuition of Existing

Different as they are in their technical elements, explanations of aesthetic experience commonly make reference to "ineffability," to an aspect of exposure to beauty that defies adequate expression. Descriptions of moments marked by acute awareness of beauty indicate that these are moments of unparalleled insight into reality. The observer not only understands as never before *what* something is but is gripped by the fact *that* it is.[24] It would seem then that the artistic awareness of the beautiful involves, perhaps even coincides with, philosophical realization of existence.

If this is so, a number of important conclusions follow. The most basic act of human knowing is the judgment of existence, of which every predication is a limiting specification.[25] Existence is that which is shared by the real referents named by all logical subjects of predication; existence is the one characteristic common to the knowing subject, to his/her knowing, and to the intermental and extramental object known; existence is the universal principle of linkage among all that is not purely intentional being. Because of this commonality in existing there is a radical analogy that runs through all our knowing; nothing that is, is totally unlike anything else. This participation in existence roots genuine metaphor; the true poet's mastery of metaphor is inseparable from the

24. This seems to some commentators to coincide with what Heidegger says of the role of the *Kunstwerke*. "He [Heidegger] seems to be saying . . . that the phenomenological grasp of being does not happen fortuitously but only through artistic mediation. Heidegger insists so strongly on this last point, in fact, not only in 'The Origin of the Work of Art' but in a number of the later essays, that it is not a violation of the spirit of his philosophy to call it an inquiry into aesthetic ontology," Lentricchia, *After the New Criticism*, 89.

25. On the unique role played by "the negative" in the reference to transcendence implicit in each judgment of existence, see K. Burke, in *Language as Symbolic Action* (Berkeley, 1966), 419–79. For a pioneering and penetrating study of the judgment of existence, one that was widely influential in the early twentieth century, see J. Marechal, *La point de depart de la metaphysique* (Louvain, 1926), particularly cahier V.

insight that what is, *is*. Conscious of existents existing, the poet glimpses also the unlimited reaches of existence that are only suggested by what actually is, glimpses the ineffability of existence that neither things nor thoughts, even in their symbolic connotation, can begin to comprehend.

While aesthetic experience illustrates more clearly, perhaps, the depths of metaphysical insight involved in a judgment of existence, such insight is implicit in all knowledge of the real world. Unfortunately, we do not have a developed logic that is grounded in the potential infinity of "to be" that is implied in any predication, a logic that does not see the word "is" as empty of meaning until involved with some characterizing predicate but views it as full of all meaning until limited by a particular predicate. And in that moment of fullness, and implicitly thereafter, "to be" is an acknowledgment of a limitlessness in existence upon which all limited existing draws.[26] Glimpsing that this dependence of limited existence upon the unlimited is more than logical relationship may be the heart of poetic insight. For the prophet it is intrinsic to the religious experience of the Transcendent.

INDIVIDUAL AND UNIVERSAL

Contemporary literary criticism has highlighted yet again what has been a perennial issue in critical explanation of literature, the interplay of individuality and universality. Structuralism, on the one hand, has worked to uncover patterns that underlie all mythic and narrative expression, giving to universal paradigms a priority over human experience of individual happening. Deconstruction, on the other hand, seems to be adhering to a radical focus on the irreducibiity of the individual existent—above all on the individual thinker—reminiscent of the most extreme forms of nominalism. Before the appearance of these two movements, a similar dialectic could be observed in the New Criticism's reaction to Romanticism's stress on individual aesthetic appreciation.

Great literature and art, or for that matter all human expression in lesser fashion, provides a fascinating instance of the basic philosophical problem of "the one and the many." Though the artistic work itself, for example, Shakespeare's *Hamlet*, is singular, it has been seen or read by

26. Since Saussure, the attention to linguistic symbols and the notion of sign and signified has focused on the intramental world of logical structures (that is, the code and the meaning); but is this not due to the fact that the copula, *to be*, is not seen to be full of meaning as expressing the judgment of existence and to have therefore an unavoidable reference to "the outside"? On fuller "content" of the copula, see J. Derrida, "The Supplement of Copula: Philosophy before Linguistics," in *Textual Strategies*, ed. J. Harari (Ithaca, N.Y., 1979), 82–120.

millions of people. To some extent all share in a certain central meaning; but each person in the audience grasps a somewhat distinctive meaning; and the same person may understand the play somewhat differently on different occasions dependent upon the interpretation given the play by a particular actor or producer.

Aristotle's *Poetics* already indicates that the ability to trigger this kind of individual identification with something universal in the artifact is a hallmark of genuine literature. However, the issue of commonality co-existing with individuality is not limited to literature. All predication is a matter of applying common terms to particular subjects, which pre-supposes that people somehow possess in their knowledge general ideas that they see realized in the existent individuals they experience. The history of philosophy has been in large part a series of attempts to provide an explanation of the origin and applicability of such common ideas. Philosophers today are no closer to agreement, and their task has been complicated. Not only must they, as in earlier ages, build on grammar, rhetoric, and logic; they must deal with the research into language by behavioral and social scientists.

These new disciplines of knowledge do not simply add to the philosopher's burden; they make it more difficult for him or her to avoid the deeper question: how to explain the commonality of humanity. Darwin may have undermined any simple solution in terms of a common human *species*, yet there is some observable sameness among humans and something in that sameness that differentiates them from everything that is not human. "Human nature" has proved over the centuries to be a somewhat helpful notion; but it is an abstraction, which, if applied absolutely to practical judgments about human behavior, can lead to inflexible legalism and neglect of free human decisions. The only existential referent for "humanity" is the multiplicity of individual humans; but one would not wish to go the route of a radical nominalism that denies an extramental basis for universality.[27]

At least one other possibility of taking account of the commonality of human existence can be learned from the biblical technique of typology and from Dante's use in the Divine Comedy of the "figural method." Erich Auerbach has drawn attention to Dante's use of historical personages as "figures," indicated the biblical precedent, and described the way in which the worldview underlying this usage controlled people's

27. Responding to secular humanism's rejection of traditional use of "human nature," Bruaire suggests that the unique human situation of commonality in the midst of irreducible individuality can only be dealt with if one moves from the notion of "nature" to that of "spirit"; he then goes on to argue that "created spirit" can find meaning only in terms of a desire for union with God. See "Negation," 276–77. On earlier modern philosophical discussion of this issue see R. Williams, "Schleiermacher, Hegel and the Problem of Concrete Universality," *Journal of the American Academy of Religion* 56(1988): 473–96.

understanding of history for more than a millennium.[28] As we saw in typology and the figural method, historical personages (and legendary ones, like Aeneas, thought to be historical) are seen to embody or symbolize characteristics, experiences, and meanings common to humans of every culture and historical period. Moreover, the personages fit into a sequence that is interpreted theologically as history's progress towards the final achievement of God's creative purpose. The technique is grounded in the assumption that history has an overarching unified meaning because it is guided toward its final goal by divine providence.

A danger in this technique is that a later meaning tends to overshadow or change the meaning of an earlier personage or happening; the classic instance of this is the way in which, until quite recently, a Christian reading of the Hebrew Bible overlooked the religious meaning intrinsic to the history of Israel and saw that history as nothing but preparation for Christianity. Being warned against that problem, we can move a step beyond typology and propose that the actual human beings who exist and act in the unfolding of time are all, to a greater or lesser degree, contributors to the composite meaning that constitutes human history. There is an overarching "story" into which all these individual stories fit; its meaning is more than a composite of all these many meanings and all of them find part of their meaning because of their role in the large story. This presumes, of course, that human history does make sense; and it really presumes that there is some form of divine direction that takes account of the identity and worth of each human person.

It may not be moving too far beyond this to substitute "history," taking the term to refer to the actual succession of humans as they appear on the scene and become part of humanity's story, for other symbols of human commonality. Preserving as far as possible the distinctive significance of each person and inserting their individual stories into the one "big story" implies that each life is a word in the unfolding explanation of what is meant by "human." We would not, then, be dealing with "human nature" but with the concrete population of humans; and community would be established by a network of interrelationships rather than by participation in some common nature. There would be an underlying *commonness* grounded in genetics, but *community* as a personal reality would come about through and in proportion to conscious sharing of selfhood and of the experience of being human.

28. Auerbach's classic *Mimesis* (Princeton, 1953), contains his analysis both of biblical typology and of Dante's "figural method." See also his essay "Figura" in *Scenes from the Drama of European Literature* (New York, 1959; Reprint. Minneapolis, 1984), 11–76. For an exposition of Auerbach's critical methodology see G. Green, *Literary Criticism and the Structures of History* (Lincoln, Neb., 1982).

While this view needs to be complemented by that detailed by Kenneth Schmitz in "Commmunity, the Elusive Entity"—which is the most satisfying exploration of the dialectic between individual and community with which I am acquainted—they do not seem to be opposed. Schmitz rightly insists that there is in each person a potential and need for relatedness to others that precedes the emergence of individual identity. Thus "community" is built into being humanly personal.

In such a view, understanding as accurately as possible the functions of symbols, especially of language, becomes critically important. Communication is not only the *source* of human community; it is the *functional reality* of community. Discourse is the very fabric of being human together. Without real communication a gathering of people is only that: a gathering. A group becomes a particular kind of community through a particular kind of communicating. If there is anything that language studies have taught us, it is the centrality of language in the creation of community through use of symbols.[29]

Paradigms

Recent decades have become sensitized to the value of each individual's story. In many circles "telling one's story" has become a fad. Granting the values of such a practice, there is often the implied suggestion that all such stories are of equal value, that none are richer in meaning than any other, and that to suggest the opposite is unacceptable elitism. To accept such a contention is to deny all worthwhile ambition and achievement and to reject all art and literature that deals with the "larger-than-life." But if, on the contrary, one wishes to preserve such human notions as role models or religiously such things as the "imitatio Christi," one must deal with the symbolic function of *paradigms*.

As soon as one takes a good look at the concept of paradigm, one is perplexed by the apparent coincidence of opposites: a paradigm is such because as an individual person or thing or happening it is *distinctive*; yet its very distinctiveness consists in realizing in unique fashion some general characteristic, some "essence." This is why a paradigm is imitable.

Several important contributions have been made to resolving this seeming contradiction. Mircea Eliade, whose contribution to comparative study of symbols' role in religion is unparalleled in the past half century, has coined the enigmatic phase "the paradigm is the real."[30] To some extent he seems to be saying much the same as Aristotle when

29. See K. Schmitz, "Community, the Elusive Entity," *Review of Metaphysics* 37(1983): 243–64.

30. See M. Eliade, *The Sacred and the Profane* (New York, 1961), 95–107, where he discusses the way in which the religious myth functions as paradigm.

in the *Poetics* he indicates that people can universally identify with a given dramatic character precisely because that character is involved in some human happening as an individual of unique "heroism." David Tracy in his *Analogical Imagination* extends the discussion into theology by exploring the character and function of "a classic." He draws from current discussion of "the classic" among literary critics but probes also the grounds for certain *happenings* or *persons* functioning as classics; obviously he sees such reflection as crucial to a Christology that takes Jesus' human career seriously.[31]

Any number of questions have surfaced in this area, particularly about the establishment of a traditional canon of "classic literature," including increased probing of the source and legitimacy of the biblical canon. Both Marxist sociology of knowledge and feminist criticism have indicated the extent to which the establishment of a canon of literature is an ideological decision rooted in social power. Beneath such questions lies the problem of trying to determine the nature and bounds of "tradition" as well as the criteria for determining the validity of any claims made for a certain view or practice being "traditional."[32]

Community

To raise the question of "tradition" inevitably leads us to the role played by various communities—ethnic, national, religious—in the literary processes debated by today's professional critics.[33]

Communities are responsible, for example, for much of the paradigm structuring that underlies literary narrative, myth, and ritual; even if one attributes these structures to certain innate forms intrinsic to human consciousness, their development still may be in large part the distillation of centuries of insight and treasured memories. Without denying the occasional and unpredictable appearance and irreplaceable role of unique artistic geniuses, literary artistry emerges from a preparatory

31. Tracy, *The Analogical Imagination* (New York, 1981), 99–229. For a short study that reviews several differing historical notions of "a classic," see F. Kermode, *The Classic* (Cambridge, 1983). The contrast that Kermode describes between the "imperial" classic which propounds an official point of view that can be differed with only under pain of being heretical and the "modern" version of the classic which is tolerant of change and plurality seems particularly relevant to the present-day crisis within mainline churches concerning acceptance or rejection of dogmatic statements from the past.

32. One of the more thorough and analytic studies of tradition is E. Shils, *Tradition* (Chicago, 1981). It provides valuable insight into the reciprocity of continuity and discontinuity and helpful guidance in discovering the influence of cultural symbols on the evolution of Christian tradition.

33. Technical discussion of what is today called "reader-response criticism" overlaps somewhat the topic here treated, but does not extend as broadly. On "reader criticism" see *Reader-response Criticism*, ed. J. Tompkins (Baltimore, 1980); E. Freund, *The Return of the Reader* (London, 1987).

cultural development of a people and must find some such receptive culture or it would not be preserved.

At the same time, the human experiences of those who make up a given literary public provides a constantly changing criterion against which any expression of the meaning of those experiences is measured. If you will, the changing scene is a powerful "deconstructing" influence, especially in times of major social upheaval. Moreover, it is the germinating insights and wisdom of the community with which the true artifact must resonate, either to reinforce or to challenge, in order for it to play an essential role in a community's cultural maturation.

Again, though the contribution of technical criticism to literary appreciation cannot be denied, a large measure of aesthetic sensitivity is developed by *praxis*, by people's exposure (ideally accompanied by some intelligent explanation) to the beautiful in language or art or music or bodily movement. Educational procedures such as the Montessori method or Karl Orf's approach to musical training have proved the formative effectiveness of such experience of beauty in a person's earliest years.

The cultural history of any group illustrates the interplay of objectivity and subjectivity in people's observation, interpretation, and expression of their life experience. What is unique about modern times is neither the occurrence nor the recognition of subjectivity in knowledge—artistic giftedness has always been seen as something internal to the poet. But only in modern times has subjective consciousness been looked on as "the real world." Yet, community existence can only partially honor this identification: communication, which is the sine qua non of community, implies a basic correspondence of internal awareness to extramental existents (including spoken words). So, while communities, especially as the level of formal education rises, can profitably take account— indeed to survive in peace, must take account—of the distinctive consciousness of each of their members, they must also depend on conventions of symbolic discourse that have a commonly understood meaning because they point to some similarly experienced happenings.

Out of the treasury of its historically evolved memory, a community provides interpretative patterns by which its members can individually and corporately understand the life in which they are immersed. At the same time those patterns of that life, always in flux and sometimes drastically so, are altered through use by people. The artist more than others is sensitive to this interplay and contributes to it by giving form to the newest stage of community interpretation. This is a role quite different from that of the "priest," charged with the preservation and performance of ritual, that is, with the forms within which previous

generations discovered and expressed themselves; religious histories record recurring tension between priest and prophet.[34]

The "dramatistic" approach to language and social evolution that was developed by Kenneth Burke and then interpreted in more sociological categories by Hugh Duncan is one of the more suggestive attempts to detail the social-structuring power of symbols.[35] Whereas Burke's theories combine much of the recent literary critical discussion with psychological insights, drawn particularly from Freud, Duncan's work brings together literary study of symbols with the anthropological/sociological reflection on symbols that we examined in an earlier chapter. Between them they illustrate the extent to which in the past several decades the notion of symbol has served as an integrating topic in both humanistic and scientific research. From the point of view of our present study, it is significant that both scholars focus on symbolic action in the field of religion.

THEATER AS SPECIAL INSTANCE

Nowhere are the intertwining of literary criticism and literary creativity and the constantly oscillating moods of both more evident than in the theater of the past century and a half.[36] Already in the 1820s and 1830s, Victor Hugo had led a movement for a more "realistic" or "naturalistic" approach to the theater instead of the obvious theatricality of Greek or Shakespearean or classic French drama. The break with older patterns found seminal formulations in Zola's advocacy of naturalism in his preface to *Therese Raquin* (1873) and in 1888 with Strindberg's introduction to *Miss Julie*. However, this was balanced by the romanticism of Wagnerian productions at Bayreuth from 1876 onward and by the emergence of a symbolist movement in theater that grew out of the symbolist school in France but quickly spread to other countries.

Interaction between the various trends was widespread, so much so that it is almost impossible to situate many of the major playwrights in

34. One of the more intriguing recent studies of the role of memory in the development of individual or group self-understanding is hermeneutical phenomenology. See S. Erikson, *Human Presence* (Macon, Ga., 1984), which probes the process by which the meaning of experience is both discovered and constructed. See also W. Brenneman and S. Yarian, *The Seeing Eye* (University Park, Pa., 1982), which applies the approach of hermeneutical phenomenology to a study of the distinctive bodiliness of ritual symbolism; and D. Levin, *The Body's Recollection of Being* (London, 1985).

35. See K. Burke, *Language as Symbolic Action* (Berkeley, 1966); *The Philosophy of Literary Form* (New York, 1974); and *The Rhetoric of Religion* (Boston, 1961); H. Duncan, *Communication and Social Order* (New York, 1962) and *Symbols and Society* (New York, 1970).

36. In threading my way through the history of recent theatrical developments I have found no book more helpful than John Gassner's *Directions in Modern Theater and Drama* (New York, 1965).

one or other school. Strindberg, for example, published his symbolist-expressionist work, *The Dream Play,* in 1902, only fourteen years after *Miss Julie.* As late as 1965, John Gassner could say this of the unsettled theatrical situation. "The modern stage has not reached any noticeable equilibrium: conflicts and confusions have abounded, an almost continuous state of crisis has existed in the theatre, and the search for new forms of dramatic art has gone on both with and without fanfare."[37] Still, throughout this constantly fluctuating development the basic patterns is a dialectic between realism and one or other more symbolic approach, whether it be symbolist theater as such, impressionism, Wagnerian opera, or Brecht's epic theater. All this seems to suggest that in many circles theater has been and still is expected to perform a role in society not much different from that of religious ritual in simpler cultures.

This social role of theater—both reflective and determinative—has certainly not diminished with its extension into the new media of film and television. Nor has the interplay of realism and symbolism been lessened. On the contrary, both television and film have opened up possibilities of staging dramas in realistic environments to an extent undreamed of by the legitimate stage—but without guaranteeing that the production is therefore more real. At the same time, such new forms as documentaries or dramatizations of recent historical events that are only slightly fictionalized raise the question about the boundaries of theater. Along with this, they may suggest avenues of creating more general sensitivity to those significant peak experiences whose meaning both underpins and is transformed by sacramental ritual.

One aspect of theater needs to be mentioned because of its relevance for reflection about liturgy. When one talks about literary criticism applied to a play, one is referring to three arts in addition to that of the playwright: the production of the play (including stage setting, costuming, music, dance, etc.), the acting, and criticism that now must judge the text, the acting, and the production. The actors are themselves interpreters of the play, as are the producers; but the mode of criticism employed by each is creatively distinctive. This means that the theater critic can never deal simply with the written text, for the play is the performance. The "text" with which the literary critic of dramatic literature must deal is the play as actually produced. Applying this to religious ritual, one can say that the "text" that is meant to bear meaning in liturgy is the enacted celebration that itself is already an interpretation of the communty's established ritual forms.

37. Ibid., 126.

APPLICATIONS

Recent literary study provides any number of helpful insights into the nature and function of Christian sacraments, especially into their liturgical moment. Conversely, some of the recent developments in sacramental theology appear capable of making a distinctive contribution to current linguistic, literary, and artistic study of symbolism. We might briefly point to seven areas where such creative interchange is already occurring or could occur with mutual profit.

Liturgy Human Discourse

It is commonly acknowledged that Christian liturgy is "word"; yet the post-Reformation period had witnessed two contrasting tendencies to deny this statement: the Protestant substitution of a "word service" (preaching and response) for ritual and the Catholic neglect of the evangelical dimension of Christian ritual. Pioneering attempts to overcome this artificial dichotomy are little more than thirty years old.[38]

As a dialogic act, Christian liturgy is not *theater*; it is not meant to be a spectacle. Yet, as we have seen, present-day Christians inherited a long-standing practice of people observing sacramental rituals while they were being performed by an official celebrant. Eucharistic liturgy in particular had become a performance which the faithful were expected to witness, and minimally take part, on a regular basis. Their motivation for doing so was fulfillment of the religious obligation to worship God. A radical shift is now occurring—for Catholics a shift made explicit in Vatican II's *Constitution on the Sacred Liturgy*—in which the liturgy is seen to be the action of the entire assembly; and the problems encountered in taking this new direction bear striking resemblance to some of the difficulties encountered by the quest toward "realism" in the theater. However, in Christian sacraments the question is not "How can the play engage human life as it is and still remain authentically *theater*? but rather "How can liturgy engage Christians in their actual life experience and still remain distinctively *religious ritual*?"

As situations of discourse, Christian sacraments, and in particular their liturgical moments, are essentially communication and therefore subject to all the dynamics proper to human communication. However, as understood in Christian faith, they are more than that: they involve divine revelation, they are Word of God; the communication taking place is most centrally divine-human communication. In and through the sacramentalities of Christians' lives, interpreted by the significance

38. For example, Karl Rahners "Word and Eucharist," in *Theological Investigations* (Baltimore, 1966), 253–86.

of Jesus' life and death and resurrection, God speaks to believers and they as hearers of the Word respond.

For those who experience being human in this context of Christian belief, sacraments provide the ultimate unifying horizon of their consciousness and affectivity. Clearly, for this to happen, sacraments must actually function as living symbols—which, unfortunately, is not always the case. But when they do so function, sacraments are word, a communicating activity that creates personal community. In the significance of the various areas of Christian sacramentality persons are meant to discover the commonalities that link them to one another: shared destiny, shared mission, shared discipleship, shared social identity, and sharing one another in friendship.

Thus, selfhood is created, not in isolated religious autonomy but rather in relationships that grow out of cognitive and affective communication. Even the unusually gifted and faithful, the prophets and saints, who apparently face greater isolation and exercise greater autonomy than others, do so as part of the effort to enrich the communication taking place in the community of believers.

The character of sacramental ritual as a community activity challenges those who would ground the unity of human knowledge in some system. Granted all the various relationships that link ideas and images into some pattern of consistency, human knowing is a *life* process; as life it grows organically and not mechanically; in both individuals and communities there is a progessive assimilation and criticism and correction and development that ideally works toward integration amid ordered complexity. When such integration is not taking place, it indicates that the psychic life of the individual or the community is not as healthy as it should be, or that the contributors to that process—such as formal education or liturgy—are functioning inadequately.

Sacramental Causation, Objective Symbols, and Subjective Awareness

Symbols do not communicate meaning automatically; their effectiveness is conditioned by the extent to which their meaning is grasped by the observer—this bears on what classic theology referred to as *ex opere operantis*. But it is not generally recognized that a sacramental symbol— for example, a eucharistic liturgy—is never neutrally objective; being a word of revelation it has a poetic/prophetic role and therefore functions in proportion to the religious insight and creative skills of those who do the symbolizing. However, there is a unique situation in rituals such as Christian liturgies: those who speak the symbol, the assembled Christians, *are* the symbol; their sacramental action is their self-expression as believers; the word they hear is themselves for they are the sacrament. The paradigm instance of this is Christian marriage: the

couple are the sacrament. In the course of their life together, each discovers his or her identity in relationship to the other, each discovers more fully what it means to be human, and in the case of a Christian marriage each person discovers the meaning of discipleship. Thus sacrament is self-discovery.

Since they are meant to transform the meaning of human life in its totality, Christian sacramental symbolisms involve interpretation of people's entire experience. Here one encounters a problem that has been highlighted by much of the debate taking place among literary critics: to what extent do Christian sacramental rituals *discover* the meaning of people and of their world, or to what extent do they *create and impose* a meaning? To rephrase the question in "political" terms: to what extent do Christian sacraments operate ideologically? At least to some extent liturgical celebrations are intended to assist the participants to make sense out of an experience of the world that is relatively chaotic. In this way they respond to the threat to meaning which a number of commentators on twentieth-century culture have highlighted. Besides, the Christian interpretation of human existence enshrined in sacraments is a profound challenge to current ideologies—St. Paul long ago said that the wisdom of Christ is nonsense to both Jew and Greek.

But it is not just awareness of meaning. The process of establishing self-identity, whether of an individual or a group, involves *decisions* as to who and what one wills to be. Freedom of the knowing and willing subject is intrinsic and essential to mature interpretation of life experience; but Christianity—and it is not alone in this religious belief— sees such freedom as limited and in need of God's action of liberating humans from evil. Such liberation comes in large part from genuine listening to the Word of God; for "the truth will make you free." Sacramental liturgy as enacted word is intended to be a freeing experience; it is intended to transform the meaning of people's lives by the liberating significance of Jesus' death and resurrection.[39]

The manner in which the self-perception and worldview of any individual or group can be transformed in liturgy is conditioned by the aesthetic sensitivity they bring to the enactment of sacramental symbol. While formal academic development of artistic appreciation is certainly advantageous, and contemporary literary criticism has done much to clarify our imaginative and analytic use of symbols, the sensitivity that enriches liturgical experience is more fundamental. It is a resonance with what is good and beautiful; it involves a reverence for creation and particularly for persons. It makes it possible for people to glimpse in

39. One of the most profound and compressed expressions of this matter is contained in John 6, where the acquisition of "eternal life"—that is, the ultimately personal existence of risen-Spirit-life—is grounded in acceptance of the one sent as "Word of God."

their particular life experience the glory of God "deep down things" and to celebrate this in liturgy. Conversely, liturgy is meant to have a sensitizing influence on Christians' consciousness, leading them as they acknowledge creation's God to greater awareness of and appreciation for that creation.

Synchronic and Diachronic Symbolism

One of the more fascinating aspects of Christian ritual (and of the Israelite/Jewish ritual that precedes it) is the interplay of what present-day semiotics refers to as the *synchronic* and *diachronic* aspects of symbolism. Because they deal with the meaning of such fundamental human experiences as birth, death, and friendship, Christian sacraments are intertwined with the pattern of symbolisms that is operative at any given moment of time. Linked with these essentialist significances are the recurring (cyclic) patterns of human experience, whether the immediate happenings such as the sequence of the seasons or the "explanation" of these happenings through the mediation of a "combat myth." Yet, these common patterns take on a distinctive meaning in each individual life and are in constant flux as the sequence of events that make up human history unfold. These events are not just individual instances of universal patterns; they are the outcome of human choices and accidental happenings and, because they challenge stereotyping and prejudice, they are inescapably iconoclastic.

Sacramental liturgy because of its eschatological dimension absorbs and transforms this latter (diachronic) kind of significance. Liturgies are covenant happenings, that is, occasions on which the group, reflecting upon the implications of its past and present, commits itself to creating a particular kind of future. Such "contractual" celebrations translate the more cyclic significances of human experience into the precise meanings of people's lives in a given existential situation. Because they are commemorative of the Christ-event and eschatologically oriented to "eternal life" and at the same time draw from the symbolism of natural elements such as food and water, the ritual forms of sacramental liturgy in themselves synthesize synchronic and diachronic symbolism. There is a further dimension to the synthesis: though the ritual patterns remain relatively constant, the ritual happenings that these patterns structure occur as part of the evolving process of a community's faith life. The eucharistic experience of a U.S. Christian in the late twentieth century is at one level coincident with the eucharistic experience of someone in twelfth-century England; but it is also very different. The life experience that provides a hermeneutic for interpreting the ritual is radically changed by the past eight centuries of history; and

conversely the transformation of human culture's meaning by euchar-istic significance is as different as are the two cultures involved.

Tradition and Life Experience

As much as any other element in a people's culture, their ritual is the agent of transmitting tradition. For Christian communities, to be more specific, it is in sacramental liturgies that their stories as individuals and communities are integrated into the recollected story of past generations of Christians. Such retelling is much more than an informative exercise that helps satisfy people's curiosity about their roots and that legitimates their activities and institutions. It is in recovering and then either cher-ishing or repudiating their traditions that people discover and create their individual and shared identities. If liturgy is what it is meant to be, it is a celebration of a community's *Christian* identity, a profession of faith, a recalling of people's story. Ritual is also normative; Christian Eucharist is the ultimate "law" that guides the community's activity, because it makes present in unique fashion the call to discipleship. However, behind the ritual form as transmitting a tradition that is instructive, normative, and hope-giving lies the generations-long ex-perience of being Christian from which the biblical and liturgical and structural expressions of Christian faith flowed. It is this experience, starting with the religious experience of Jesus, that is the primal word of God; it is in this experience that divine revelation takes place. This indicates the fundamental role of vicarious experience as word and that on two levels: the experience of previous generations of Christians, as far as that can be recovered; and the shared experience of one's con-temporaries, as far as that can be communicated. What this says relative to the use of present-day literary methodologies as aids to interpreting sacramental rituals is that valuable as accurate exegesis of the "text" is it is meant to lead beyond the text.

Narrative Character of Gospel and of Liturgy

Present-day analysis of narrative structures, of their roots in paradig-matic patterns of consciousness or in remembered experience or both, and of their role in diachronic symbolisms, has thrown considerable light on the character of biblical and liturgical expression of Christian faith. Because the belief of Christians is directed to a sequence of his-torical happenings—the life and death of Jesus and his disciples' sub-sequent experience of his resurrection, narrative form is intrinsic to expression of the gospel. The literary form "gospel" grew out of the primitive community's recollections of Jesus' teaching and healing and very likely represented an insistence on the historical grounding of

Christianity in response to gnostic attempts to reduce Christian faith to a body of wisdom teaching.[40]

Insight into the capacity of this gospel narrative to bear universal meaningfulness is provided by modern studies of fundamental narrative structures such as "the quest." Moreover, realization of the widespread use of narrative to give meaning to basic life experience in terms of movement toward a goal makes one wonder if "story" is not the privileged technique for religious education. Indeed—and this will be expanded in the next chapter—it may well be that the narrative of "history" is the only ultimate symbol for the divine saving presence in humans' lives.

But there is another dimension to Christian liturgy which, on the assumptions of Christian faith, carries it beyond other narrative or ritual forms. This is Christian liturgy's distinctive character as *anamnesis*. Like any number of other religious or cultural rituals, Christian sacramental liturgy— most obviously eucharistic liturgy—is recollection by a community of originating "events," in this case the life and death of Jesus. And as in other cases, for instance, a Jewish seder, the *meaning* of the originating events is still dynamically present in the worldview and motivations of the memorializing community. However, for Christians the originating event includes the transhistorical reality of Jesus' resurrection as "Christ and Lord," which involves his continuing personal presence to believers in each succeeding generation. In effect this means that *anamnesis* as applied to Christian liturgy implies that the mystery-event being celebrated began in the historical happenings being recalled but continues on in what Christians are now doing as body, that is, sacrament, of the risen Lord.

This distinctive realization of anamnesis is evident in the eucharistic prayer itself; in all its diverse cultural and historical forms it begins as prophetic acclaim of God for "the great deeds" of sacred history, but as the prayer moves to the formula of institution and the *epiklesis*, the psychological focus shifts; the faith of the community is now attentive to the "great deed" of salvation that God is working *now* in the presence of the risen Christ and in his Spirit-transformation of the gathered community.

Transformation through Presence

It is at this point that explanations of symbolism provided by anthropology, psychology, or literary criticism prove helpful but insufficient. These disciplines discuss the presence (or absence) of *meaning* in symbols, the presence (or absence) in thought or imagination of *reference*

40. See J. Robinson and H. Koester, *Trajectories through Early Christianity* (Philadelphia, 1971).

to some significant reality that provides "centering" for human use of symbols. But liturgy is meant to incarnate such symbol-carried meaning in the significance of the persons who are performing the ritual and who are doing so sacramentally, as symbols of the saving presence through the Spirit of the risen Christ and of his Abba. The key symbolism of Christian ritual is not that of washing or anointing or meal, but rather that of the actual persons carrying out a ritual of washing or anointing or sharing a meal. It is their gathering together in ritual expression of faith that makes *present* the risen Christ. The presence of meaning in ritual symbol is caught up in the presence of transcendentally meaningful persons.

Liturgy as Theater?

As one reflects on the theatrical ferment of the past century or so, one cannot but see resemblances to the liturgical malaise that has surfaced in the Christian churches. Yet, the more important lessons to be learned from modern theatrical developments may be negative; the things theater should be are not what liturgy should be, for *liturgy is not theater*. Unfortunately, past centuries and our own have too often looked on sacramental rituals as spectacle; even the arrangement of space within church buildings has been designed to draw an audience's attention to the sanctuary/stage "where the action is."[41] Realizing now the theological truth that Christian liturgy is something Christians *do* rather than *attend*, insight into the liturgy's dramatic dimension needs to be thoroughly rethought.

Having said this, there are several lessons to be drawn from reflecting on dramatic presentation, whether it be legitimate stage or film or televison. For one thing, in Christian liturgy as in theater the "actors" are involved in an interpretation, and the transformation of their consciousness that takes place (sacramental grace) is dependent on the precise meaning they have in mind and express through the liturgical forms. Again, the environment of the staging—the arrangement of space, the relative location of the actors, the lighting, the use of color— is an essential even though often overlooked element in the symbolic communication taking place. Then, too, the use of other arts such as music or dance must be authentic in a double sense: it must contribute intrinsically to the dramatic movement and not be adornment or distraction; at the same time it must contribute in its own distinctive artistic mode as good music or good dance. Finally, dramatic symbolism is

41. On the shift in architectural conception of the function of a Christian church building, see E. Sovik, "Images of the Church," *Worship* 41(1967):130–41 and *Architecture for Worship* (Minneapolis, 1973).

usually more communicative when it is spare, when meaning is suggested rather than imposed explicitly, when people's imaginations can flesh out the details in terms of individuals' expectations, memories, emotions, and understandings.

CONCLUSION

There is one final observation drawn from literary criticism in general and in a special way from theater that leads to reflection on Christian sacramental liturgy. It has special importance for it can bring us closer to grasping the distinctiveness of sacramentality. Literary studies draw attention in one way or another to the distancing that takes place when the meaning present in the poet's awareness is formulated in words, even inner mental words; and in dramatic presentation there is a further dimension of such distancing, that is, theatricality, which makes the human experience being portrayed a vicarious experience for the audience. Christian sacramentality, by way of contrast, is rooted most deeply in and measured in its effectiveness by the awareness, not of divine distance, but of divine presence. It is this consciousness of presence that is the core of the symbolizing religious experience. The externals of liturgy translate this awareness in word and gesture—they are profession of faith, but without the animation coming from the awareness of presence the sensible dimensions of liturgical symbol are lifeless shell. Distancing is foreign to sacramental experience; presence of course always bears the implication of an experienced "thou," but not of a strange "other," and if authentic sacramental experience of the divine causes awe and wonder this is not because of the distance of the divine but because of its intimate immediacy.[42] Openness to divine presence in sacrament is the essence of worship.

42. Bruaire, "Negation," 283, bases the possibility of humans becoming "spirit," gaining freedom and truth, on the possibility of divine *presence*, that is, on the absolutely free divine gift of self to humans.

13

Experience as Basic Symbol

In one sense it is immediately obvious that each person's own personal experience is the basic symbol through and in which that individual comes to know both self and world; and recent research in the fields that we have examined details the manner in which this experiential symbol functions. Still, recognition of daily experience as a key symbol has come slowly, perhaps because of the tendency of researchers to focus on more intense situations of human consciousness—psychological pathology, poetic creation, ethnic rituals—where the dynamics of symbolic causation are more evident.

Experience is not, as some earlier theories of knowledge contended, a matter of consciousness mirroring a prestructured outside world. We have become increasingly aware of the extent to which each human, most basically in early childhood years, needs to sort out the complex manifold of sensible stimuli and fashion it into an intelligible world. Any number of influences contribute to this process of interpretation, construction, and integration, but ultimately the individual's unique state of awareness is that in which and through which all else is known.

All this rests on humans' power of symbolizing through language and ritual and of communicating with one another through these symbols. The process of intertwined symbolization and communication involves a constantly evolving dialectic between the conscious self and "the other"; people identify themselves as they construct their world. Through this creative self/world experience people establish the "space" within which they can act with benefit to themselves and others.[1]

Accurate or inaccurate, one's experience of surrounding reality and particularly of significant other persons is, for that person, what reality is all about. The experience can be educated, deepened, altered, criticized, and corrected, but there is nothing that can replace it as the

1. See L. Elhard, in P. Homans, ed., *Dialogue between Theology and Psychology* (Chicago, 1968), 140–41 (hereafter cited as *Dialogue*).

foundation of all one's knowing. Even if one has psychologically re-treated to a world of illusion, the illusory awareness is for that person what reality is all about.

If the sequence of experiences, with its intentionality constantly po-larized by "others," is the fundamental symbol that breaks human iso-lation and provides an unfolding bridge of knowledge to the outside world, it is also the symbol within which a person comes to discover and identify himself or herself. There are degrees of insight into one's experiences, there are more or less educated interpretations of those experiences, there are varying capacities to confront with open self-confidence the implications of experience, but there is nothing that speaks more fundamentally to each person about their distinctive identity.

EXPERIENCE AS SYMBOL OF GOD

It would seem to follow unavoidably that their intertwined experience of self and world is the basic and enduring symbol through which humans can come to whatever knowledge of the transcendent, that is, God, is possible. Other "words of God" there may be, such as Scriptures or ritual, but these can find their meaning only in interpreting and being interpreted by people's experience. Various religious traditions have expressed this in distinctive but overlapping fashion—"finding God in all things," "being contemplative in action," discovering "that thou art."

There are, however, two paths that can lead from personal experience to some awareness of the divine. The one proceeds—though not all philosophical traditions agree that it can so proceed—by way of rea-soning from such things as the perceived contingency of one's self and one's world to the existence of a noncontingent. The other proceeds from religious experience, that is, one's own immediate consciousness of God or a mediated consciousness that comes in trusting acceptance of someone else's experience of the divine. It is in this second instance that one can speak about "the presence of God," a being-for-another on the part of God that is grounded, as is all personal presence, in a self-communication. All presence is conditioned by the free "listening" of the recipient of the communication; what is distinctive about presence in this religious instance is that the "listening" consists in the faith of the religious believer. Divine presence in religious experience is de-pendent upon humans being "hearers of the Word."

Current studies in hermeneutics have helped us to appreciate the extent to which and the manner in which one's presence to oneself as

well as the presence of others is dependent upon the subjective inter-
pretation that is intrinsic to all experience. Thus, religious experience
of divine presence, no matter how genuine, is always conditioned by
one's culture, by the doctrinal instruction provided within one's religious
community, by the experience of liturgy—and so constantly in need of
ongoing criticism and purification. At the same time, there is an un-
derlying core awareness of divine presence that provides essential con-
tinuity in the midst of developing consciousness, much the same as does
one's self-awareness.

In recent decades, both theologians and religious educators have
become aware of the foundational role played by personal experience.
A half-century ago almost all mainline Christian theologians were still
following the time-honored method of starting with a classic formulation
of faith, for example the christological creed of Chalcedon or a passage
from the New Testament, and attempting to probe its meaning in the
light of some other knowledge. Now theologians are increasingly aware
that their starting-point must be the shared faith experience of a be-
lieving community—though the large fundamentalist wing of theology
in the United States still insists on the biblical text itself (read "literally")
as that from which Christian reflection must begin.[2]

Much the same shift to stress on religious experience has marked the
past few decades of religious educational theory—and to some extent
religious educational practice. Benefitting from research in the psy-
chology of religion as well as from the more experiental approach of
theology, catechetical training, and catechetical materials have stressed
the role both of the student's general human experience and of his or
her experience of sharing faith within a believing community.[3]

However, in both theological reflection and religious education there
has been a laudable emphasis on awareness of self-as-related to the
transcendent and on awareness of the community in which one finds
oneself situated, but comparatively little stress on awareness of God-
who-is-present. Symptomatic of this, and perhaps its basic cause, is the
relatively minimal awareness of divine presence in the celebration of
Christian liturgy. Ritual is, as we saw in earlier chapters, meant to be a
privileged context for a community and individuals within community
experiencing ultimate meaning through becoming aware in symbolic

2. On European "discovery" of experience as a starting-point, see the dialogue of H.
Kung and E. Schillebeeckx with U.S. theologians in *Consensus in Theology?* ed. L. Swidler
(Philadelphia, 1980). However, the shift in Catholic theology was already observable as
early as Congar's 1946 article "Theologie" in *Dict. Theol. Cath.*, 15, cols. 342–502.

3. See especially the work of J. Fowler and T. Groome, *Christian Religious Education*
(San Francisco, 1980). Also W. Meissner's two books, *Life and Faith* (Washington, D.C.,
1987) and *Psychoanalysis and Religious Experience* (New Haven, 1984).

activity of ultimate reality. If ritual is not this for people, they lack the indispensable starting point for growth in understanding of their faith.

Vicarious Experience

In all human psychological existence, vicarious experience plays a major role. For each of us, present and remembered experience is a very limited affair—linguistically, geographically, culturally, and socially we have but one context of immediate happening, even with all the advantages of modern travel and communications. Yet, this severe limitation is overcome by the ability we have as persons to share in the experienced selfhood and worlds of others. This ability is so basic and so constantly relied on that people scarcely advert to it—which is another way of saying that we take for granted that we can share human life in communities of various kinds.

Daily conversation is the most common source of complementing one's individual and immediate experience by sharing in other people's. Taking for granted a fundamental human commonality in conscious awareness of the happenings of life, people are constantly communicating to one another the events, major or minor, that constitute their ongoing life history. In this way people share in the intertwined happenings that make up the history of a neighborhood or town or nation, and consequently interpret themselves and their individual experience in the light of this broader reality.

The recent explosion in communications technology has widened the exposure of people to others' experience, not just in their immediate vicinity but throughout the world. For the moment, this enrichment of consciousness is limited because of most people's relative inability to resonate with cultures other than their own; but media such as television appear capable, if used judiciously, of broadening people's horizons and opening them to appreciate the happenings in human lives worldwide.

If the phenomenon of vicarous experience can be extended spatially, it can also reach back in time through the shared memory of human communities. This can be informally realized through folklore and sagas and storytelling; it can be structured into the traditions that a group consciously transmits from one generation to another through education or ritual or law; it can be even more formally organized into the unified narrative we refer to as "history." Despite all the differing theories as to what truly constitutes history, there is an underlying agreement that historical study is meant to acquaint today's humans with what it meant for people of an earlier age to experience being human. And we often voice the hope that today's women and men can learn from this earlier human experience, that is, that vicarious experience

can provide a broader source of insights to guide our present-day decisions.

Even though Von Ranke proposed as the ideal of historical study the reconstruction of past happenings "as they truly were," scholarly historical research does not pretend to recapture the psychological states of those who lived in past epochs. Such is left to the arts, particularly to literature, where imagination enters in to re-create for both the artist and the observer a vicarious experience which, because it is highlighted, can both deepen and challenge the meaning of ordinary daily experience.

Today, film and television provide an unprecedented expansion of such vicarious experience, to such an extent that the basic sequence of exposure to human life is changed for young people as they grow up. Besides, there is an almost limitless range of vicarious experiences to which people can choose to expose themselves, from documentaries to first-rate dramatic presentations to professional athletics to soap operas to television evangelists. And then there are the experiences of fulfillment carefully suggested by television commercials. All this creates a complex symbol of human life today in the light of which people situate and appraise the happenings of their own individual lives.

Interpreted Experience

As never before, then, experiences of all kinds act to symbolize and interpret for people what it means to be human. But the other side of the coin is that all these experiences, whether individually immediate or vicarious, are themselves already *interpreted* experiences. We have seen in previous chapters the insight into such interpretation that has been provided by the social and behavioral sciences as well as by literary criticism; and we can, then, summarily list the principal interpreting agencies and note the central role played by symbols.

People's life-style and housing and dietary patterns, their family and civic and religious celebrations, their occupational and recreational use of time, their technology and art, their processes of education—in short, all the things we lump under the notion of a people's *culture*—constantly speak symbolically about the meaning people attach to human life and incarnate the values that govern the conduct of life. Which is to say that the basic day-by-day experience of people, as they interpret it in their particular historical time-frame and with the every-present mindset of their mother tongue, is an all-embracing symbol that synthesizes the manifold interpretative elements of their culture.

Another major source of interpretation is the particular happenings to which the person has been exposed in his or her past, either individually or as part of a group. While, as we indicated, this can be

expanded by vicarious experience, such extension has meaning and can enter into one's hermeneutic only in so far as it can be related to some personally experienced reality. A teacher knows that there are many topics about which students can gain understanding (as opposed to mere informational knowledge) only if they are given the opportunity to experience directly what is being discussed in the classroom. Enrichment of one's experience by exposure to a broad spectrum of happenings—for example, by living in another culture for a time—provides, then, a greater capacity to discover meanings in life.

Simply being involved in happenings is not enough, however, to guarantee a person's ability to interpret experiences accurately. If there is anything that constitutes a gain in modern thought, it is the insistance that our observations of the world around us or for that matter of ourselves, must be questioned regarding their accuracy, that our opinions and even our convictions must be tested to see if they are solidly grounded, that our knowledge must be seen as always incomplete and in need of amplification.

One is not born with such a developed ability to experience accurately and in depth. Modern development of the social and behavioral sciences has made us realize the need to discern the underlying dynamics of our actions as individuals and as groups if we are to grasp what is really happening, and made us aware at the same time of the need to employ the methodologies of these sciences if we are to have more than a superficial grasp of our experience. At the same time, such technical knowledge needs to be combined with a developing sensitivity to our surroundings so that it becomes realistic instead of purely academic. And any particular happening needs to be viewed within the broader context of present and past happenings, so that its meaning can be apraised with balance and perspective.

As we have tried to indicate, the symbols that people use in this process of interpreting their experience are of central importance, for they are intrinsic to the actual experience of people—as things happen, people shape their personal awareness of those happenings according to certain models, though for the most part they are not aware of the interpreting role of the most basic of these models precisely because they are so basic.[4] Much of the task of education in today's world consists in helping people to discover the models (that is, symbols) they are actually using, to evaluate the appropriateness of these models, and to help them develop the capacity to find and use symbols that will most accurately and beneficially shape and communicate their human consciousness.

4. On one's name as the central symbol of a person's existence, see L. Elhard in Homans, ed., *Dialogue*, 140.

In a word, we must pass from naive awareness of reality to critical awareness.[5] This requires a process of consciousness-raising which, if one is thinking of accomplishing this for the bulk of people, is an immense undertaking. Yet, there can be no more fundamental educational task; for the consciousness people have is the measure of their capacity to exist humanly and to enter into the creation of their own personhood.

The very fact that such conscientization cannot be accomplished by a person without outside help makes clear the key role of a community's transmission of tradition. Each individual human is born into a particular way of life that is grounded in an understanding of what being human is all about and inherits a particular understanding of what the good life could and should be. That distillation of previous generations of experience constitutes a group's wisdom, a synthesis of the values by which it tries to survive and prosper, and the hopes by which it guides its management of social existence. Naturally, explicit verbal instruction plays the most obvious role in the process of handing on this community wisdom generation by generation, but it must be accompanied by congruent ritual and life-style if it is to be heard and translated into people's lives. But if all these traditional societal influences mold the individual's awareness of what seems to be immediately objective experience, the experience itself gives a unique translation of the tradition that the community has been sharing with the person. Thus, neither experience nor interpretation can exist independently of the other.

HISTORY AS KEY SYMBOL

For several decades books about the nature of "history" have abounded, and historiography has become a standard element of scientific study of history.[6] This has found an interesting and instructive application in the fields of biblical and theological studies. As a matter of fact, the very notion of "history of the Bible" or "history of theology" has changed drastically in the past half century as "history" has been discovered to be *intrinsic to* the developments being studied.

In some of the earlier attempts to find a consistent unifying theme for a theology of the Old or New Testament, scholars such as Eichrodt

5. This progression toward critical awareness has been the focus of several of today's leading thinkers: for example, Paul Ricoeur, *The Conflict of Interpretations* (Evanston, Ill., 1974), Bernard Lonergan, *Insight* (New York, 1957), Karl Rahner, *Spirit in the World* (New York, 1968), and Paulo Freire, *Pedagogy of the Oppressed* (New York, 1970).

6. For a sampling of recent views of "history" see the anthology, *The Philosophy of History in Our Time*, ed. H. Meyerhoff (New York, 1959).

or Cullmann sought some overarching category—for example, "covenant"—that had served in biblical thought as an all-embracing symbol to interpret the religious community's historical experience of "divine revelation."[7] Such attempts proved futile as research into the biblical texts revealed an irreducible plurality of "theologies." Particularly since the work of Gerhard von Rad, it has become increasingly evident that the tradition preserved and transmitted by the canonical literature involved the entirety of the community's history and that the dynamics of that history constitute the very essence of its revelation. Whatever was the reality of divine revelation, it occurred in the sequence of experiences out of which the biblical traditions and writings emerged; and in the light of what we have already seen about religious experience being the primary Word of God, it is clear that theology must strive to recapture vicariously those originating experiences as its starting point.

That the happenings of any period of history will be known through interpretation, by those who immediately experience them or by those who attempt at a later date to recapture them, is clear. And some models/ symbols will inevitably be used in that interpretation. However, the prevailing symbol underneath the various interpretative symbols that have been used in various cultural/historical situations to understand the religious history of a community is that history itself. As far as is possible through careful critical historical methods, the raw sequence of experiences—which, of course, means essentially the consciousness of those who underwent the happenings—should be recovered; it is the mediating symbol through which the character of the believers as believers and the character of the divinity present in their experience can be known. It is in this consciousness that the divine "intervention" of presence occurs; this is, then, the heart of what traditionally has been called divine revelation.

We humans know the nature of things in terms of what they do— we assume that in some way an effect resembles its cause. This is the fundamental pattern of our experience, which we simply take for granted even when we know about Hume's questioning of the principle of causality and Kant's classification of it as an a priori category of understanding. So, in those religious experiences that found expression in sacred literature and ritual, humans came to understand the human person as *homo religiosus* and their divinity (or divinities) as the one(s) who ultimately guided them and their world. The symbol of divine providence pervades the world's religions but conveys a drastically different meaning as one moves from religion to religion or, within any given religion, as one moves from one historical period to another.

7. W. Eichrodt, *Theology of the Old Testament* (Philadelphia, 1961); O. Cullmann, *Christology of the New Testament* (London, 1963).

Today there is occurring what may be in human history so far the most drastic reconsideration of divine providence.[8] It comes in response to the fundamental religious question: what, if anything, is God, if there is a God, doing to influence human life? Though still alive in much uncritical belief about human life and the agencies at work in the universe, the *magical* understanding of providence (already challenged and attacked in the biblical writings) has been thoroughly discredited by both science and theology. So, too, the *miraculous* view, which sees God quite directly and in detail moving the forces of nature and of human activity, has not been able to withstand modernity's discovery of the autonomy of created reality and of humans.

What has emerged to replace these discredited understandings of divine providence is twofold: On the more philosophical level there is the insight into a creative role of "ground of being," that is, the sustaining of things in existence and operative potential by an uncreated transcendent "other." On the theological level there are the beginnings of a sophisticated "theology of presence," growing out of traditions of divine revelation and divine granting of "grace" but transformed by modern insights into the development and transformation of persons through communication.[9]

CHRISTIAN EXPERIENCE

For any theological reflection on a personal presence of the Transcendent to humans there is, obviously, no other possible starting point than the religious experience where the presence occurs.[10] In Christian terms this experience is an awareness of God's Spirit animating the awareness of a faith community; the revealing experience is first and foremost a communal experience. Obviously, it is individual believers who, each in unrepeatable fashion influenced by their distinctive personal hermeneutics, are aware of the divine presence; but their awareness exists precisely as a share in the communal awareness, a share in the community spirit. This experience is "word" to the community; it is their awareness, individual and corporate, that speaks to them a revelation about themselves and about the Transcendent. But, in faith, the experience is also the "Word of God" through which the God revealed in Jesus as the Christ is present to them through communion in the one

8. On the nature of this shift and its link with modern historical consciousness, see L. Gilkey, *Reaping the Whirlwind* (New York, 1976), 159–318.

9. See, for instance, P. Schoonenberg, "Presence and the Eucharistic Presence," *Cross Currents* 17(1967): 39–54; S. Terrien, *The Elusive Presence* (New York, 1978).

10. On personal presence and its link with the role of symbols in experience, see B. Cooke, *Sacraments and Sacramentality* (Mystic, Conn., 1983), 42–53.

Spirit. What this implies is that a Christian community must learn to hear itself, to become increasingly aware of the deeper meaning and dynamics of its own ongoing experience. It must become conscienticized, or—to use Paul's expression—it must "wake up."

Any such Christian understanding of divine presence in a continung communication depends upon two elements of Christian faith: belief that Jesus of Nazareth, having passed through death, exists transhistorically in transformed human existing that is finalized by the continued giving to humans of his life-giving Spirit; and belief that in faith reception of this Spirit the Christian community exists as body/sacrament of the risen Christ. Implied in these two fundamental tenets is the insight that a Christian community's experience of believing and of living out that belief, that is, its consciousness of ongoing discipleship through the power and direction of the prophetic Spirit, is the "word" in which it discovers the presence of the risen Christ and of his Abba as it simultaneously discovers its own identity.

Presence in the Ordinary

Since Jesus, in his historical career and even more in his risen existence, functions as unique Word to speak God's self-giving as Abba, and since Christ's Spirit experienced by the community is the same Spirit shared by Christ with his Abba, the community's experience of Christ's presence is the experienced presence of God as revealed in Jesus.

What this faith vision demands, however, is the abandonment of any imagined activity of God "behind the scenes." Divine presence is not a matter of "God being somewhere"; rather presence, as an awareness of an "other's" self-giving in communication, occurs as a constitutive element of consciousness. Moreover, while there may be "peak experiences" of this presence that occur in ritual or in exceptional moments of religious awareness, the basic and continung matrix of divine presence is people's day-by-day experience of being Christian. Liturgies may provide occasions for formalizing and therefore intensifying the awareness of presence, but this can occur only if there is the more constant "low-level" sense of presence to be intensified.

In this perspective divine providence does involve a guidance of human affairs, but it is a guidance that takes place through the divine self-gift providing both insight and motivation for humans as their decisions and actions shape history. Acknowledgment of and grateful response to the presence of this self-giving divinity, which is, the essence of worship, is meant to occur primarily in ordinary daily experience and only then in specific religious celebrations of this presence.

Throughout history the notion has prevailed that contact between the divine and the human comes only in special moments rather than

in ordinary passage of time. Frye, for one, has pointed to the constancy in the world's literature of this theme of special enlightenment coming in an "ideal experience."[11] It is this emphasis on the unusual, on what is distanced from ordinary human experience, that is being challenged by a theology of *constant* divine presence. While there remains the need for certain highpoints in experience—such as rituals—that can bring about or renew a deepening insight into life's meaning by intensifying an awareness of divine presence, there is growing theological agreement that God does not come and go in people's lives, that graces are not provided every now and then according to need and God's watchful providence, but that instead—to put it in the metaphorical expression of Rev. 3:20—God "stand(s) at the door and knocks."

It is the ordinary sequence of experiences that provides the context of consciousness in which awareness of divine self-giving and therefore the presence of a saving God occurs. All experience, then, is able to function as word of revelation if a person is willing to listen to it in honesty and respond in fidelity. Discovery of and personal relatedness to the divine does not involve a God at a distance. While conceptual and imaginative formulation of this divine presence is intrinsic to human knowing, and therefore a certain "distancing" is unavoidable at the level of understanding, the consciousness of presence—like the knower's consciousness of self—continues to enjoy a logical priority that is capable of challenging the idolatry of mental structures. What this means is nothing less than a psychologically informed reinterpretation of the classic idea of humans as *imago Dei*.[12]

Evangelization and catechesis, consequently, must deal with this primary level of human awareness if they are to effect the transformation of the human person that constitutes the reality called "sanctifying grace."[13] There has been a hesitation, among both theologians and church officials, to admit such an element of "mysticism" in all situations of genuine faith—especially in situations of non-Christian faith. For one thing, this faith always extends beyond the structures and the formulations that officials and theologians have provided and demands their continuing reformation.[14] Admittedly, there is room for self-deception and fanaticism in humans' awareness of personal relatedness

11. Frye, *The Critical Path*, 30–31. "The ideal experience itself, for the shrewder of these writers at least, never occurs, but with intense practice and concentration a deeply satisfying approximation may occur very rarely. The curious link with religion—for even writers who are not religious still often employ religious terminology or symbolism in this connection, as Joyce and Proust do—indicates that this direct analogy of ideal experience is typically the way of the mystic or saint rather than the artist."

12. Interestingly, humans as *imago Dei* are central to the influential nineteenth-century theological synthesis of Matthias Scheeben. See K. Klein, *Kreaturlichheit als Gottebenbildlichkeit* (Frankfurt, 1975).

13. See B. Cooke, *Sacraments and Sacramentality*, 230–38.

14. See O'Meara, "Beyond Religion," in *Theology of Ministry* (New York, 1983), 47–75.

to the divine; but there are safeguards against such delusion, above all in the submission of individual experience to the loving and listening judgment of a believing community. However, to deny the existence of such a basic experiential dimension to religious faith is to deny to the community of faith its corporate prophetic character. In the Christian context it is to deny that the animating Spirit of the Church is—as the most ancient creeds attest—the Spirit of prophecy.

CONCLUSION: UNITY IN FAITH?

There remains, however, a fundamental unanswered problem: how is some kind of unity to be achieved if one recognizes both the authenticity and the distinctiveness of ordinary daily Christian experience? Are we not left with a plurality of religious experiences, as many as there are human beings, extending for centuries in thousands of different cultures? What is there that can bring them into some kind of commonness so that intelligible communication can take place and genuine community in faith emerge? In the midst of these innumerable "words" is there some unifying word which all can hear, even if each hears it somewhat distinctively? Or to put into the framework of our present study, is there any symbol or myth that has the power to touch and interpret with a unifying meaning all the various life-stories of the human race?

Christianity's classic response, a response perhaps little understood, is that the one God who is revealed in Jesus is the single Ultimate, which, present implicitly or explicitly, can polarize *all* human knowing and seeking; and that Jesus of Nazareth in his life and death and resurrection is "God's parable." But is there some commonly shared symbol by which the reality and the character of this transcendent God revealed in Jesus can be expressed, communicated and made present to humans worldwide? The tentative response of this essay is to suggest that unity is to be found in the history in which we all share and into which our individual and corporate experiences fit as pieces in an immensely complex mosaic, and in ritual that enables us through its anamnetic dimension to identify with and embrace that history.

14

Theological Epilogue

For religion around the world since the dawn of time the bottom-line question has always been the nature of divine providence. What, if anything, is the Ultimate Power (God, the gods) doing to affect the functioning of the universe and the affairs of humans? Some individuals, philosophically inclined or religiously devout, have pondered the intrinsic reality of the divine, desiring to understand better God-in-self. But the practical human question, the triggering religious question, and even the sourcing question for those who seek to know God-in-self, is that of God-for-us.

Ancient nature religions, hoping to control or at least cope with the powers of order and chaos that they encountered, performed rituals and recounted myths. In succession the three great Western religions, Israel/Judaism, Christianity, and Islam, cherished the belief that the divine had *revealed* its compassionate but just relationship with humans: God is Creator, Savior, and ultimate goal of humankind. God directs the forces of nature and guides the course of history for the benefit of those humans who respond to the divine call and command; God blesses the good and punishes the unrepentant sinners. As philosophy and science emerged to propose other explanations for the functioning of nature and the course of history, the meaning of divine providence became ever more questionable and there began a demythologizing of the notion that in recent centuries has resulted in a widespread abandonment of the very idea.

For centuries, and to some extent up to the present, people thought of providence in *magical* terms. All reality, including the divine, was considered a closed system that functioned according to a predetermined pattern in which ultimately irresistible forces interacted in fatalistic fashion. In the last analysis, humans had no freedom in determining their destiny; their only hope was to discover the magical formula of ritualized words or rituals and, having discovered it, to

control the happenings of their lives. Belief in astrology is today's remnant of this magical view of providence.

Basically, the canonical writings and the traditional theology of the great religions oppose such a magical view of divine activity, though their attacks on it reflect the prevalence and popularity of magic in the lives of their adherents. However, there was little, if any, opposition on the part of Christianity (and for the sake of simplicity let us confine the discussion to it) to another understanding of providence which for lack of a more suitable term we might call the *miraculous* view. Briefly, this view sees God as constantly involved in working minor miracles, moving directly, though unseen, the forces of nature and the actions of humans. What this entails is a two-level world: a sensible level in which the physical laws and the free choices of humans seem to be the effective causes of what happens, and a behind-the-scenes level where the real determining action is being carried on by God or by spiritual legates of God such as the angels.

Modern theological history has been dominated, to a large extent, by the attempt to reconcile this view of divine activity with genuine human freedom through the debate over predestination. This debate has had a fundamental impact on the development of modern European culture. Slowly, however, as physical science has discovered more adequate explanations of the forces that shape the evolving universe, as psychology has thrown light on the forces that work in the conscious and unconscious worlds of human awareness, as social sciences have researched the dynamics of humans' shared life in society, less credit has been given to God's providential influence in these areas.

IS GOD DEAD?

And so the key question for faith and belief is no longer how providence works but, whether there is such a thing as divine providence. The question is already answered in the negative by the millions for whom "God" is a meaningless word, for whom the conclusions of science are the ultimate, even if incomplete, explanation of human existence. Scientific physics and psychology have demythologized revealed physics and psychology; *if* there is a God, that God is not active among us as a partner in the human struggle to survive and develop, but a distant and irrelevant deity.

Honest theological appraisal of this situation suggests that if the notion of divine providence is open only to magical or miraculous interpretation, that God is indeed dead. The fact that neither Christian faith nor Christian theology has accepted "the death of God" indicates, however, that there is another possible interpretation, one that can honor

the validity and the value of modern science and welcome scientific discovery as part of the effort to purify human understanding of the divine. This third interpretation see providence in terms of the personal presence of the divine that is brought about by God's self-revealing Word.

Apparently, this approach to explaining divine influence in terms of personal presence opens up a viable avenue for Christian faith in today's world, because it can fully honor science's research into the forces that work in nature and in human history. But appearances can be deceiving, for the very notion of divine-human communication seems itself a mythic attempt to deal with an ineffable transcendent. Without some such communication that would in nonmetaphorical form express the divine self-giving, "divine presence" could be nothing more than the product of human imagining. Modern linguistic analysis, as well as recent psychology and sociology, has proposed in the sharpest fashion the basic issue: what is the nonmental reality with which "God-talk" correlates?

Or, to put the question another way: can there be any appropriate religious symbols for the divine? Or are all human attempts to refer to the divine inevitably idolatrous? The historical recurrence of iconoclasm indicates that these are not empty questions. Instead, if one admits— as it seems that one must—that no categories of understanding and no images are capable of expressing the transcendent, it is difficult to identify some medium by means of which a truly transcendent divinity could reveal to humans what it is for God to be God. At some point metaphor can be helpful, but even metaphor has to be preceded by some insight and the question recurs: what medium can enable this original insight?

The bridging medium of communication between God and humans to which this book has pointed is human experience itself, the basic awareness of self and world existing. It is each person's experience that is for that individual the fundamental "Word of God." It is one's experience of being blessed or not, of self-esteem or self-depreciation, of being cared for or isolated and abandoned, that speaks concretely about God-for-us. Clearly, this raw word of daily experience requires interpretation—the entirety of education, formal and informal, is an effort to enable this interpretation. And the primary instrument for this interpretation is other experiences, the individual's own prior experience and the vicarious experiences that are shared through conversation or rituals or literature or other art forms.

Distinctive among these vicarious experiences are the religious experiences of the charismatic prophets, for it is they that bear witness to a self-revelation of God to humans that is antecedent to and irreducible to any psychic structuring. For Christians this immediate exposure to

divine self-expressing finds a unique fullness in Jesus of Nazareth and his human experience. His experienced life and death and resurrection is, as some contemporary scholars name it, "God's parable"; it is the story through which the divine reveals what it means for God to be for humans and how humans in response should be for God. While Jesus' career has undergone constant interpretation, beginning with the way in which his immediate disciples viewed him and with the traditions that underlie the New Testament literature, it is that career itself, that is, a particular sequence of human experiences, that embodies the divine self-revelation, the "Word of God." However, that distinctive "word" should not be viewed in isolation, for the fullness of the communication that takes place there is achieved only in extension of the Christ-mystery throughout history, in the relation of that core meaning to the experienced meanings of other people's lives.

The question arises, however, whether in the faith experience of Christians today the awareness of divine presence includes the presence of the risen Christ. Here, too, recent scholarly developments have had major impact: decades of critical study of New Testament texts bearing on Jesus' resurrection have moved us away from an excessively physical interpretation of the Easter event and toward an appreciation of the essentially faith character of the original experience of Jesus' resurrection. While at first this seemed to threaten the reality of Jesus' passage into risen life, it has instead opened up the possibility of the Easter experience being a constant element in Christians' faith throughout the centuries.

Some "word," however, must communicate that presence, if those accepting the risen Christ in faith are to experience him as still present to them. That such a word exists is suggested by the second development: the emergence of the *sacramentality* of human existence as a seminal theological category. This has been due in large part to the recent research into symbolism that we have sketched. Actually, a basic reorientation of theological epistemology and method is occurring; Christian life itself, particularly in its ritual moments, now functions in theological reflection as starting-point rather than as "practical application." It is in experiencing Christian discipleship—and here theologies of liberation, especially feminist theology, have made a major contribution—and in realizing its sacramental dimension that the presence of the risen Christ is experienced in the sharing of his Spirit.

It is in this way that God-for-us can be experienced as loving, caring, nondominating, exercising power as Servant rather than Lord, opposing oppression of the weak, forgiving human frailty. For those who in faith and belief open themselves to this interpretation of their life meaning, experience becomes one of God-with-us, experience communicates and establishes the divine saving presence.

Such a view of the transcendent and its relationship to the human breaks through the distancing that historically flowed from the philosophical notion of *ontological participation*. It shatters, too, the imaginative translation of transcendence as *spatial removal*—God dwelling up in heaven; or better, it makes clear the metaphorical character of such imaginative language. Thus, not only is divine power immanent as primary cause of creation, but in the mystery of transcendent personhood related to humans God is immanent, that is, present, in the awareness of those who are "hearers of the world." This resonates with the Pauline language about the salvation effected in Jesus as the Christ: believers possess, not a share in divine eternity or divine infinity, but participation in the familial relationship between Jesus and his Abba, participation in their Spirit poured out to enliven humans as persons.

LIFE IS SACRAMENTAL

If divine presence comes about through people's awareness of their life's meaning as Word of God, it follows that human experience is radically sacramental. Life's basic experiences possess a meaning capable of pointing to transcendence and it is this potential for eschatological reference that is realized in the meaning of Jesus' life and death and resurrection. For this fuller significance of human experience to function actively in people's awareness it must, at least from time to time, be explicitly and effectively formulated so that it can operate as a hermeneutic for people's understanding of self and world. This is where ritual is meant to enter the picture.

Rituals of one kind or another have always played a major role in humans' lives. To name only a few instances, they have served to initiate individuals into family or tribal groups; they have publicly celebrated and formalized marriages; they have dealt with the tragedy and mystery of death; and they have been the setting in and through which humans sought to make contact with the higher powers that they believed influenced them for good or ill. In all these cases, and in all other vital ritual, the enactment drew from and fed into the deepest meanings of people's life experiences.

For the most part, religious rituals have been characterized by their separation from the profane context of ordinary daily life at the same time as they were believed to have unparalleled impact on that daily life. As attempts to deal with the sacred, they were carried on in removed sacred space, often at times (such as the solstice) heavy with sacred implication, by persons designated and empowered by their mana and possessing secret knowledge of ritual magic. Religion dealt with mystery

that could be explained only in myth; and ritual was the dramatic enactment of the myth which allowed people to share in the mystery.

The Christian Gospels point to something drastically different: in Jesus of Nazareth the transcendent Creator becomes "personally" involved with humans' daily existence. The divine presence intended as the focus of providence in human history occurs precisely in the consciousness of this individual human. There is no need for Jesus to search for contact with the divine in Temple or harvest sacrifice or priestly intervention, though sharing in his people's religious rituals is part of his being a first-century Galilean Jew and thereby celebrating the underlying sacrality of his entire experience. The mystery of Jesus lies not in secret revelation of a distant and unknown divinity but in the intimate presence to him of his Abba.

With his passage through death and into the full Spirit-life of "resurrection," Jesus becomes the risen Christ remains present to "his own" in human history through the continuing communication of his (and his Abba's) Spirit, continues in this gift of his Spirit to be even more the embodiment of God's self-revealing Word, and extends his own sacramentality through the sacramentality of the Christian community that serves as the body of Christ. But just as the entire historical life experience of Jesus was Word of God and matrix of divine presence, so also it is people's ordinary lives that are the receptacles of divine presence.

Rituals there must be to celebrate this presence, for ritual is intrinsic to humans' existence as symbol-making beings, but these can serve as authentic witness to the God revealed in Jesus only if they are inseparable from the remainder of daily life, only if in them people learn increasingly to celebrate the experienced sacredness of every day. This is the basic challenge that perennially faces the ministry to Christian liturgy: to facilitate the interpretation of life's meaning by the meaning of the Christ-event and to draw from life's meaning to make realistically meaningful the "great mystery revealed in Christ Jesus." Christian rituals are not meant to be "religion" as that term is commonly understood.

Does it follow, then, that if the intellectual distancing rooted in philosophical notions of ontological participation and the ritual distancing involved in cultic sacrality are to be abandoned, that there is not place for the religious institutions that for centuries have mediated Christians' contact with God? The answer would seem to be yes and no. Christian faith and belief are of their essence social, and humans cannot exist or act socially without institutions. But whatever institutional forms prove necessary for the well-being of the Christian community must be such as nurture the *presence* of the risen Lord and of his Abba in the gift of their Spirit.

Drawing guidance from "the signs of the times," it seems that one key to dealing with the need to renew church structures is the recent shift towards modeling the Church as community rather than political organization. In such a view there is no place for *hierarchy* as an image of the source and nature of authority, nor of ordained who stand *between* the faithful and God rather than with the faithful in the presence of God, nor of power other than truth and love transformed by God's Word and Spirit, nor of rule other than "the kingdom of God." There will always be need for leadership, a need also for administering the practical side of the Church's life and activity; effective administrators and inspiring leaders should be sought and treasured as charisms granted the Church. But these persons are meant to perform a needed service for their brothers and sisters who share with them the saving presence of God; they are not *by virtue of official position* to be privileged possessors of faith understanding, grace-giving power, and a "direct line to God."

Changing institutional structures will not, though, satisfy the deepest need for renewal in the Church. It has been the thesis of this book that the heart of a "new creation" in Christian life must come at the level of the symbols that shape and animate the community's shared life. We must identify those symbols already operative in our cultures which are humanizing or dehumanizing; we must understand through critical analysis the actual communicating of symbols that unite us as persons or alienate us from one another; and we must discover if these bear any relationship to the sacramentality of Christians' life of faith. More specifically, we need to see how Jesus' life and death and resurrection impact as Word of God on the symbols that shape the consciousness of post-Enlightenment humanity; and having found that, we need also to find language and rituals capable of bringing together the sacramentality of today's world with the sacramentality of the Christ-mystery.

But if this task is immense, the means of accomplishing it are at hand. Because of the deepened understanding of symbolism's role in human existence, it is possible as never before to discover, appreciate, and nurture the meaningfulness, that is, the sacramentality, of our lives. This possibility is already in process of being realized. Exciting, even if often painful, the movement toward equality and freedom that is at the heart of today's social revolutions heralds a new epoch in human history. What is at stake is nothing less than the dismantling of patriarchy as the cultural framework of human life. This touches humans' self-understanding, especially about gender identification and sexual roles; it touches the application of this new worldview to people's relationships to one another; and it touches the social arrangements that result from a deepened insight into the nature of personal community.

In this period of intense cultural ferment, when accurate application

of these new insights to interpreting human experience is indispensable, Christian ritual has an all-important contribution to make. Its role is to inject into people's daily awareness the faith vision revealed in 'God's parable," the life and death and resurrection of Jesus as the Christ. But it is also its role to make believers more aware of their own sacramentality as the word, the communication event, through which God is made present in Word and Spirit.

If Christians (and others, too, in the contexts of their own belief systems) can live conscious of divine presence to their ordinary life experience, can learn to celebrate this saving gift in their human and formally liturgical rituals, and can minister to one another's recognition of and cooperation with this mystery of "God with us," the future can be enriched by a new, maturely critical, and lived-out vision of divine providence, a source of guidance and hope and creativity. God, the God of people's real faith and belief, can cease being a "distant God"—which, of course, the true God never was.

Subject Index

Index of Names

Abelard, 158
Adler, A., 302
Aeschylus, 14
Akehenaton, 131
Albertus Magnus, 200
Alcuin, 134–36, 200
Alexander, P., 98 n.32; 101 n.42; 102
 nn.45–47; 107 n.53
Alexander of Hales, 161
Allers, R., 38 n.2
Allport, G., 302 n.28
Althaus, P., 202 n.68
Amalarius, 135, 154, 200
Amann, E., 104 n.50
Ambrose, 111–12
Anastos, M., 108 n.54
Anderson, D., 100 n.37
Andrewes, L., 218
Aristotle, 159, 168, 334
Arius, 73–75
Arnold, M., 242
Ashton, M., 198
Athanasius, 73–75
Auerbach, E., 175 n.95; 335
Augustine, 29, 43, 113–19, 144–45,
 157, 168, 186–87, 189, 193–95, 214

Baldwin, J., 159 n.35
Bangs, C., 219 n.4
Barkan, L., 192 n.36
Barnes, T., 66 n.37
Barnet, H., 273
Barth, K., 243 n.62
Basil of Caesarea, 76–77
Baum, G., 272
Becker, C., 228 n.34
Becker, E., 298, 304, 305 n.37
Bedard, W., 85 n.117
Behm, J., 25 n.48

Bede, 126 n.2; 133
Bellah, R., 272, 276, 284 nn.35, 38
Bellarmine, R., 218
Benedict of Aniane, 129
Benedict of Nursia, 129–30
Benoit, A., 68 n.47
Benson, R., 184 n.119
Berger, P., 284 n.37
Bernard of Clairvaux, 146, 148, 160,
 179, 211, 213
Bernardi, J., 77 n.83
Bettoni, E., 168 n.80
Blair, P., 126 n.2
Bloch, E., 227 n.29
Blumenthal, A., 273
Boas, F., 273
Bonaventure, 161–64, 167
Bonhoeffer, D., 257
Bornkamm, G., 37
Bossuet, J., 227
Bourke, V., 114 n.15; 187 n.9
Bousma, W., 194 n.45
Bouyer, L., 219 n.6
Bowersock, S., 15 n.12
Bowker, J., 312 n.51; 313
Boys, M., 256 n.68
Brabar, A., 38 n.3
Brecht, B., 340
Bremond, H., 236 n.53
Brenneman, W., 339 n.34
Brentano, F., 308 n.43
Brooks, C., 18 n.24
Brown, E., 296 n.13
Brown, N., 300 n.24; 317 n.60
Brown, R., 11 n.1; 16 n.18; 22 n.40;
 24 n.45; 28 n.58; 31 n.64; 33 n.67;
 47 n.21
Browning, D., 311 n.50
Browning, R., 313 n.55

375